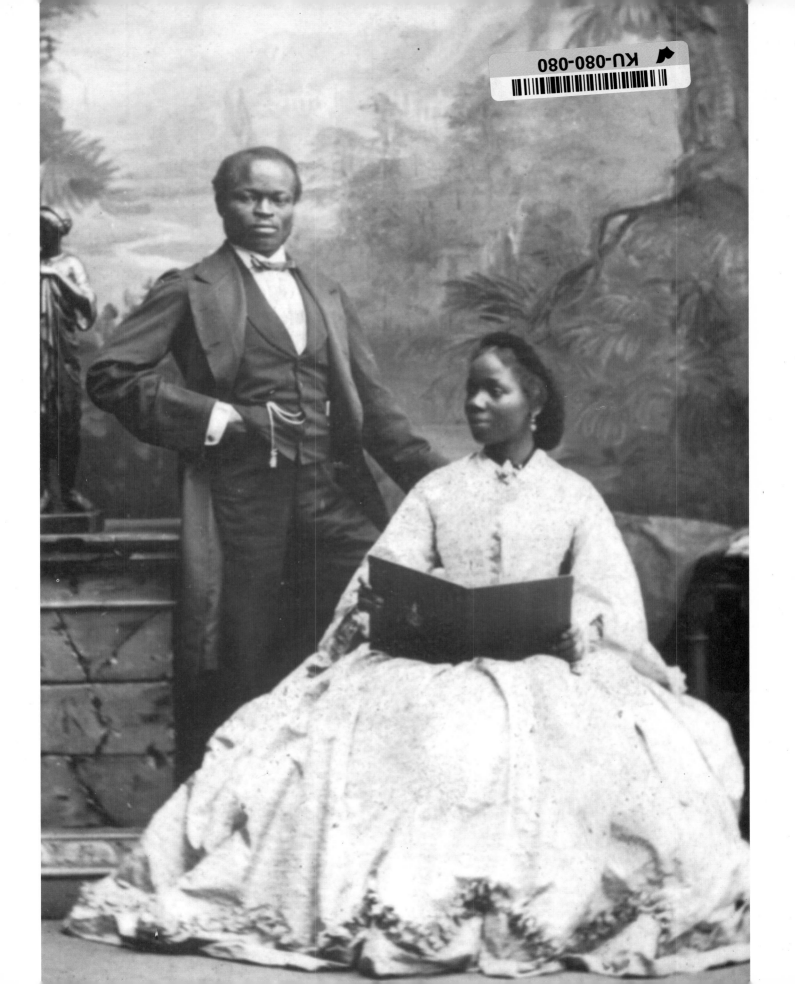

Previous page:
The Prince of Dahomey
(now the southern part of Benin)
and his wife, 1864

Paul Gilroy

BLACK BRITAIN

A Photographic History

Preface by
Stuart Hall

SAQI
in association with
gettyimages®

For Matthew and his generation

ISBN: 978-0-86356-540-3

A full CIP record for this book is available from the British Library.
A full CIP record for this book is available from the Library of Congress.

Manufactured in Lebanon by Chemaly & Chemaly

Concept developed by Endeavour London Ltd

info@endeavourlondon.com

SAQI

www.saqibooks.com

in association with

gettyimages®
www.gettyimages.com

Preface

by Stuart Hall

This book uses the photographic image to document the process of postwar black settlement in Britain in the twentieth century. It deploys the rich possibilities of the visual image, not only to record what happened but to set people, places and events in wider social and political contexts. The aim of the book, then, is to provide the resources, the visual raw materials, for a richer reading of the formation of Britain's black diaspora and the tumultuous and contradictory process of black settlement – its pains and pleasures, achievements and failures, trials and tribulations.

The experience of black settlement, which provides the underpinning narrative of the volume, has been a long, difficult, sometimes bitterly contested and unfinished story. Thanks to the amnesia which has overtaken British popular memory of its long imperial past, this is often represented in very truncated form, as if it all only began the day before yesterday. In fact, as we know, there has been a black presence in Britain for more than 400 years, profoundly shaped by the unequal relations of slavery and colonisation which connected the two societies. The legacy of that troubled past continues to influence the direction and destiny of the Black British diaspora and is present here, if only as that 'absence' which allows the 'presence' in the images to signify.

This volume is focused on a particular moment in this longer story: the twentieth century. The images are arranged in rough chronological

sequence but, as Paul Gilroy argues, the book is not in any conventional sense a history. Its main source is Getty Images, one of the largest and most diverse photographic archives. The original impetus behind the production of these photo-images was to illustrate stories in the popular press of the time – and the great majority were indeed published, with descriptive captions and datelines. Many of the later ones appeared in that paragon of photo-journal magazines, *Picture Post*. Their primary value lay in their informational content, their use of emotional impact to stimulate the viewer, or to exemplify the strange and exotic nature of their subject matter. Their 'newsworthiness' constituted the primary 'layer' of their meaning. We are interested in going beyond the documentary. Nevertheless, this documentary aspect remains a necessary starting point, particularly as memories fade and contexts are forgotten. In any event, the story is certainly not as well or widely known as it should be, even amongst those who have a stake in its future.

Readers will therefore find many familiar images of key people and representative events from across the century: Paul Robeson and Lord Kitchener, the Calypsonian; Learie Constantine and Gary Sobers; Shirley Bassey and Bob Marley; visitors like Martin Luther King, Jr and Malcolm X, homeboys like Lenny Henry and Ian Wright. Each pair of names in this casual list carries its own story about change across time, which bears on the wider issue of 'settlement'.

Some images have become iconic, like the jubilant Kelly Holmes swathed in the Union Jack, so often reprinted that they have become virtually synonymous with the events they were designed to illustrate. Others are key figures from twentieth-century black political life and thought – C L R James, George Padmore, Kwame Nkrumah, W E B DuBois – who are not so easily recognisable: their political significance for the formation of a black diaspora being less widely known, understood or appreciated. There are many images of the crisis points which landmark the process of settlement across the century: the mixed experience of prejudice and fraternization in the forces during World War Two, the arrival of the *Empire Windrush*, the Colour Bar,

the Notting Hill riots, the funeral of Kelso Cochrane, the Deptford Fire, the Brixton Riots and the murder of Stephen Lawrence.

The period seems to fall into two rough halves. There was already a significant black presence in Britain before the war – seafarers, travellers, entertainers, artisans, labourers, servants – which is well represented here. The *Windrush*, which is often given an originary status in the narrative of the formation of a black British diaspora was not really the origin of anything. Rather, it served as an important hinge between the large numbers of black men and women already represented in many walks of British social life before the war, for which the first half of the volume gives rich evidence, and the later arrival (in significantly enlarged numbers) of black people as an identifiable group, to live, work and settle on a permanent basis. This second wave included those who came to serve as volunteers in the armed forces in World War Two, and stayed on or returned, and the thousands of black migrants who followed soon after.

The story of black settlement is about not only how this generation and their successors made a life, created communities, struggled for their rights and recognition, resisted racism and established a black presence in British society, but also how their presence 'on native ground' summoned up old fears and stereotypes and awakened new prejudices and enmities among 'the natives'; how it was seen to constitute a deep threat to the British way of life as an 'alien force', and so unsettled popular misperceptions of the so-called mono-cultural character of 'Britishness' and of white British society. This is the deeper story, around which the visual 'evidence' of the book is organised.

This century, fortuitously, coincided with the domination of social representation by the still photographic image (later accounts will no doubt have to give greater space and weight to the moving image – film, televisual and digital) and the book deploys the rich possibilities of the visual image, not just to record the key events but to try to interpret what they meant to and how they were understood by those who lived them. It brings into visibility aspects of social life which are beyond or behind the headlines, in which the more immediate interests in people

and events are always embedded but which have tended to fall out of the conventional accounts.

Thus we see black men and women caught in the struggle to find a place to live and set up home in the alien conditions of urban inner-city poverty; but also, in domestic life, at home with friends and families – a dimension less public and visible, but often more intimate and revealing. We see couples 'walking out', dancing and dating, going to church, getting married, parents looking after children, and the children themselves. We see people relaxing, playing games or sport, dancing, singing and making music, drinking, entertaining themselves in the clubs and cafes, and engaging in that most familiar of West Indian pastimes – standing about at street corners, 'skylarking'. We see them struggling to get jobs, facing the tough, unforgiving world of unemployment and, when successful, the grim cycle of hard work, low wages and harsh working conditions in factories, hospitals, on the buses, hairdressing or sweeping the streets.

The selection here tries to shift the emphasis from events and personalities to this wider canvas of everyday social life. It sets them in the longer sequence of the 'social worlds' which were being constructed. It not only supplements the conventional story but provides the visual basis for wider interpretive readings. These images, then, contain a rich store of what we can only call 'indirect evidence' – if we only can find ways of getting at it. The book therefore challenges the limits, not only of what we already know but of *how* we know it. They are not illustrations to an already-completed narrative but part of a contested story whose full meaning is only now coming to light. Paul Gilroy calls them 'fragments of an unfinished history'.

The purpose of showing the images is, in the end, interrogative. The images are designed to make us ask questions. What do the images tell us about the black experience? What do they say about the way former colonised and colonisers have negotiated living and working together in the same space? When do black communities emerge and why do they awaken such hostility? How does a visible, identifiable and distinctive

black identity arise? When does racism become more visible and how much of the narrative can be organised within its stark polarities?

Here we are greatly assisted by the complexity of the photographic text itself. The photo-image signifies – communicates meaning – in a variety of different ways. The camera provides a sharp focus on what the image is manifestly about – the subject, centred in the foreground of the frame. The image is supplemented in dramatic visual and emotional impact by the ways it has been handled, its positioning, cutting and framing. These practices of representation foreground certain aspects, marginalise others. They establish a hierarchy of meanings.

But they can always be read from their margins, for their backgrounds. We can focus more on what can be called the 'incidental evidence'. Who are these people? What is their social background, their class, racial and gendered position, and do these apparently incidental things matter? What are they doing, where and with whom? What are they wearing? What do the expressions on their faces and their body language tell us about how life is being lived and experienced?

The still image arrests the flow of time, freezes the event, allowing us to look longer, get more out of it. But it is not complete – it can't, in the end, 'speak for itself'. What signifies is not the photographic text in isolation but the way it is caught up in a network of chains of signification which 'overprint' it, its inscription into the currency of other discourses, which bring out different meanings. Its meaning can only be completed by the ways we interrogate it.

Think of the graphic image of the black policeman on page 188. Its dramatic impact is enhanced by the way the figure fills the frame, is sharply focused against a blurred background; by the way head and body are tilted; by the open face, the concentrated look, the physique which fills out that prototypical British uniform and helmet; by the pointing finger. However, since the relations between black people and the police and the recruitment of black people to exercise this kind of social authority over the public have come to represent a sort of 'fever' chart' of the whole process of black settlement, and says so much about the difficult and contested issue of identification and belonging, we must

also bring a set of searching questions to bear on this image. When was this picture taken? When did he join the police force and how has he been treated since he joined? Is that date significant of certain turning points in the ongoing process of exclusion and assimilation and the progress of black people towards full citizenship? Can we read in his bearing the black self-pride he clearly brings to what he is doing – and where did he get that from? Can we read on his face the difficult choices of identity he negotiated before this decision was taken? How has he balanced the contradictory pulls between professional pride and racial solidarity?

These, of course, are questions – frameworks – we bring *to* the image in order to make it testify. They oblige the image to take its place along a spectrum of belonging and identity which has proved to be such an important part of the contested process of settlement. No wonder the figure – so fully self-sufficient in its own terms – says *so much more*, appearing to connect a past we can no longer clearly see and a future which lies beyond the frame towards which he is urgently pointing.

Introduction

No single book of photographs can furnish a complete documentary record of black life in Britain. That history is too big, too complex and too diverse to be plausibly organised into a single, seamless visual sequence. The ambitions of this collection lie in a different direction. It aims to present beautiful fragments, startling components of a whole but unfinished historical experience. I hope that the frame and some of the mortar for this mosaic will be provided by the viewers and readers. A collaboration of this kind results in a distinctive and uneven sense of history. Its inconsistencies are more than just a reflection of the patchy coverage of black settlement in the newspapers and magazines from which the images in this book are largely drawn.

The archive that has been filtered in order to produce this selection, assembled from images of newsworthy and sensational events, is enormous. Its original purposes were a long way from the commemorative intentions that underpin this project. The pressures that shaped it do not

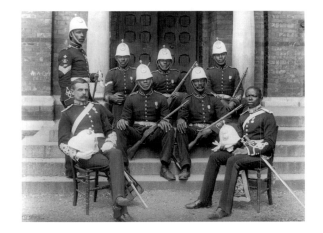

Representatives of the African colonial forces of the British Empire in England for Queen Victoria's Diamond Jubilee, 1897

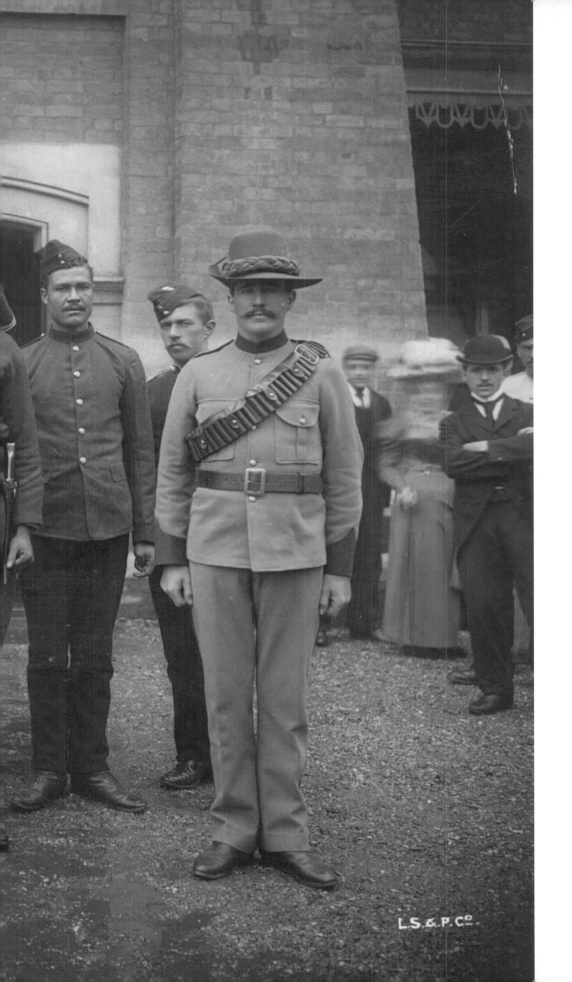

Colonial troops of
the British Empire
in England for the
Diamond Jubilee,
1897

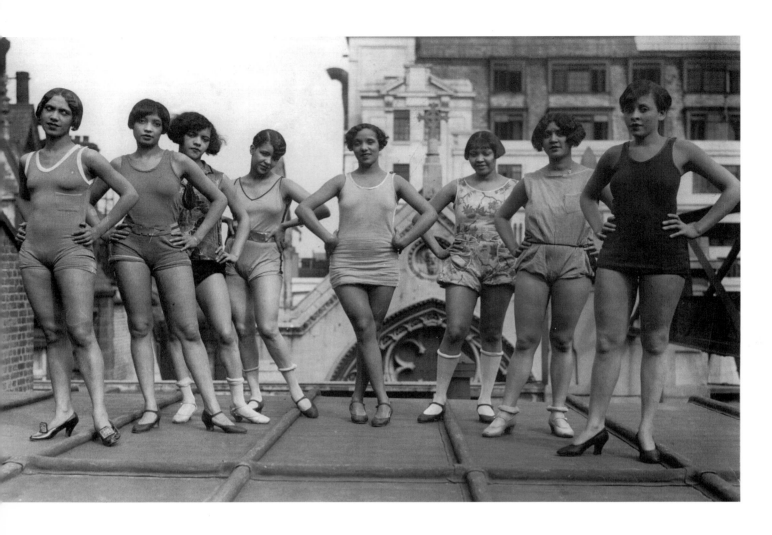

Champion Charleston dancer Gwendlyn Graham with the chorus of *Blackbirds* on the roof of the London Pavilion theatre, 1928

correspond to the untidy task of documenting the life of a community in the making. Instead, the archive reproduces the narrower image-world of the popular publications where most of these pictures were first published – not as illustrations but as powerful visual components in larger, urgent arguments about nationality, community, morality, justice, poverty and inclusivity as well as changing patterns of government at home and abroad. Public understanding of the country's racial problems was actually created in and transmitted by those pages.

Most of the time, Britain's black presence was identified and projected there not as a single difficulty to be overcome but as a series of interlinked social, economic and political problems for the nation either to solve or to tolerate. These problems were not always simply imported by the immigrants themselves. Sometimes they were, like Britain's 'Colour Bar', ugly and shameful reactions triggered by the incomers'

arrival, for which they were cruelly and perversely held responsible. The pictures occasionally transmit the idea that the immigrants have been caught up in a web of local conflicts that they did not create, but which will only ever be solved if their situation is taken into account.

Official visits made to the UK by rulers, military personnel, celebrities and entertainers from overseas are prominent in the pictorial pageant of the archive. A few homegrown black stars drawn from the worlds of sport and entertainment are over-represented, and such figures started to appear more frequently as black culture circulated more widely and found new users.

The pleasures and duties of Empire were brought home to Britain's domestic readers, and later on photographs were used to summon up all the difficulties and stresses that had been triggered by black settlement. After that, the questions of whether and how black incomers might

African children at the Cape-to-Cairo Red Cross fete at Central Hall, London, 1915

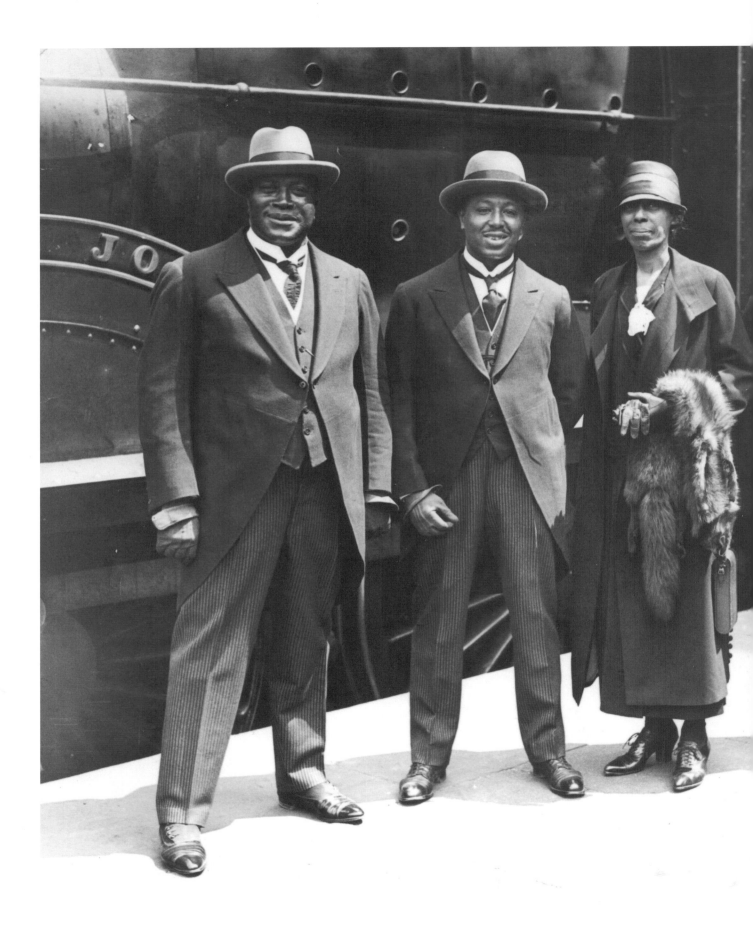

The American Fisk University Jubilee
Singers on their way to Windsor
Castle to sing for King George V and
Queen Mary, 11 June 1925

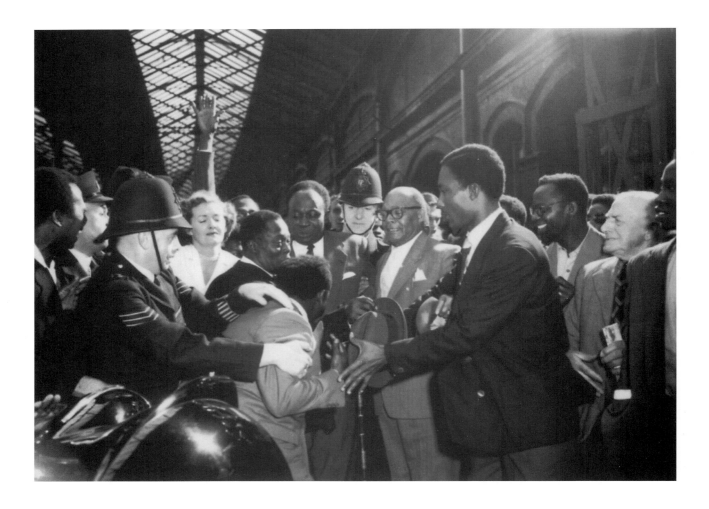

Ghanaian Prime
Minister Dr Kwame
Nkrumah (next to
a police constable)
arrives in London for
the Commonwealth
Prime Ministers'
Conference, 18 June
1957

Facing page:
Children in Bute
Town, Cardiff, 1954

belong to the national community unfolded slowly. A distinctive body
of images addressed to that possibility was gradually created.

It is important to remember that this archive was not shaped
by any worthy impulse to record the progress of Commonwealth
immigrants as they became settlers and citizens. It grew from a simple
commercial plan to sell more magazines by entertaining, warning
and even shocking readers into a new understanding of what racial
differences might mean in increasingly postcolonial circumstances.
At one pole, large-scale immigration and, at the other, the emergence
of newly independent post-imperial nations defined the political field
in which this novel understanding of race and nation would evolve.
The visual archive that resulted was not tainted by those commercial
origins, but its fluctuating thickness corresponds to the periods when
the publications that formed it were at their most popular and when the

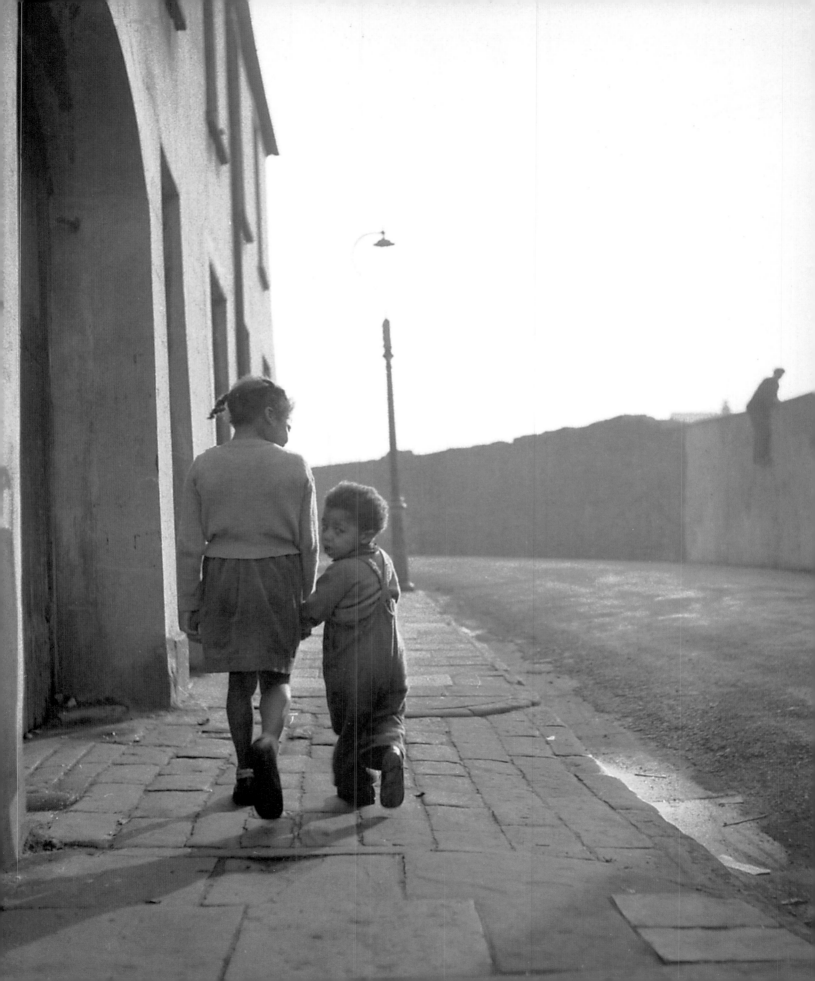

history of black settlement here was judged to be at its most eventful, particularly after the start of substantial post-1945 settlement of citizens from the emergent Commonwealth.

The earliest photographs displayed in this book reveal that black social and cultural life in Britain significantly preceded that official mid-twentieth century moment of arrival. The consolidation of Britain's black communities challenged the idea that immigration was a series of difficulties that had been imposed upon an unsuspecting nation. There was continuity to the idea that Britain had acquired a national race problem, but there were also moments when the common-sense authority of that fearful diagnosis started to fade. In those flashes of an alternative understanding, the challenges involved in what we would now call multicultural coexistence with newly-arrived black citizen/settlers and their children begin to appear in a different light. At that point, another burden falls on to the shoulders of the incomers and their advocates. The visible immigrant presence can project tantalising glimpses of Britain's hopes for a more just and less conflict-ridden future. Images of the immigrants' difficult lives are deployed to convey the country's desire for redemption from the racism that had made the war against Nazism and Fascism necessary and the processes of decolonisation painful and difficult. Those poignant images of frustration and injustice could communicate uncomfortable truths that merely political words were, at that point anyway, simply unable to name.

Three seamen outside Dumbar House on the West India Dock Road, Limehouse, London, circa 1925

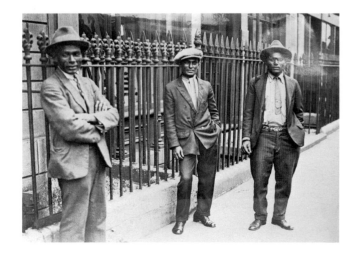

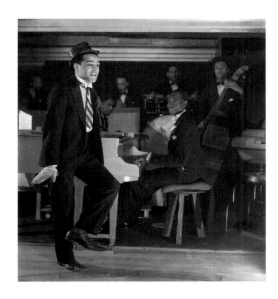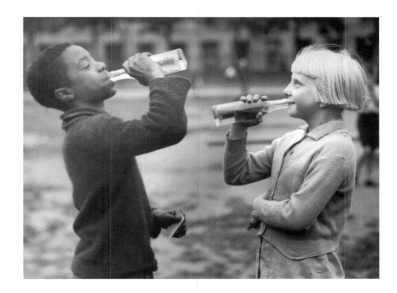

Nowhere is this power more apparent than around the idea of racism. It could not be spoken of in polite company, yet the images that captured it could convey its poisonous force and corrosive effects on the quality of life for both the immigrants and their hosts. The histories of settlement and struggle celebrated here should not, therefore, be interpreted as a simple journey from invisibility to visibility. They help to identify a number of additional steps that can be understood best as a series of bitter negotiations over the terms and conditions of visibility. In other words, these images were often ambiguous, and usually contested. It is sometimes impossible to separate their power and moral currency from the struggle to control their meaning. That cultural battle was conducted alongside economic campaigns against exploitation and political activity aimed at justice, equality and winning recognition. We will see that sometimes these various strands of community-building activity were close together, but that there were also long periods when they drifted apart. That pattern accentuated fluctuations in the rate at which the images appeared and in their ability to get a grip on a changing postcolonial world divided by racism.

This photographic archive is also uneven because some of its images are well-known – even iconic – while others are so unfamiliar that to encounter them can prove something of a shock even now. This collection places the familiar and the unfamiliar together. In doing

Left: Organist Fela Sowande accompanies a comic dancer and member of 'Dark Sophistication' at the Old Florida nightclub, London, January 1938

Right: Two children from Tiger Bay in Cardiff during a day of tea and games sponsored by the Colonial Defence Association, 31 July 1938

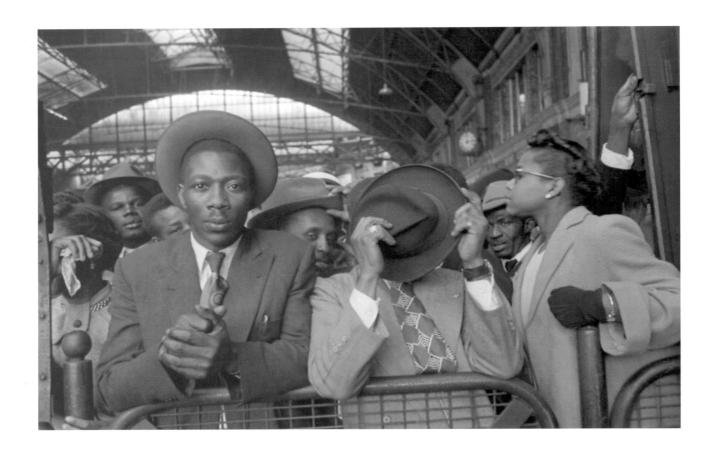

West Indian
immigrants at
Victoria Station,
London, after
their journey from
Southampton Docks,
27 May 1956

so, it aims not only to stimulate memory but also to challenge it. The selection that follows includes an invitation to reread the better-known images in new settings created by the pressure of less familiar ones. Hopefully, the important work of commemoration will be transformed by an experience of discovery that accompanies it. Both experiences are carried along by the promise of making Britain into a different place: somewhere more at ease with the irreversible fact of black settlement and more able to reconcile itself with the ongoing consequences of its long colonial past.

One last aspect of the archive's unevenness derives from the way that these images have floated upwards from below rather than drifted down from on high. In the book's later stages, as it moves closer to the present, the images project an open history that engages the living memory of viewers and readers more directly. Those almost contemporary photographs ask powerful if implicit questions. Who and what is going to be included in Britain's official portrait of itself, and how has that

official portrait changed over time? An important task of this collection may be to suggest how a multi-ethnic and multicultural nation can belatedly rediscover itself in the vibrant photographic sequence that shows its zigzag progress, first from Empire to Commonwealth and then into the new political and cultural environment represented by a dazzling and largely peaceful multiculture that nobody had anticipated.

Racism in Britain has often denied black life here any historical dimension. The resulting condition of 'historylessness' has been a measure of black marginality. The contemporary struggle against racism has sometimes involved a grim tussle over what can count as authentic British history. The place of empire, colony and commonwealth in that narrative has been especially contested. Black communities have had to fight not just for rights and for justice but also for a measure of recognition linked to demands for an overdue acknowledgement of their incontrovertible belonging to Britain. As those conflicts have been recognised as elements of national history, we have discovered that the

Immigrants from the West Indies arriving at Southampton, 27 May 1956

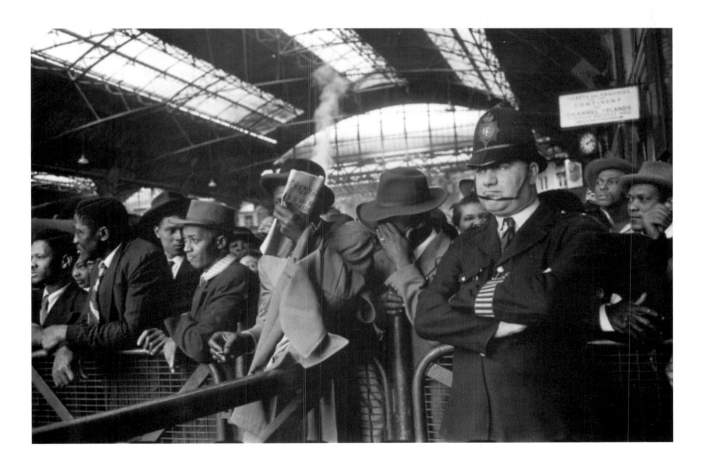

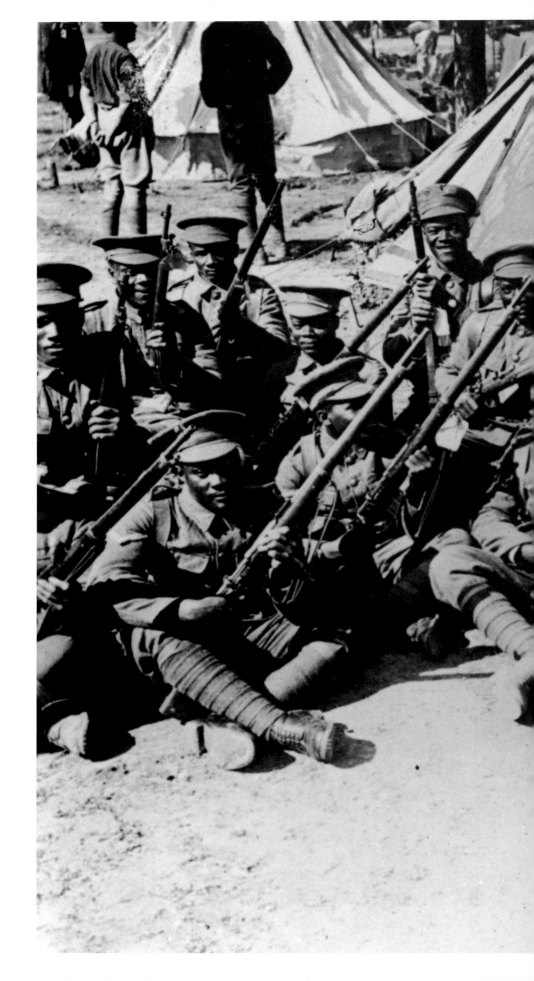

West India Regiment,
Amiens, 1916

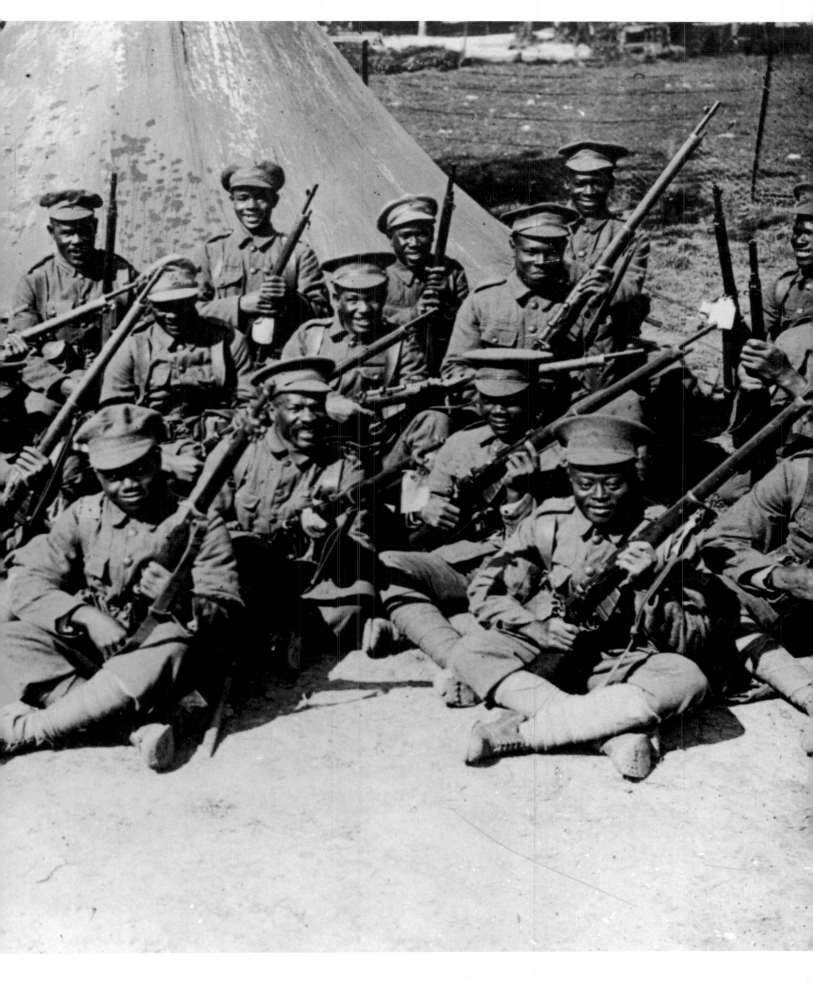

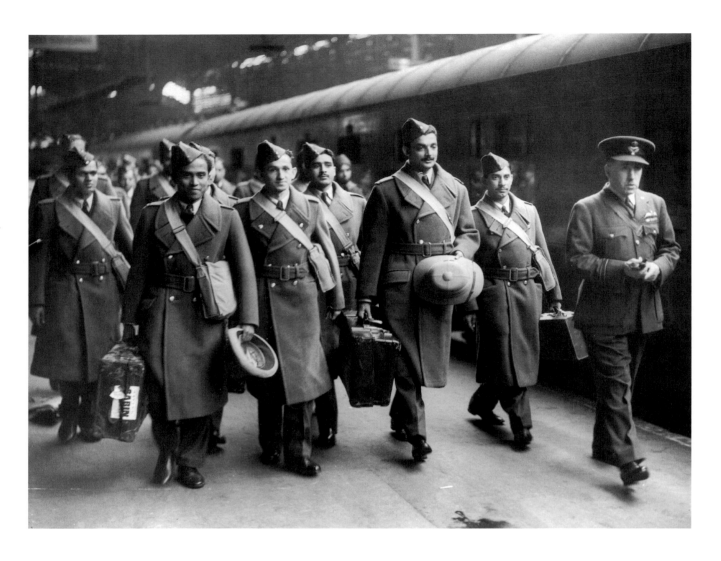

Indian pilots arriving
at London Station
were greeted by Dr
Louis Greig,
8 October 1940

line between the past and the present is not as fixed as we thought it was. It can be moved around. Where the threshold between past and present falls determines when and how this embattled history can appear, what its shape will be and the extent of its claims upon those who inherit it.

It should be obvious that bringing these diverse images together has involved a number of inescapably political decisions. The selection below includes a few that foster understanding of the forms that racism took and others that help to reveal the character of the struggle against it. Though it would have been easy to exclude them, the organised racist groups that campaigned for the 'ethnic cleansing' of the country have been made visible here because this history is incomplete without acknowledgements of their activities, which were also part of how the black community was formed. Whether they came from the

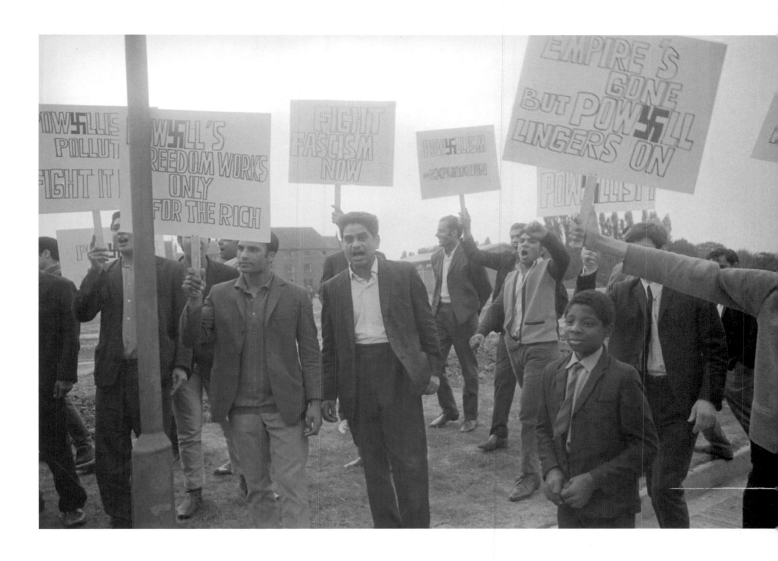

Anti-racist demonstrators in Wolverhampton protesting against Enoch Powell's controversial immigration policy, 9 June 1970

British Union of Fascists or their post-1945 descendants, informal and spontaneous associates like the Teddy Boys, skinheads and other freelance killers, it seems to me that their presence is a small but significant part of the story we need to construct in order to endow our belonging to Britain with depth.

Though it is now felt to be far away, some pictures have been drawn from the era in which Caribbean- and African-descended peoples made common cause with various communities of South Asian origin through the mediating symbol of blackness, based upon the simple fact that for most of the period covered by this volume all non-whites could be judged and dismissed as wogs, niggers and jungle bunnies. That alliance is an important part of the history of black settlement here. Of course, other, more uncomfortable questions, such as how

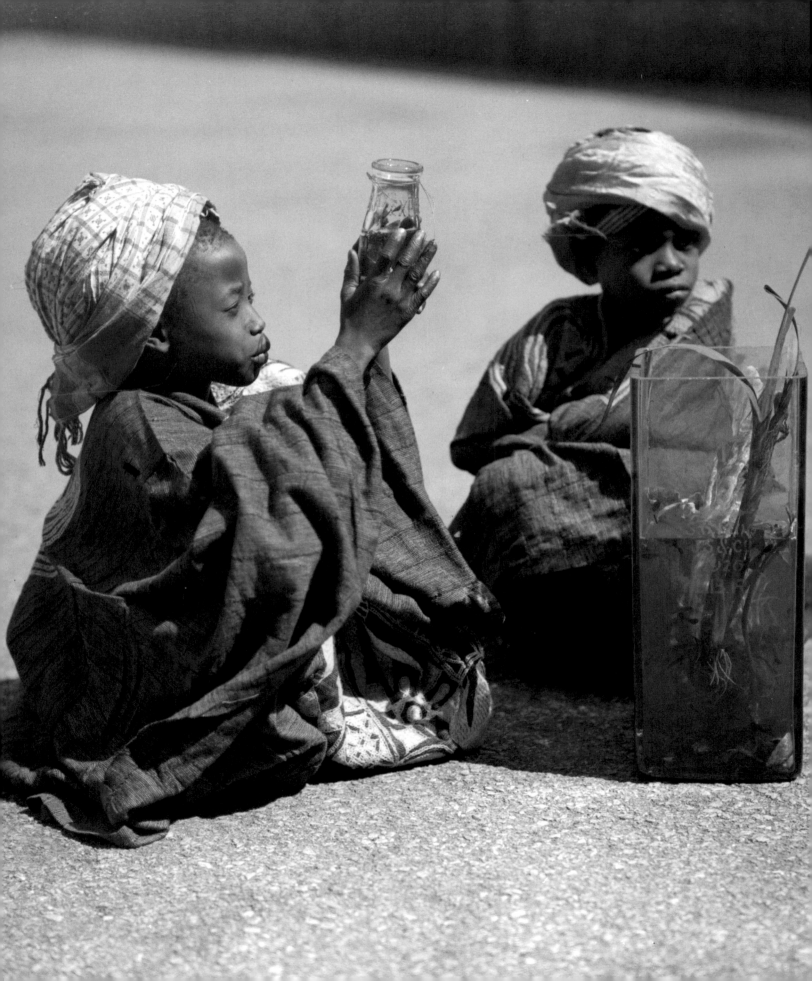

struggles conducted elsewhere – by African Americans and by colonial peoples battling for independence – informed, inspired or just touched the choices of black Britons, remain pending. These photographs suggest only tentative answers as to how to we should grasp the global dimensions of black Britain's local experiences. I hope that taken together, those small gestures will contribute to a distinctive tone in which the images, and the histories they produce and prompt us to recall, are not prematurely closed off or boxed in but remain open to the breadth of the world that can never be reduced to the workings of racial hierarchy alone.

I must say loudly and clearly that the issues raised by making the history of black Britain visible in this way cannot easily be separated from the problems involved in remaking British history in more inclusive and more accurate forms that might even foster the self-consciousness of a multicultural nation at ease with the irreversible fact of its own diversity.

This is not a book for black people only, and the history it marks out is not held collectively and exclusively as their property. This is a history that, even now, those who are complacent, powerful and indifferent to the suffering of Britain's minorities find easy to overlook.

A family at home in Tiger Bay, the dockland area of Cardiff, 18 March 1939

Facing page: Grandsons of Nigerian ruler the Emir of Katsina, examining a jar of tadpoles at a school in Acton, London, 15 May 1933

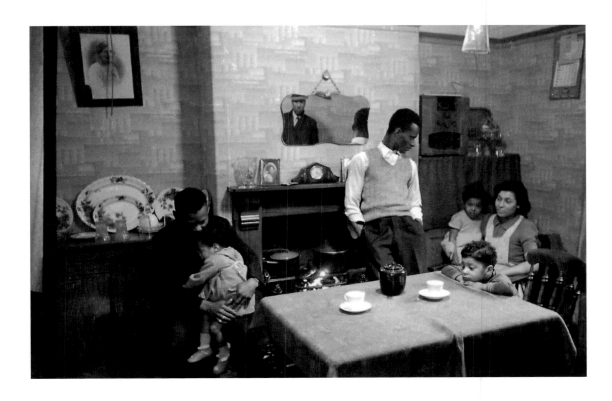

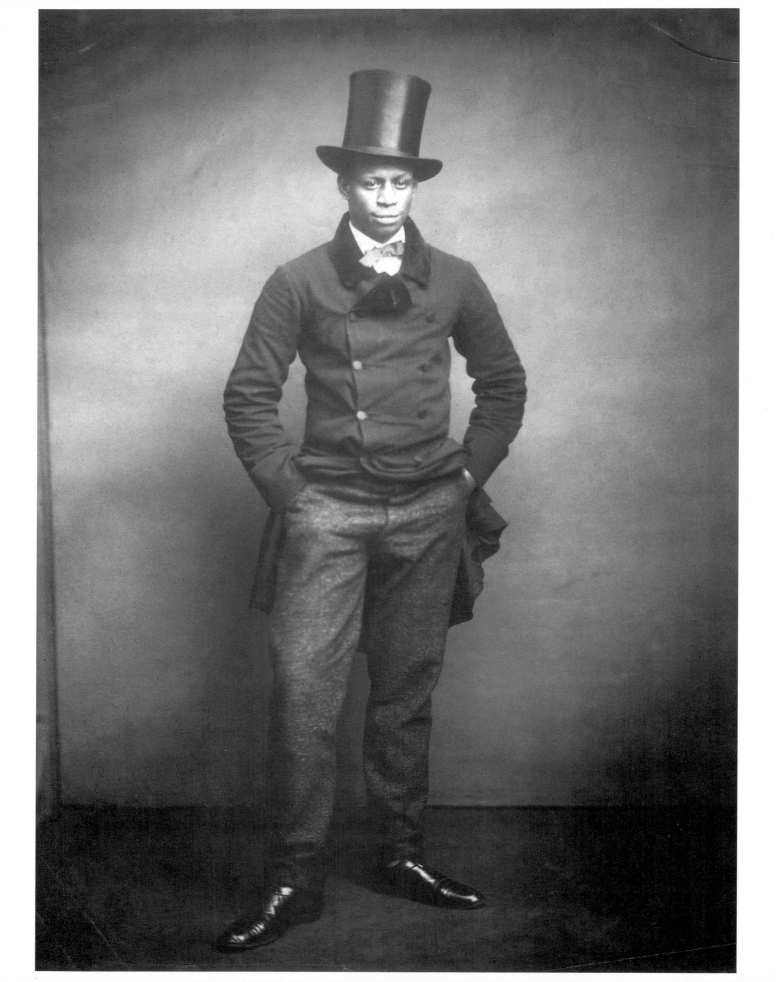

A young man looks past the camera with an enigmatic half-smile. His carefully posed stance, the angle of his shiny top hat, his tie, his collar and his fashionable demeanour all confirm the accuracy of the caption from the archive that had originally supported this portrait: here, indeed, is 'a young dandy'. This dandified young black man appears to be pleased with himself. Without props or backdrop he seems comfortable with the prospect of seeing himself being seen. The shutter may even have captured him anticipating just how good his photograph is going to look. Perhaps the cool pose he has struck helps him to feel able to control the terms on which he is to become visible.

There is much more to this affirmative image than the racism that we know must have been swirling around the nameless young man in 1890. The scramble by European states to set up colonies in Africa was underway and many Britons encountered black people as slightly less-than-human forms of life fit to be placed on display in fairs, circuses, zoos and dioramas. This had indeed been the fate of the troupe of Pygmy visitors whose portrait is included below and who were on show in Britain between 1905 and 1907. By contrast, this young man's carriage and seeming confidence draw the eye. His evident self-possession invites our interpretations but somehow defies them at the same time.

Without the young man's name or any context for his portrait, today's viewers are required to assemble a historical frame for him

Facing page:
A young dandy wearing a formal suit and top hat, circa 1890

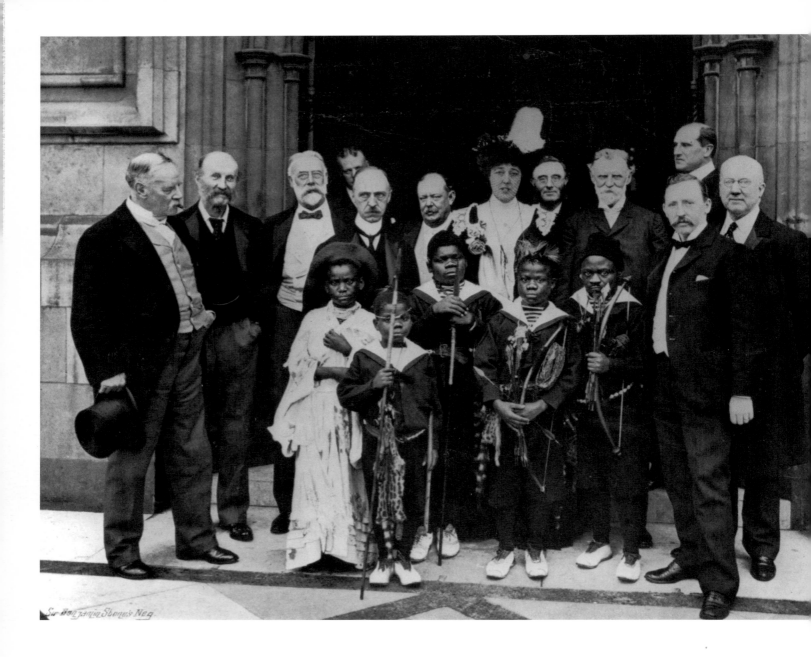

Pygmy tribespeople from the Ituri Forest in Central Africa, on the terrace at the House of Commons, 1902. Members of Parliament standing behind them are, from left to right: Sir John Batty Tuke; Lord Nunburnholme; Mr Price; Mr J Harrison, explorer; Sir Charles Cayzer; Mr King; Lady Hutchinson; Sir Walter Foster; Sir R Ropner; Mr N Hoffman, interpreter; Sir Lees Knowles; and Sir Charles Hutchinson

and, at a considerable distance, to imagine his history and personality as things that lead up to the present. His anonymity is also significant. It offers an appropriate point of departure for this commemorative enterprise. In these pages there are many individuals without names whose lives still contribute precious historical resources to the collective life of black Britain. This anonymous young man looks as though he might have been local, but he was photographed on his own. That solitary condition prompts us to consider how much work was still to be done in building the variety of communities we are now able to take for granted.

Throughout the twentieth century, British cultural life registered the impact made by a succession of black travellers from Africa, the US and the Caribbean. The first of those visitors were as important in giving meaning to black life here as the ordinary working people who were busy carving out their lives against the odds at the other end of the social and economic scale. Initially, the more visible black elites often consisted of dignitaries and military personnel coming to Britain to enact their loyalty to the Imperial Crown. Other visitors would be drawn from the fields of sport, theatre or music, and as the movements for independence from Britain grew, increasingly from colonial and Commonwealth politics.

Sheikh Abdullah Ali al-Hakimi leads a procession of Muslims along the streets of Cardiff, as part of a religious ceremony honouring the memory of Sheikh Ahmed ben Mustafa al-Allawi, 22 August 1937

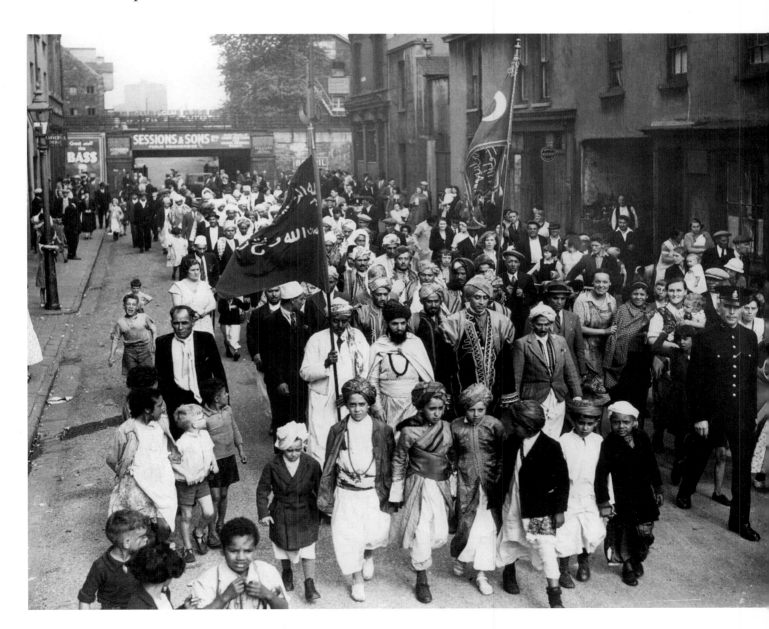

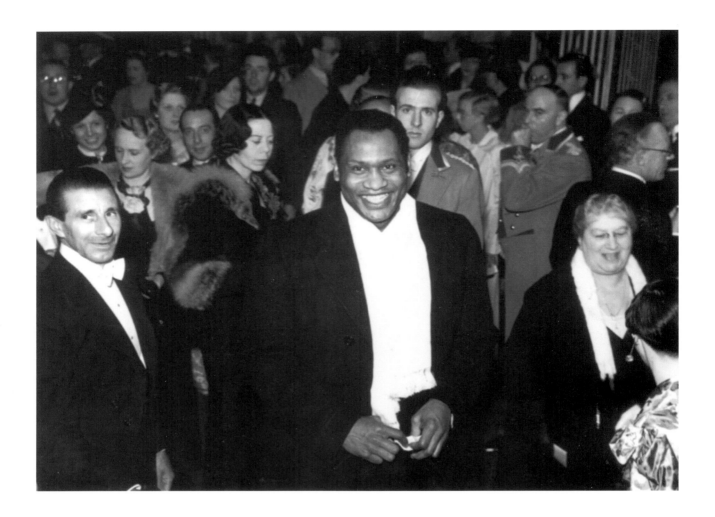

American singer and actor Paul Robeson (1898–1976) at the first night of *Showboat*, in which he starred as 'Joe', Leicester Square Theatre, London, 1936

Facing page: English boxer Dixie Brown with his children, 8 May 1936

The presence of those notables and celebrities shaped the wider meanings of blackness that were in transatlantic circulation. They also helped to define what racial difference would mean in the popular consciousness of both blacks and whites. The first decades of the twentieth century saw black culture being packaged and sold for profit. These cultural commodities could be carried across the world by performers and players and be transmitted far from their places of origin in such forms as sheet music, phonograph records, books and films.

The demand for justice under colonial rule, the struggle against lynching in the US and the concern for the plight of indigenous peoples in Africa and Australasia were among the more explicitly political initiatives undertaken during this period in the name of race. None of these activities stopped at national boundaries.

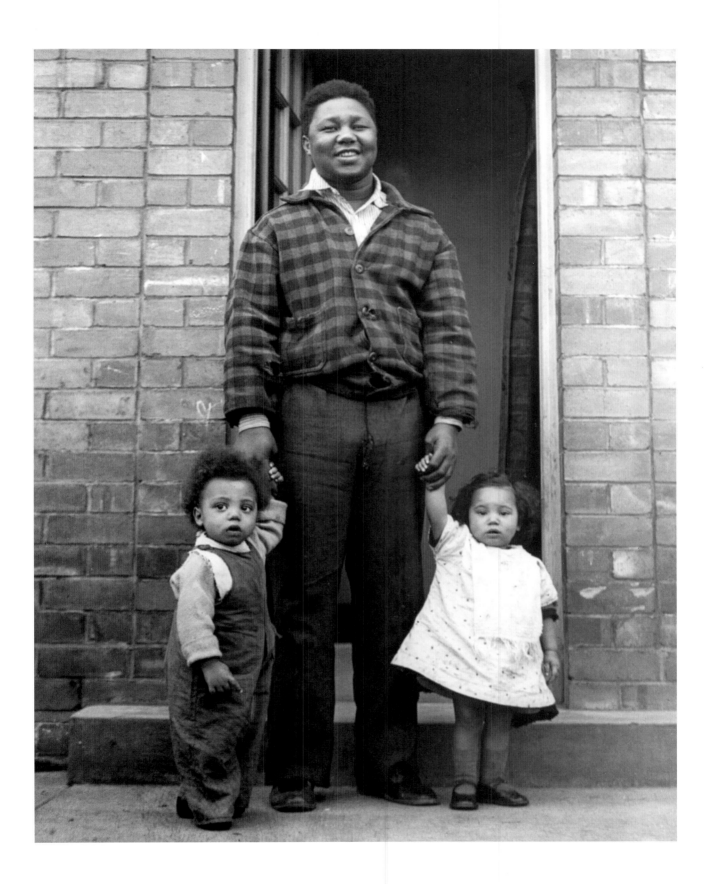

In the aftermath of New World slavery, some of Britain's most important black visitors were engaged in establishing African American culture as a significant commercial force by finding new remote markets for it. As a result of their efforts in what we now think of as the cultural industries, elements of that culture became both valuable and popular. The automatic assumption that being black necessarily involved being poor started to alter.

A world away from the prominent actors, singers and crowned heads were the seafarers whose lives and casual labour lay at the core of Britain's long-established areas of black settlement in port areas like Cardiff, Stepney (London) and Liverpool, where discrimination and prejudice were routine.

During the summer of 1919, Cardiff was the scene of extensive and violent rioting in which firearms were widely used. The disturbances began after a scuffle between black and white men escalated into several days of organised attacks on the city's black population. The immediate causes of this conflict lay in the economic recession that had hit the shipping industry particularly hard and intensified competition in the labour market. These riots were characterised by various patterns that would recur throughout the century. There was a degree of collusion between police and the racist mob, and there were repeated coercive attempts to deprive black seamen of their citizenship, confiscate their passports and force them back into the status of aliens, as though their belonging to Britain were not only inconvenient but wrong or inauthentic. The tempo of the conflict was maintained by anxieties about the consequences of sexual contact across the colour line. The situation in Cardiff remained tense and precarious throughout the inter-war years.

George Dixon, an unemployed, sixty-seven-year-old sword swallower who had worked in Lord Sanger's travelling circus, has a weary face that looks as resilient as the stone 'hut' in Pontypridd where the intrusive camera has captured him brewing up his tea. Dixon's worklessness signals the disposability of black labour and points towards the uneven distribution of work in a society and an economy

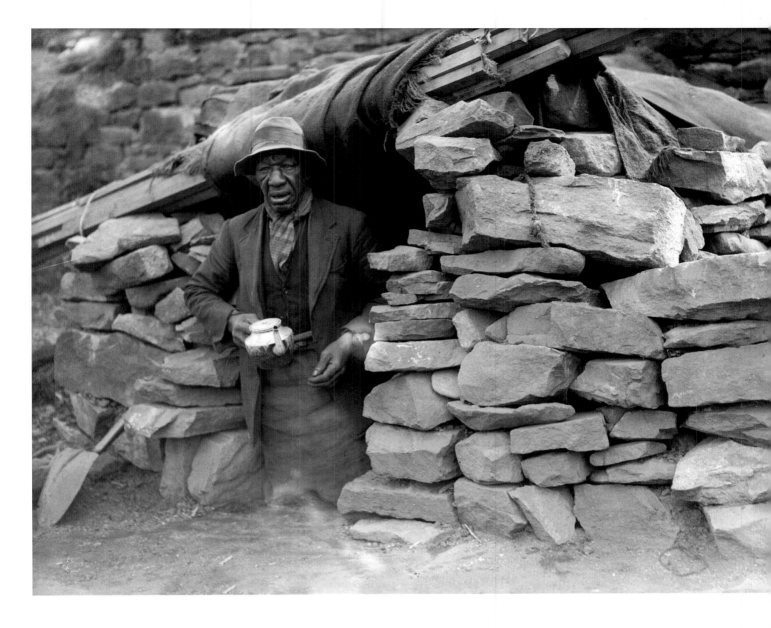

Unemployed sword swallower George Dixon in front of his stone hut in Pontypridd, 22 May 1936

that could function without challenge along racial lines. He, too, has been photographed alone. On the other hand, Pastor Kamal Chunchie was a veteran of World War One and a convert to Methodism from Islam. In 1930, from a base at the Coloured Men's Institute he had established in London's Canning Town, he was busy with the task of organising a community clinic that would work against the social perils of opium. He and his team have been pictured with the ancient technology of the wind-up gramophone, which looks as though it has been enlisted in the pursuit of their good cause.

The atmospheric image of a nameless model sitting for an art class

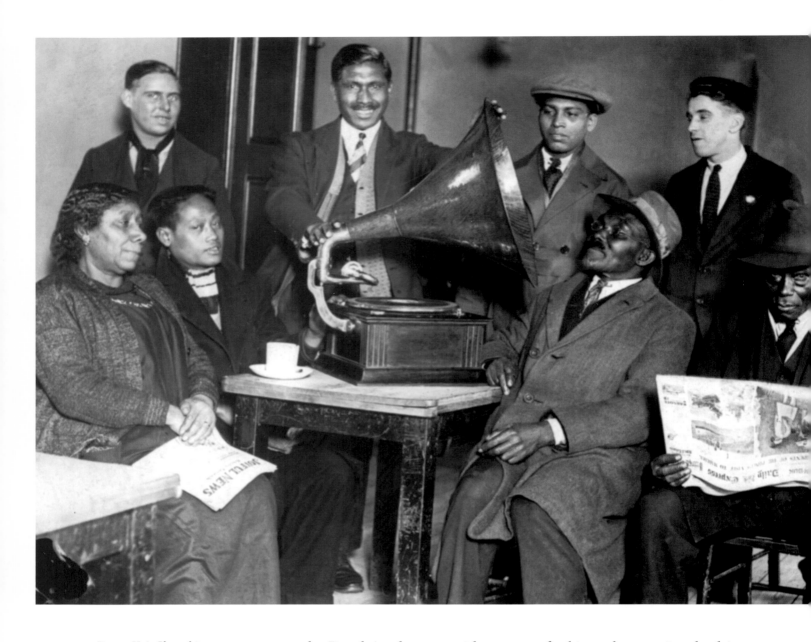

Pastor K A Chunchie with his assistants at London's Docklands where he started a clinic to treat opium addicts, 1930

at the Royal Academy provides a way of asking what was involved in submitting to the special forms of scrutiny that were directed towards the bodies of the racially different. Here, it should trigger inquiries into the rules that governed the representation of racial difference. It prompts us to reflect both upon the issue of how race becomes visible and on the related question of how it feels to see oneself being seen, to be caught by the gaze that is powerful enough to fix people in racialised roles that they cannot escape.

It is easy to forget that the rare act of actually touching a black person for luck was a well-established folk practice in many parts of

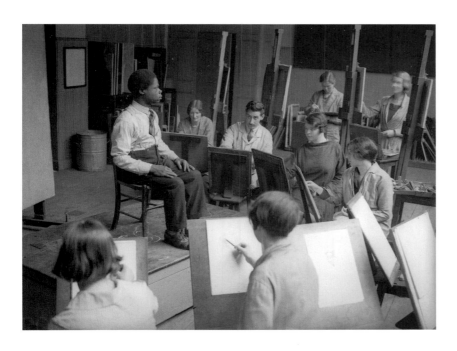

Left: Artists at the
Royal Academy of
Art, London, 7 April
1930

Below:
Racing tipster Prince
Monolulu, June 1931

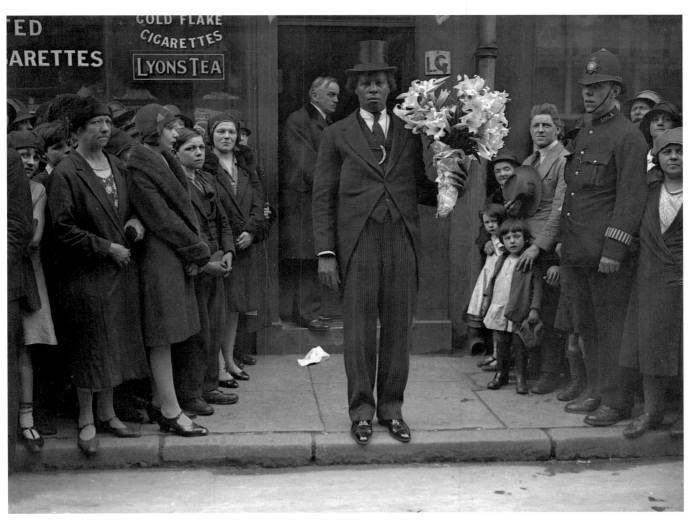

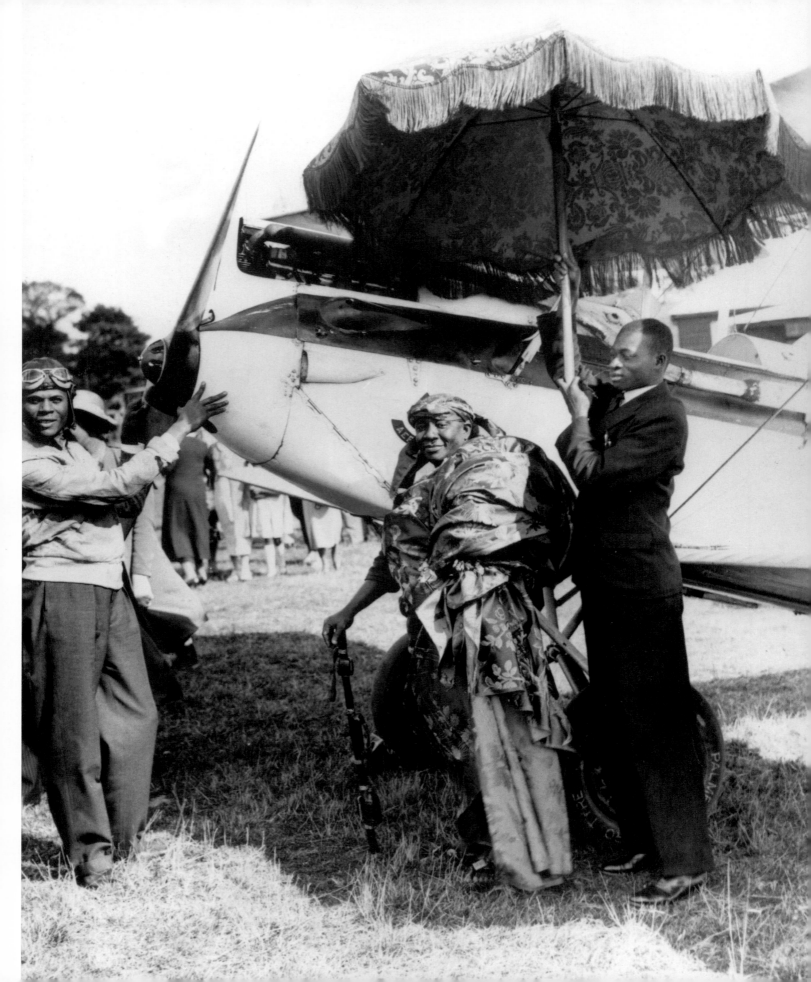

Europe where black settlers were few. Ras Prince Monolulu, who worked, among other things, as a racing tipster on Britain's race courses during the inter-war years, was able to turn this particular association to his own advantage. Monolulu had been born Peter Carl Mackay in 1881 in St Croix, then part of the Danish West Indies. He was among the most famous black men in England during the 1930s, when he successfully plied his tipster's trade from a soapbox at race meetings. Against the geopolitical backdrop of the invasion of Abyssinia by Italy, Monolulu represented himself as a prince of the Falasha tribe. He left an autobiographical volume, and his extraordinary life counterpoints that of the black flyer Hubert Fauntleroy Julian, who has been pictured here after taking a visiting chief from the Gold Coast on a leisure flight from an aerodrome in Essex. Julian, who was born in Trinidad but lived much of his life in the US, had completed a transatlantic flight in 1929. He volunteered to be part of the Abyssinian air force defending the African country against the invading Italians.

Fascists could be found in every country. The British division of that movement, which contributed so much to the development of racial politics, is represented here by a striking image of an enthusiastic troop of female Mosleyite 'blackshirts' in their trademark uniforms. Of course, there was much more to the everyday dynamics of black life in Britain during the 1930s than the impact of their organised opposition to the black presence.

During this period the tempo and texture of everyday life in black communities start to become visible. Racial divisions supplied a easy marker for the social and economic problems found in places like Cardiff and Merseyside.

The first images of the interior spaces of black dwellings are brought to light, and there are fewer images of blacks outside. Though they are seen as a transient presence, they have begun to be photographed with their children or in larger groups engaged in a range of pursuits that conveys the idea that they might eventually become a permanent fixture. The veil of exotica that had been placed around many images of blacks starts to fade, and as it retreats, a stronger sense of black people as bearers of social problems begins to take its place.

Facing page:
Sir Ofori (Osfori) Atta, Paramount Chief of the Gold Coast, after his first flight at the East Anglian Aero Club, Albridge, Essex, 27 August 1934. Pilot Colonel Julian, known in the US as the 'Black Eagle', is on the left

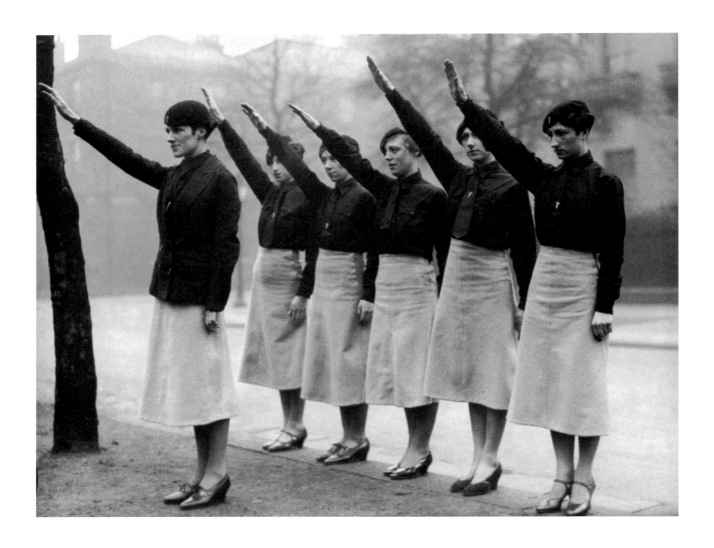

Blackshirts from Sir
Oswald Mosley's
British Union of
Fascists on parade in
Liverpool, 1935

Facing page:
Jamaican-born Dr
Harold Moody (1882–
1947), President of
the British Christian
Endeavour Union,
1930

The 1930s saw wider changes in the visibility or racial differences and the meanings attached to them. Of course, African American celebrities like Paul Robeson were now identifiable figures in the expanding global circuitry of popular culture both as live performers and on film. Britain's areas of substantial black settlement had also started to generate and perhaps to require sporting heroes of their own. Changes in cricket introduced more black West Indians to British spectators and their blackness was no obstacle to appreciation of their prowess on the field.

The outbreak of war in 1939 would set in train events that would reshape the institutional workings of British politics. There were many dimensions to this change. Among the most telling was the gradual creation of a political awareness of racial divisions and, in particular,

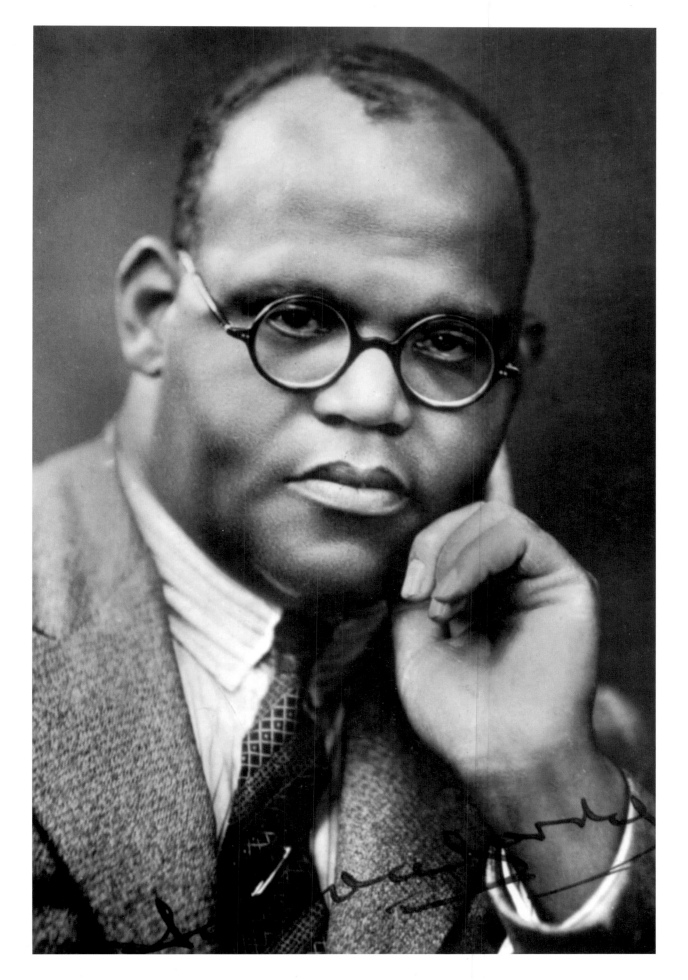

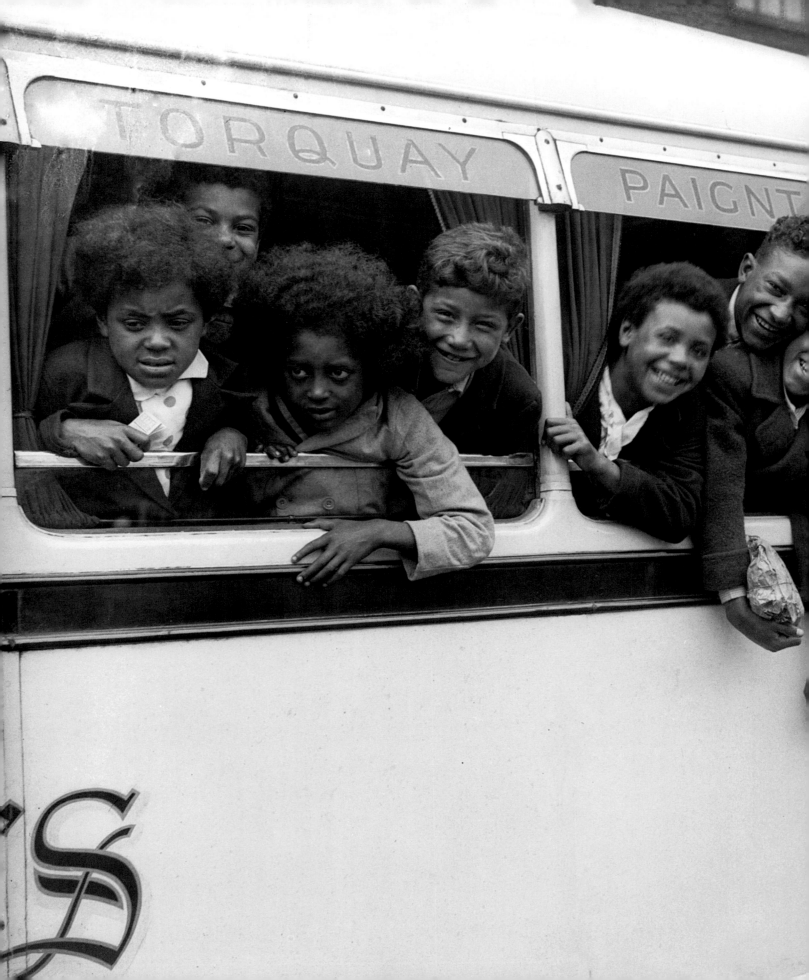

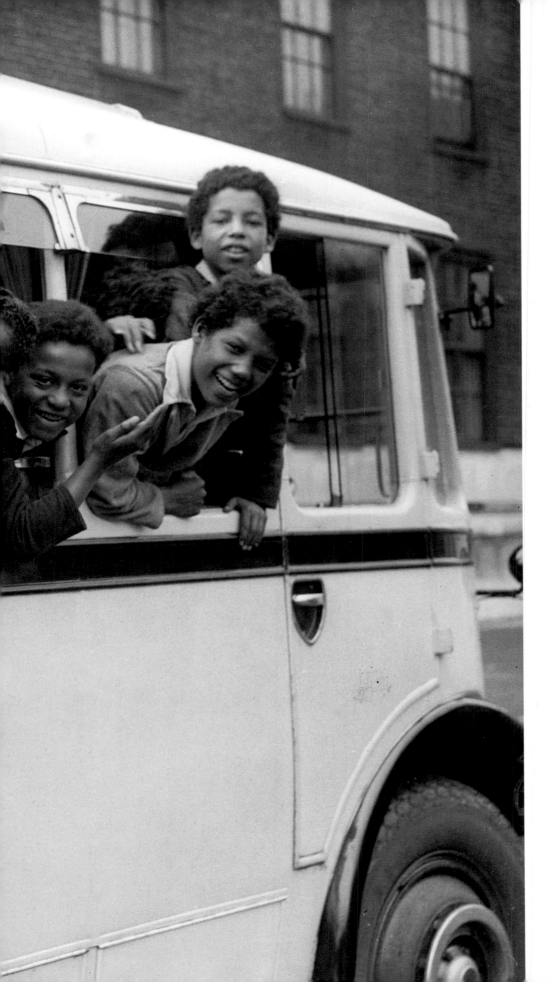

A group of children
leaving the Friends'
House in Euston
Road for an outing
to Epsom Downs,
organised by the
Society of Friends,
the League of
Coloured People and
the Coloured Men's
Institute, 17 July 1936

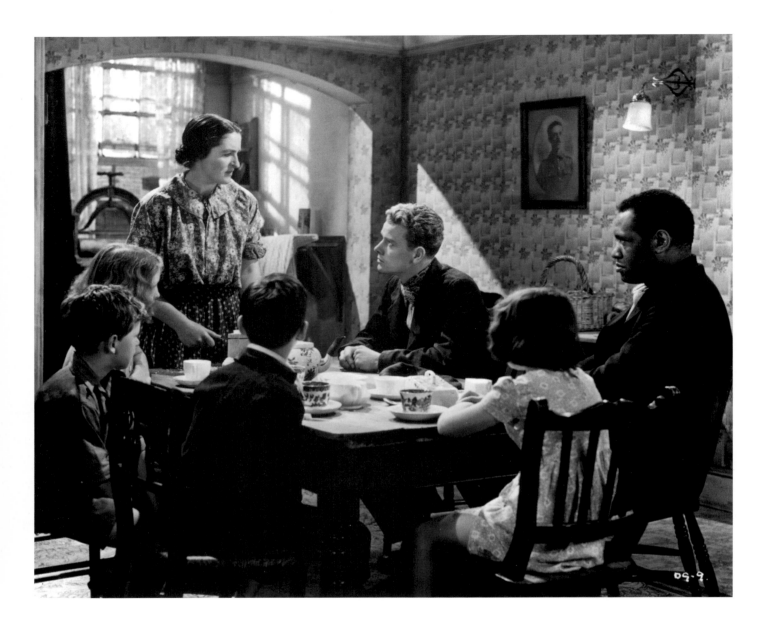

American actor Paul
Robeson in a scene
from *The Proud
Valley*, directed by
Pen Tennyson for
Ealing Studios, 1940

Facing page:
Sir Learie Nicholas
Constantine
(1902–71), West
Indian cricketer and
statesman, 10 May
1939

of a strong sense that immigration represented a fundamental political
problem for British society. Race emerged during the following years
as an undeniably political issue. It would become closely connected to
the varieties of nationalism associated with the end of Britain's imperial
role.

In the postwar world, popular anxiety about race and immigration
was endowed with extraordinary power to mobilise a broad current of
opinion; beyond the boundaries of respectable politics, it had the ability
to put hordes of angry people into the streets determined to resist the
encroachment of black immigrants into their traditional territory.

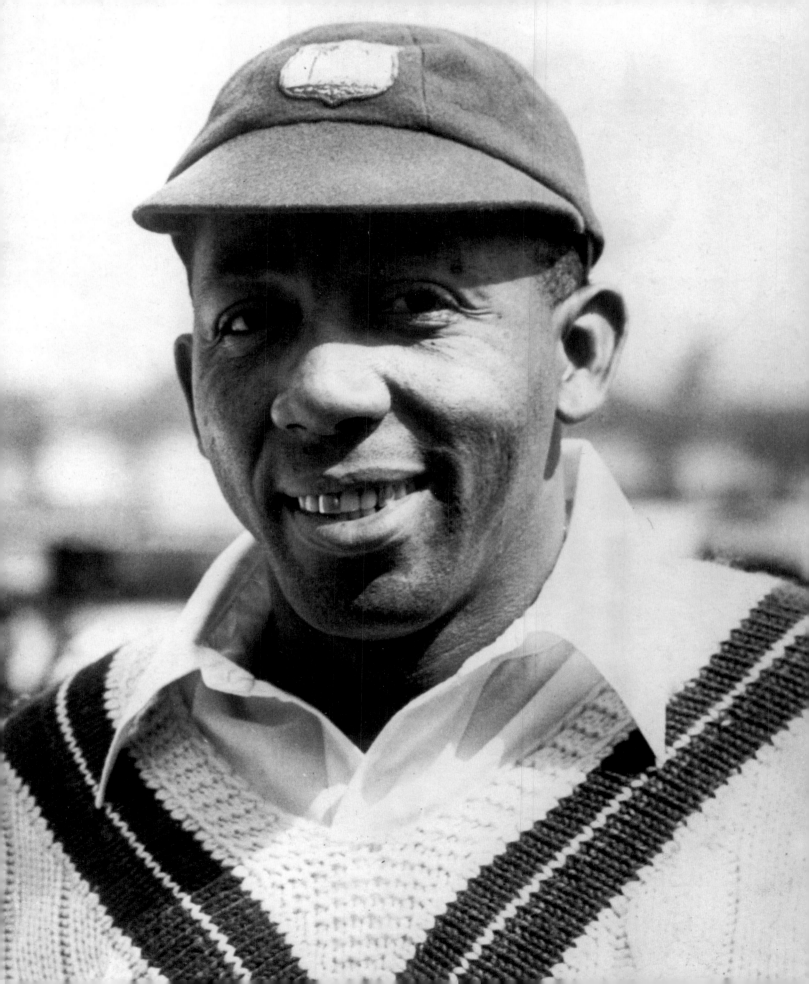

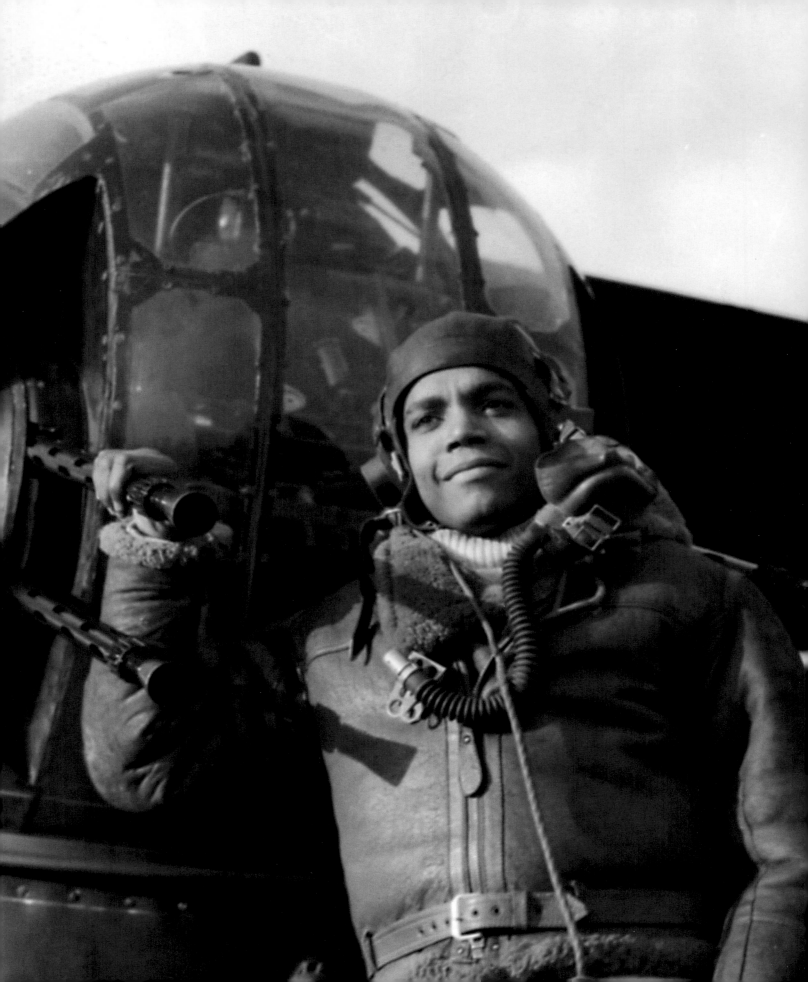

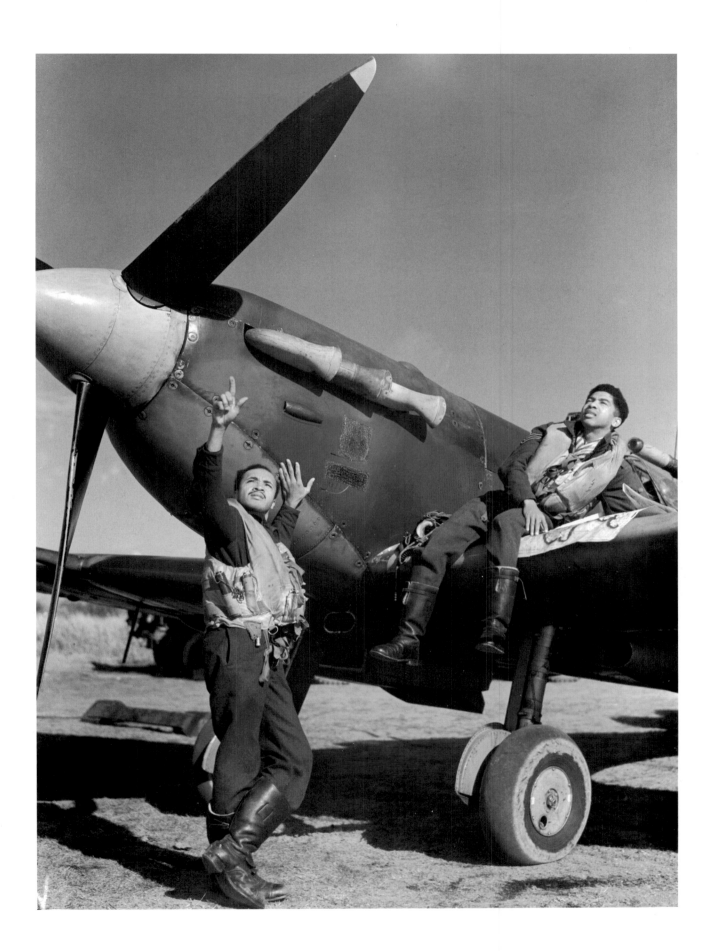

Right: Trinidadians Vivien Huchoy and Elaine Williams at an Auxiliary Territorial Services (ATS) training camp, 4 December 1943

Below: Odessa Gittens (front) on her way from London to an ATS training camp, 4 December 1943

Previous page, left:
Royal Air Force Sergeant Lincoln Orville Lynch. Lynch, from Jamaica, volunteered for service in the RAF in 1942, and in 1943 won the Air Gunner's trophy during training in Canada. On his first operational flight he shot down a German Junkers Ju 88

Previous page, right:
Royal Air Force airmen A O Weekes of Barbados (left) and Flight Sergeant C A Joseph of San Fernando, Trinidad (right), 1943

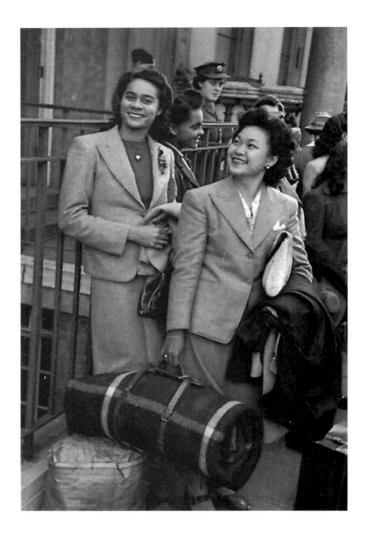

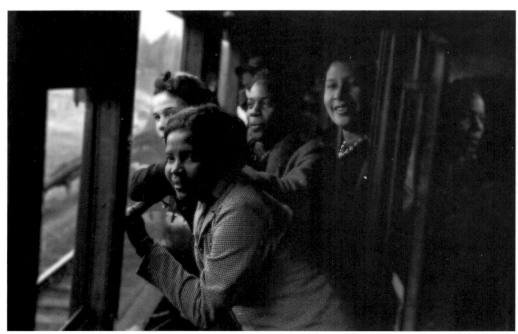

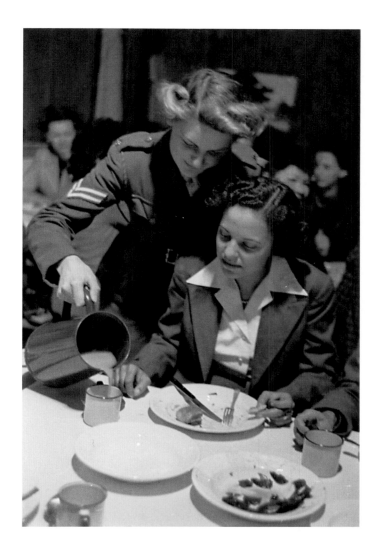

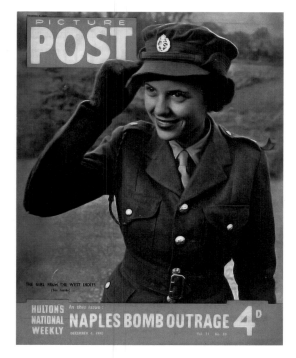

Though it is sometimes remembered in very different terms, the war effort had involved the mobilisation of large numbers of military personnel from the colonies. They stood firmly with Britain in its time of need and duly sacrificed themselves in the line of duty to defend a country where their citizenship would be increasingly called into question. Colonial participation in the war provided the key to the pattern of economic migration that followed it. The post-1945 settlers were British subjects and passport holders with the same rights and entitlements as the native-born.

This collection provides a good opportunity to underline the contribution made by Britain's colonial and minority soldiers and flyers to the nation-defining, Second World War against Nazism. It's not just

Left: Georgy Masson, one of thirty West Indian women who volunteered for the British ATS during World War Two, at an ATS training camp, 4 December 1943. She was born in Oxford but had lived in the West Indies since the age of eight

Right: Georgy Masson on the cover of *Picture Post*, 4 December 1943

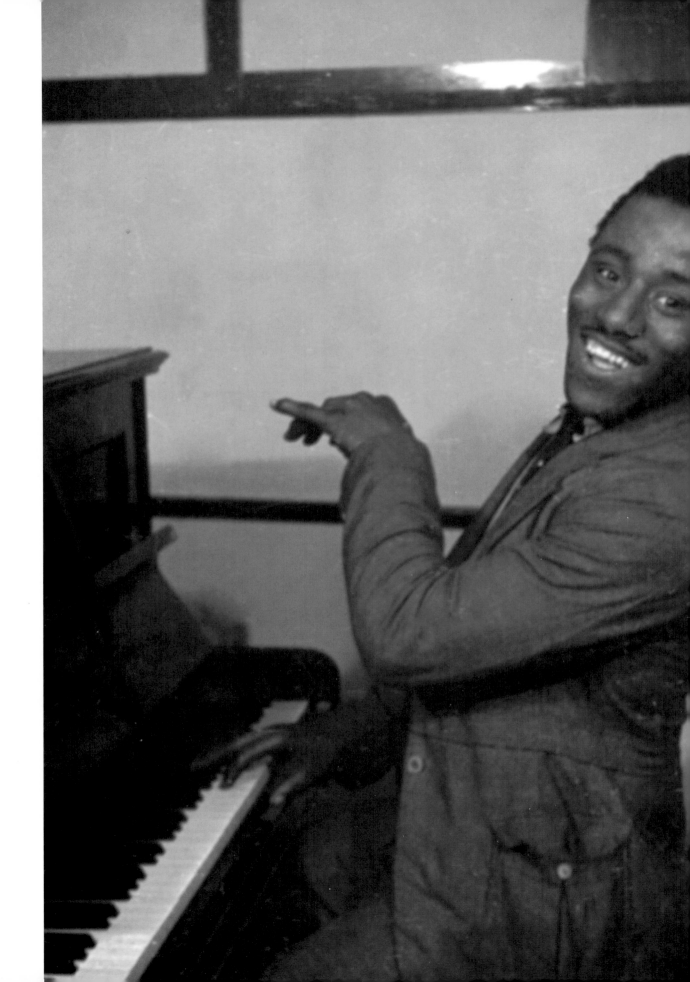

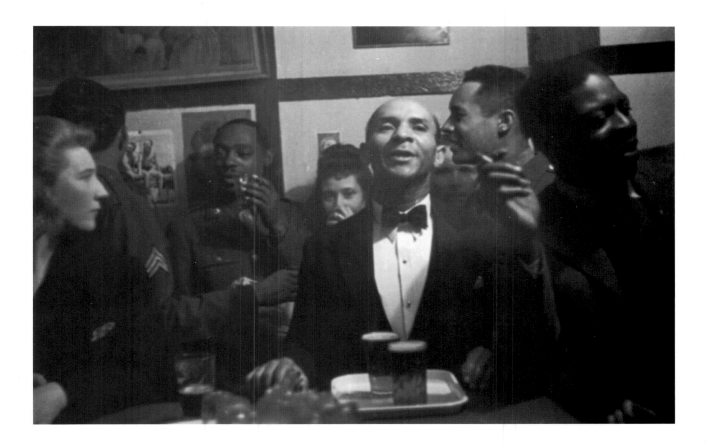

that World War Two is still routinely represented in Britain as though blacks and other minorities played no part in it; it is also the case that it remains for many people the nation's finest hour, a special shared moment in which a simpler and more culturally homogenous country knew and understood itself through its heroic and dogged resistance to an unprecedented evil.

Today, recognising this contribution issues a challenge to the idea that Britain could only achieve that special form of togetherness because, at that critical point, it remained undiluted by immigration. To the contrary, the success of the anti-Nazi war effort was conditional upon the contributions made by personnel from the colonies.

Young men and women from Britain's colonies were centrally and extensively involved in the struggle, and there is an enormous amount of photographic evidence that brings their contribution home. Seldom-seen images of the involvement of colonial forces in imperial Britain's military power play a significant part in clarifying this connection, and

Bouillabaisse International Club, Piccadilly, London, July 1943

Facing page: Johnny, pianist and dancer, at the Bouillabaisse International Club, July 1943

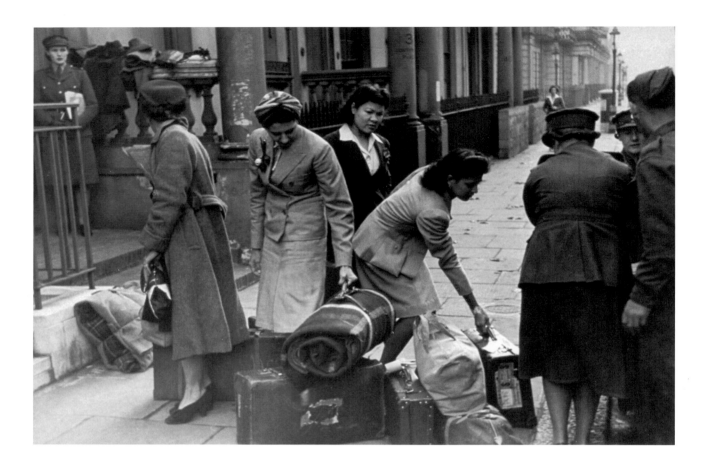

Top: ATS recruits from the West
Indies, December 1943

Right: Babatunde Alakija trains
at the Receiving Wing in Flying
Training Command, 3 April 1941.
Alakija's father, the Rt Hon. Adeyemo
Alakija CBE, was a member of the
Legislative Council at Lagos

Facing page, top: Una Marson,
Jamaican broadcaster, journalist
and author, having lunch at the BBC
canteen, November 1943

Facing page, bottom: West Indian
ATS volunteers being served tea at
the Colonial Office in London, 1944

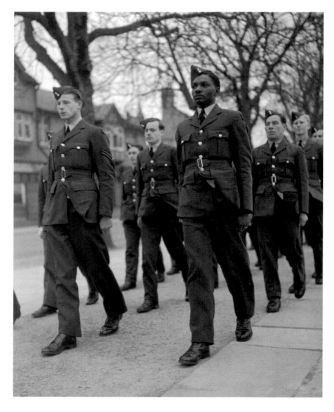

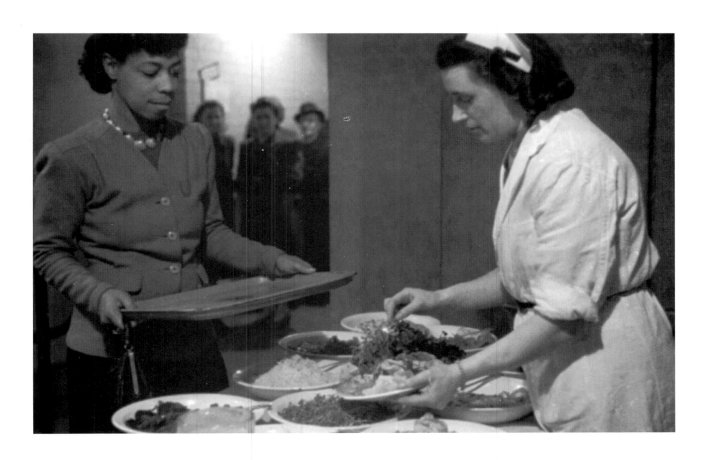

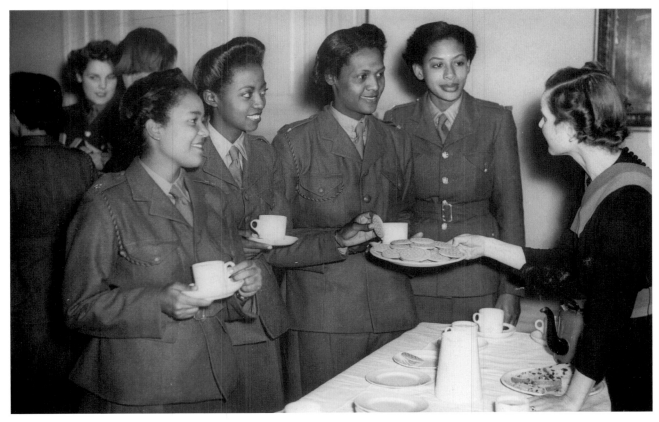

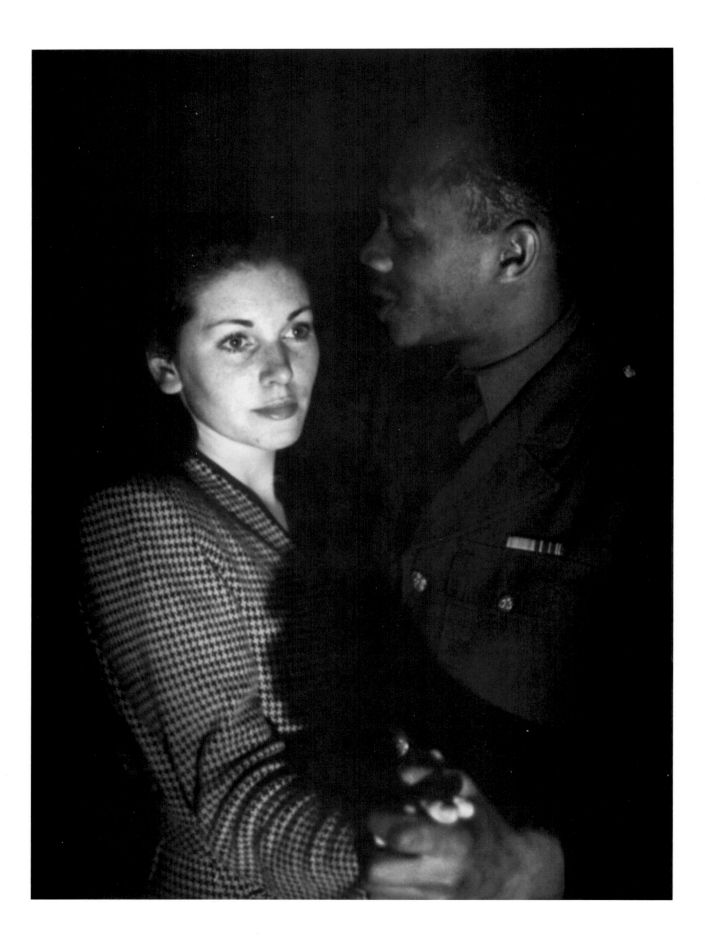

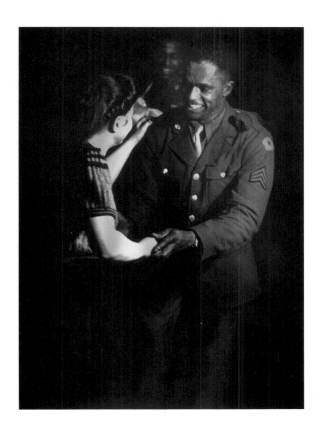

Left: A Welsh woman dances with an American soldier at the US Forces club in the local chapel, Morriston, Swansea, 1944

Bottom: London, 1943

Facing page: A couple dancing at Frisco's International Club, Piccadilly, July 1943

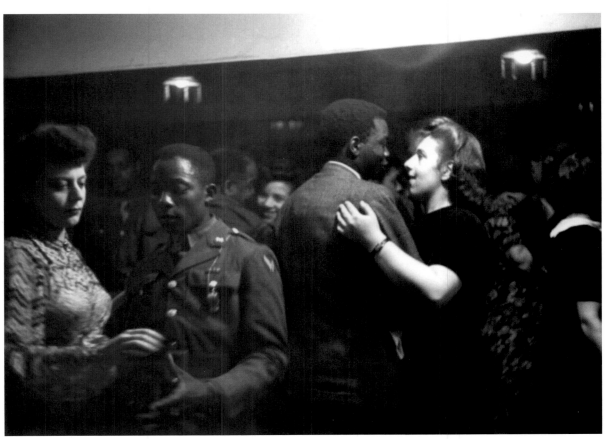

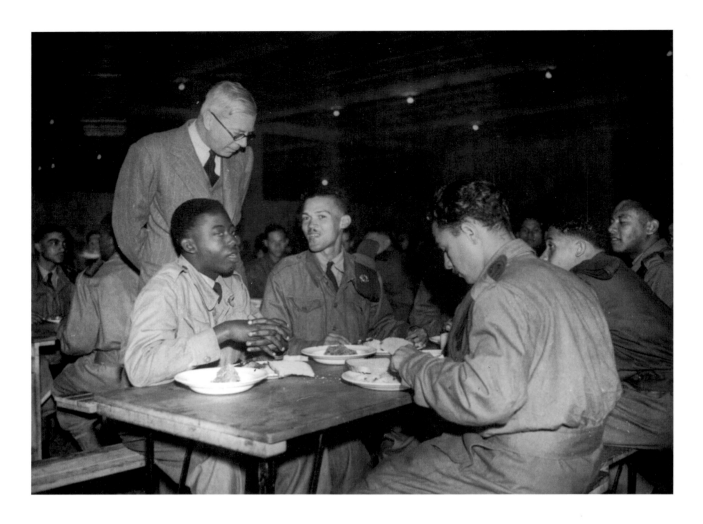

Colonel Oliver Stanley, Secretary for the Colonies, chatting with the first RAF West Indies contingent to train in England, July 1944

in establishing the rightful place of black service personnel at the centre of the nation's official memory.

Colonial citizens were not only part of the military war effort, they aided the struggle in other ways too, through the reach of the BBC World Service and through a range of other paramilitary contributions in industries deemed vital. They were also heavily involved in the Merchant Navy.

After the US entered the conflict, large numbers of African American men and women were stationed in the UK. Their arrival raised a number of contentious issues, particularly when local authorities were reluctant or uneven in enforcing the stern and rigorous forms of racial segregation demanded by the Jim Crow US military, which was not desegregated until 1951. In England, they maintained separate facilities along racial lines and enlisted the cooperation of the

government in dividing pubs, clubs, cinemas and dance halls. In Suffolk, whole towns were reserved for the exclusive use of a particular group. Eye and Diss were designated as black, while Horham was named as a recreational area for whites. The River Dove provided the boundary.

African American service personnel and their British friends who found the prospect of turning England into the Deep South unattractive inhabited an underground culture. They formed a hidden public world where cross-racial contact was an unexceptional part of life, and where ordinary working people were often welcoming and appreciative. Social dancing was at the heart of this unanticipated process of interaction, play and pleasure. To male and female alike, the blacks were stylish and cool. Their way of being was as attractive and influential among young people as it was frightening and disorienting to others. This was the point when black culture – especially music – started to find significant

A contingent of the Women's Army Corps from the US, among whom were the first black women assigned to overseas service, 1945

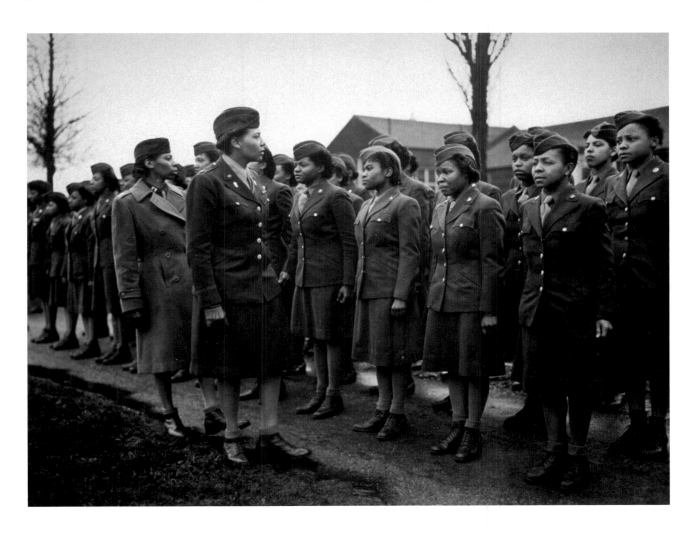

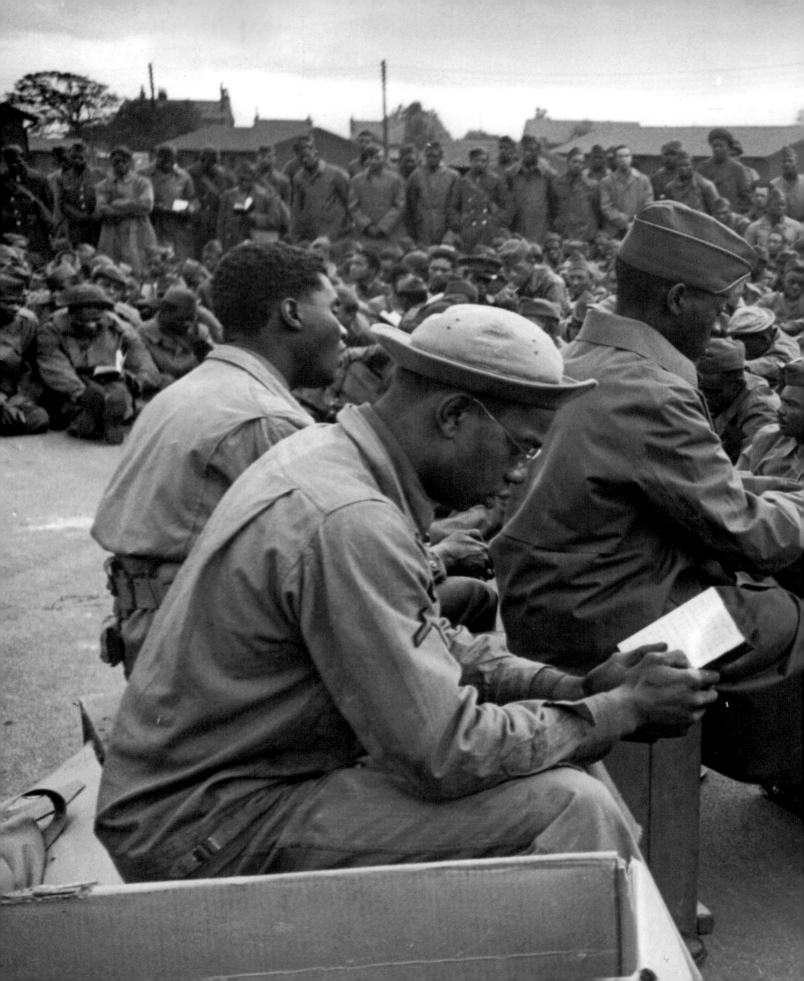

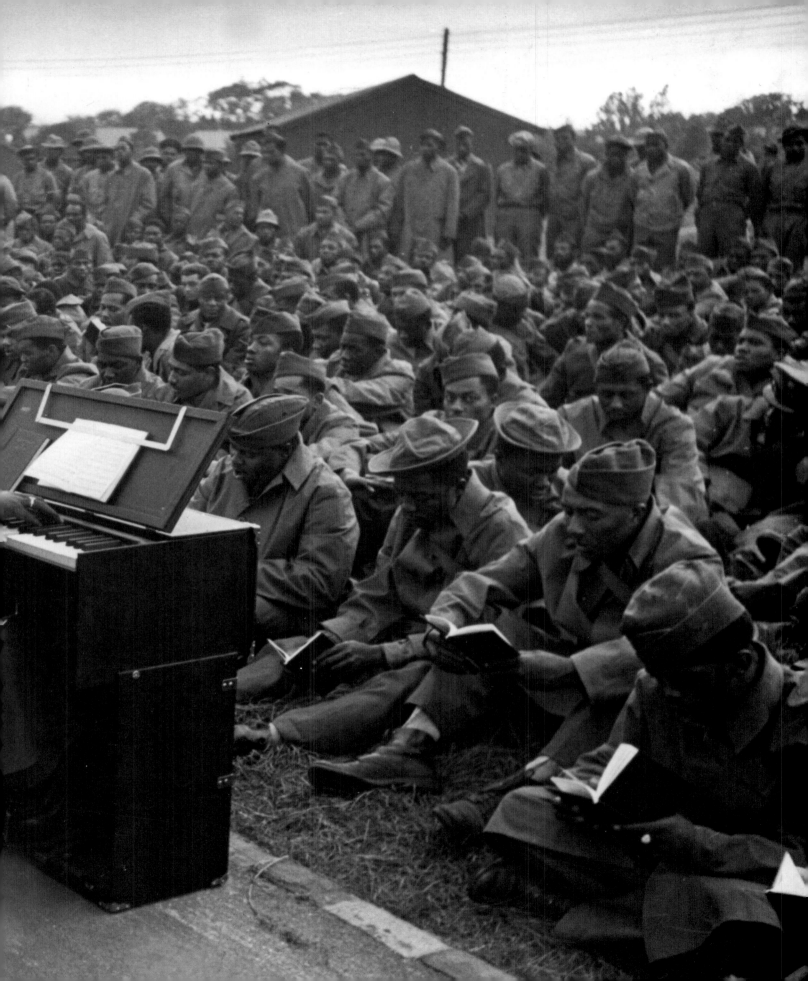

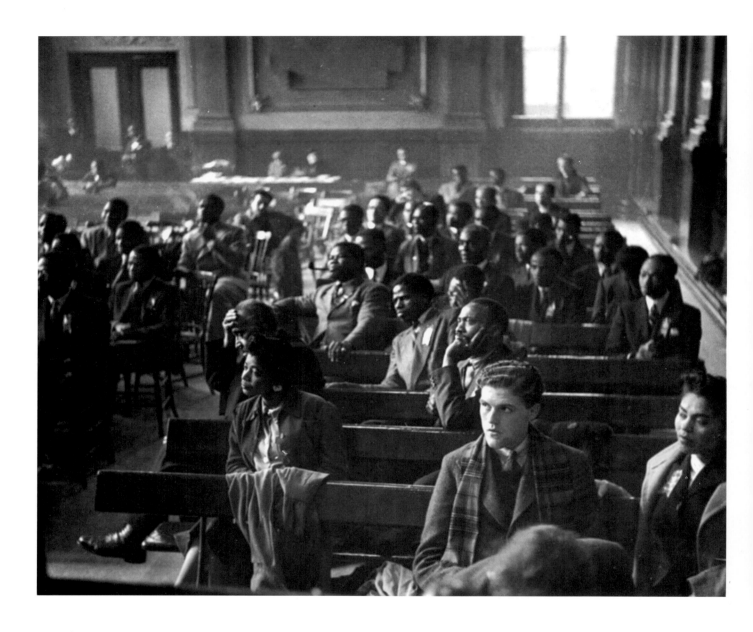

Pan African Congress
in Manchester,
October 1945

Previous pages:
Organist Corporal
Raymond Du Pont
playing hymns on a
portable harmonium
during an evening
service for
US soldiers,
12 September 1942

white audiences and alter the sensibilities of Britain's white working class. It should be noted that this process of intermixture offered no guarantee that the new consumers of black culture would be equally well-disposed towards its creators.

The Pan African Congress held in Manchester in 1945 signalled the earliest attempts to adapt the political mood of the anti-Nazi struggle to a different campaign against racism and white supremacy. The conference aimed to help transform the colonial settler regimes but also to shift them in the direction of political independence from the European powers.

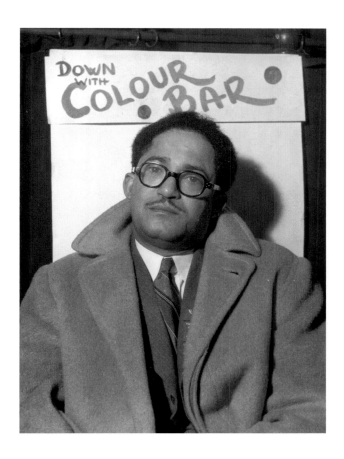

These were the birth pangs of a radical, transnational movement dedicated to redirecting the political morality that had been defined by the struggle against Nazism and Fascism into the battle against colonial rule, which was also judged to have used racism as a divisive instrument of government and a means of exploitation. W E B DuBois, George Padmore and Jomo Kenyatta were the most prominent figures among a whole cast of the international black leadership that attended this historic coming together at the hub of empire, on British soil. The newspaper shots of the audience show that this event was not considered relevant only to the daughters and sons of Africa and its diaspora. White participants are clearly visible in the audience, and today the banner 'Jews and Arabs unite against British Imperialism' is a striking sight to the left of the speakers' podium.

Outside the smoky halls where national liberation and other anti-colonial plots were being laid, the political geography of black settlement had started to alter Britain's bomb-battered cityscapes. The

Left: E J Du Plau, a Liverpool welfare worker responsible for hostels and centres for black seamen, at the Pan African Congress in Manchester, October 1945

Right: Chief A S Coker, a Nigerian trade union leader, at the Pan African Congress in Manchester, where he demanded full franchise for the black workers represented by his union, October 1945

Right: Kenyan statesman Jomo Kenyatta (1891–1978) at the Pan African Congress in Manchester. After a spell in prison for his alleged leadership of the Mau Mau Rebellion, Kenyatta became the first president of the Republic of Kenya in 1964

Bottom, left: George A Padmore (1902–59), Pan African movement leader, 1945

Bottom, right: W E B DuBois, American writer, civil rights campaigner and delegate at the Pan African Congress

Facing page: John McNair, General Secretary of the Independent Labour Party, addresses the Pan African Congress in Manchester

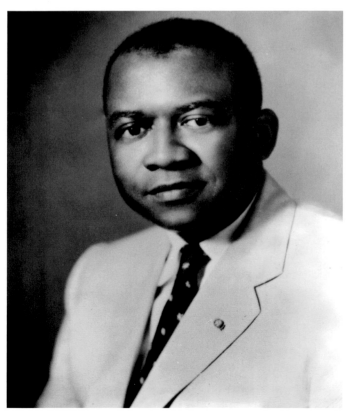

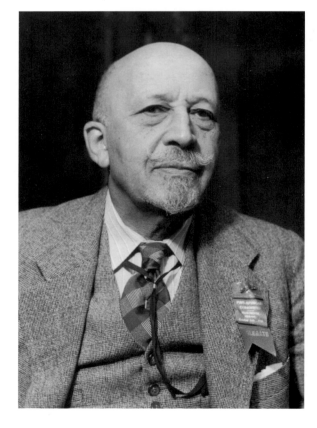

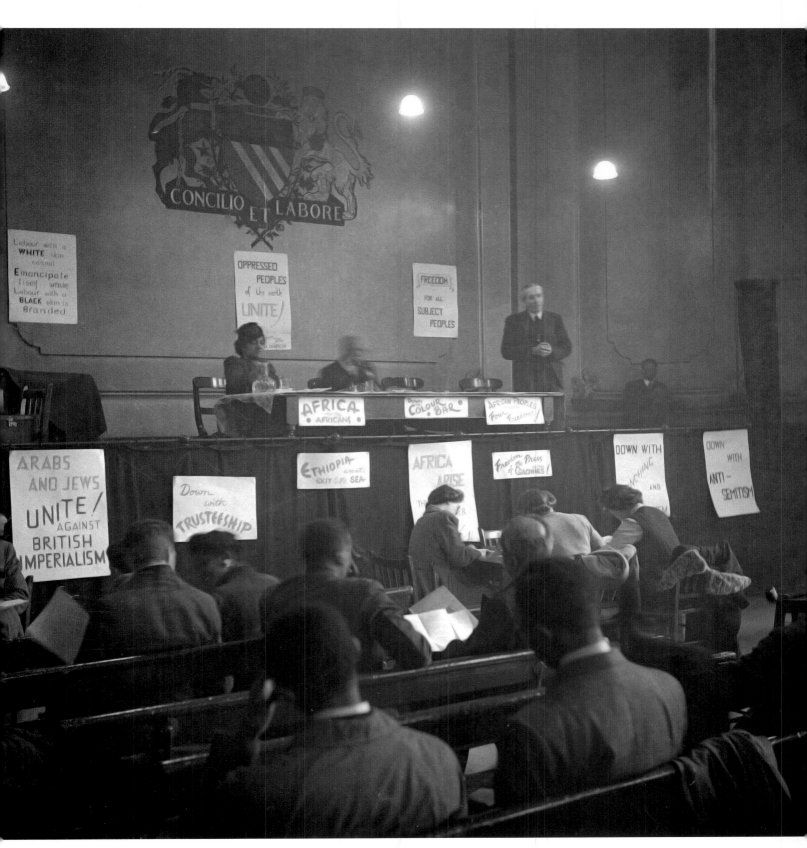

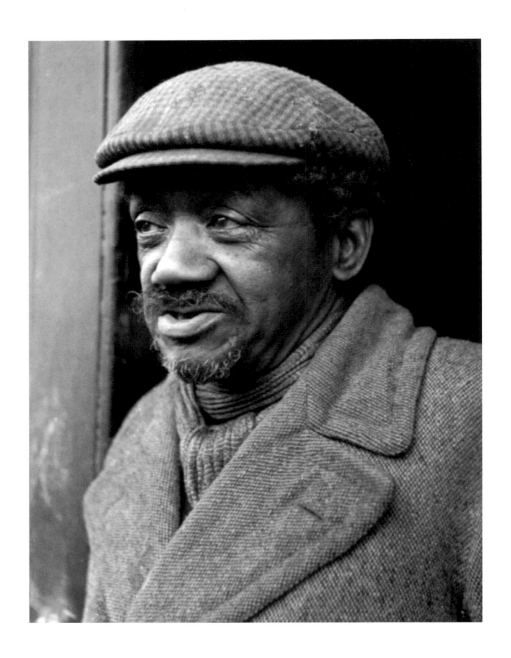

A man in the Gorbals area of Glasgow, January 1948

Facing page, top: A group of Jamaican immigrants scrutinise a map of the London Underground, 1 July 1948

Facing page, bottom: Cable Street at night, Stepney, East London, 13 November 1947

old dockland areas remained the primary places where the country's new black problem was becoming visible, but that problem of race was assuming unprecedented dimensions not through the increased volume of settlement alone but as a result of its changing character. Britain's expanding black population had begun to appear in new locations. Black workers could now be found anywhere. They toiled wherever there was work that the locals did not want to do because it was dirty, difficult, poorly paid and dangerous, or wherever the effects of war meant that labour was in very short supply.

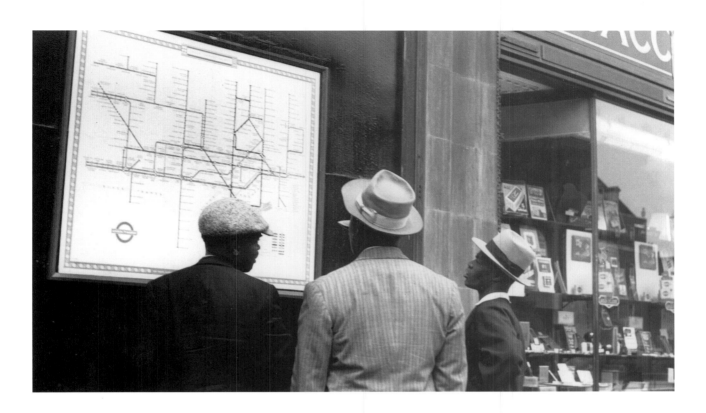

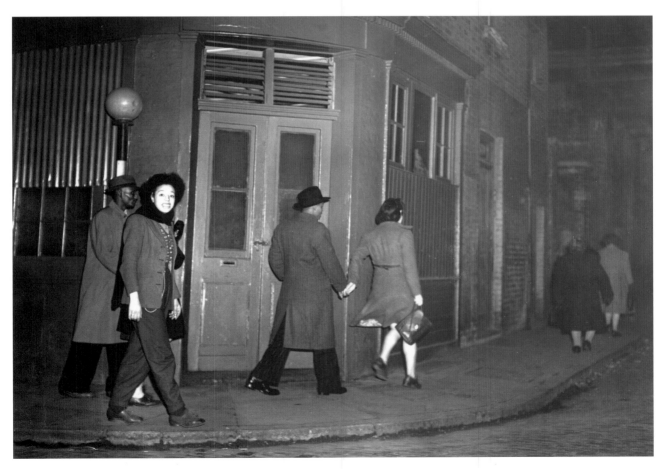

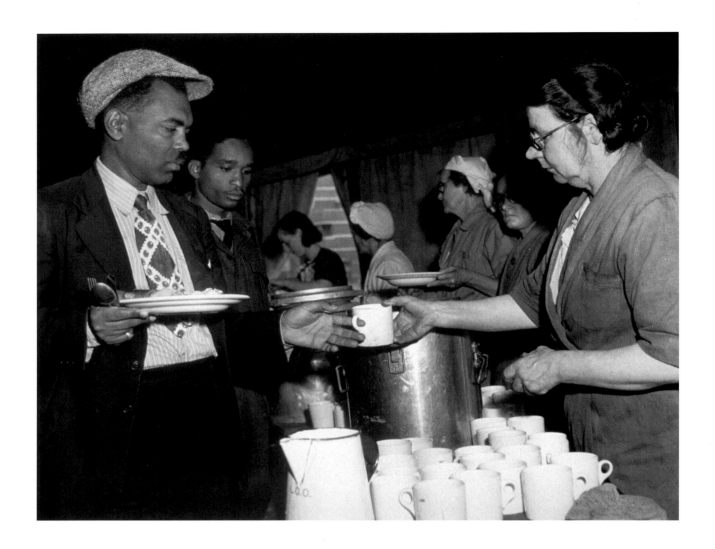

Jamaican immigrants collect meals from the canteen set up for them at a hostel in the Clapham air raid shelter, London, 1 July 1948

Facing page: The ex-troopship *Empire Windrush* arriving at Tilbury Docks from Jamaica with 482 Jamaican immigrants to Britain aboard, 22 June 1948

A new map of the country was gradually being made in which locations like Brixton and Notting Hill would become known as places where blacks could be found in substantial numbers, and where stable, perhaps permanent residential communities were being consolidated. Both areas were conveniently positioned close to the railway termini where these immigrants, already familiar with the idea that Britain was their mother country, had arrived. Of course, there was no area in which black settlers were a majority.

The photographic record from this period involves what looks like a rather repetitious search to locate and record the primal scene of black arrival. In that special moment the alien incomers' first encounter with their ambivalent and sometimes hostile hosts is captured, frozen and made available to official memory. Sometimes that historic meeting

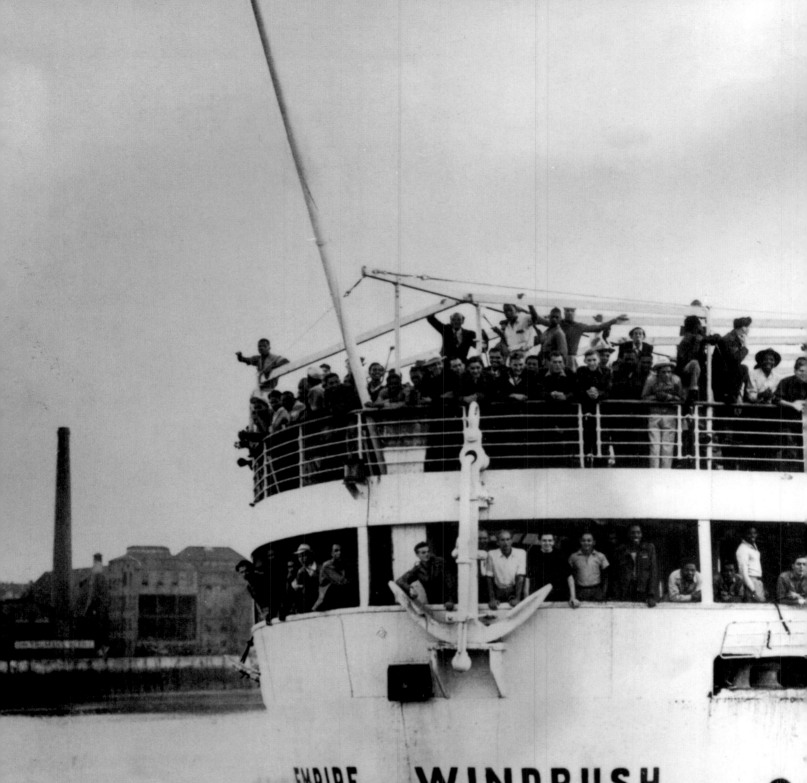

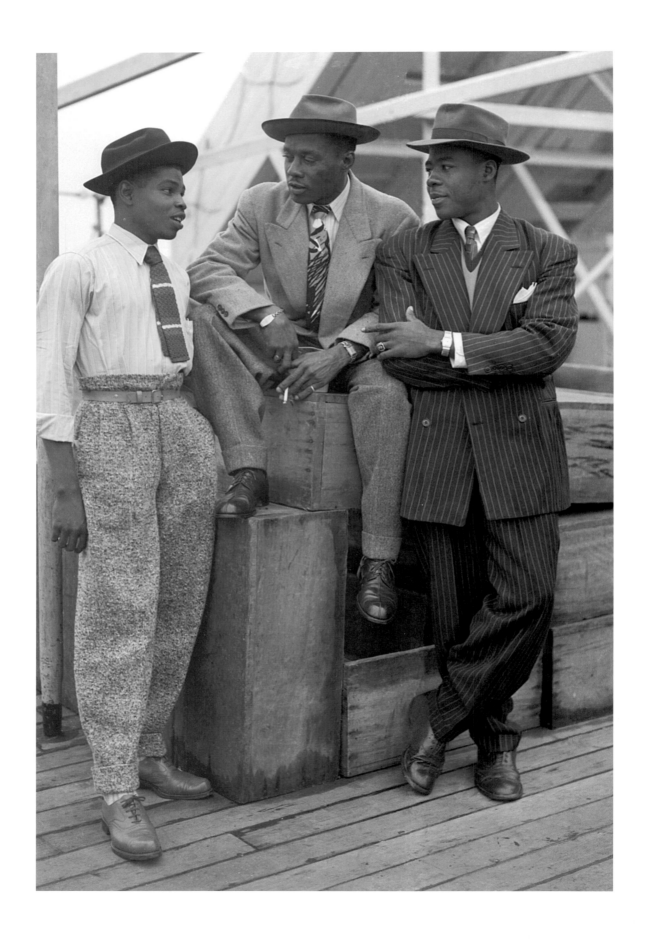

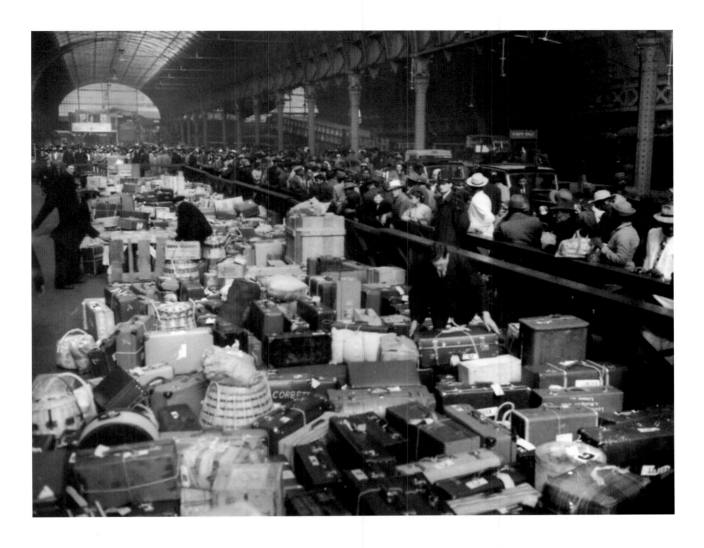

was staged at the port of entry. There are very well-known, even iconic images that convey the excitement and enthusiasm of innocent, well-dressed travellers bearing too many pieces of luggage. Perhaps a police officer will be stationed in the foreground to establish their potential threat to law and order. They were seen treading gingerly on the gangplank or being met by stern government officials. They were snapped in the trains that bore them up to London and glimpsed outside symbolically resonant buildings like the Labour Exchange; sometimes they were photographed on factory steps or even at work on the assembly lines. The photographers' intentions were consistent. This event was to be understood as the start of something big, significant and fraught with danger. More often than not, that epochal first contact was discovered already to be underway in the streets where the dynamics

A group of 1,000 West Indian immigrants with their luggage at Paddington Station, London, 9 April 1956

Facing page:
Three Jamaican immigrants (left to right): John Hazel, a boxer; Harold Wilmot; and John Richards, a carpenter, arriving at Tilbury aboard the *Empire Windrush*, 22 June 1948

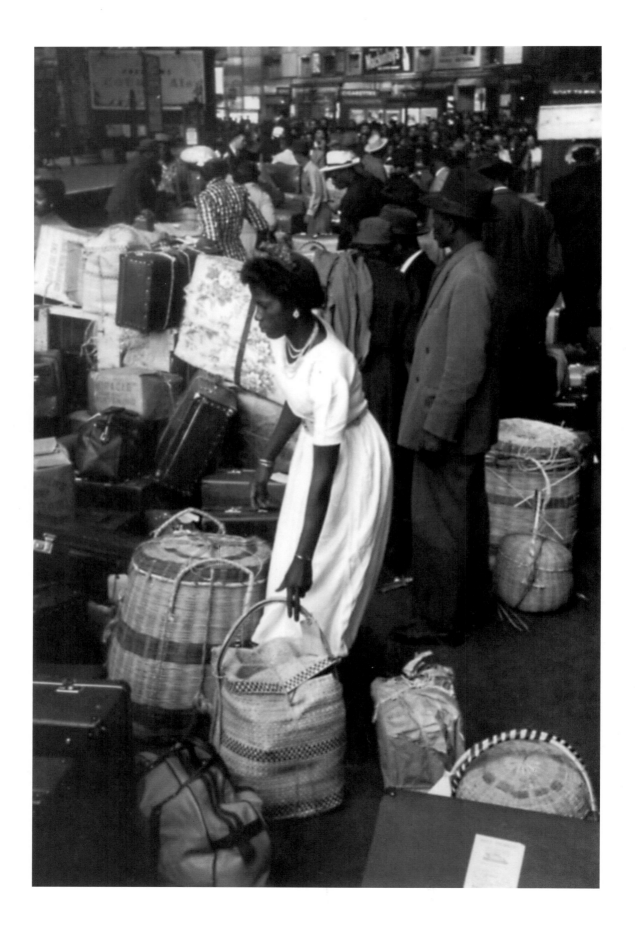

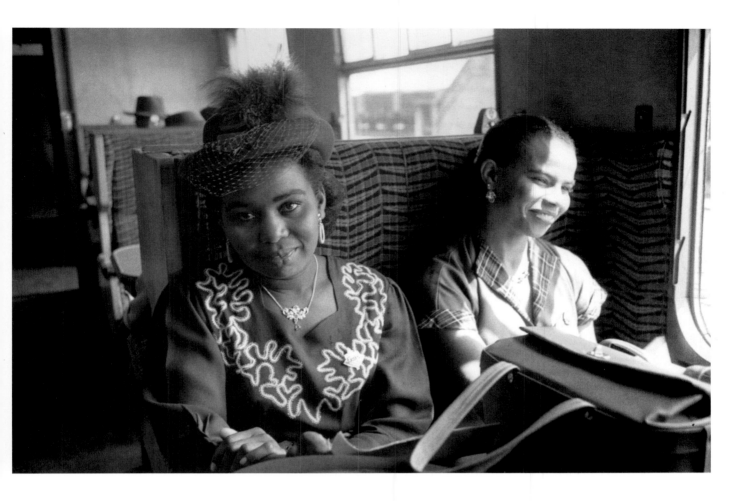

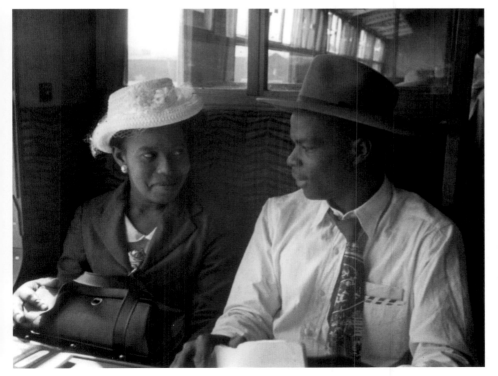

Top: Two West Indian women on the train from Southampton to London Victoria, 27 May 1956

Left: Newly arrived from the West Indies, a couple take the train from Southampton to Victoria, June 1956

Facing page: West Indian immigrants arriving at Victoria Station, 27 May 1956

Following pages:
Left: Men standing outside a Labour Exchange, Liverpool, 1949

Right: Immigrants waiting in the Customs Hall at Southampton Docks after disembarkation, 27 May 1956

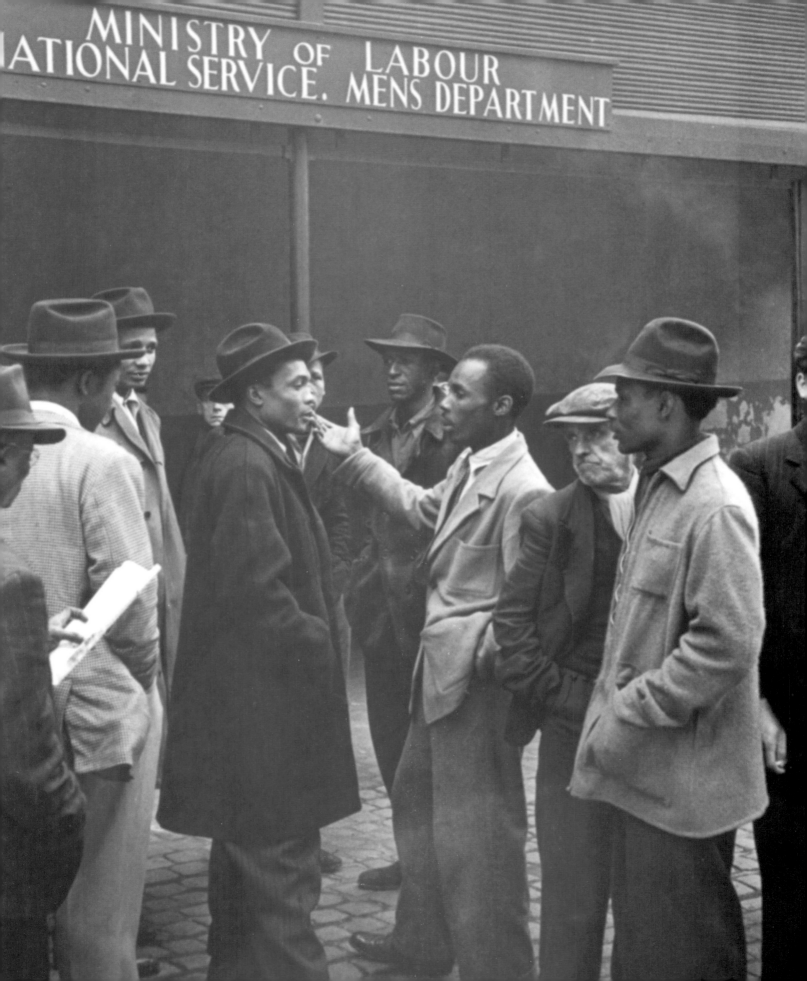

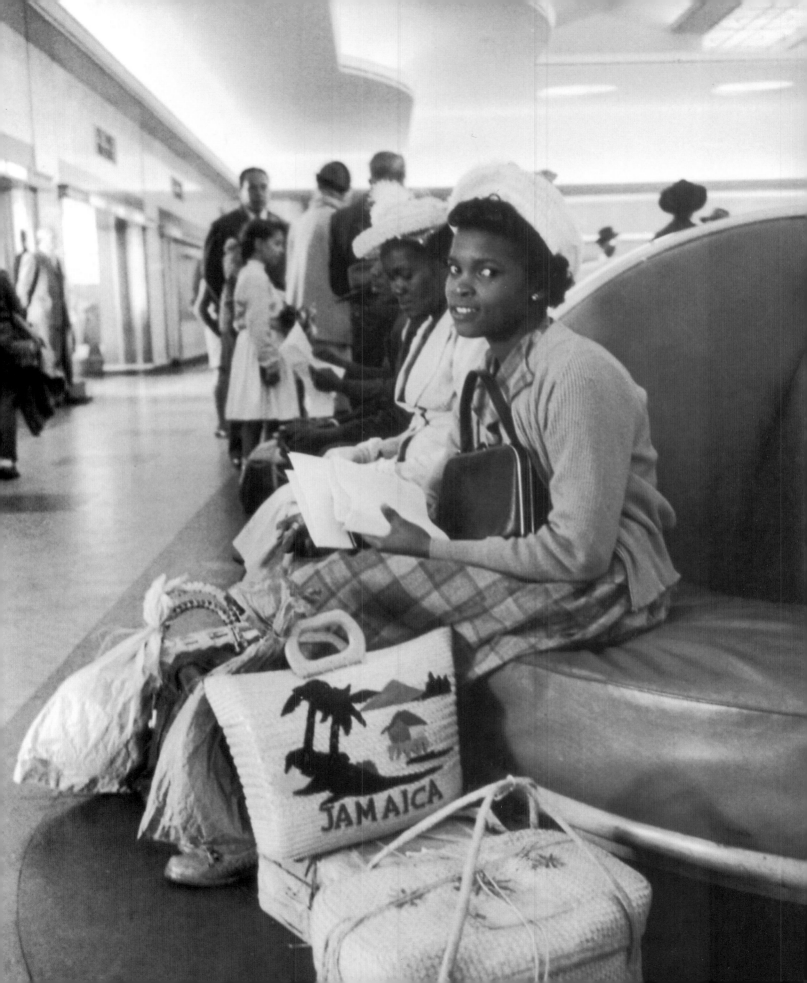

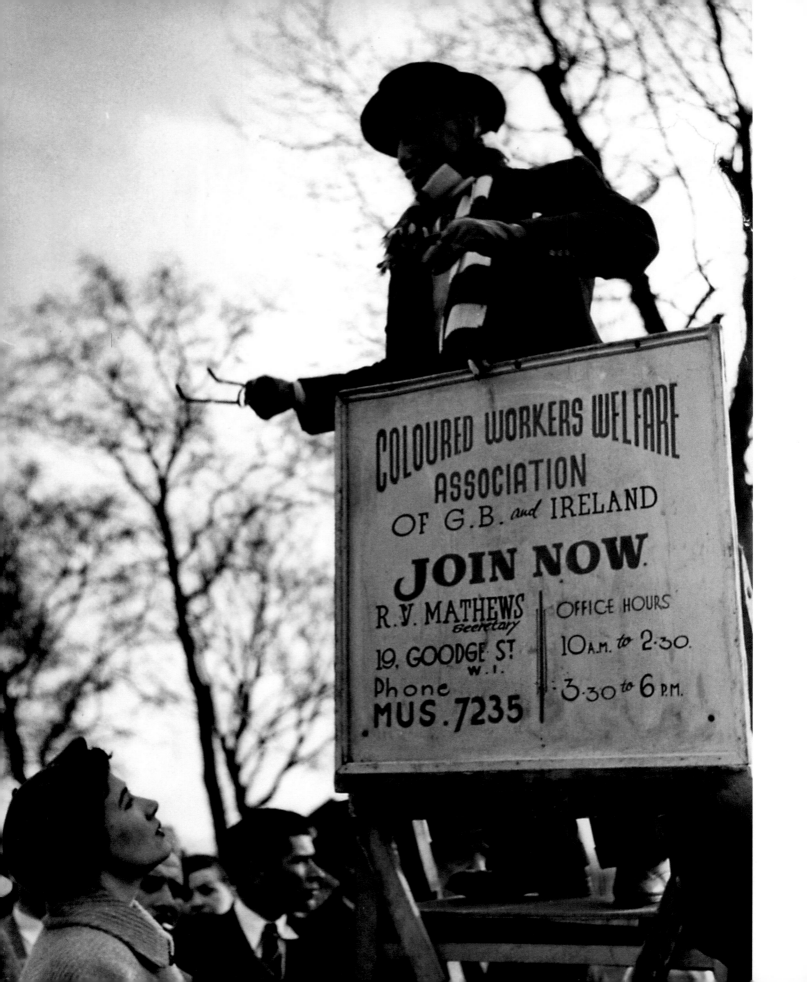

of this invasion and the coerced interdependence that resulted from it were to be painfully negotiated.

The pressure to locate and record the start of Britain's great transformation combined with the desire to locate a historical threshold between 'before' immigration and 'after' it. The sequence of images here suggests that this quest was a misplaced endeavour. However, the resulting photographs are memorable not least because they direct attention towards the imaginary beginning represented by the celebrated arrival of the *Empire Windrush* at Tilbury in June 1948. That event is acknowledged and represented here but not as the start of something. In this context, it appears as an important occurrence drawn almost at random from deep in the middle of a stubbornly hidden but entire history.

The flow of immigrants increased sharply after the late 1940s. From that point, the idea of the Colour Bar came into play as a rhetorical device which framed the immigrant experience of disenchantment as much as the habitual occurrence of injustice. This was especially true when the phrase was used in relation to the effects of the abiding postwar housing crisis into which the incomers had been pitched. (As a child, that phrase, 'the Colour Bar', raised a host of difficulties for me.

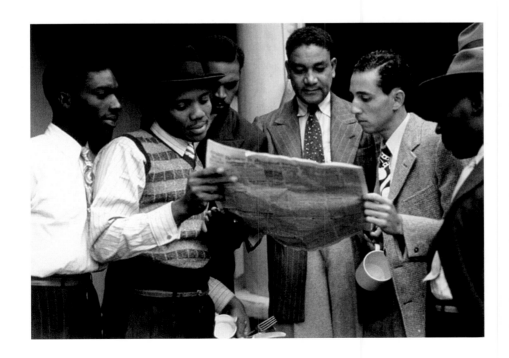

Jamaicans reading a newspaper aboard the *Empire Windrush*, 22 June 1948

Facing page:
A member of the Coloured Workers' Welfare Association of Great Britain and Ireland at Speaker's Corner in Hyde Park, London, February 1955

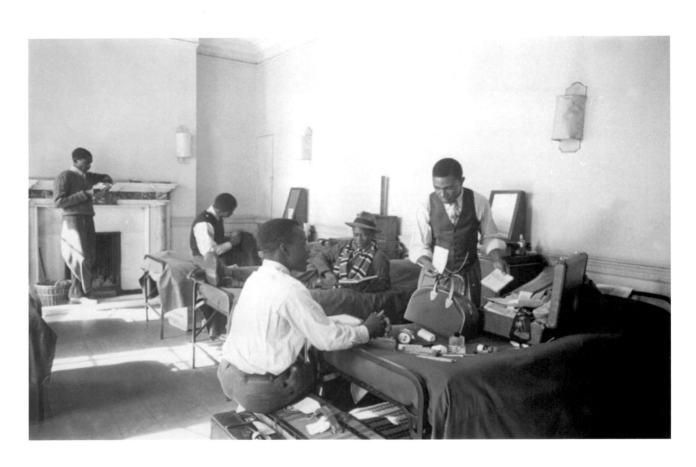

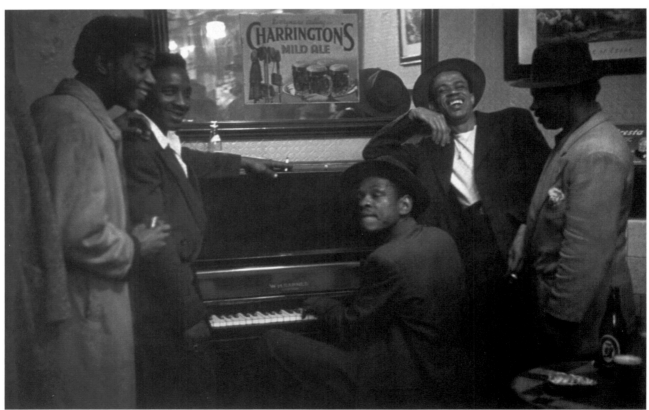

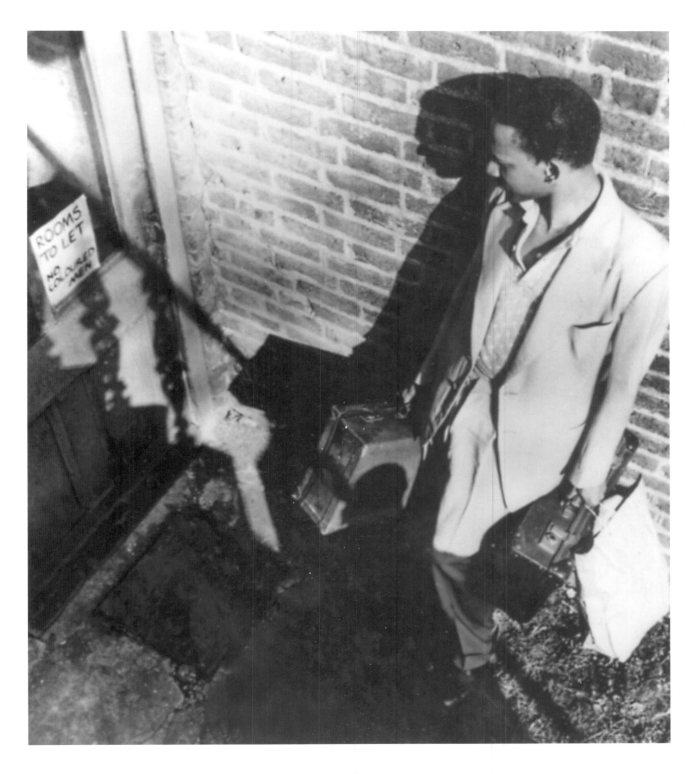

An immigrant reading a sign on a boarding-house door which reads: 'Room to Let – No Coloured Men', September 1958

Facing page, top: Immigrants from the colonies unpack their luggage in a shared room at a British hostel, 1949

Facing page, bottom: Stepney pub, London, 1949

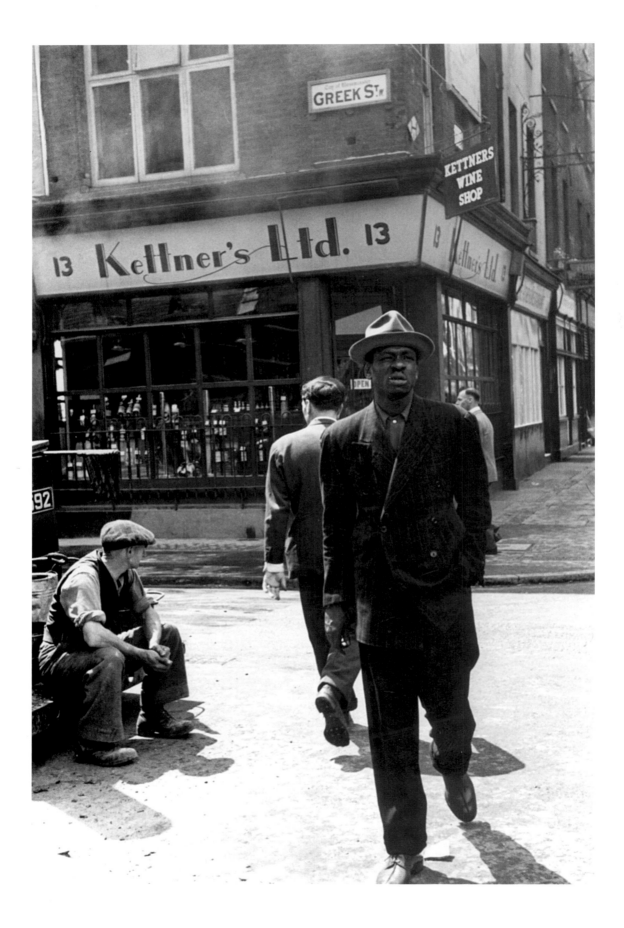

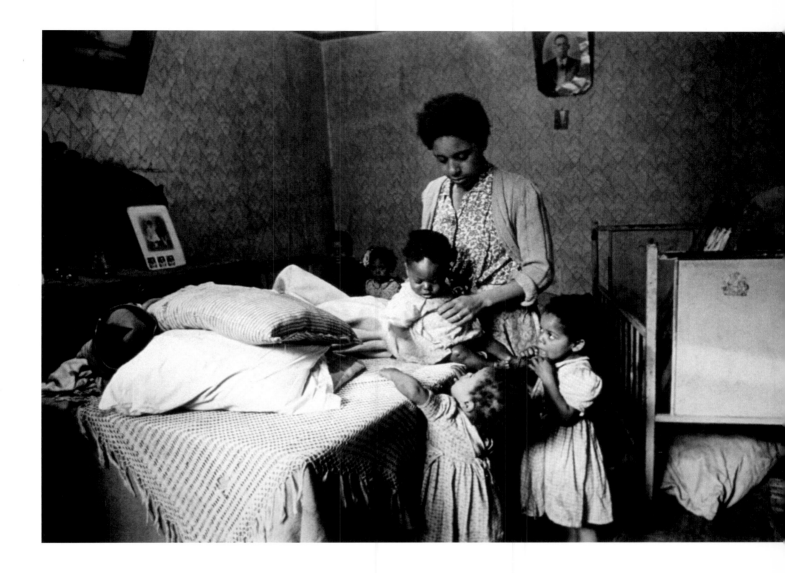

I struggled in vain to visualise it. It was especially confusing that it could be found in pubs. What was the bar actually made of? Was it iron? It certainly sounded as if it was made of metal. Was it painted in any way? I imagined it as a multicoloured, hinged obstruction like those used to block traffic from straying onto the railway tracks at level crossings.)

These documentary pictures manifest the Colour Bar not in the neuroses of its white supporters but in the tragedy of a black presence that appears stubbornly out of place – homeless in its new home. Now, the words 'Colour Bar' help to define the painful period in which Britain's blacks enjoyed extensive but empty rights of citizenship that could be easily overridden by informal patterns of exclusion in public and in private. The exclusionary mechanism was not applied in Britain's

A family in a crowded bed-sit, July 1949

Facing page:
A West Indian immigrant on Greek Street in Soho, London, 2 July 1949

Following page, top:
Windsor Street County School, Liverpool,
2 July 1949

Following page, bottom:
Women at work in a textiles factory, 1949

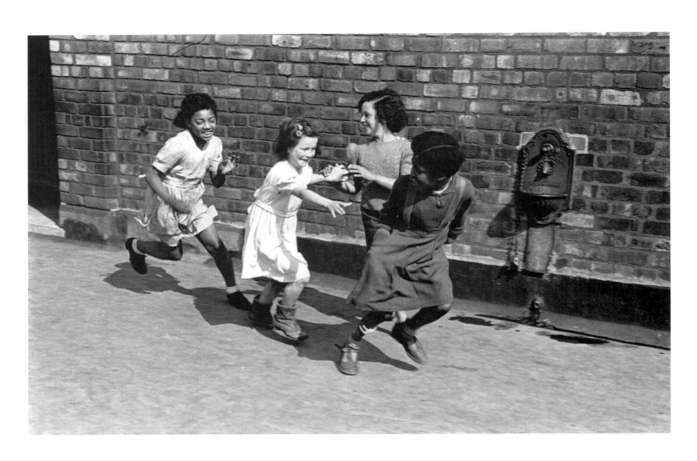

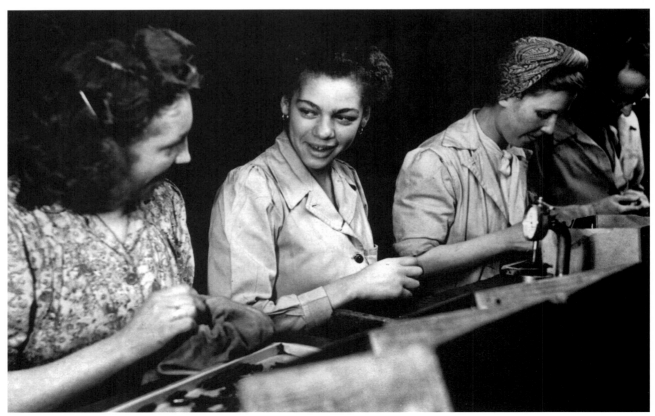

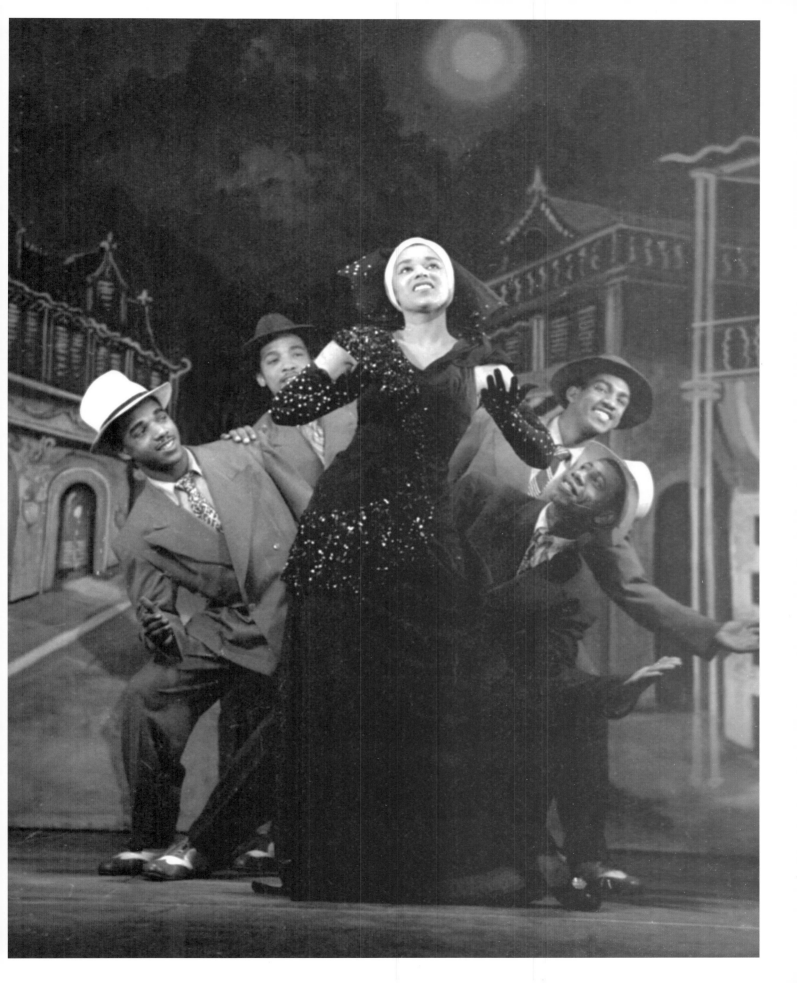

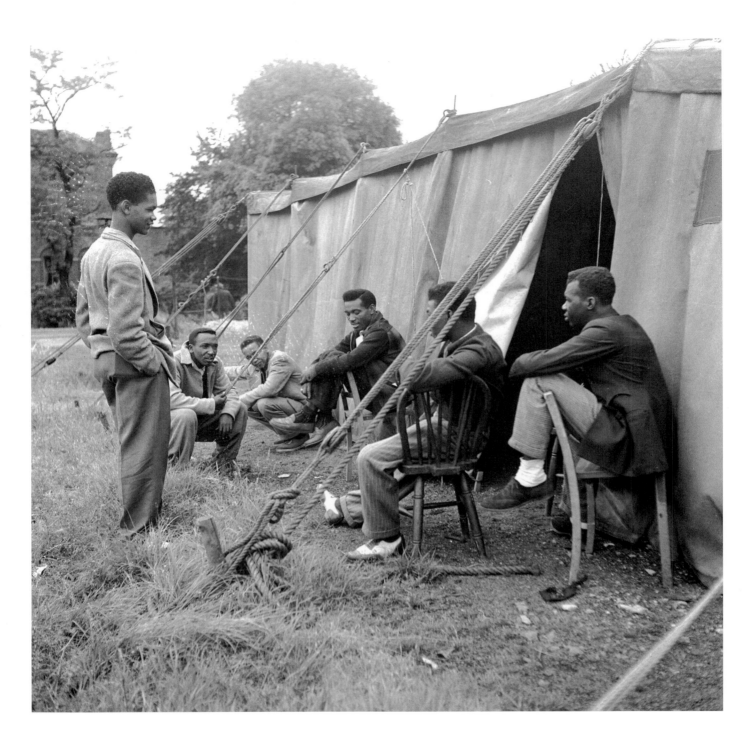

A group of Jamaican immigrants
waiting outside their temporary
home for interviews with officials
of the Ministry of Labour and the
Colonial Office, July 1948

Previous page:
Actress and dancer Mabel Lee in a
scene from *Calypso*, at the London
Playhouse, 19 June 1948

industrial workplaces though a racialised division of labour was sometimes apparent in the use of racial quotas and the patterning of shiftwork.

Old wartime structures like disused air raid shelters as well as tents and other prefabs were taken over and reused as lodgings for the desperate incomers. Sympathetic white returnees from the war who had found employment with London's Underground were reported to have allowed their black fellow veterans to snatch a few hours of sleep in the trains stored in the depots at the end of the tube lines after the system was closed for the night. The trades unions and the TUC itself were by no means consistently friendly to the new arrivals and sought to control the employment of black labour through the application of quotas in key areas like hospitals and buses.

Keith Edwards and Queenie Marques, two newly arrived immigrants from Jamaica, September 1954

Following pages: A large family living in cramped accommodation, London, 1949

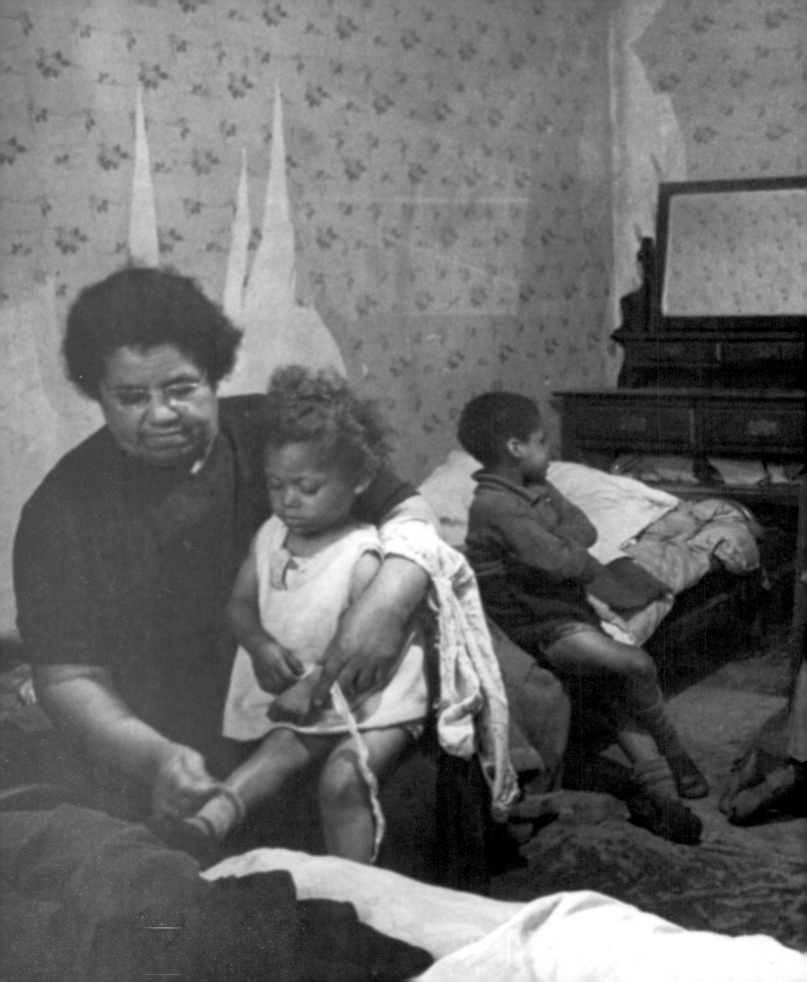

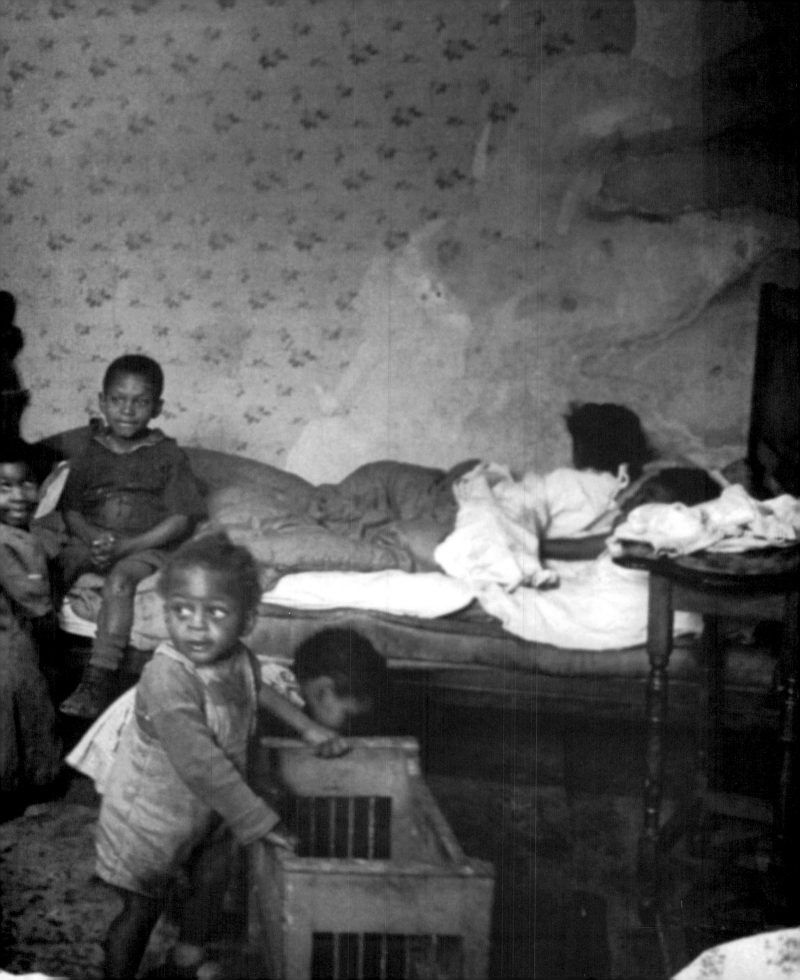

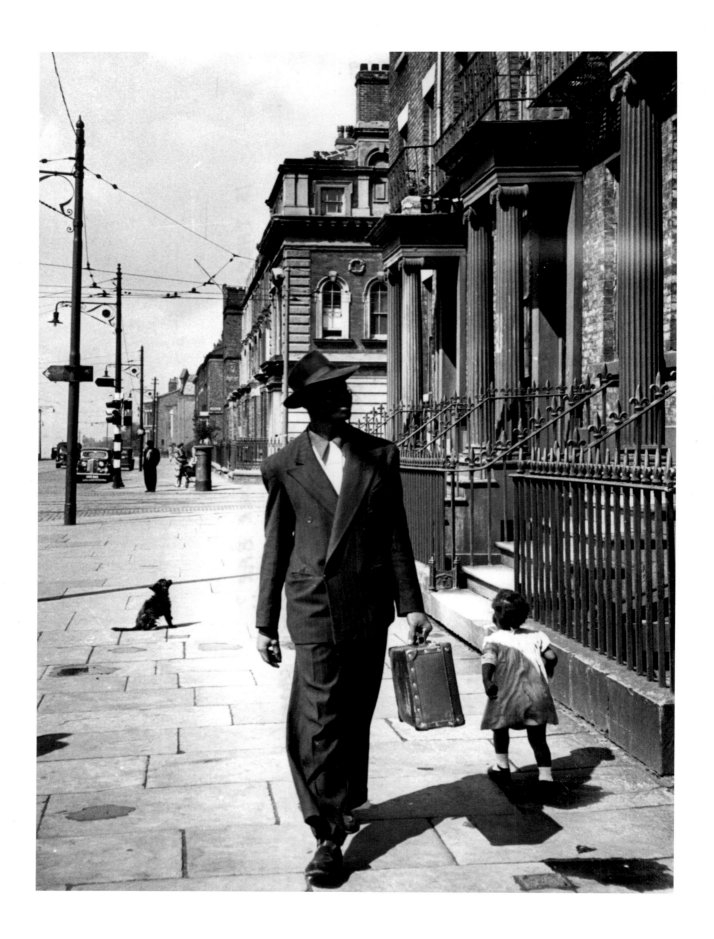

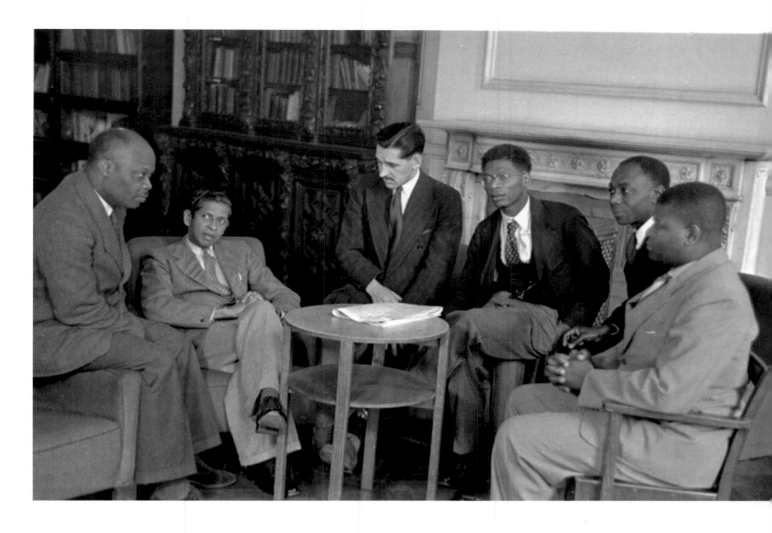

The squalor of bedsit lodgings and the Caribbean vitality that was imagined to transcend its special pressures are much in evidence in the photographic record. Images documenting the operation of the Colour Bar gave real force to the way it was being criticised. Its impermeable power was made acutely visible in the liberal images that closed off the avenue to simple denials of British prejudice and flushed out different justifications for such obvious unfairness. The foundations for future legislation against discrimination were laid in this era, when a shameful refusal to rent a room might be explained in terms of what the neighbours would think rather than any admission of personal prejudice on the refuser's behalf. These may have been especially uncomfortable issues because the undeniable fact of everyday racism risked reviving memories of the Nazis' racist regime, supposedly antithetical to the British way of doing things.

1949

Facing page:
A West Indian immigrant looking for accommodation in Upper Parliament Street, Liverpool, 1949

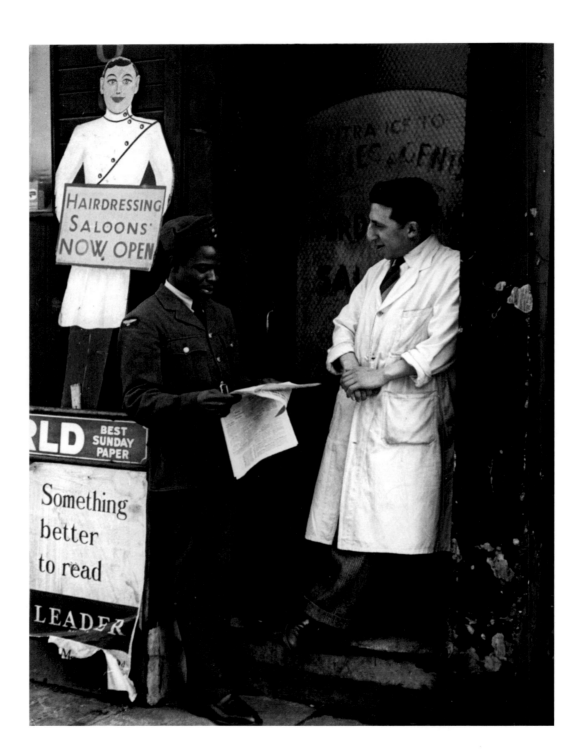

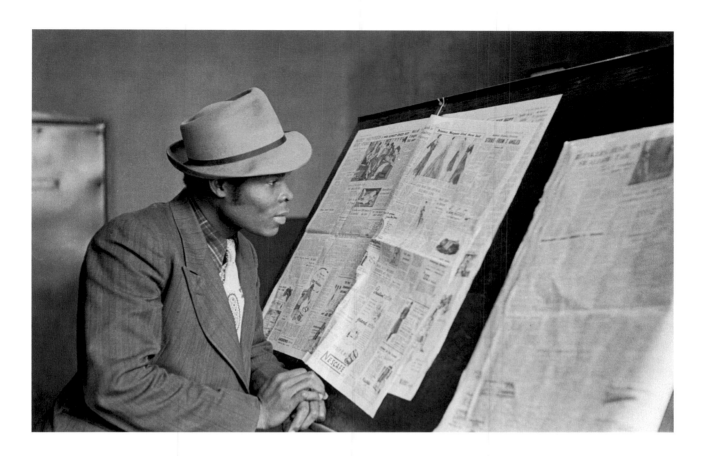

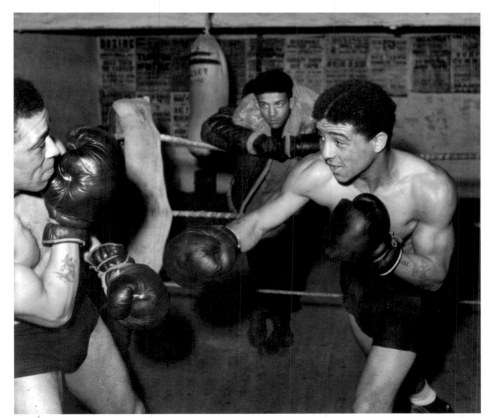

Top: A West Indian
immigrant reading a
newspaper in a Liverpool
library, 1949

Left: Brothers Dick (left)
and Randolph Turpin
sparring, December 1949.
Dick Turpin was the
first coloured fighter to
become British champion
under B B B of C rules.
Randolph Turpin became
the world middleweight
boxing champion in 1951
after beating Sugar Ray
Robinson

Facing page: Two men,
one an airman reading
a newspaper, talking
outside a hairdresser's
salon, London, 1949

Children playing
on the rooftop
playground at
Windsor Street
County School in
Liverpool, 1949

Facing page:
Piccadilly Circus,
London, 1949

Popular racism required a refusal to admit the complex and differentiated character of the incoming groups. However, it comes across nonetheless in pictures that stress the literacy of the immigrants, the diversity of their origins, their fashion sense and their seeming familiarity with their new home. All of these qualities set them on a collision course with the widespread racist outlook that saw all blacks as ignorant, brutish and subhuman. The photographic record also suggests that acknowledgement of class differences within the nascent black community was unsettling. It may have confounded the simple dualistic approach to racial difference, which is still dominant. The immigrant workers were photographed reading the newspapers in the public library, where they hunted for jobs in the help-wanted columns or passed their unfilled time searching for news from the places they had left behind. They were seen reading at the barbershop and perusing the map of the Underground system in the street – an image that underscored their alien status in the same moment it established their literacy and their ambition to master their new environment. Their visible literary appetites showed them to be willing workers and were sufficient to hint that they might not be, as the conventional racist hierarchy suggested, straightforwardly inferior.

West Indian women singing around a piano, 1949

Students, professionals, political leaders and soon-to-be celebrities were portrayed in more privileged settings than the squalor that offset the lives of ordinary workers. However, the wholesale racial differences between whites and blacks, settlers and natives, 'them' and 'us', remained substantive. These immigrants may have known Wordsworth and Shakespeare, but they talked, cooked and acted differently. Whether they were African or West Indian, rich or poor, they seemed to be connected in a deep and abiding way with the slum-like conditions they had often been forced to inhabit. Perhaps, the pictures ask, there was no coercion involved in that outcome? Perhaps these people knew no other way to dwell? If so, their poverty and filth were just expressions of what made them not only different but inferior also.

At the centre of these anxieties about racial dirt, health and hygiene lies the issue of miscegenation that they often inferred. Spoken most of the time in a dense but genteel code, the need to prevent sexual

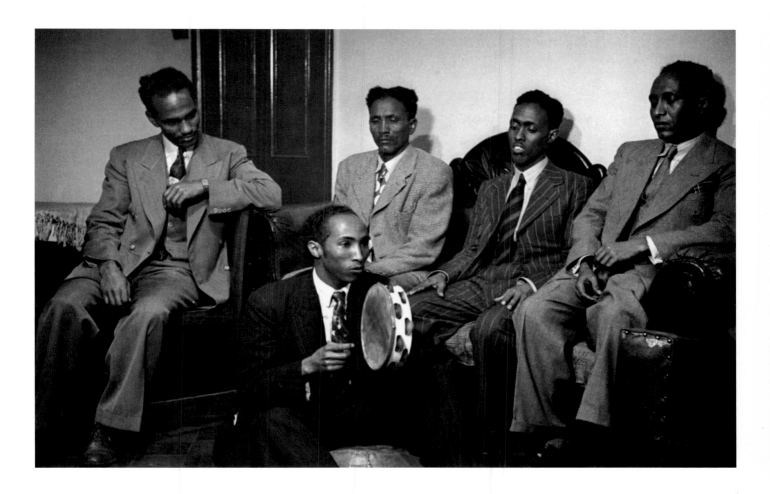

1949

contact skewed the dominant view of the incomers as essentially law-abiding and hard-working. It sent discussion off in a different direction. Supposed predation by black men on white women was another staple image recycled from the ancient lexicon of colonial racism. Those men were linked to the image of the pimp, and whether they were black or white, the women with whom they associated were marked by the taint of prostitution. If the women were unwilling, the men became rapists. If the women were willing, they became the vanguard of racial degeneration. These mythic incarnations were closely related to fears about the disproportionate role of black immigrants in the spread of sexually transmitted disease, which had been part of the US military's justification for the transposition of its Jim Crow rules.

Against the novel backdrop created by those timely questions about the extent and content of natural differences between the races, culture talk began to supply a new medium that would make racial differences

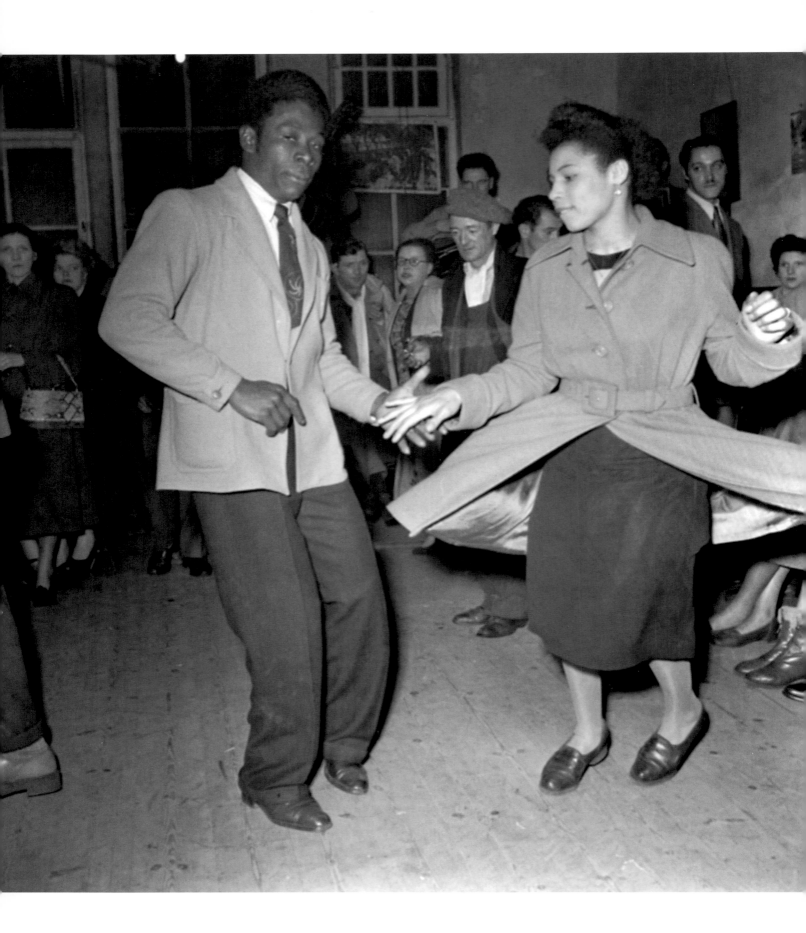

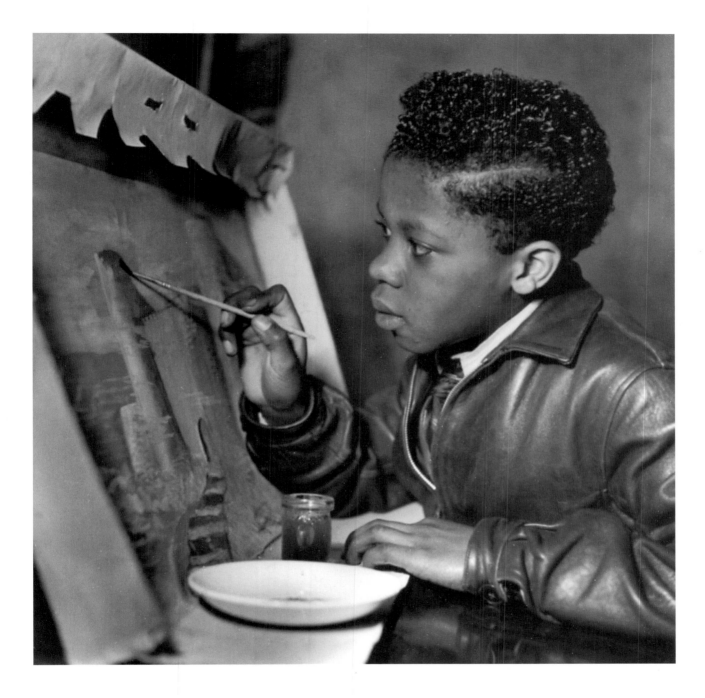

intelligible. A new variety of racism was starting to take shape. It was closely tailored to the distinctive postwar conflicts over housing and employment, but moved away from conventional notions of biological hierarchy towards the idea that the cultural incompatibilities involved in and revealed by immigration were decisive, damaging and destructive to all parties.

This new, culturally inclined racism developed in polite, coded,

Fourteen-year-old Leonard Blackett of Bute Town or Tiger Bay paints a scene from *Hamlet*, 1950

Facing page: A dance at St Mary's School, Tiger Bay, April 1950

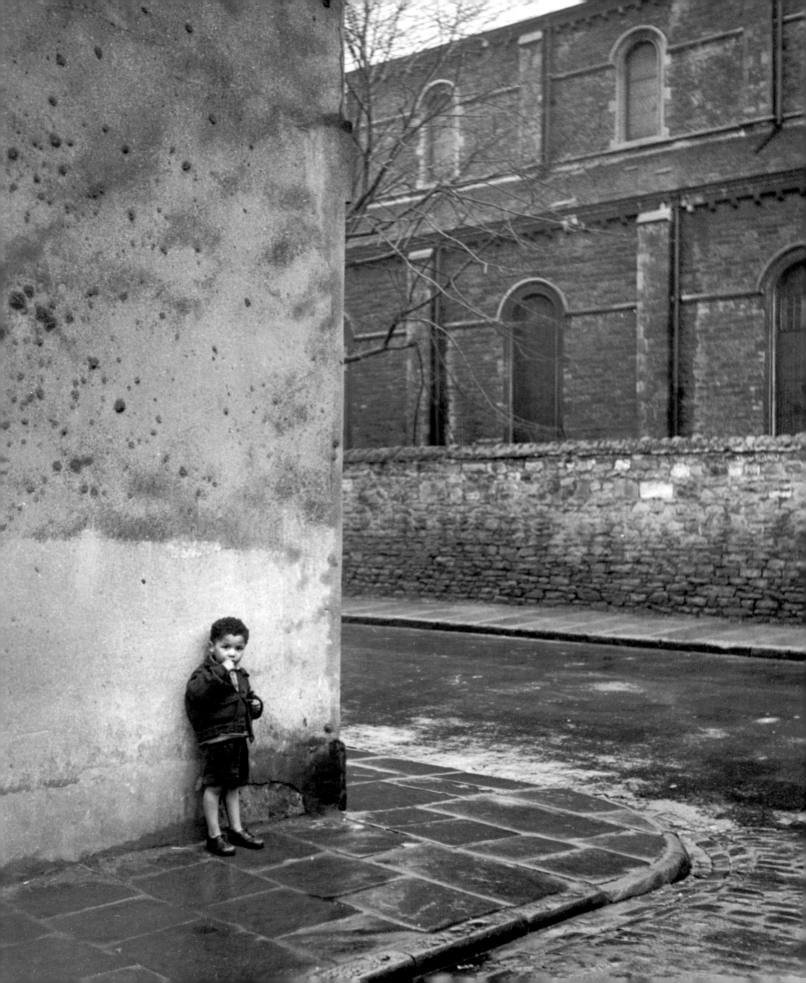

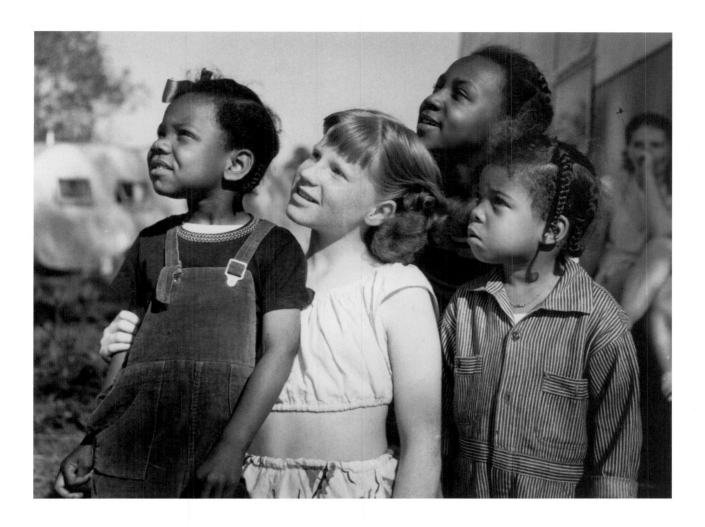

official forms as well as aggressive, popular varieties, but it did not have a uniform depth, character or consistency. Resigned to its presence, the government counselled the incomers to anticipate inevitable suspicion, discrimination and hatred. A survey conducted in 1953 discovered that almost 85 per cent of London landladies would not let rooms to students who were 'very dark Africans or West Indians'. The workers presumably fared even worse in a system that charged all blacks higher rents regardless of their status. The density of black habitation increased through this self-fulfilling prophecy, which seemed designed to confirm the very charges that popular racism had levelled. The incomers had to fight hard against this pressure to become the very images of blackness that had been predicted by the ignorance, hostility and prejudice of their British hosts.

The long, slow process, which would culminate in the assimilation

Children of members of the US Air Force stationed in Britain, June 1952

Facing page:
Tiger Bay, 1950

99

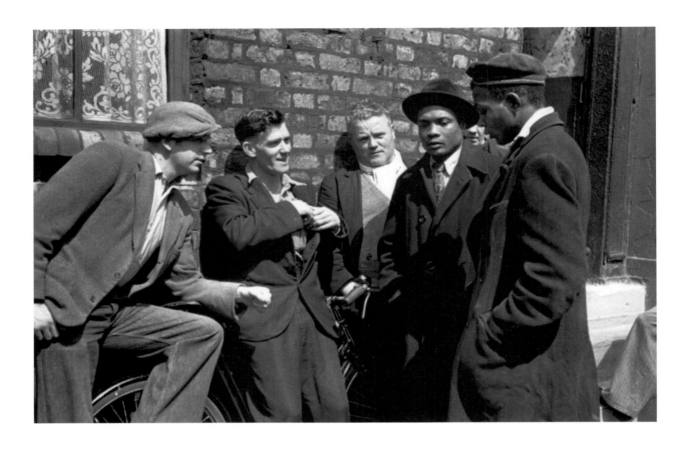

Two West Indian
immigrants talking
to a group of young
men, 2 July 1949

Facing page:
An Islamic prayer
meeting in Tiger Bay,
1950

of Caribbean settlers and their descendants into the mainstream currents of British social life, can be thought of as beginning in those everyday, street-level encounters between black and white working people. It is important to appreciate that this contact was by no means always or automatically conflict-ridden. Patterns of identification, commonality, friendship, love and connectedness grew from it, intertwined with fear and conflict.

Those more benign occurrences remain difficult to discuss. They cannot be ignored here, but neither should their significance be inflated so that they distract attention from the destructive effects of interpersonal and institutional racism with which they became enmeshed. Friendly connections across the fortifications of the Colour Bar were often anchored by shared experiences of work and play on which a sense of grassroots and class-based solidarity could intermittently be built. That connectedness could not undo racism or even banish it, but it might in some circumstances have dampened or mediated racism's effects.

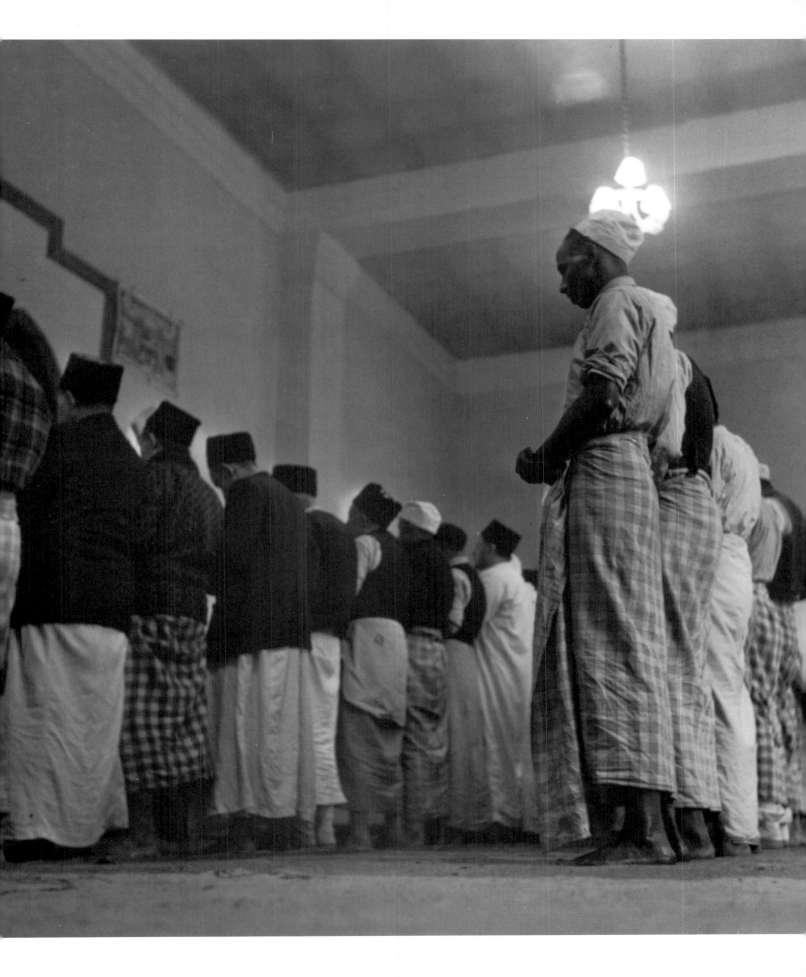

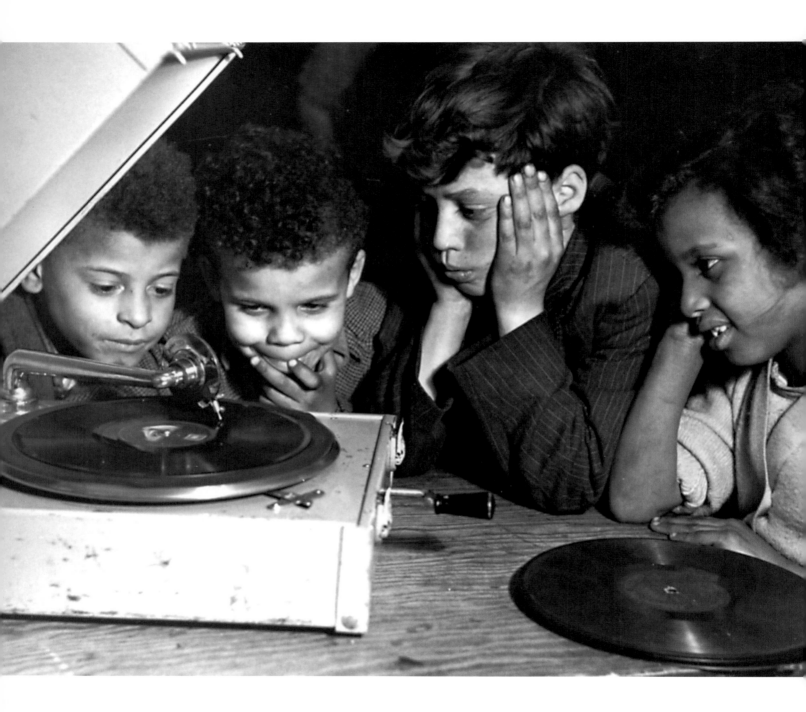

Children in Tiger Bay, 1950

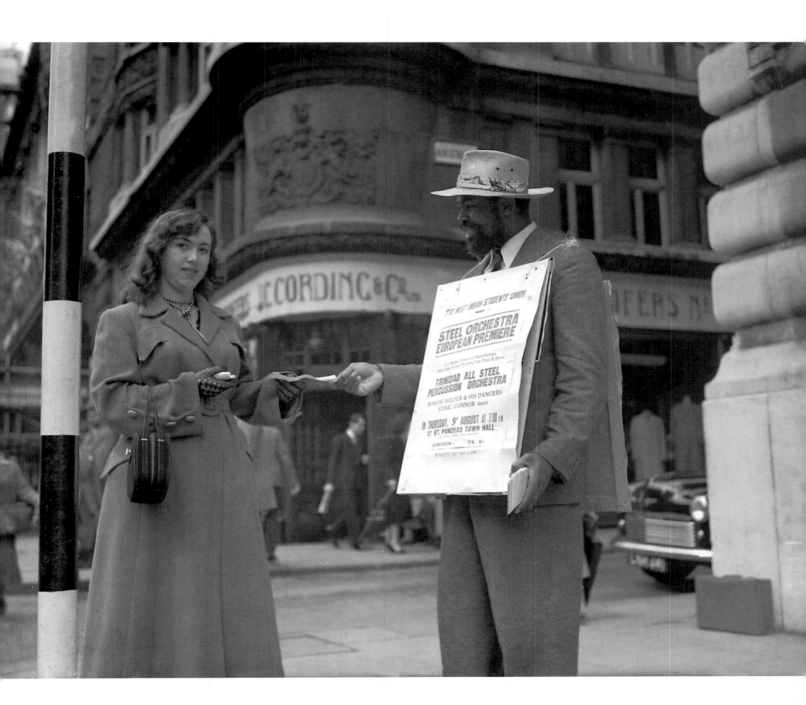

Edric Connor, a West Indian
baritone, in Piccadilly. He is carrying
a sandwich board advertising a
concert by the West Indian Students'
Union at St Pancras Town Hall,
featuring the Trinidad All Steel
Percussion Orchestra, 8 August 1951

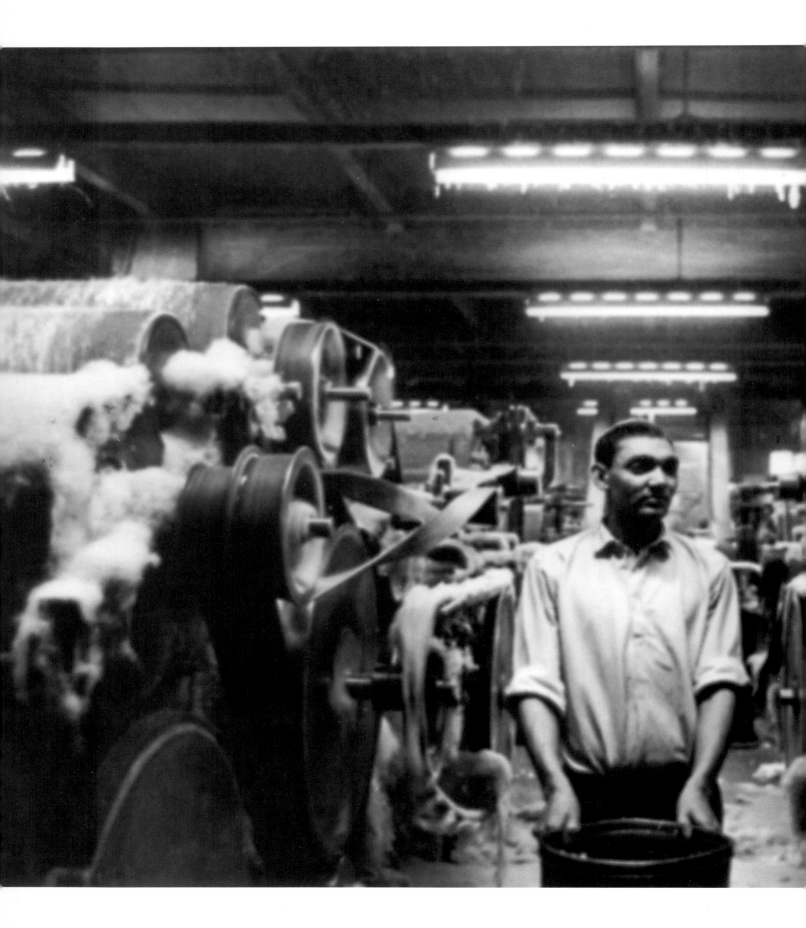

An immigrant employee from
Pakistan at work in a spinning mill
in Bradford, West Yorkshire, 1950

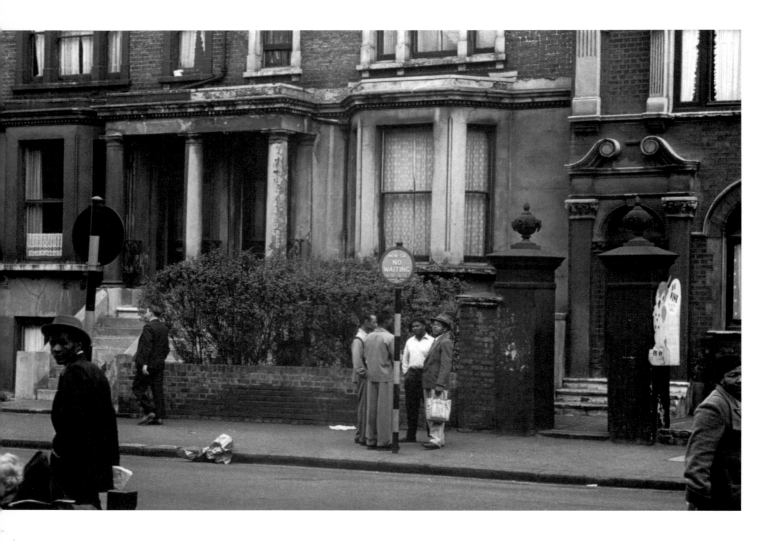

Brixton, 1952

Facing page:
Tiger Bay, 1950

As they moved into Britain's metropolitan centres seeking safe, warm houses and secure employment, the incomers encountered more than the habitual humiliation of the Colour Bar. They met with vicious and brutal intimidation organised by a political movement oriented by the impossible and absurd imperative to 'Keep Britain White' (KBW). Along with the old lightning-flash insignia of the Mosleyites, that frightening slogan was painted on the walls of the bomb-damaged, inner-city neighbourhoods where black communities were being established against the odds. The restorative fantasy of a white Britain was promoted by organised racist and nationalist groups. Their ideological and organisational roots lay in the prewar Fascist organisations that had previously allied themselves with Hitler and targeted the Jewish presence in Britain as alien and repulsive.

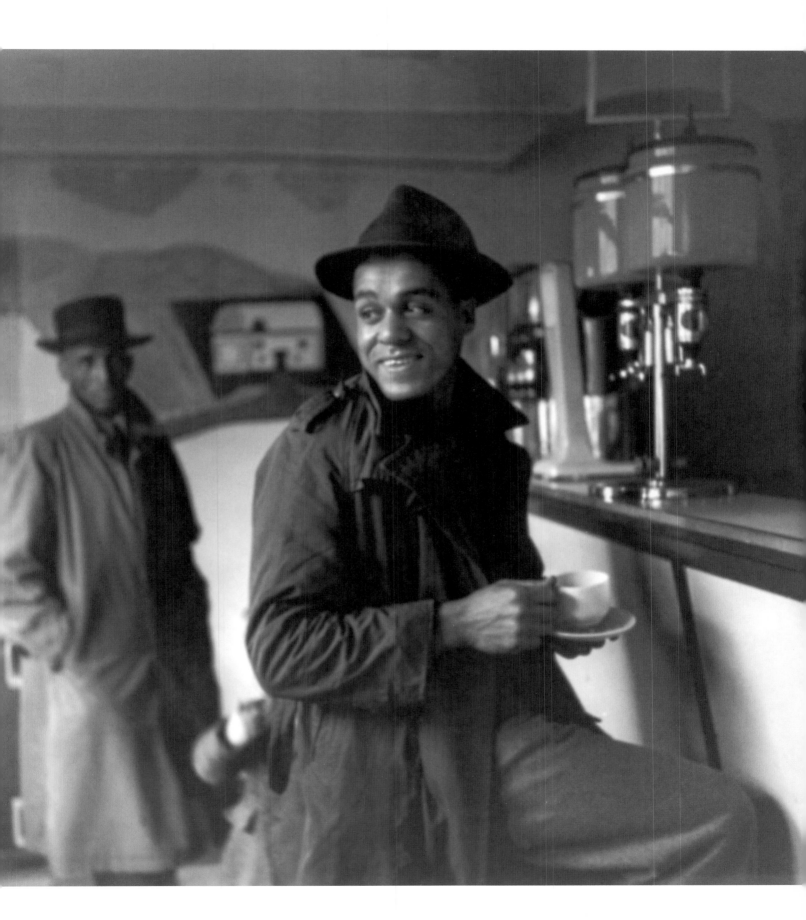

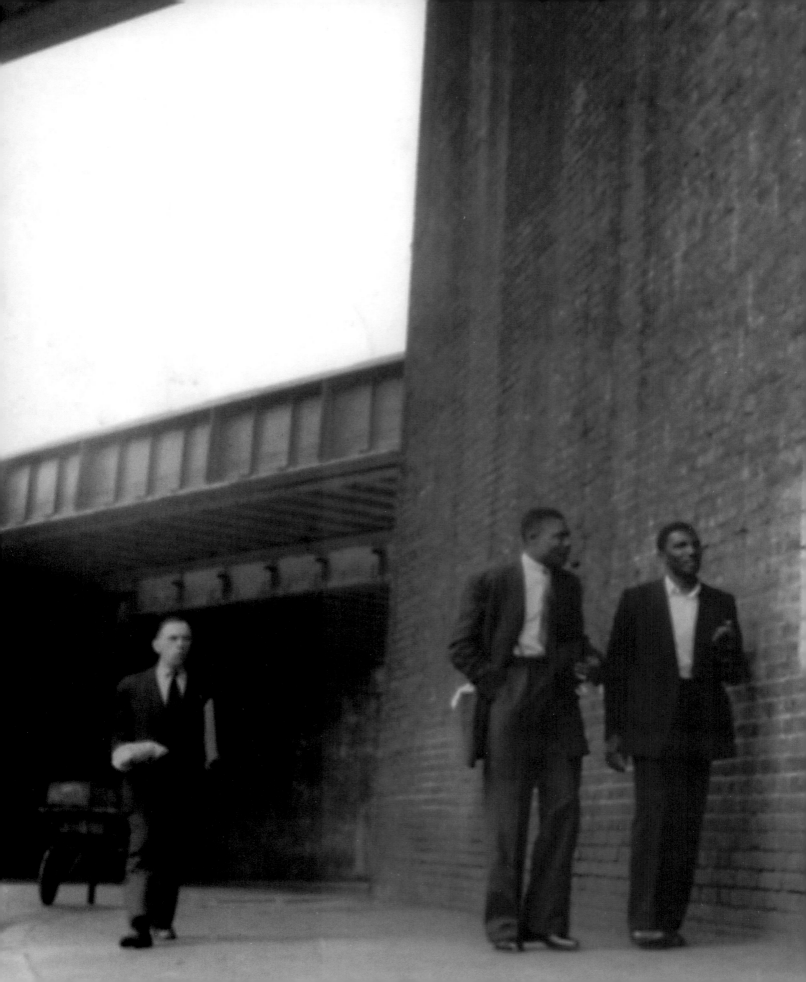

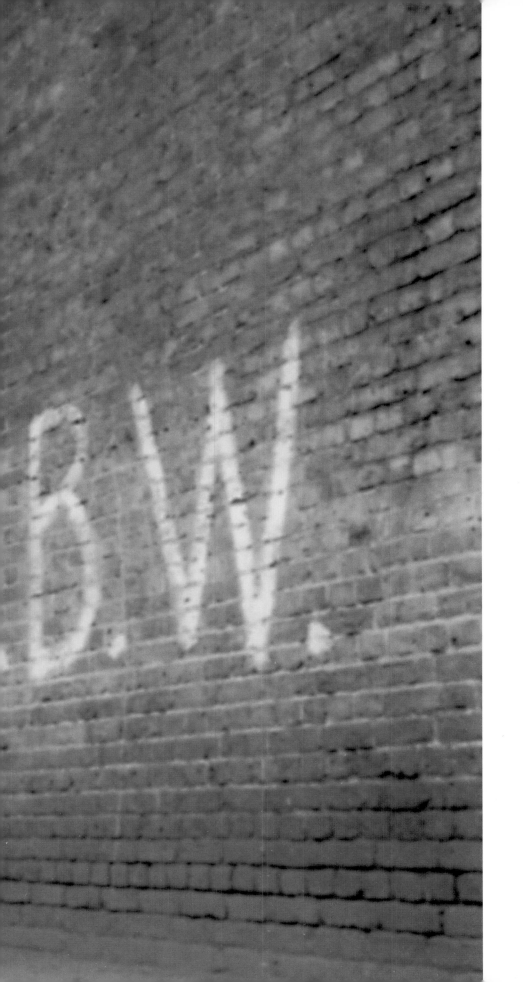

'Keep Britain White'
graffiti in Brixton,
1952

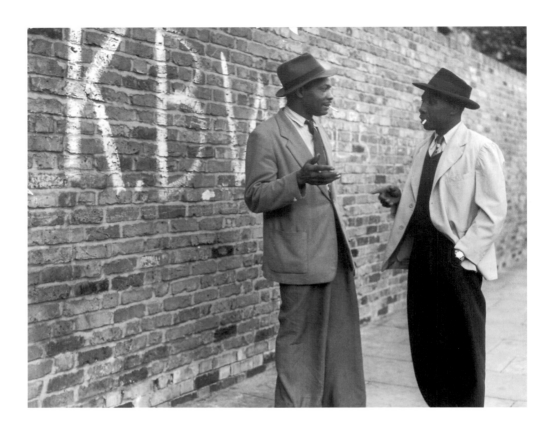

Top: Jamaican men talking in
Brixton, 1952

Right: Members of the White
Defence League preaching
violence and hatred towards black
immigrants, Trafalgar Square,
London, 24 March 1959

Facing page: Majbritt Morrison,
twenty-six, and her husband
Raymond after an initial court
hearing following her arrest for
obstruction during the Notting Hill
disturbances, September 1958

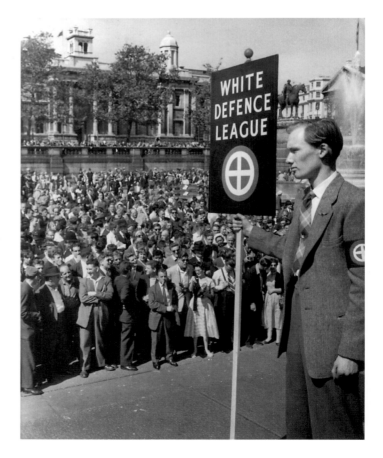

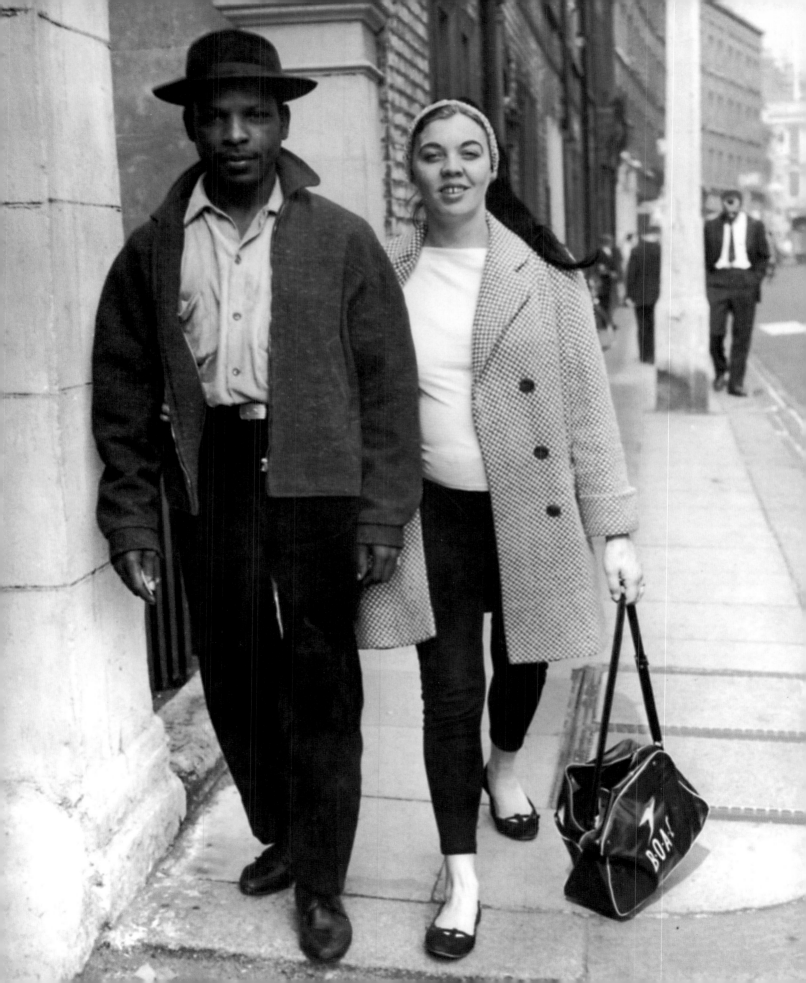

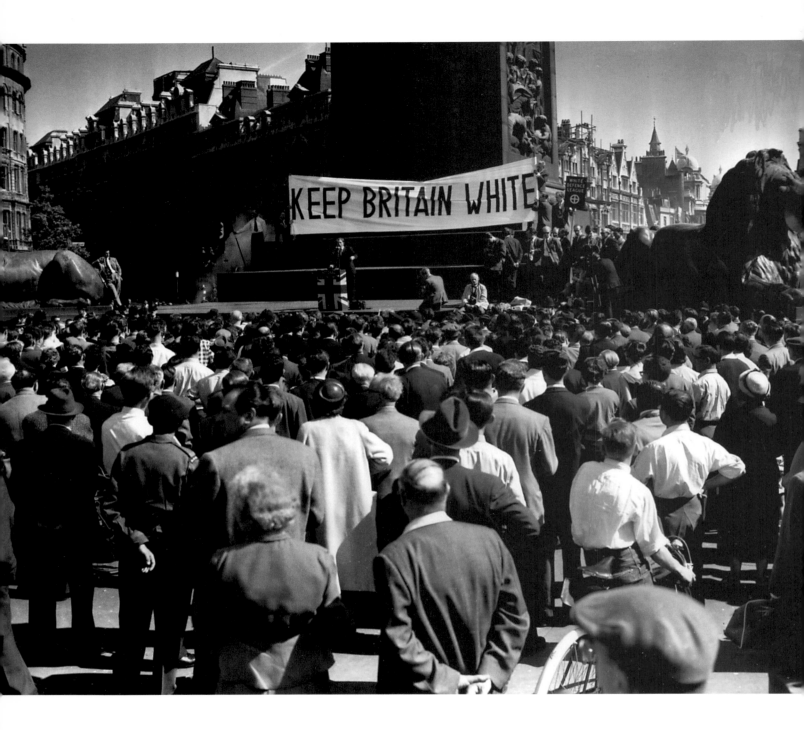

The 'Stop the Coloured Invasion'
protest meeting in Trafalgar Square,
London, 1959

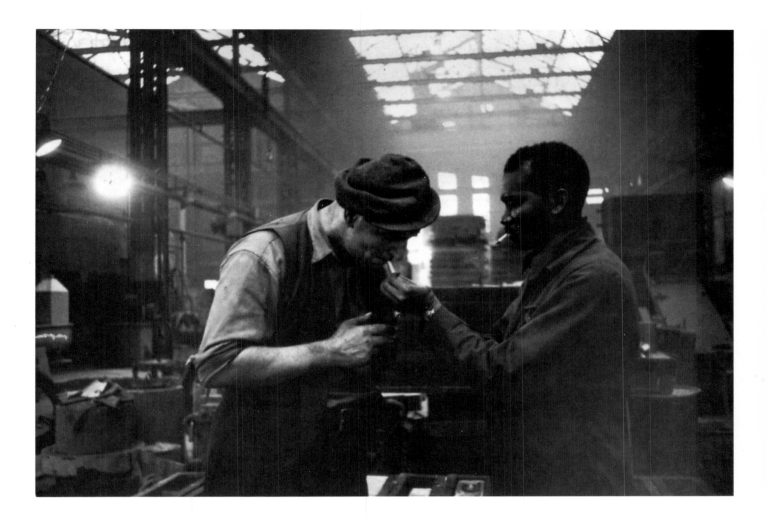

At first, the KBW graffiti appears to have been addressed as an instruction to disenchanted whites who shared the contested space it delineated by marking racial divisions on the surface of the damaged, transitional city. However, the graffitti's intimidatory imperative is understood better as a warning to the new settlers. It told them that they were at risk from the violence of a resentful minority who would not be reconciled to their presence.

The racist and ultra-nationalist groups once again found the courage to conduct their campaign of intimidation in public rather than at night after the pubs had closed. Black settler communities that understood their own vulnerability resisted these groups, and were determined not to be cowed by the flick knives and petrol bombs intermittently directed at them by the Teddy Boys and their associates. The determined opposition to this intimidation was reinforced by an

Jamaican immigrant Kwesi Blankson gives workmate Jack White a light at the Phosphor Bronze Company, where he is in charge of the oil burners, 22 January 1955

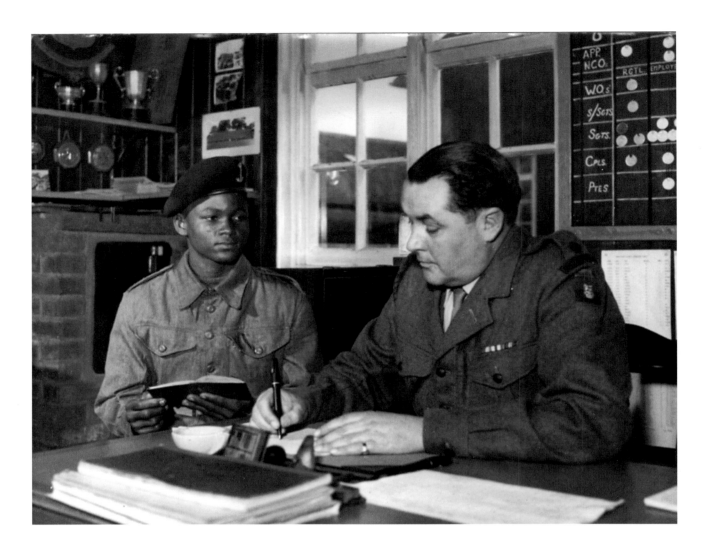

Major P C Stocker, in charge of intake at the Army Apprentice School in Arborfield, interviewing apprentice tradesman Thomas Basare from Kumasi, Gold Coast, Africa, February 1957

Facing page: Soldiers from a contingent of the King's African Rifles (Askaris) during a visit to Windsor Castle, Berkshire, 17 July 1957

emergent sense of entitlement and belonging. It was strengthened further by an understanding of the salience of race politics in the emergent geopolitical architecture of the Cold War world, which had been brought home by the Suez crisis and the war in Korea.

The battle against South African Apartheid and the rekindling of US civil rights struggles would prove to be inspirational far from their immediate places of origin. The struggles that black Britain conducted for rights, dignity and recognition would be influenced, if not exactly guided, by those examples. Local struggles necessitated a new political leadership, represented here by the figure of the visionary Trinidad-born communist Claudia Jones, better known as the initiator of London's own Carnival festivities, which began indoors in St Pancras Town Hall in 1959, a decade after Jones was deported from the US.

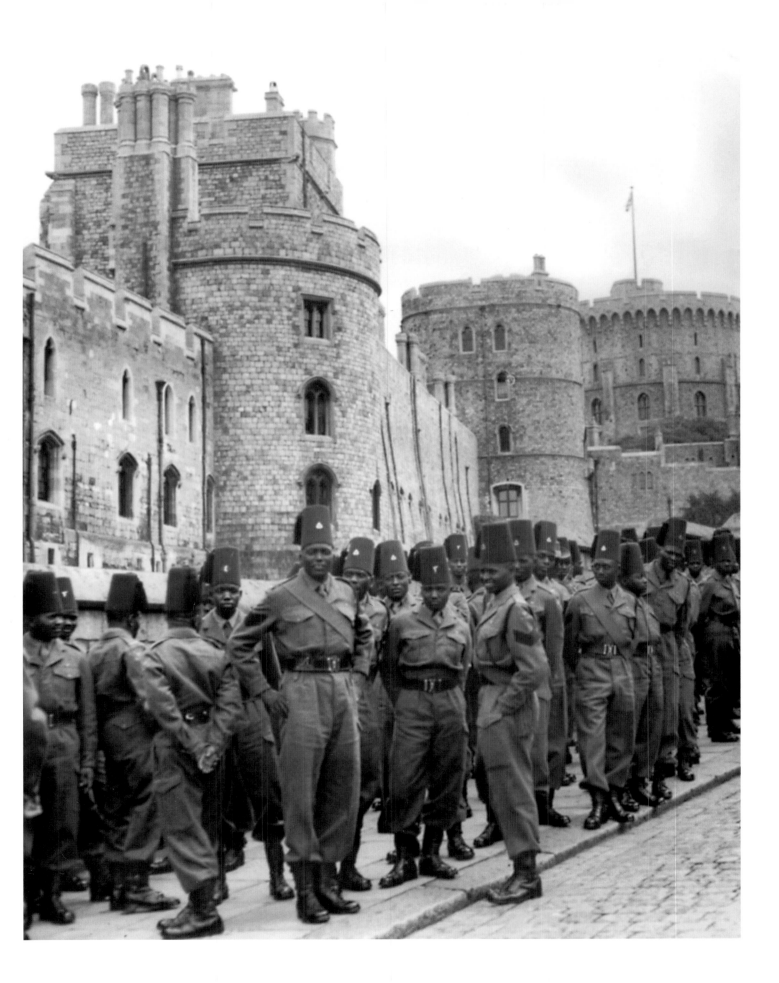

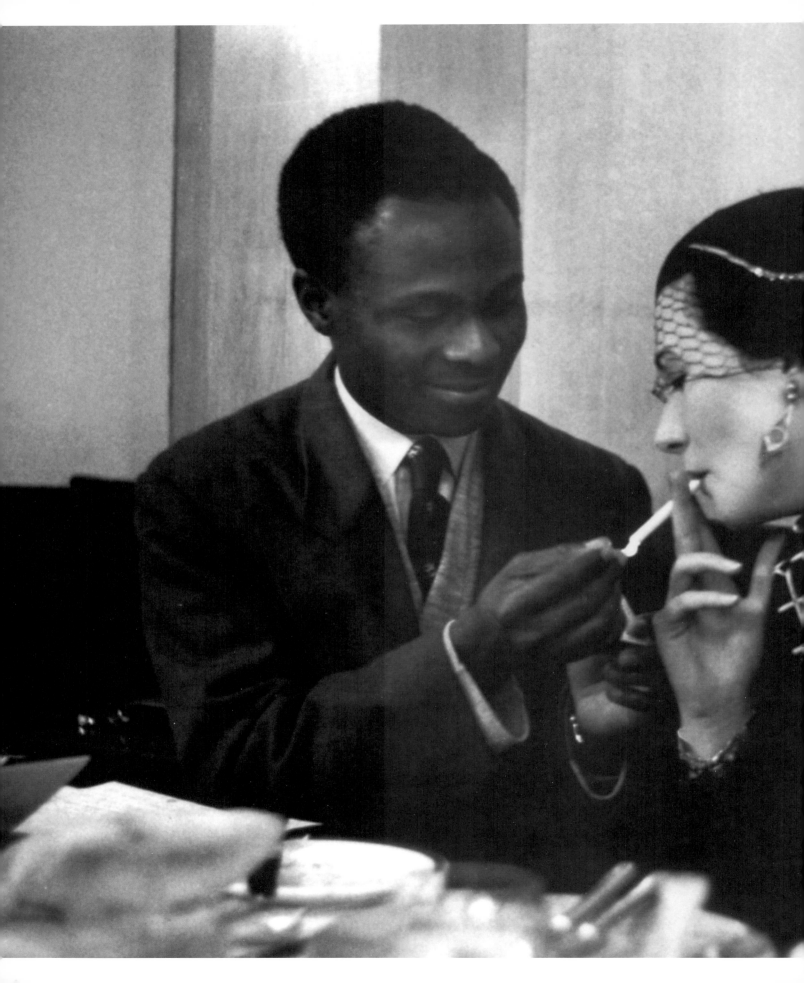

A Nigerian man offering a light to a
South African woman at a London
restaurant, 1955

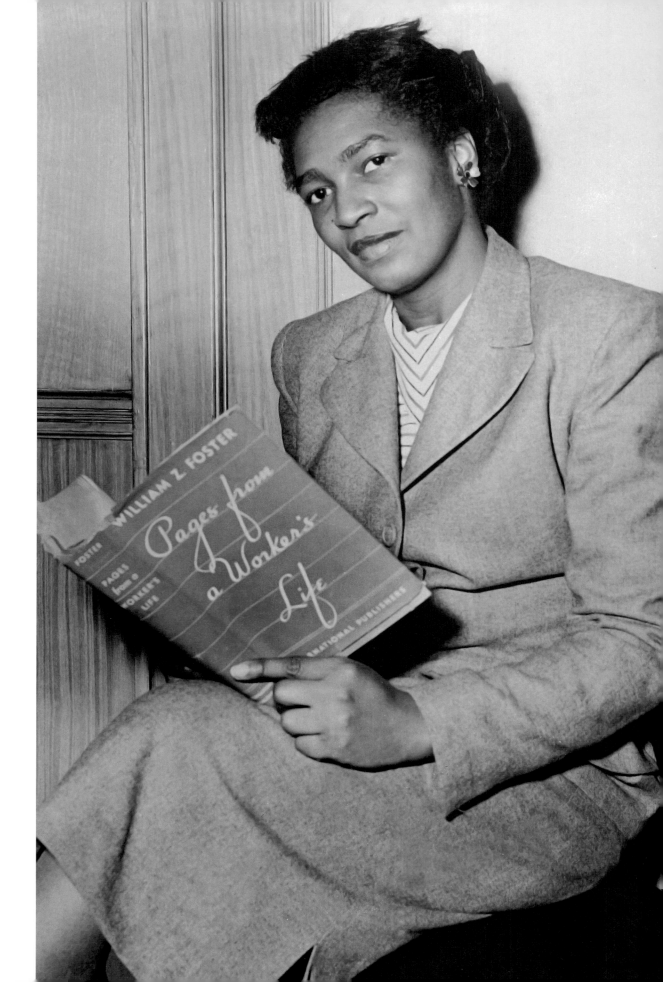

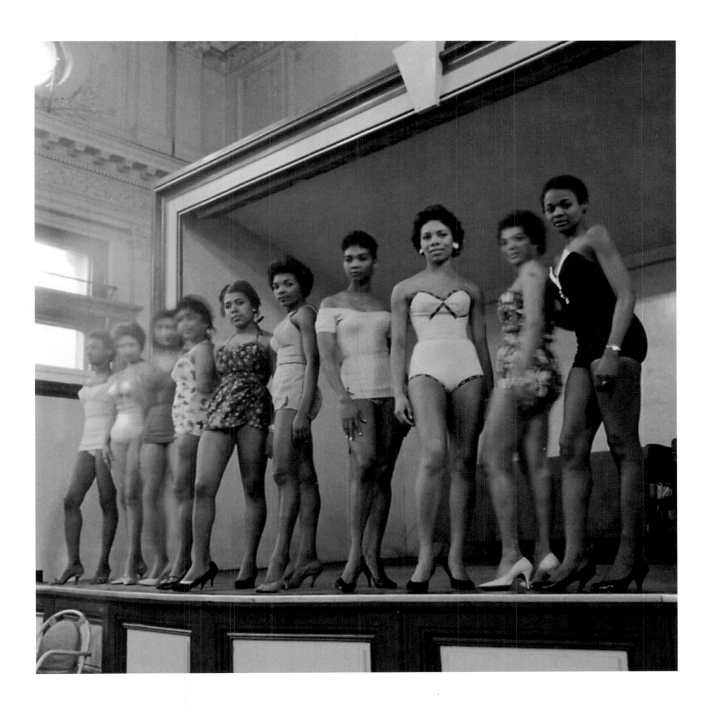

Competitors for the Carnival Queen title rehearsing at Holborn Hall, Gray's Inn Road, London. The first Caribbean Carnival was held in St Pancras Town Hall in January 1959

Facing page: Claudia Jones at the National Communist Headquarters, 35 W. 12th Street, 26 January 1948. She was arrested and charged with being an illegal alien in the US and advocating the overthrow of the government by force. Jones was born in Trinidad in 1915 and went to the US in 1924

Following pages:
Left: A grandmother with her grandchildren, July 1960

Right: Twin brothers Peter and Fred (aged thirteen) during a break in a training session at Woodford Bridge, Essex, 10 April 1959. The orphaned boys lived at a Dr Barnardo's Home

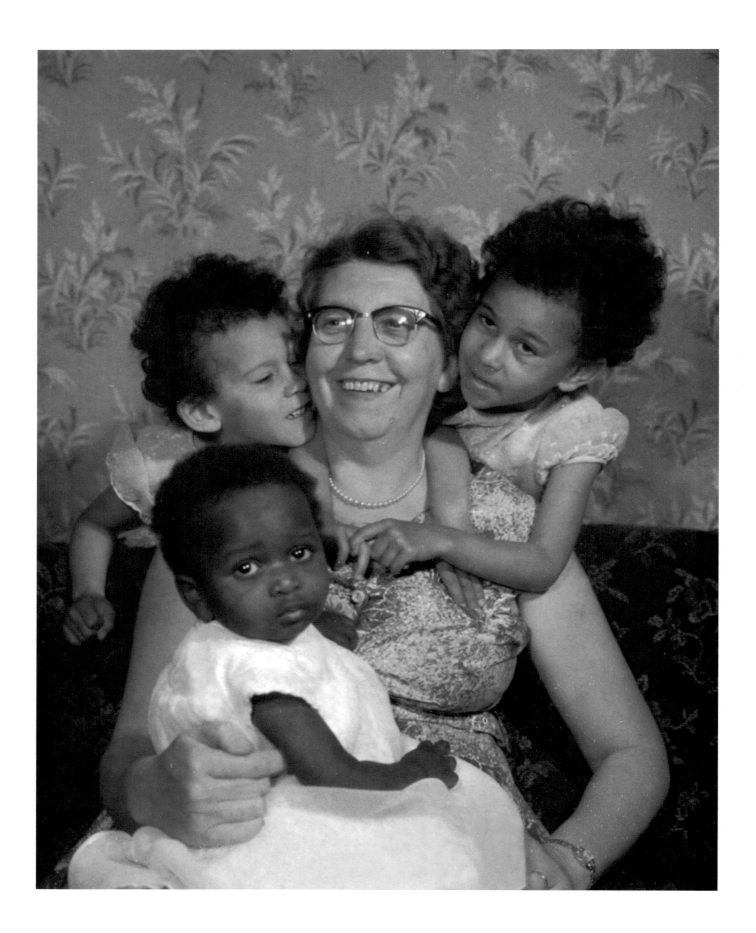

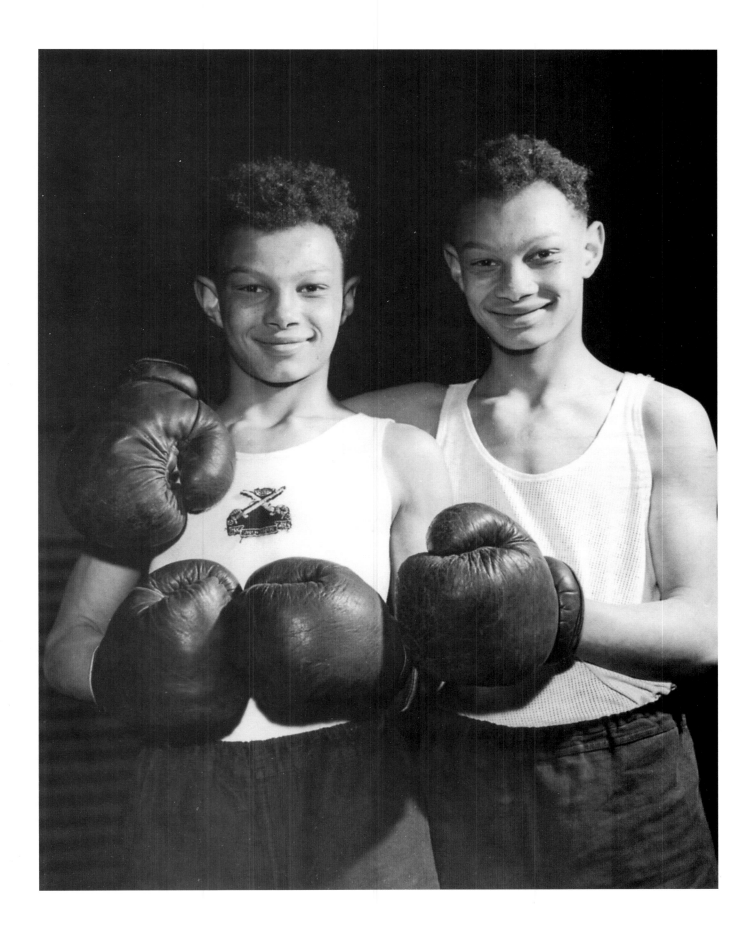

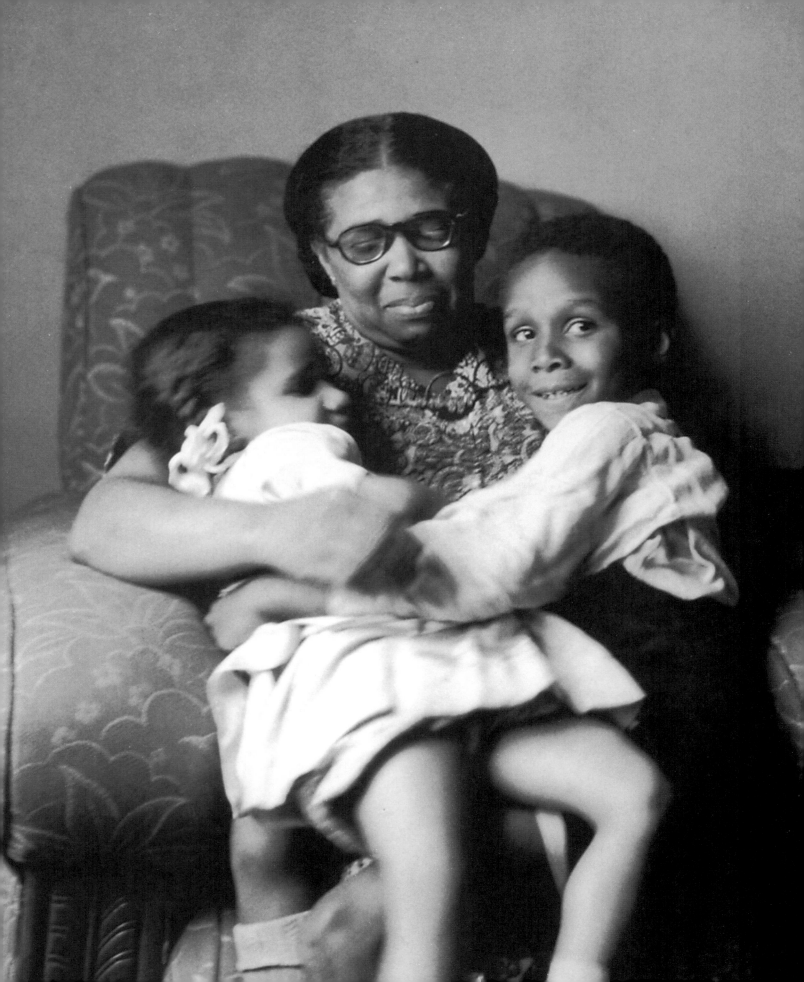

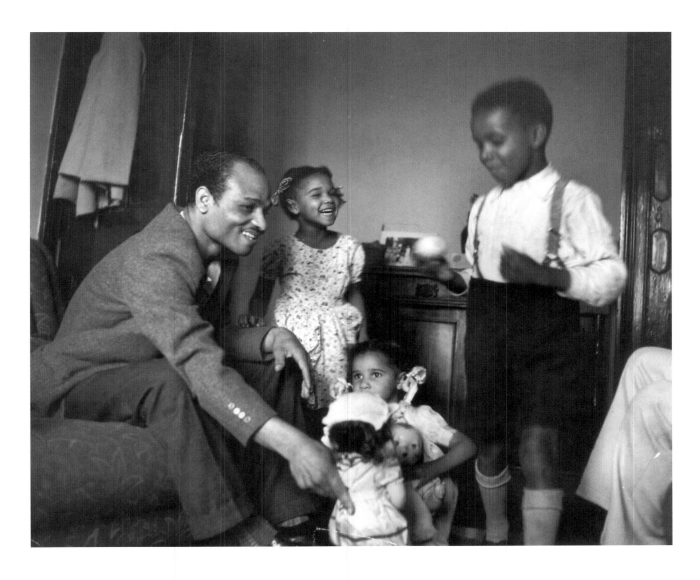

The incoming workers started to be joined by the children they had left behind until secure jobs could be found and homes established. New families were being started. Older anxieties about miscegenation and racial degeneration were reborn in the form of widespread concern for the tragic plight of the 'half-caste' children whose wretched and indeterminate existence proved the folly of interracial contact beyond all doubt. Britain's orphanages and local authority facilities were being filled with these unwanted human fruits of racial transgression. Once again the figure of the child came to encapsulate the dangers and opportunities involved in the country's understanding of racial conflict.

Unemployed fathers or those who toiled on the night shift could

A Jamaican father at home with his family, Brixton, 1952

Facing page:
Brixton, 1952

Following pages:
Mr and Mrs Sango and one of their children in their one-bedroom flat in Brixton, 1954

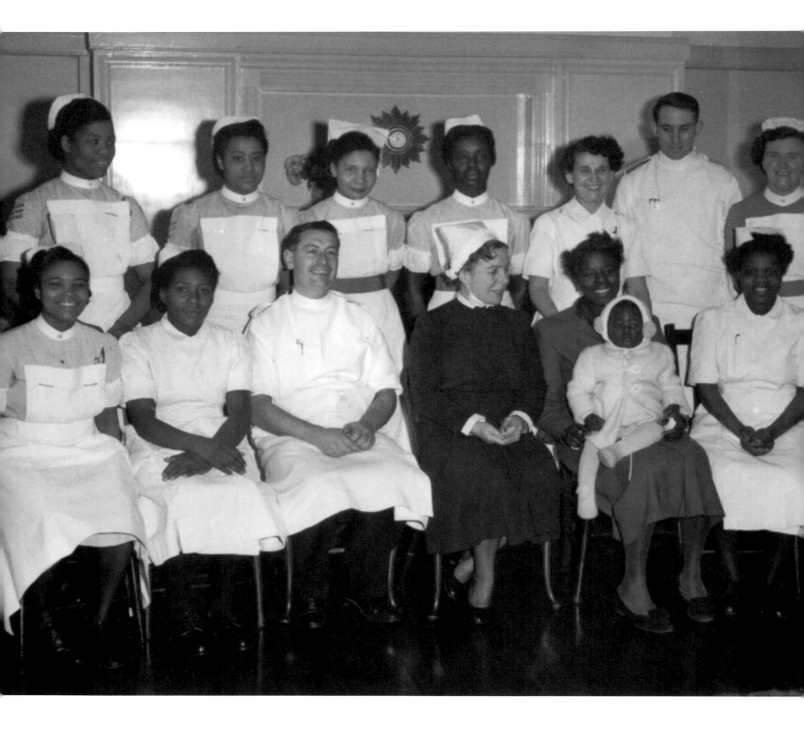

Nurses from the Commonwealth and colonies at Hackney General Hospital in London, December 1953

look after their children during the days while their partners worked. Yet even those images of loving care compounded the idea that the immigrants did things differently. For the new cultural varieties of racism, the social pathology that the incomers had introduced into Britain's body politic was not neatly confined to the places where dangerous race-mixing took place.

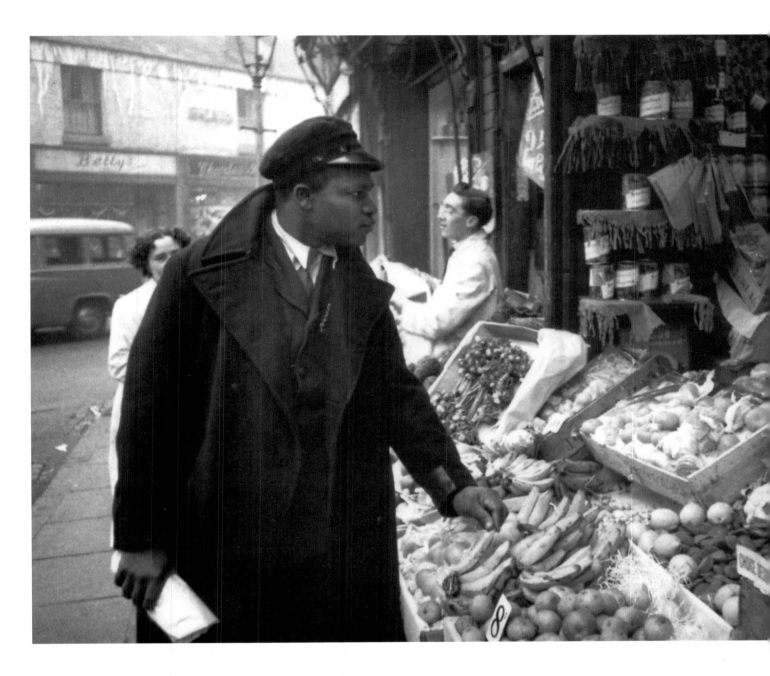

Anxieties about the invasive, alien culture imported by the immigrants increased as they sought places to shop for the foods they wanted and places to get their hair cut and dressed. Equally disruptive was their evident need for recreational spaces that were not subject to the Colour Bar, where they could drink, dance and listen to their music or just relax and recover after exhausting work. Many pubs and clubs remained closed to them, and house parties, shebeens and informal Blues dances attracted unwanted attention from hostile police.

Rue Gordon, a bus conductor in Birmingham, buying Jamaican bananas from a stall, January 1955

Following pages: Shopping at Brixton Market, 1952

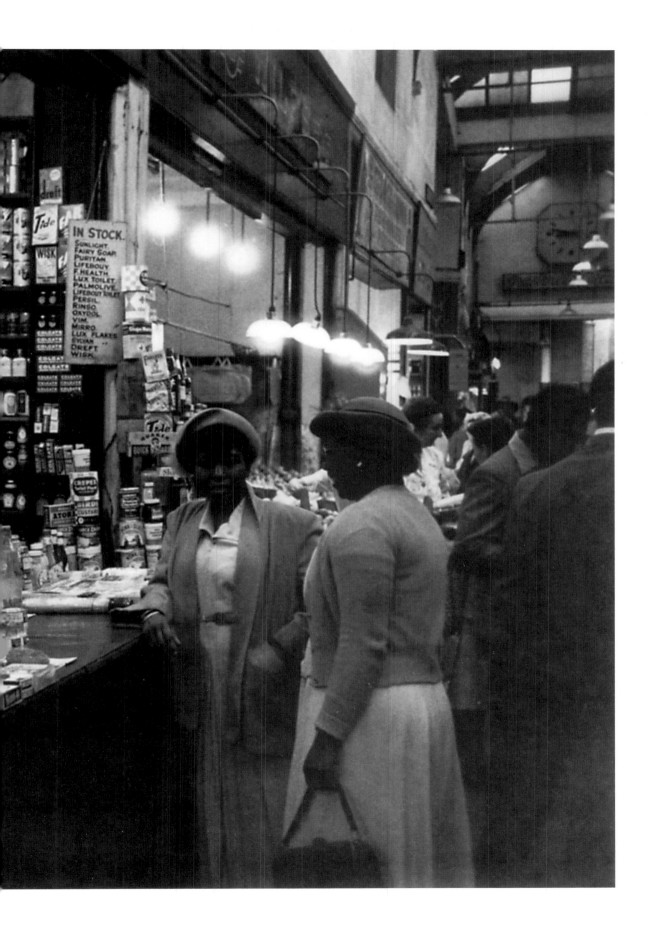

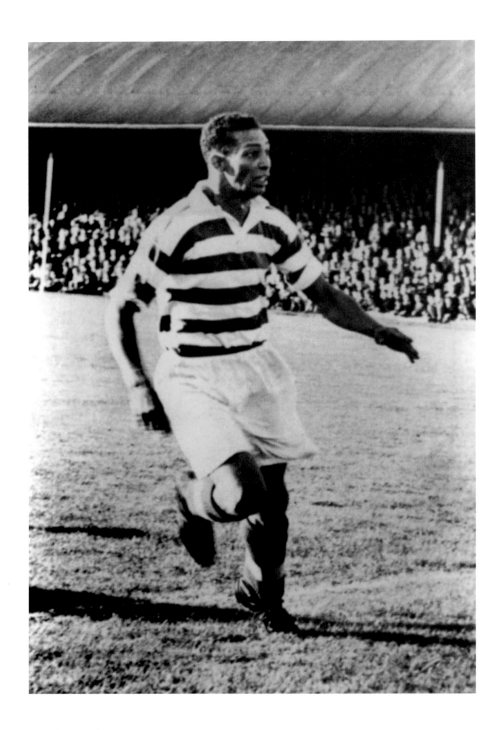

Gilbert Heron, 'The Black Arrow',
father of Gil Scott Heron, playing for
Celtic Football Club, Glasgow, 1951

Facing page: British sprinter
McDonald Bailey training at
Lilleshall for the Helsinki Olympics,
May 1952

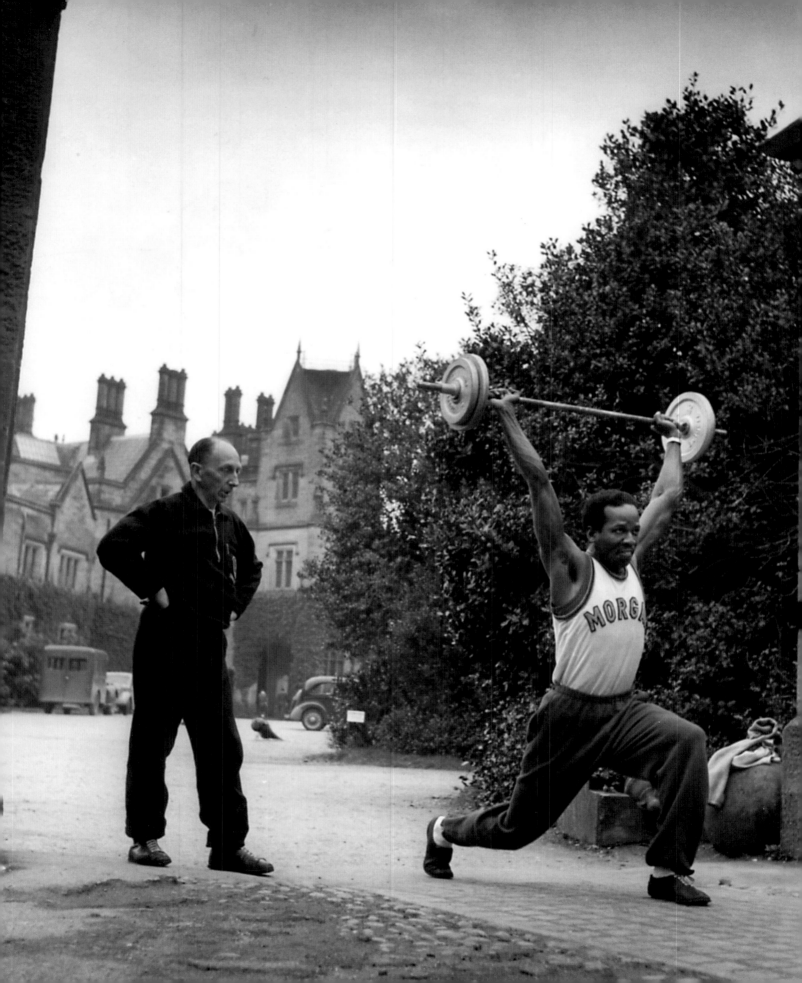

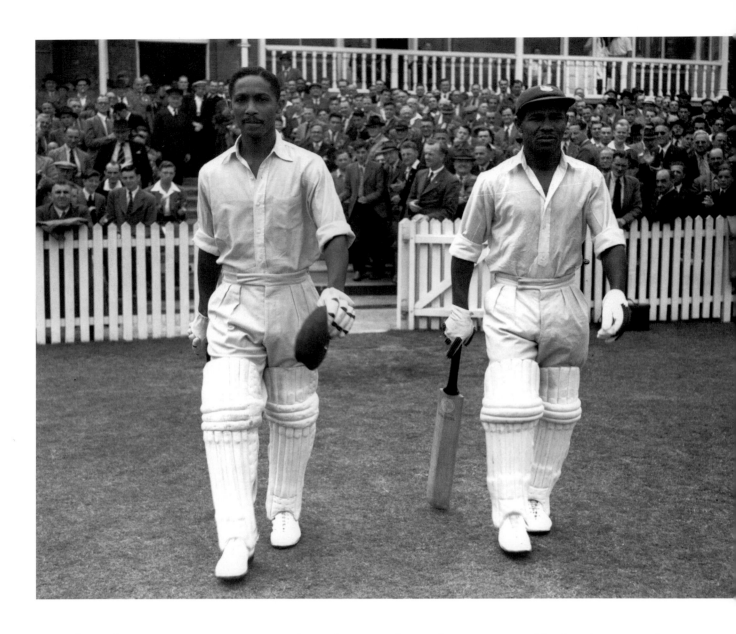

West Indies cricketers
Frank Worrell (left)
and Everton Weekes
at Trent Bridge, 1950

Britain's traditions of popular sport would also have to alter in order to accommodate the immigrant presence. It was not only that black athletes provided new symbols of excellence and daring – particularly for countries approaching the maturity of independence – but also that spectacles like the dramatic cricketing contests between the mother country and its former colonial possessions assumed a new political significance as well as a ritual one. To triumph over the old colonial masters at their own game, particularly in their own country, was a great feat that may even have offered some fleeting recompense for the indignities suffered while sojourning there.

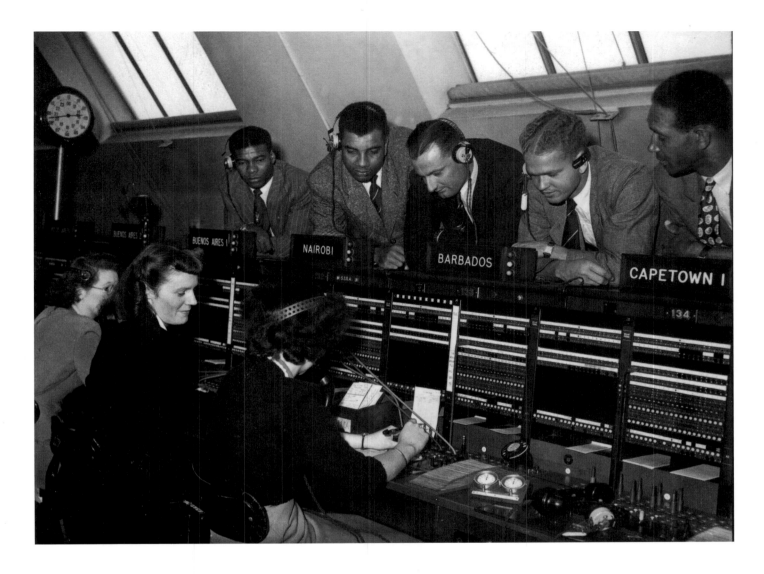

It bears repetition that Britain's cities had been badly damaged by aerial bombardment. Everyday life in those battered environments was scarred further by the other, more subtle after-effects of war, which were cultural and psychological in character. That lingering trauma helps to explain the distinctive varieties of fear and anxiety that could nourish aggressive xenophobia.

Images of tea-drinking proliferated as the locals sought reassurance that the immigrants were not, after all, as alien as had been thought. The same pictures provided an opportunity to gauge the strength and depth of the newcomers' attachment to the local habits that would measure their right to belong.

Britain's shift from empire to Commonwealth was expressed in

West Indies cricketers watching a telephone operator putting calls through to the West Indies for them from the International Exchange in London, 18 August 1950. From left to right: Everton Weekes, Clyde Walcott, John Goddard, Foffie Williams and Hines Johnson

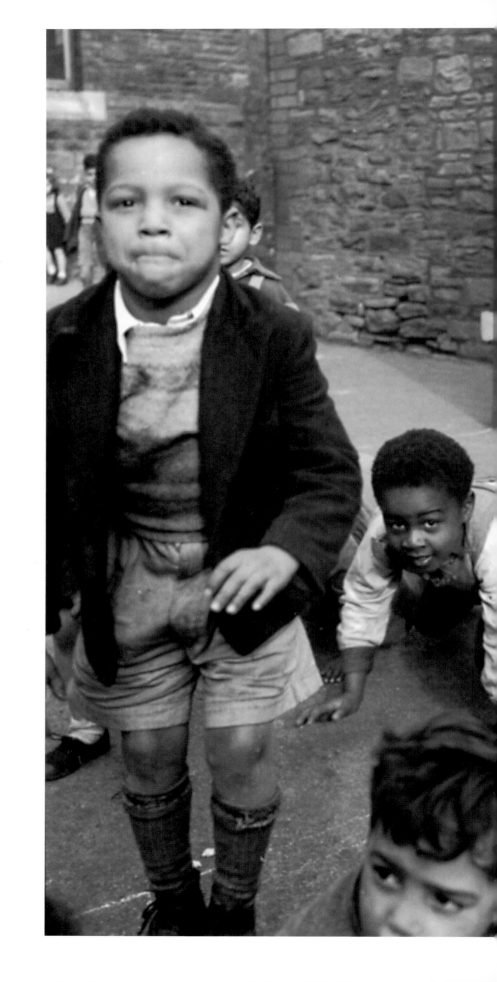

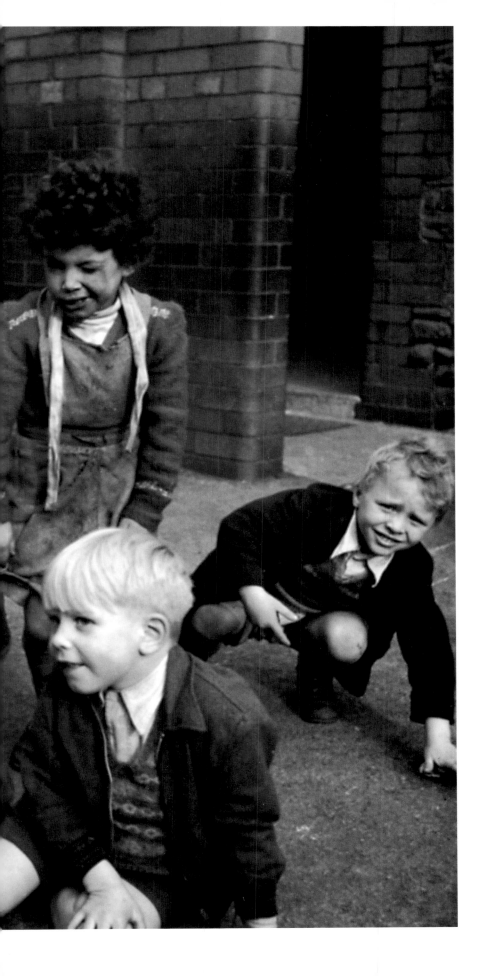

Children at a school playground,
Cardiff, Wales, 1955

Following pages:
Left: Bute Town, Cardiff,
January 1954

Right: Three African chiefs arriving
at Waterloo Station, London, to
represent their countries at the
coronation of Queen Elizabeth II, 15
May 1953. From left to right: Kgari
Secheia of Bechuanaland (modern
Botswana), King Sobhuza II of
Swaziland and Prince Constantinue
Bereng Seeiso Griffith of Basutoland
(modern Lesotho)

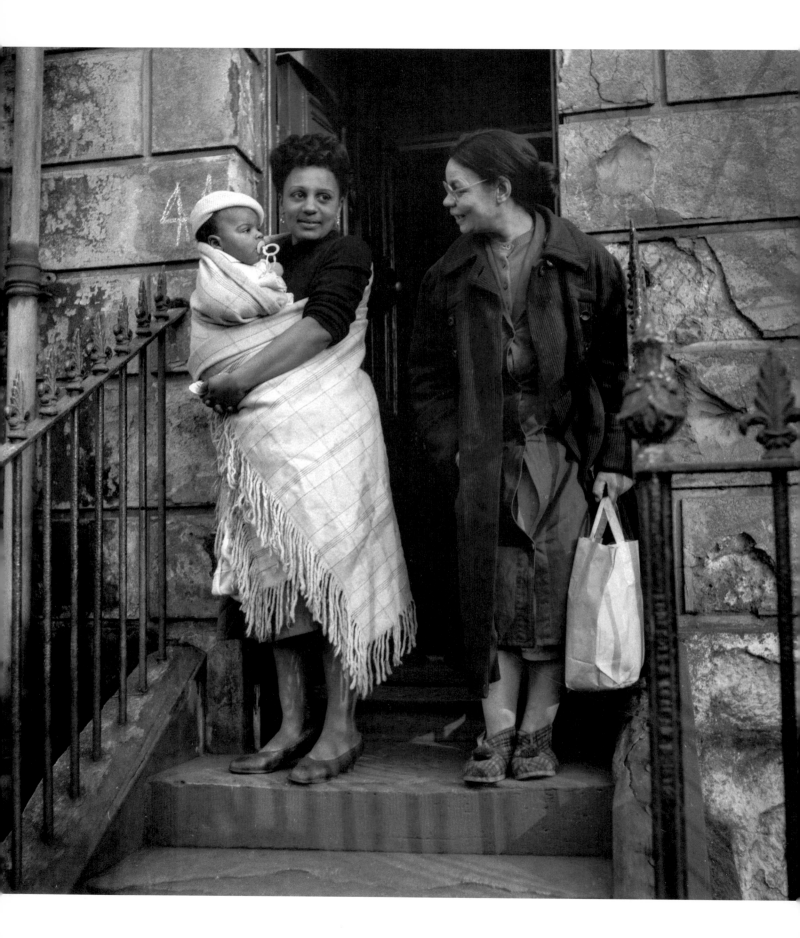

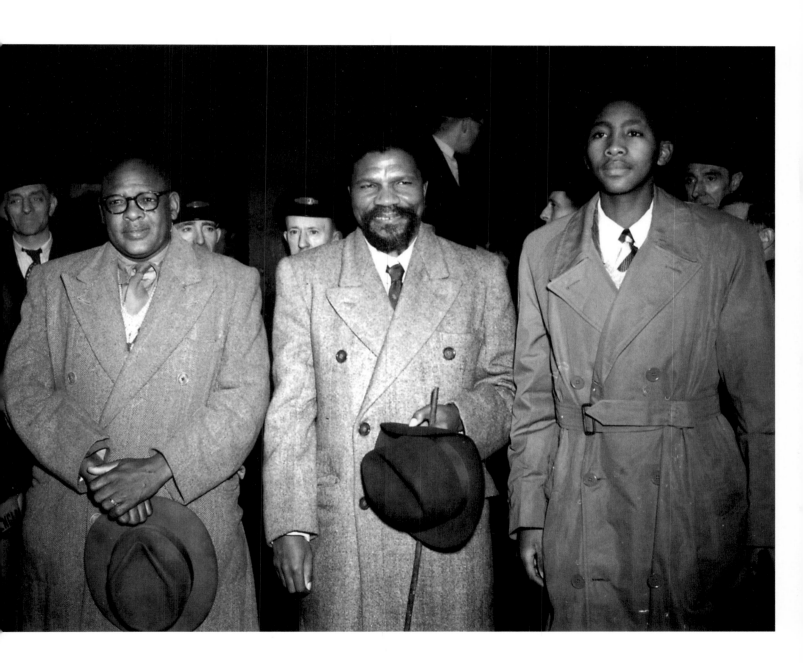

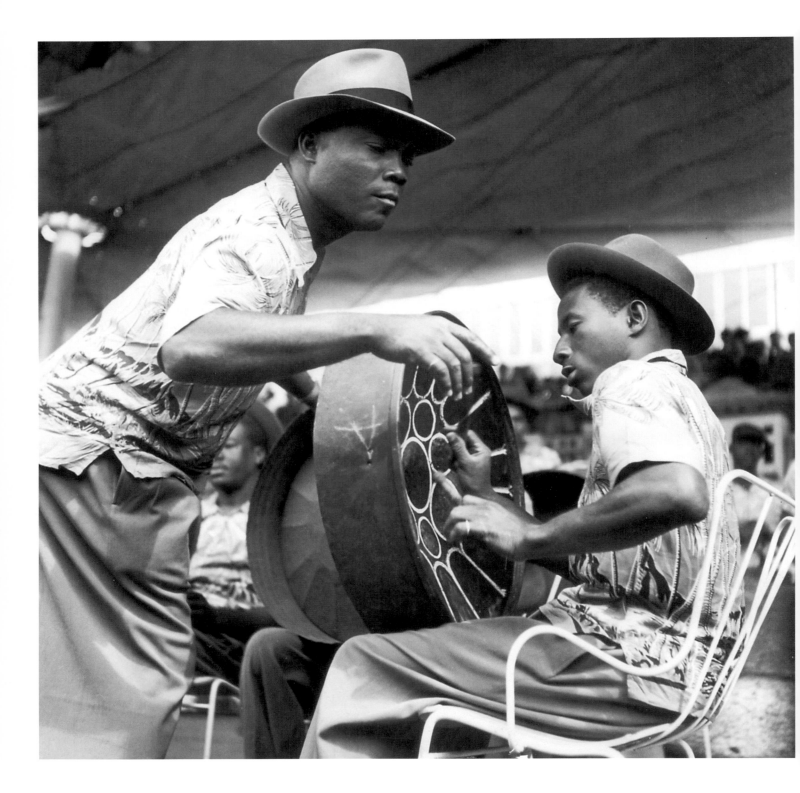

The Trinidad All Steel Percussion
Orchestra's first public performance
at South Bank, under the guidance
of its manager Lieutenant N Joseph
Griffith of the St Lucia police, 22
September 1952

Facing page: Trinidadian pianist
Winifred Atwell (1914–83) dancing
on the pier at Blackpool,
29 August 1953

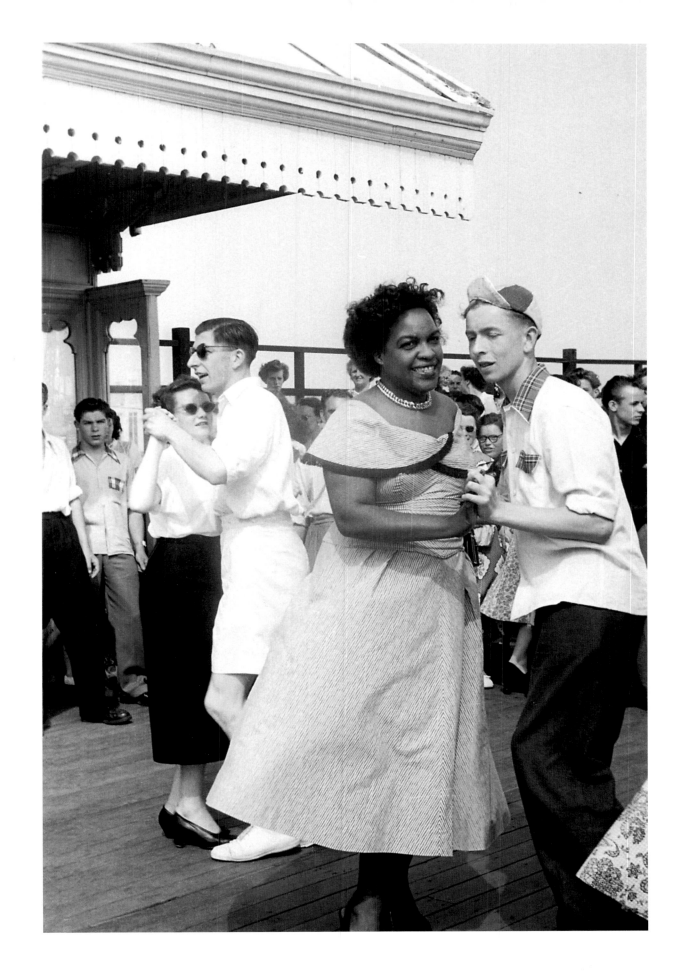

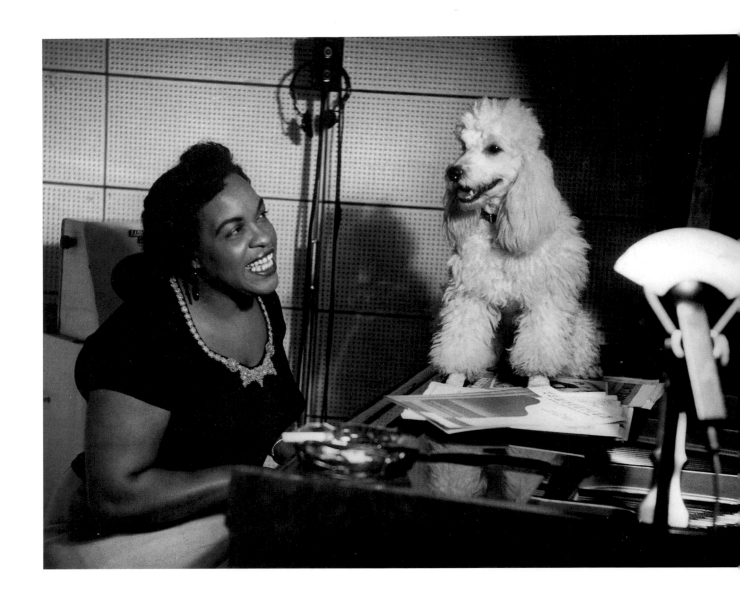

Winifred Atwell
with her music-loving
poodle, November
1954

Facing page:
Welsh singer Shirley
Bassey by the fireside
in her cottage in
Cardiff's Tiger Bay,
9 December 1955

the 1951 festival celebrating the nation's rebirth after the austerity of wartime. Something of the same spirit was evident in the coronation festivities held in the summer of 1953. The drama and performance of black culture were objects of interest in the festivities that surrounded both events, communicating the restorative spirit of the new Elizabethan age that was dawning. These events confirmed London's place as the cosmopolitan hub of the Commonwealth family of nations. It was a city where people from all corners of the ebbing empire could come together in a cultural encounter of unprecedented vibrancy that would supply the foundations on which later versions of multicultural society might be erected.

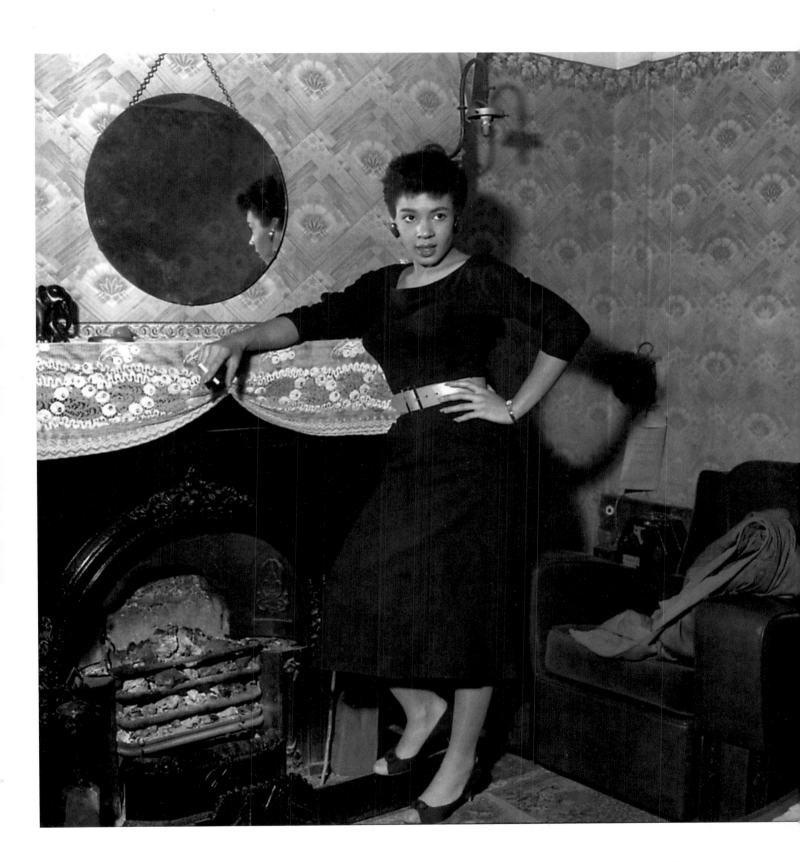

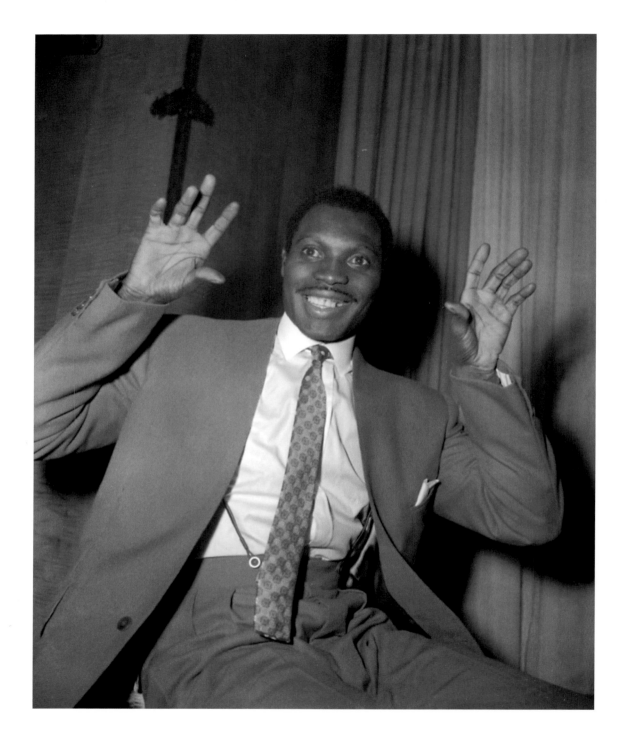

British West Indian Calypso singer
Aldwyn Roberts, better known as
'Lord Kitchener', at the Savoy Hotel,
preparing for a visit to the US to
launch Calypso on Broadway,
28 February 1957

Facing page: American singer and
actress Eartha Kitt starring in the
stage show *Zara* at the Leicester
Square Odeon, London, 1957

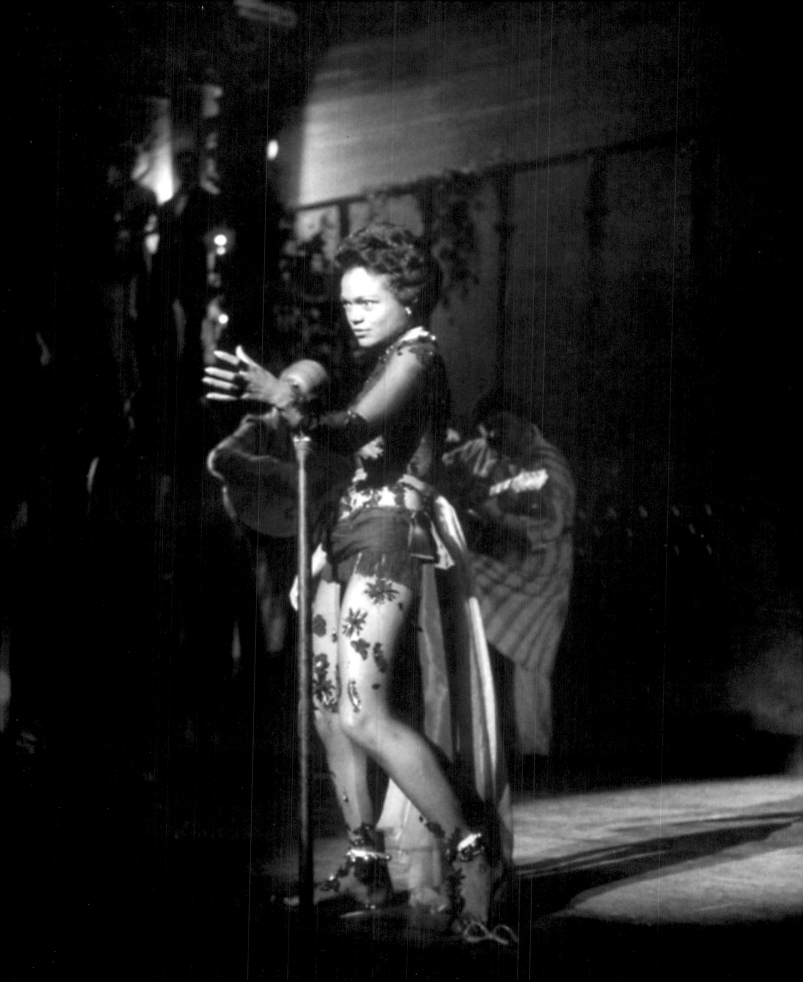

This new phase of British life was made sharply audible in the Calypsos and other music produced primarily for consumption by British blacks under the direction of Denis Preston. Many of those striking releases were sharp satirical commentaries on the character of contemporary political life and the absurdities of racism within it. Performers like Lord Kitchener, Lord Beginner and Young Tiger serenaded contemporary developments like the rise of Bebop and the independence of Ghana (which was viewed by many as the focal point of black political hope in the postwar world). The Calypsonians sang also about the forthcoming general election, conveyed their appreciation of London's Underground and voiced their great respect for the British housewife's struggles to manage her budget, her ration book and her duties in the home and beyond it.

The studious, almost bohemian portrait of the writer and poet George Lamming, caught seemingly in the act of composing an ode, presents a different face for the immigrant population than the ones which took shape among the images of poverty, suffering and struggle associated with the lives of Britain's working-class black communities. Avoiding the gaze of the camera, this educated and articulate young man with no apparent political axe to grind challenges all the assumptions of contemporary racism by simply and intuitively being that unthinkable, impossible character: a 'negro' intellectual.

The Lamming photograph pairs nicely with another staged portrait from the following year. This time, the subject is Mr Leslie King, who was identified for public recognition as the very first Jamaican to settle in the Brixton area. Looking at him sitting outside his house, it is impossible not to wonder what it was about his life there that made him want the company and protection of the large and alert Alsatian dog with which he has been photographed.

The eruption of 1958 riots in Notting Hill and Nottingham help to illuminate the many pressures he must have experienced. They were a major turning point in the postwar history of the country. Notting Hill had become 'Brown Town', a place where a new community was being created amidst the detritus of war and the ambivalence of an older

Facing page:
West Indian poet George Lamming, London, 1951

Following pages:
Left: Leslie King, 'the first Jamaican immigrant to settle in Brixton', September 1952

Right: A bootblack on his pitch in Piccadilly, 1953

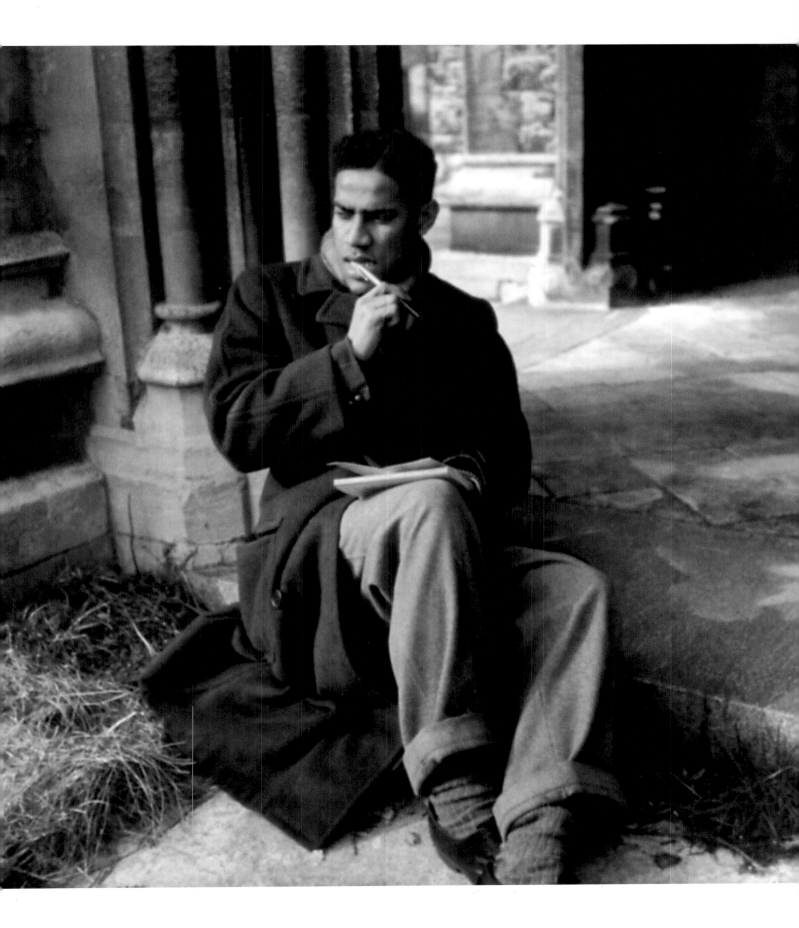

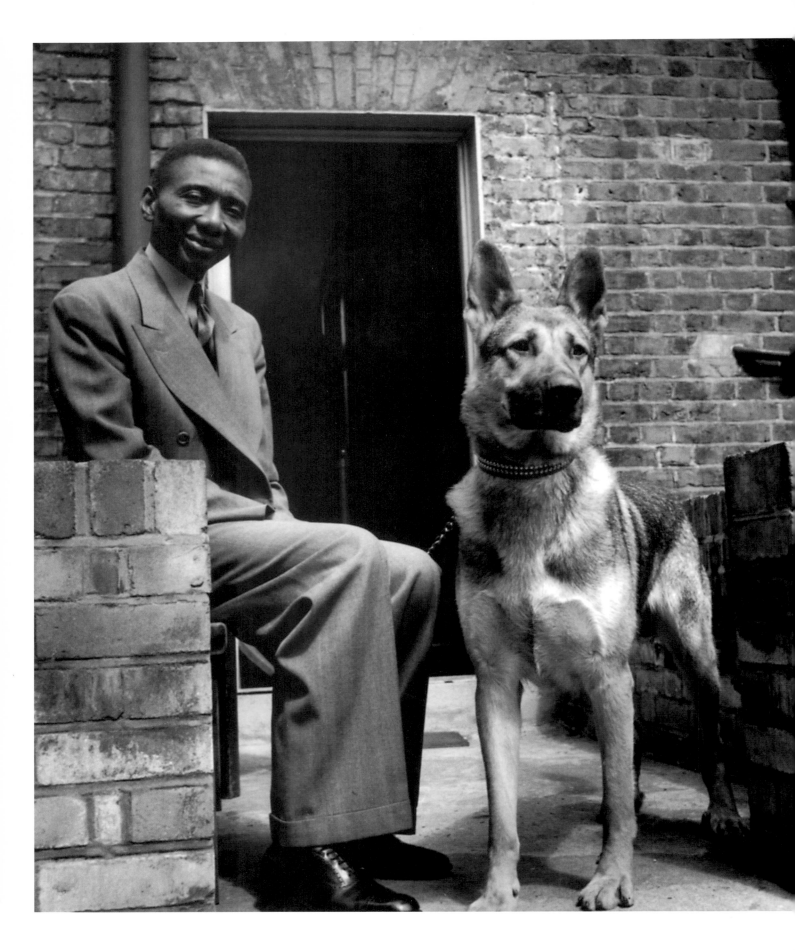

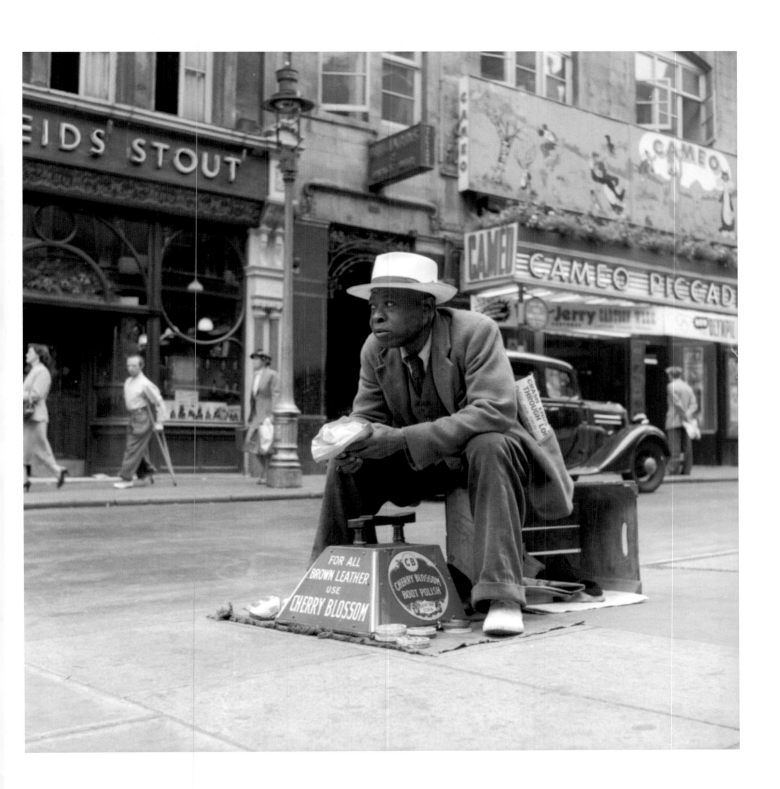

Top: Men arrested on charges of racial violence during the Notting Hill race riots, 1959

Right: A confrontation at Notting Hill Gate, 1958

Facing page: London police search a youth in Talbot Road, Notting Hill, during the race riots, 3 September 1958

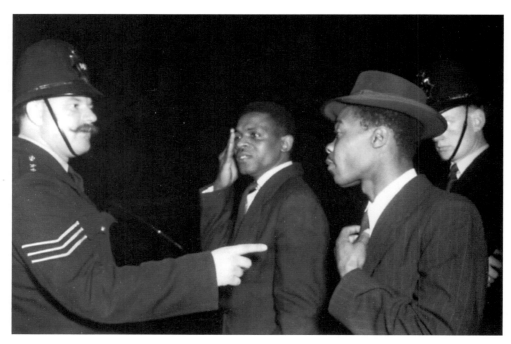

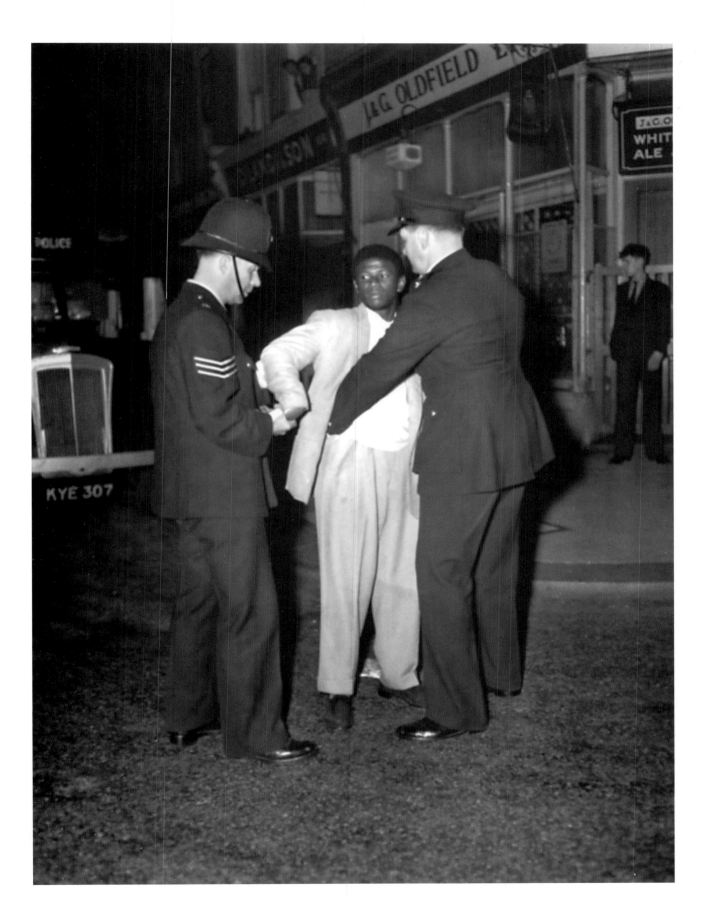

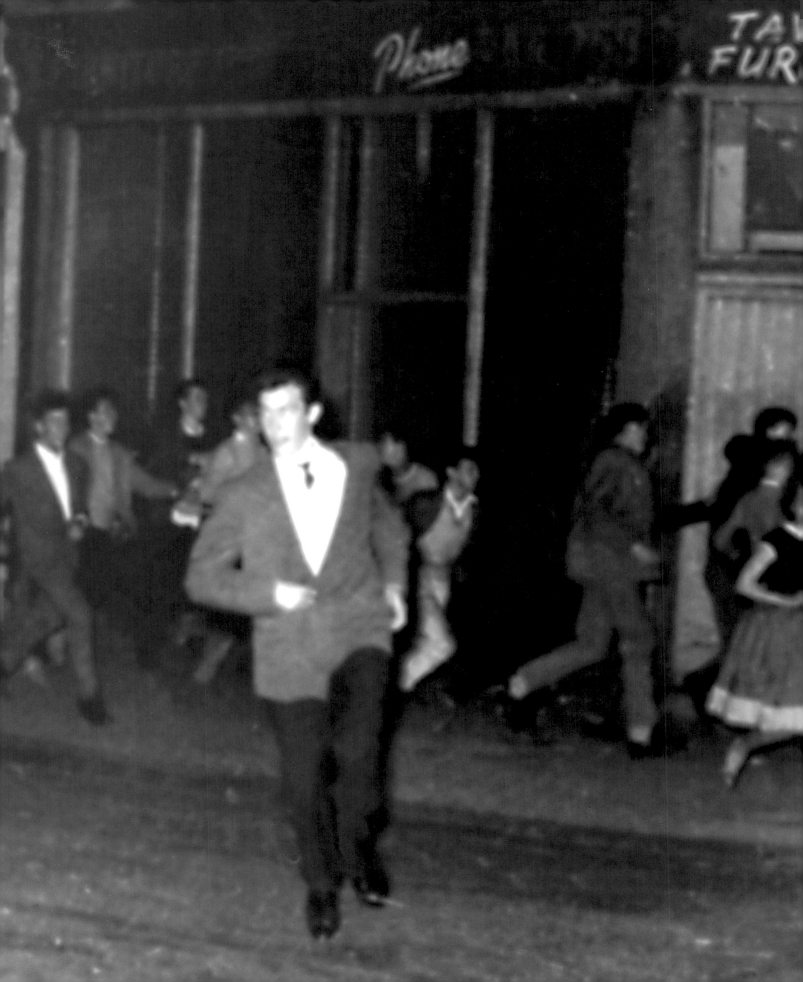

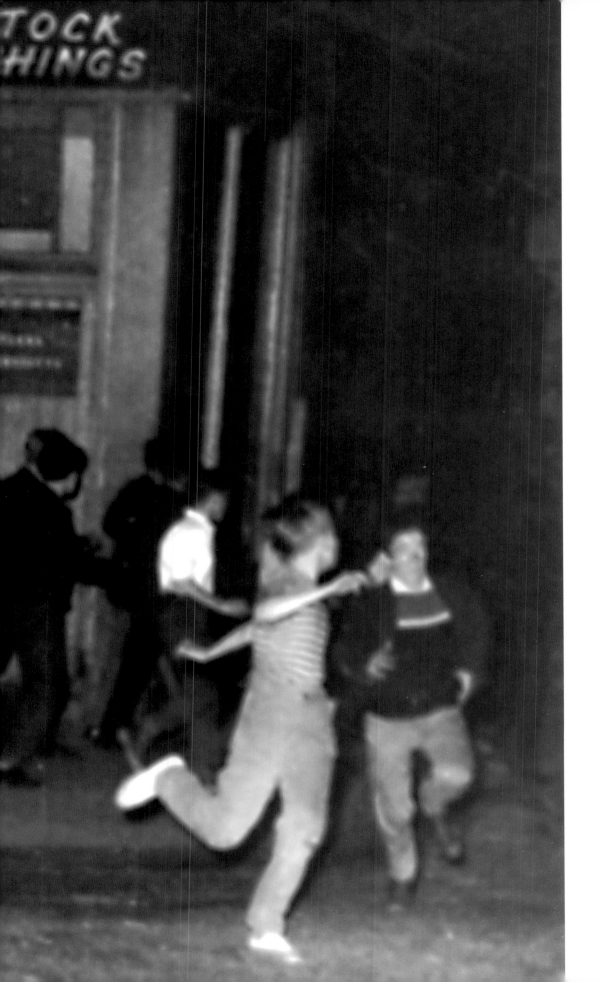

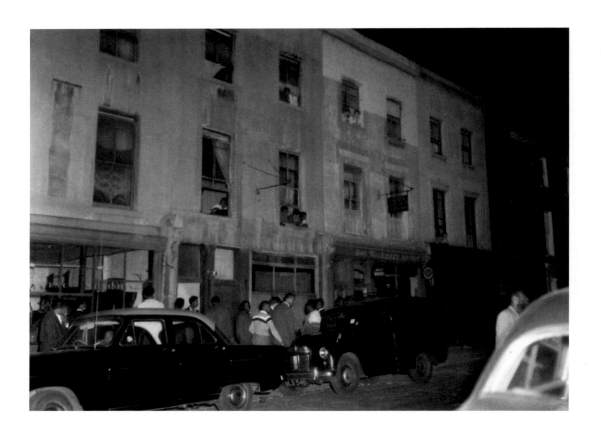

white working class, itself in rapid economic, cultural and generational transition. The catalyst for conflict was supplied by the return of Britain's homegrown fascist movement to the streets. Their murderous alliance with thuggish Teddy Boys bent on 'nigger hunting' proved to be of more enduring significance. The volatile mixing of the themes of race and youth saw hooliganism melded with decolonisation. Rock n' Roll appeared to link with both the riots and vandalism. The initial phase of the rioting escalated from a street encounter in which Majbritt Morrison, a young Swedish woman (see page 111), had taken exception to being called a 'black man's trollop', 'nigger lover' and 'white trash' while walking home from a house party. A murderous mob, chanting 'Keep Britain White!' set fire to the house where Count Suckle, one of London's first Sound System DJs, had been playing Calypsos to an appreciative gathering. The disturbances continued for several days and led to many injuries and a climate of fear that spread beyond the immediate environment to other parts of London and to other cities. The eyes of the world were turned in this direction.

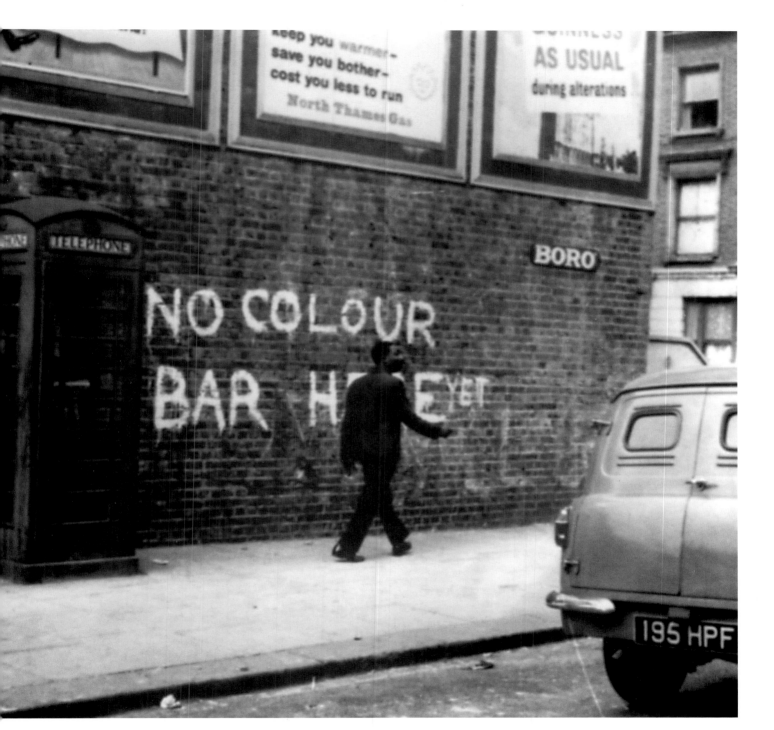

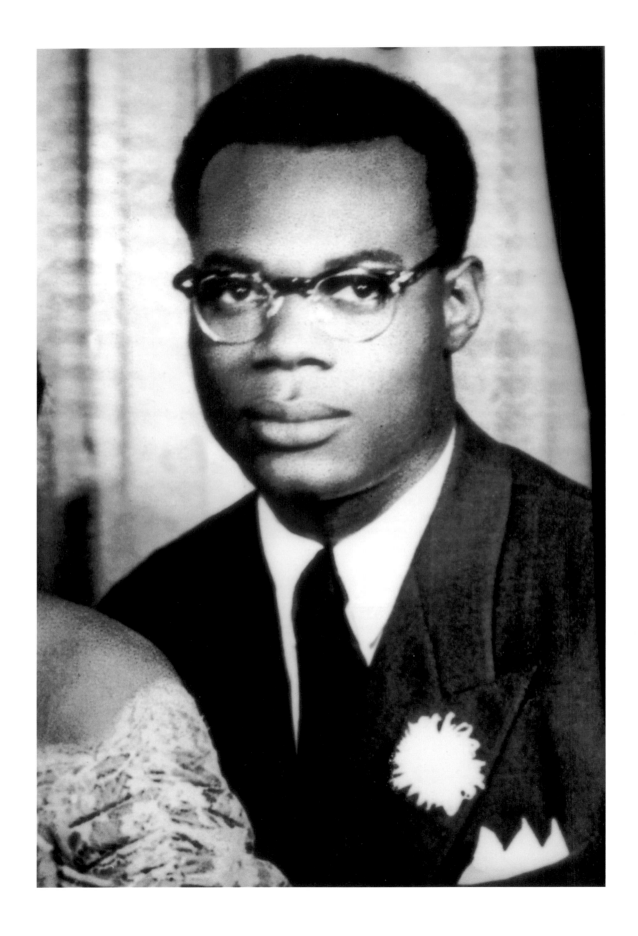

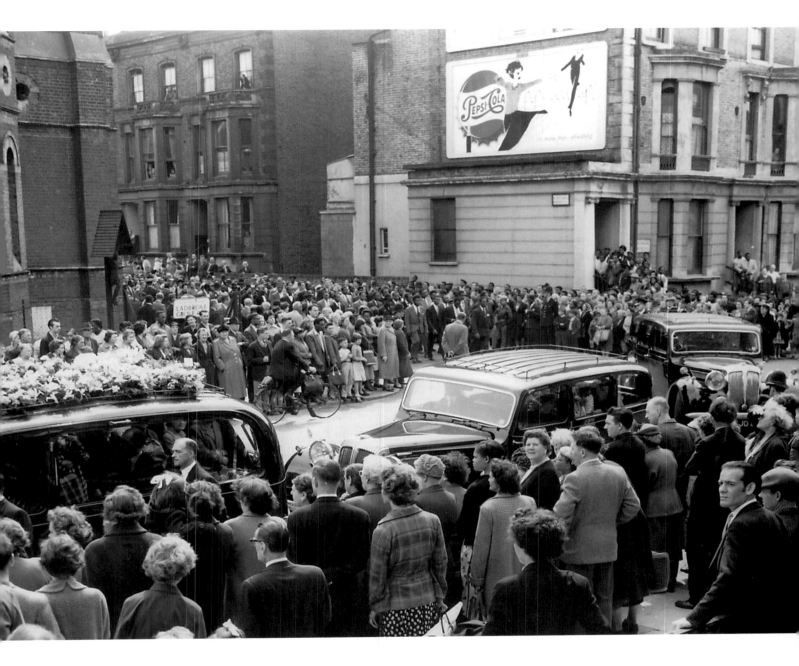

The funeral of Kelso Cochrane,
Notting Hill, 1959

Facing page: Kelso Benjamin
Cochrane, a young carpenter from
Antigua who was stabbed to death
in Notting Hill during a racially
motivated attack
in May 1959

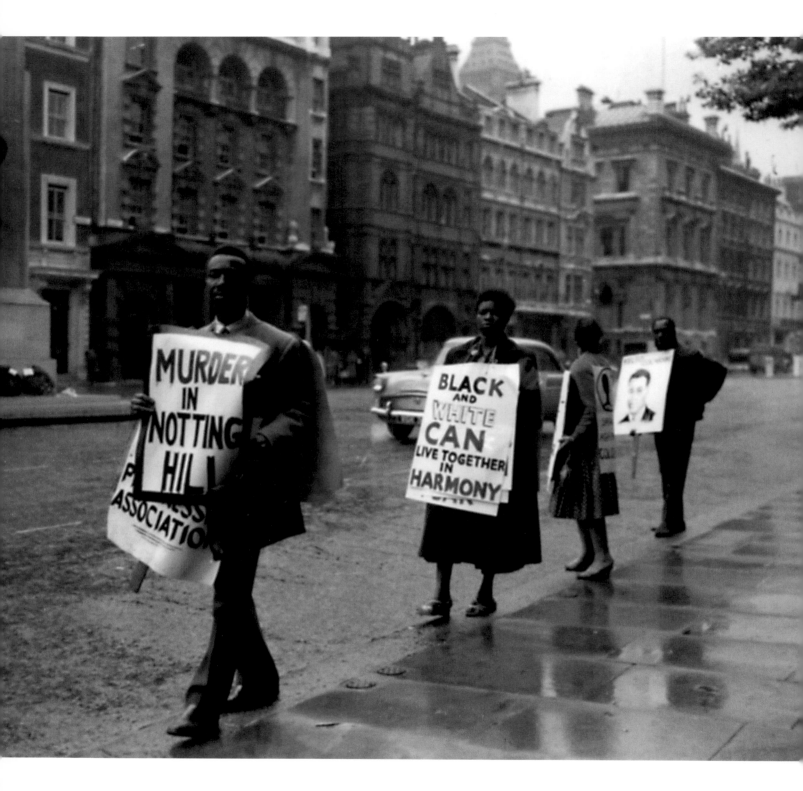

Protesters demonstrating at
Whitehall against the outbreak of
racist violence in Notting Hill,
June 1959

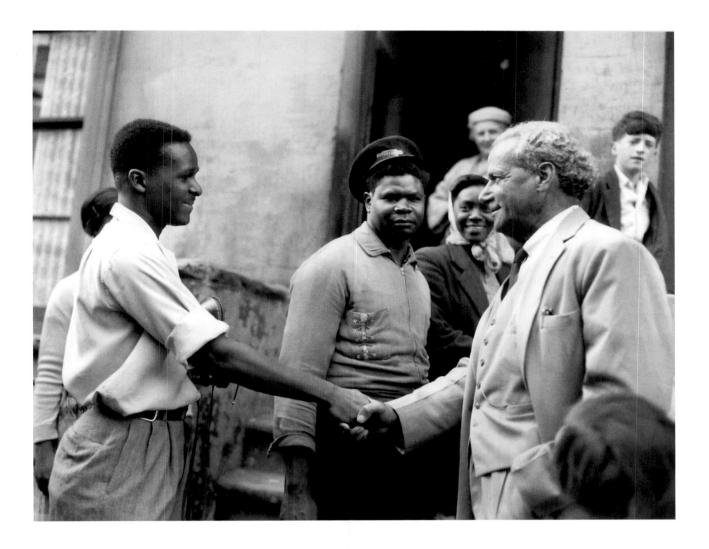

A diplomatic visit made to Notting Hill by Jamaica's Chief Minister Norman Manley clarified Britain's changing geopolitical situation. He came after the riots had died down, to check on the welfare of West Indians who had borne the brunt of the violence.

In a glimpse of a pattern that would persist until today, the shocking, eventful death of thirty-three-year-old Kelso Cochrane in May 1959 revealed the depth and character of racial violence that official political commentary had been at a loss to explain as the attacks and sporadic conflicts dragged on for months.

A large and diverse crowd of mourners assembled for Cochrane's funeral, confirming that this historic episode had affected the entire local community and showing anybody who was interested just how volatile and destructive the forces summoned up by popular racism

Norman Manley speaking with people in Notting Hill after rioting in the area, during a visit to England, 6 September 1958

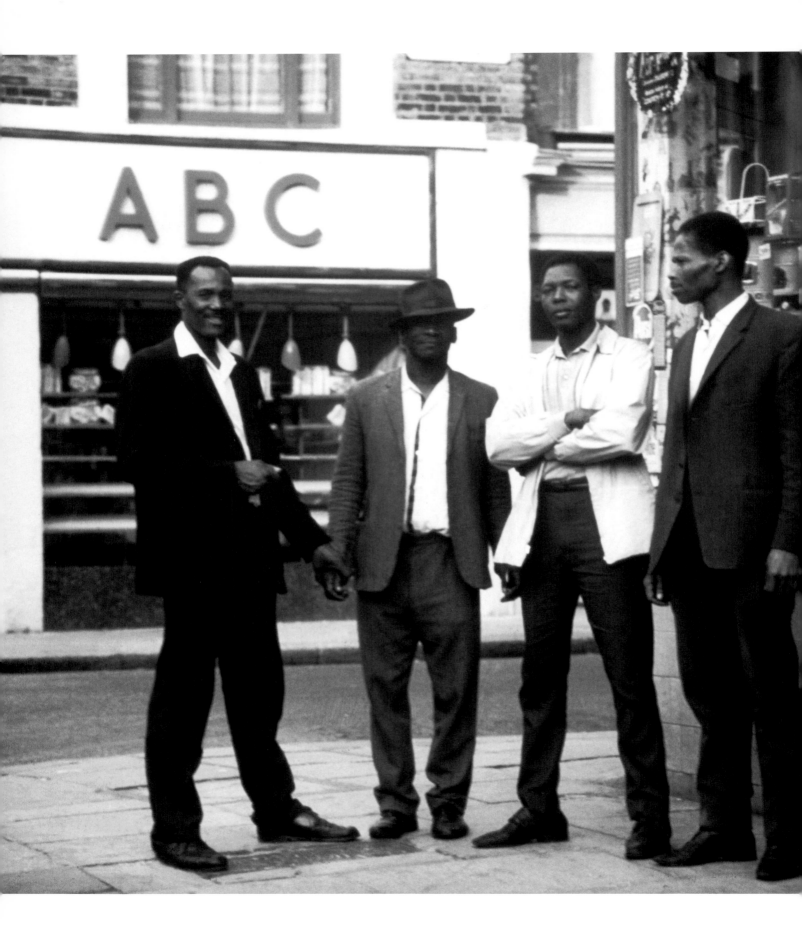

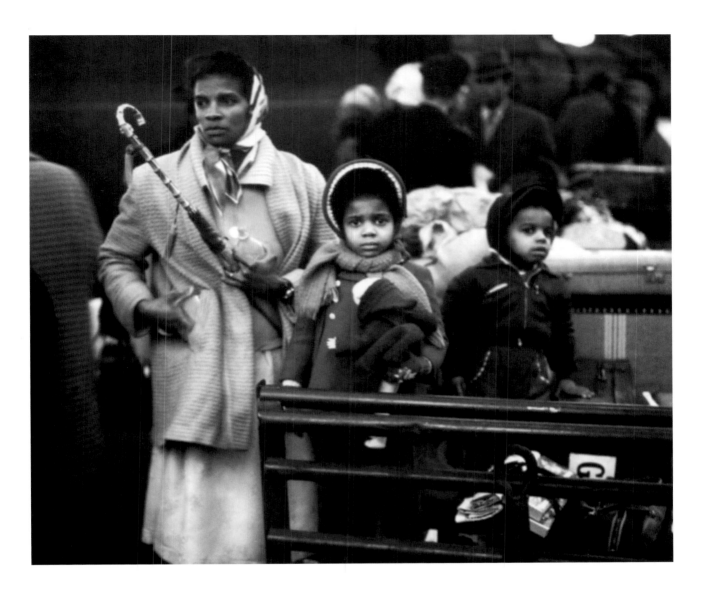

could be. It was there, as Lamming put it, that all the niceties of cricket came to an end.

Lamming may be right that the 1958 eruption involved an ending, but it also seems to have provided the source for other problems that would endure over the coming years. These included a bitter and antagonistic relationship between black settlers and the police, who assumed that criminality was the natural disposition of immigrants and aliens and approached them accordingly. From that angle, even black victims of crime could be treated as suspects and perpetrators. These assumptions persisted for many years and were still being identified at the core of police 'canteen culture' at the end of the twentieth century.

A family of West Indian immigrants returning from Britain to their country of origin, 1 January 1961

Facing page: Notting Hill, January 1960

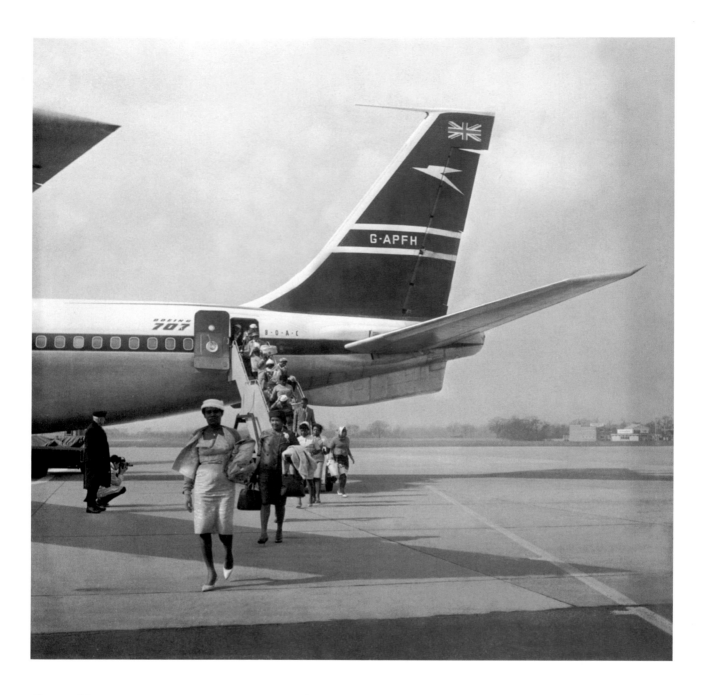

Chartered Boeing
707 airliners flying
immigrants from the
West Indies to Britain
with fares as low as £84,
22 August 1963

Just as the racial dramas of social life in Britain's bedsits were becoming visible, the British government started to move towards a cross-party consensus that amended nationality laws and sought to use them to control immigration. This strategy was defined by the proposition that the assimilation of incomers was desirable, and the amelioration of the Colour Bar would only be possible in the context of stricter statutes and the smaller immigrant population they would

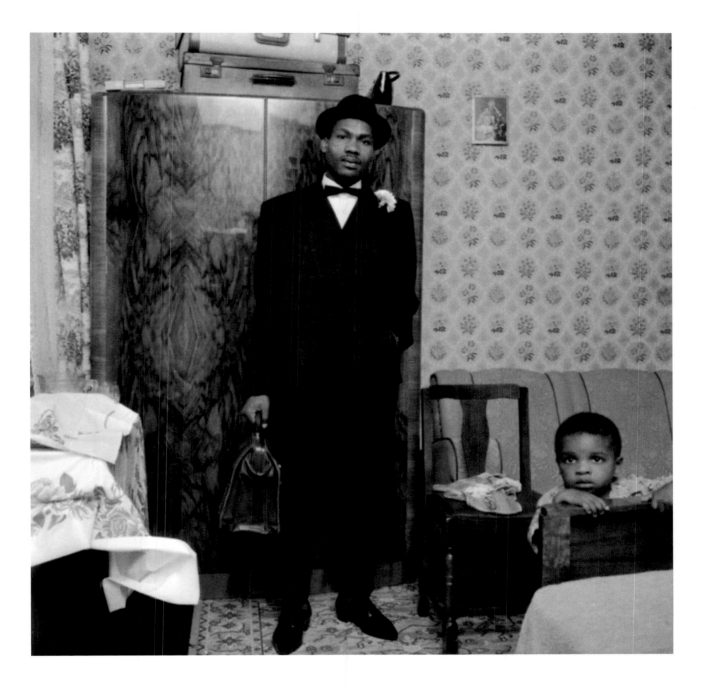

create. The need to beat the introduction of the new legislation accounted for a new bulge in the number of incomers that, in turn, fed the notion that the level of immigration was running out of control.

Answering this dubious governmental initiative placed a premium on showing that the incomers were welcome and appreciated regardless of what the politicians said to the contrary. There was a conspicuous class dynamic among the welcomers, who were not usually drawn from

Leslie Walker before marrying Carmen Bryan, who was saved from deportation, 30 July 1962

Following page: West Indian immigrants being greeted by London students at Waterloo Station, December 1961

161

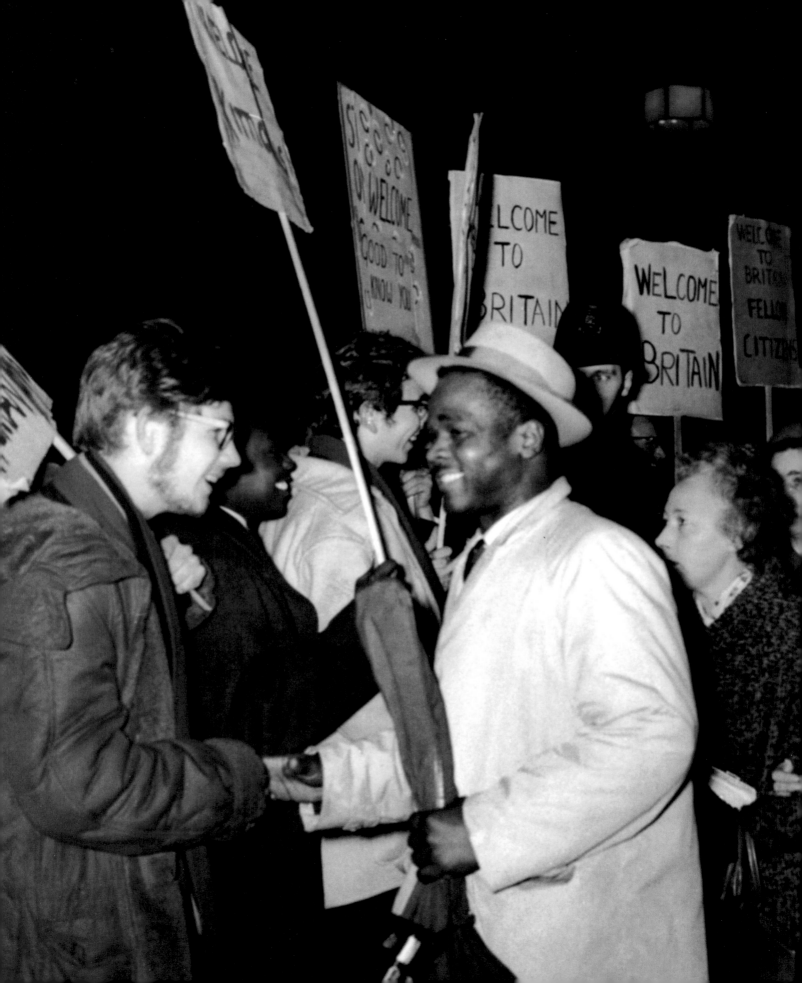

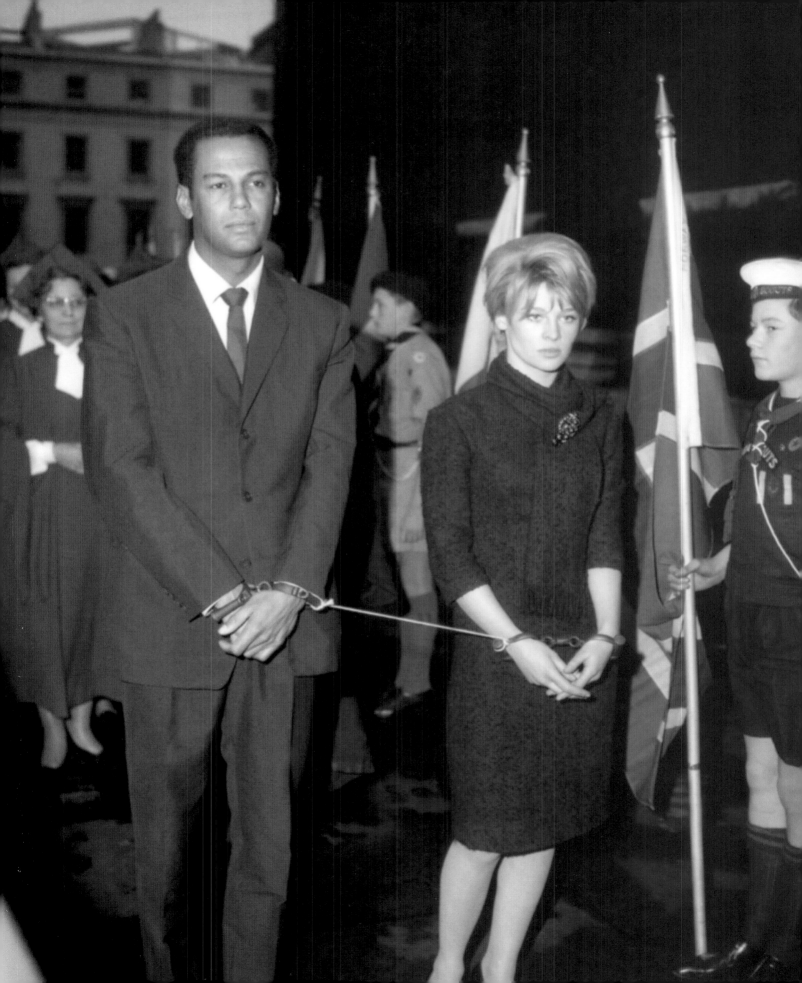

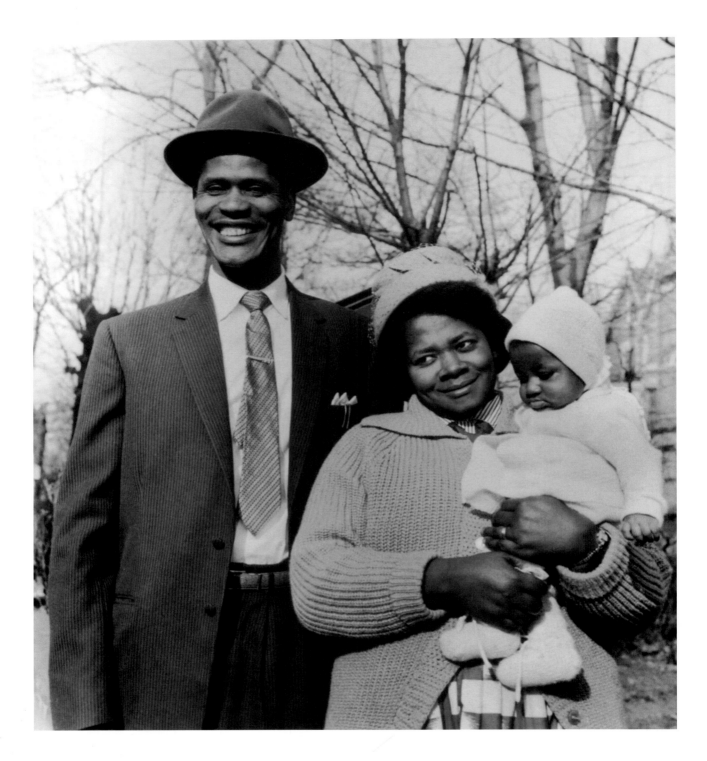

A Jamaican couple with their baby in Brixton, January 1963

Previous page: Actors Cy Grant and Julie Christie handcuffed and joined together with a cord at a human rights service at St Martin-in-the-Fields, London, held in memory of 'prisoners of conscience' throughout the world, 10 December 1961

Facing page: Pastor and Mrs Wallen outside the Church of God on Effra Road, Brixton, 1963

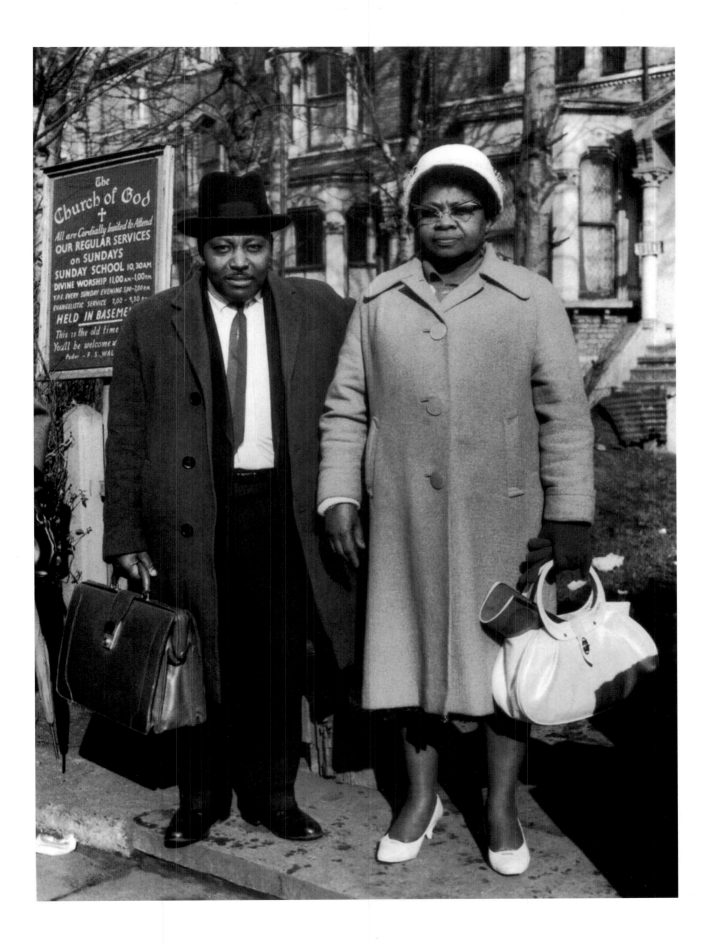

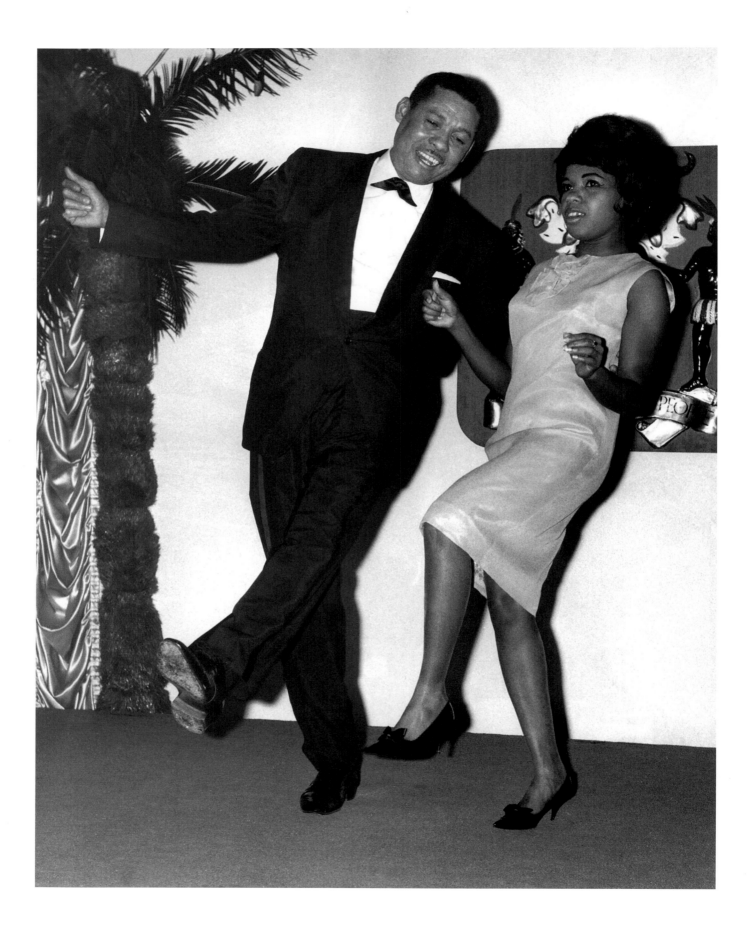

communities where competition with the incomers for housing or employment was intense. However, as the Manley visit had made clear, it was not now in Britain's global interest to become known as a place where black citizens would be badly treated.

Many things that are viewed today as basic needs were still expensive luxuries in the early 1950s. As the decade of the war came to an end, half of British homes had no bathrooms. Outside toilets were unexceptional; central heating was largely unknown; refrigerators, vacuum cleaners and televisions were rare; cars were few and far between; food was plain, dull and of a limited variety. Telephones were public instruments, and usually good only for local use, so keeping in contact with relatives and staying in touch with distant events was difficult for immigrants. Letters written on flimsy, lightweight airmail paper took a good deal of time to reach family and friends.

All of this should be borne in mind when we seek to interpret the increased appetite for consumer goods as well as the various forms of hedonism that grew up in Britain along with the sudden appearance of teenagers and youth culture. These changes were explained away with the bold political claim that the country had 'never had it so good'. Their foundations were provided by an economic boom, which also helped to offset some of the tensions involved in immigration by reducing the level of labour market competition between black and white workers.

The rationing of food came to an end in 1954. That change was followed by a boom in consumer goods fuelled by a liberalisation of the rules governing the availability of credit. Britain's delayed modernity and urgently needed national recovery were being enacted not only by the rise of the NHS, the smooth operation of cheap public transport and the introduction of rapid and reliable international communications, but by an unprecedented spread in the availability of modernising electrical goodies.

These rapid developments fitted in with a real rise in living standards. The flood of easy cash and exciting gadgets imparted a new brittleness to race politics. People did not want to see the benefits of this

Facing page:
Beverly Mills and
Boysie Grant doing
the 'Blue Beat', a dance
brought to Britain
by West Indian
immigrants, 1964

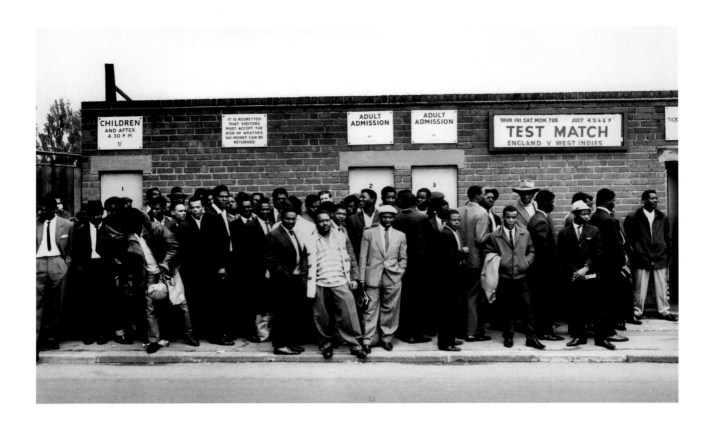

On the building signs: CHILDREN AND AFTER 4.30 P.M. 3/ · IT IS REGRETTED THAT VISITORS MUST ACCEPT THE RISK OF WEATHER NO MONEY CAN BE RETURNED · ADULT ADMISSION · ADULT ADMISSION · THUR. FRI. SAT. MON. TUE. JULY 4 5 6 8 9 TEST MATCH ENGLAND V WEST INDIES · TICK

West Indian supporters outside the Edgbaston cricket ground in Birmingham before the third Test Match versus England, 6 July 1963

Facing page: West Indian supporters during the Test Match between England and West Indies at the Oval, 1963

Following pages: West Indians queuing for the final Test Match at the Oval, South London, 22 August 1963

transformation allocated disproportionately to tropical incomers who were not acknowledged to have made the same wartime sacrifices as the hardy locals. The fresh memory of wartime was insufficient to prevent the war itself being mythologised now as the finest, noblest hour of a monochrome and culturally homogenous country.

The context for most of the postwar images of black life was created by their news value in the period when immigration became the substance and the limit of Britain's racial politics. However, as the community of immigrants cautiously adapted to long-term settlement, the visual record of its progress began to serve different purposes and interests. Even the most newsworthy photographs could reveal the settlers' determination to get the damage done by racism recognised officially as well as their need to record exactly how it had circumscribed their life chances and diluted their hopes of upward mobility. The effort to force a grudging acknowledgement of the continuing social and political costs of British racism was now being balanced against other more positive obligations.

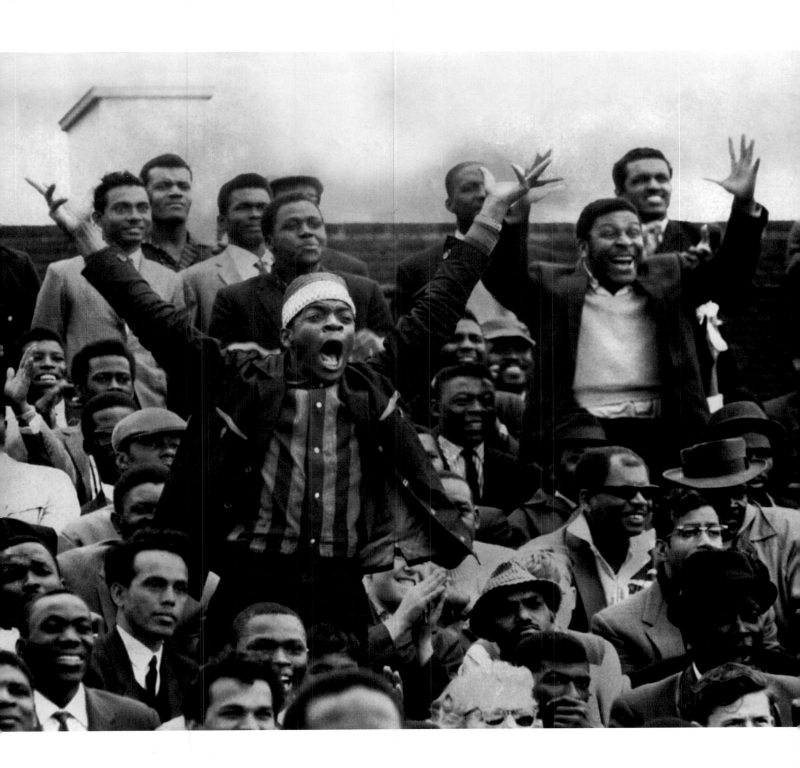

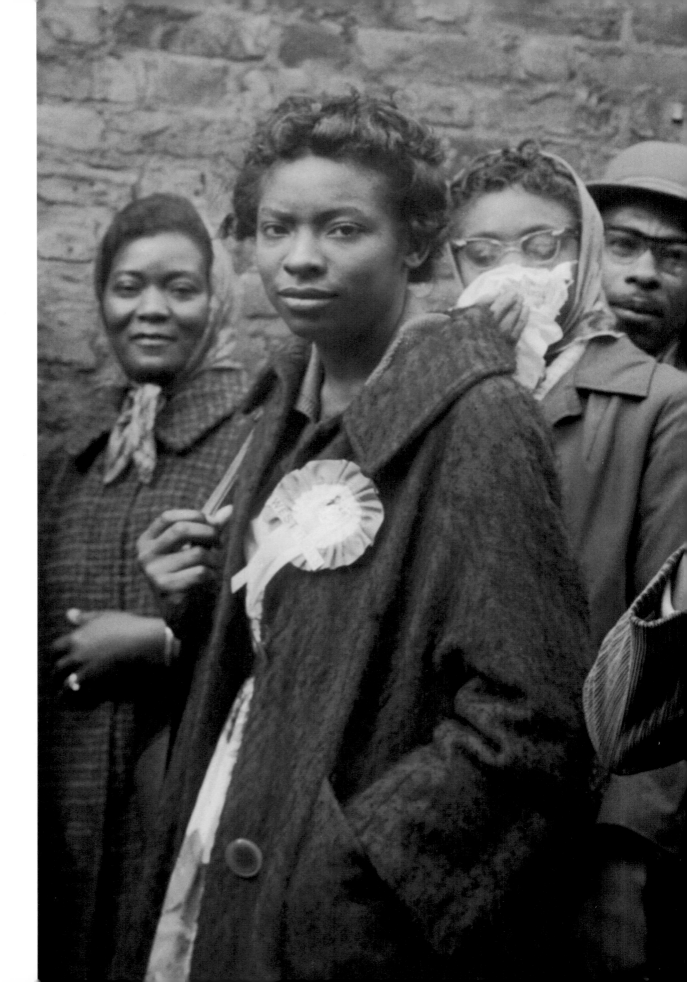

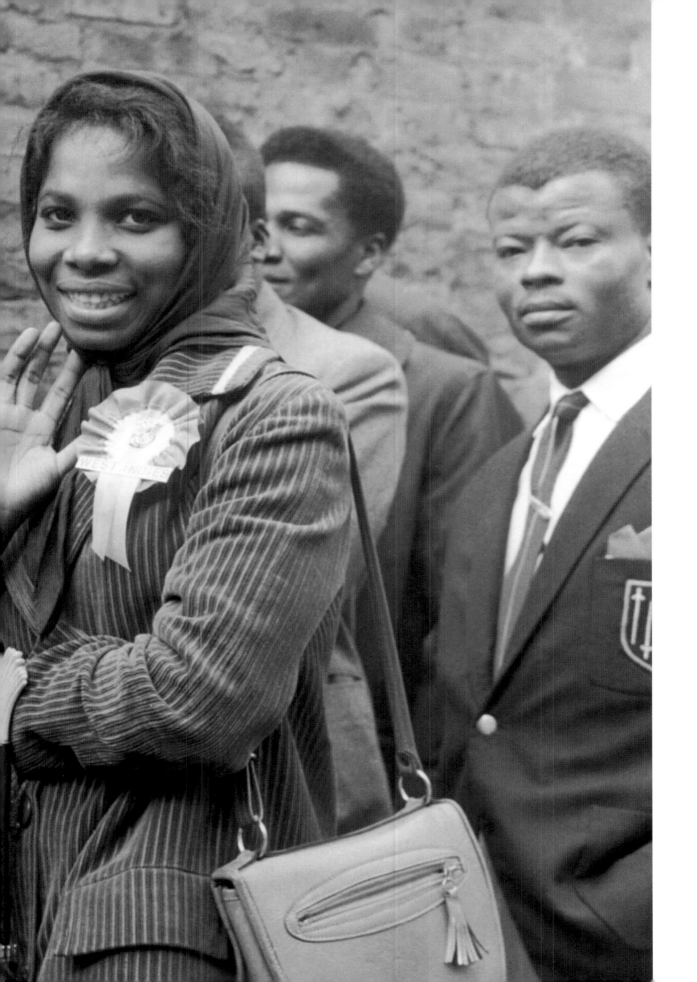

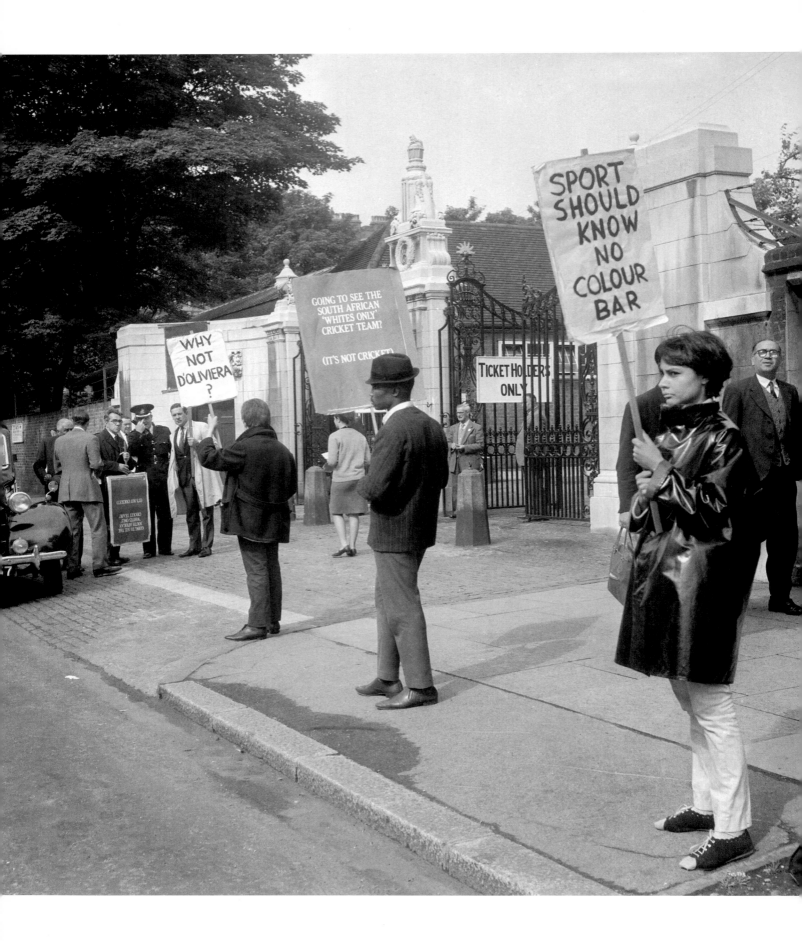

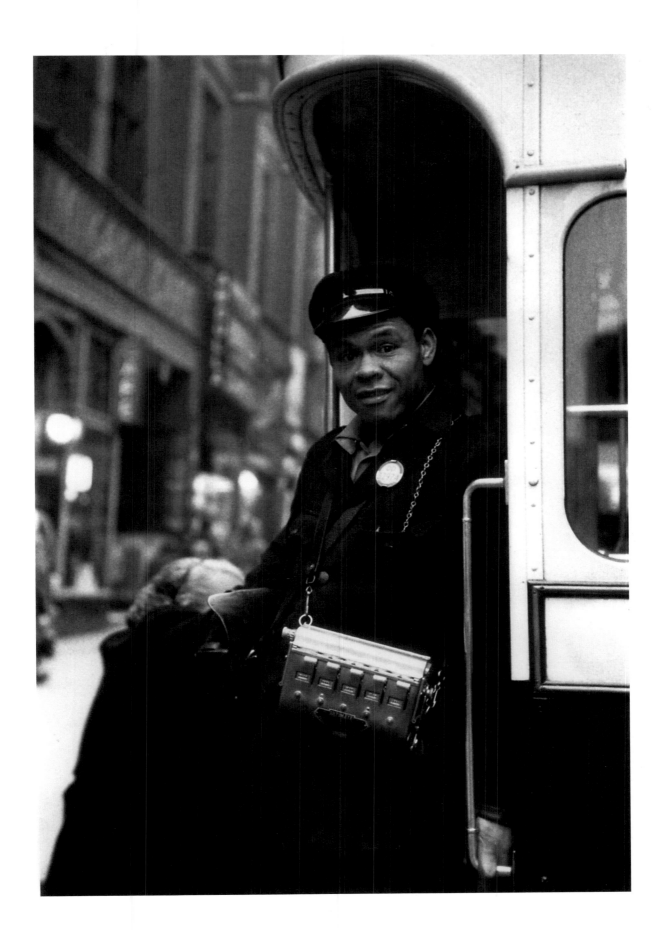

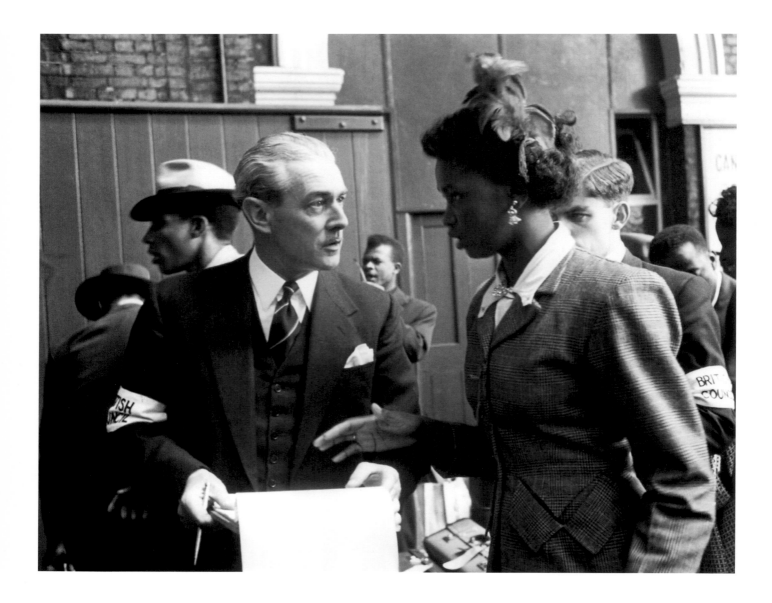

A British Council
worker talking
to a West Indian
immigrant at Victoria
Station, June 1953

Previous pages:
Left: Banners outside
Lord's cricket ground,
22 July 1965

Right: Chandler
McGhie, a Jamaican
immigrant and
bus conductor
in Birmingham,
February 1955

Undermining racist common sense and loosening its grip on political thinking meant presenting black life in its complexity and dignity as something more than a reaction to adverse circumstances and a political agenda set by others. In this new frame, documentary photography did not just manifest the enigmas of injustice. The images repeatedly summoned up the unthinkable idea of black humanity and conveyed the equally disturbing suggestion that the lives of blacks in Britain involved more than just a series of answers to exploitation and pressure. The country's sense of its own worth, and its moral stature, were felt to be at stake in the unpleasant way in which the immigrants were being treated.

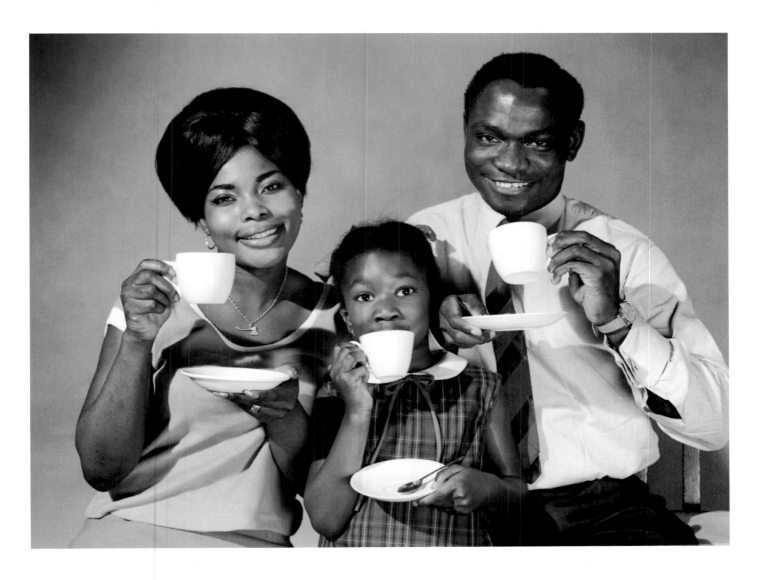

A tension between grasping the uncomfortable fact of shared humanity and giving due attention to the injuries wrought by racial hierarchy comes across strongly in the images from the 1960s. It is evident in photographs of immigrants' familial and domestic lives, where care and tenderness characterise intimate interaction under the difficult conditions created by poverty, harassment and the accumulated impact of prejudice. The same affirmation of black humanity can be detected in photographs that convey the emergent community in more public settings. Arrival was no longer the moment under repeated scrutiny. Blacks could now be seen in daylight, on British streets, going about their business, at play away from the world of crushing work,

1965

Following pages: Left: Australian-born disc jockey Alan 'Fluff' Freeman (1927–2006) welcoming Jamaican singer Millie Small back to the 'Swinging UK', January 1964

Right: British singer and television personality Kenny Lynch in Soho, London, 4 April 1966

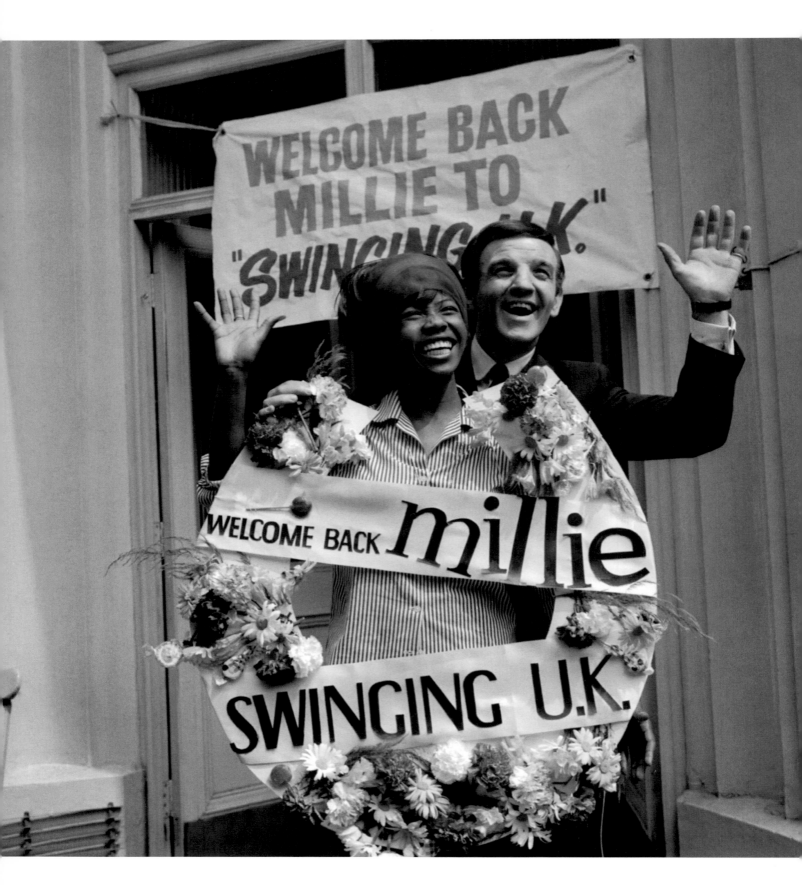

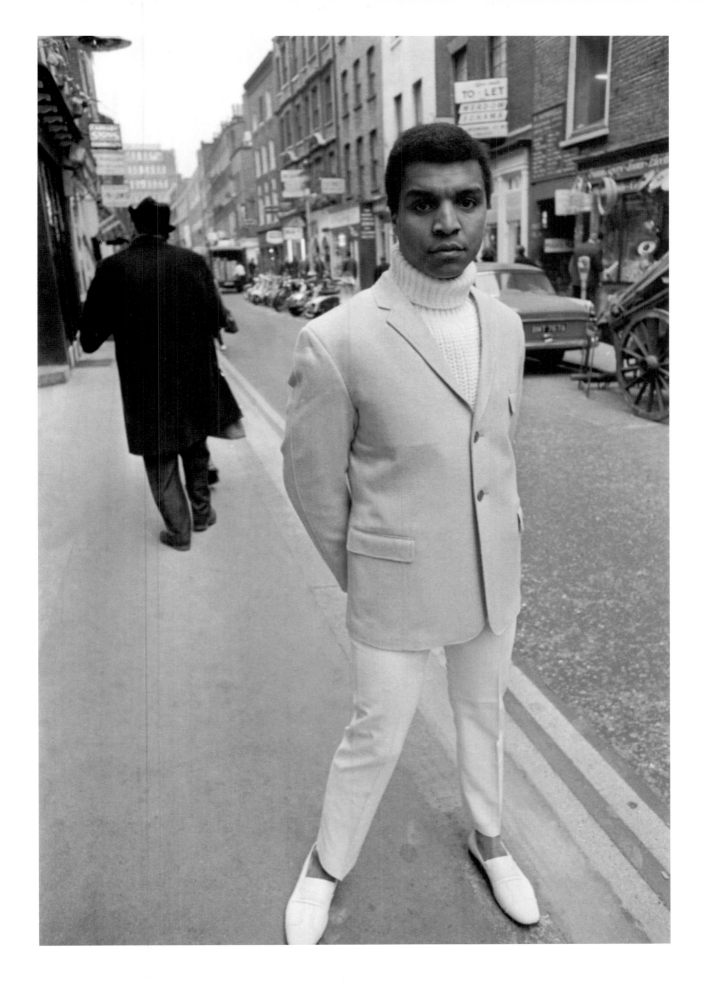

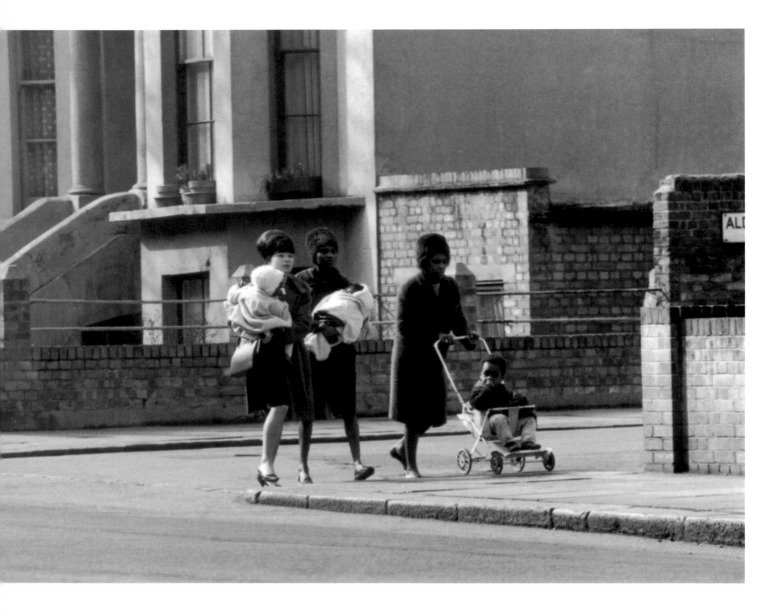

Notting Hill, 1965

Facing page:
English mother caring
for Irish and West
Indian babies, May
1968

busy building institutional spaces that would furnish them with some compensation for their exclusion and marginality.

The age structure of the black settler population was also starting to change the boundaries of what could be seen. That shift is mirrored in the archive, which overflows once again with photographs of children. Sometimes children appear to symbolise the alien presence in general, transmitting the idea that all blacks were childlike creatures while whites were judged adult by comparison. On other occasions, the child was used to draw out the hidden dangers associated with mass immigration and to project them in vivid, terrifying forms. From that angle, these

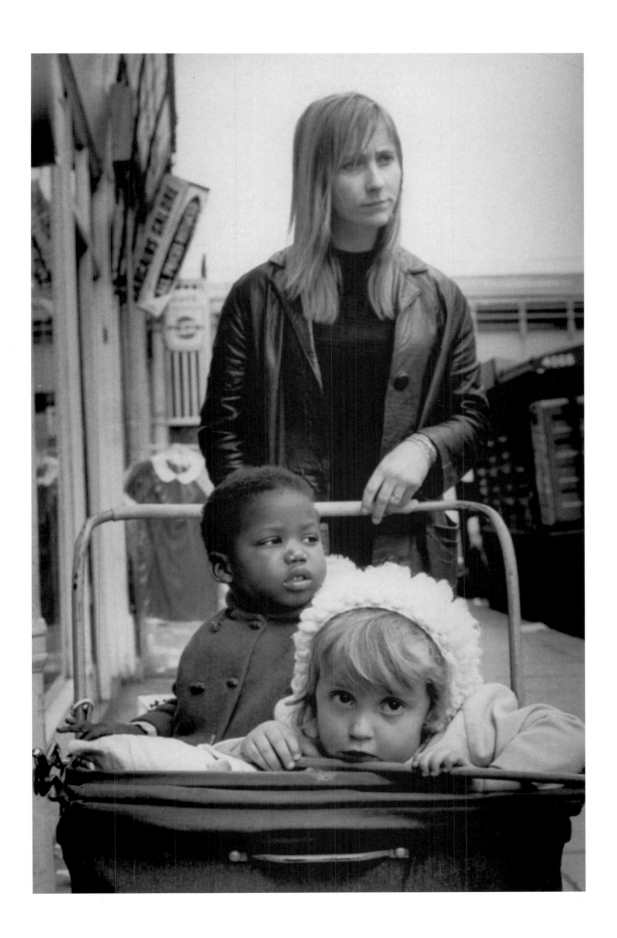

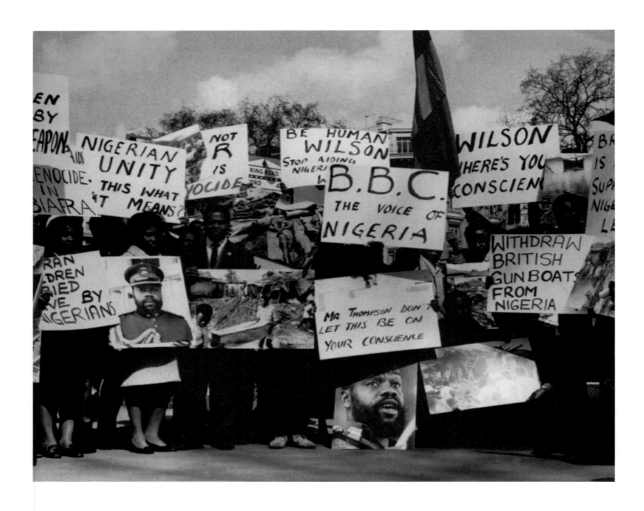

Nigerian students at a Biafran War protest rally at Speaker's Corner, Hyde Park, London, 1968

Facing page:
World heavyweight boxing champion Muhammad Ali visiting a children's home in Notting Hill, London, 15 May 1966

children supplied the proof that black fertility was a ticking time bomb, waiting to destroy the peace of verdant England from within.

During the years when immigration came to dominate Britain's race talk, it often seemed as though these demanding and disruptive kids were cuckoos in the national nest, nourished by an unsuspecting welfare state. There was a tacit warning that even if they looked sweet and charming now, these smiling 'negro' children would soon grow up to be pimps, drug takers, prostitutes and criminals. However, it would be disingenuous to overlook the way in which – during the intermediate phase of mass settlement, anyway – those same children were also identified as custodians of a future democratic promise that would only be realised if the fearless innocence of a childhood that knew no colour lines could somehow be preserved and extended in the transition to adulthood and acceptance.

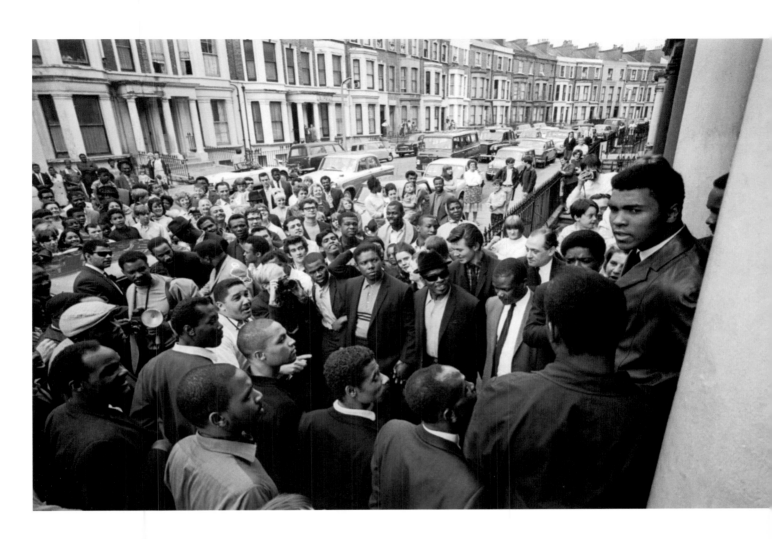

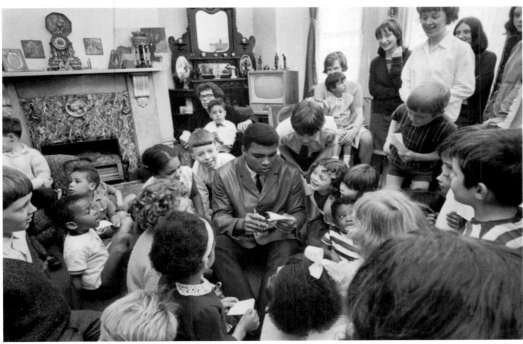

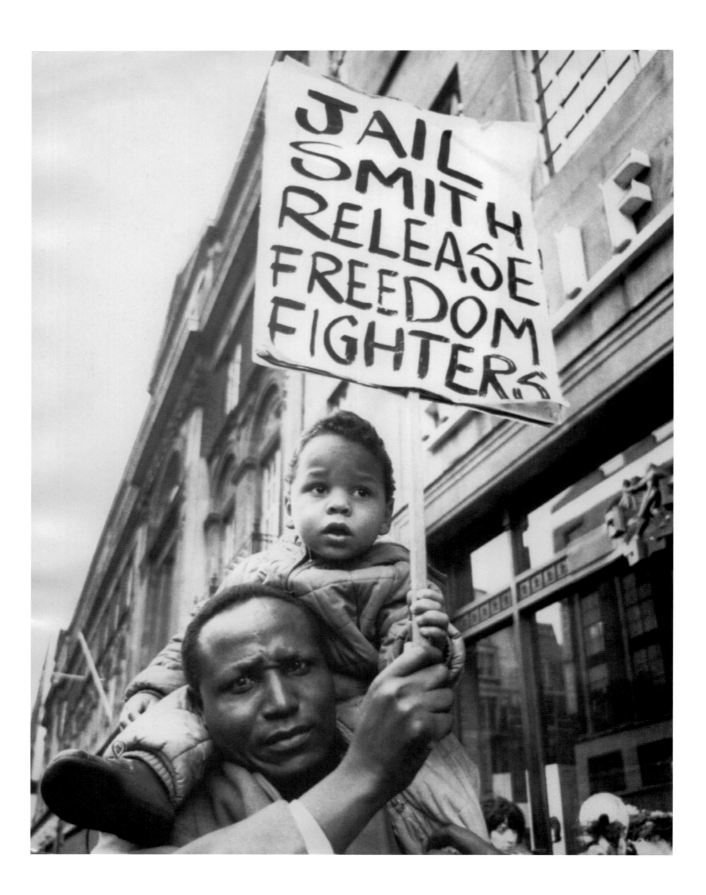

Black and white children now shared the same minders, prams, playgrounds and even grandparents. It was not at all clear what the national consequences of this great change would be. Few plausible options existed between the equally unsatisfactory alternatives represented on one side by grim projections of catastrophe and conflict, and on the other by an idealised and absolute vision of effortless harmony.

An honest desire for harmonious coexistence could be detected among the routine effects of hostility. It was connected not only to the tales of home-making and community-building that are celebrated in the portraits of immigrants advancing towards meaningful citizenship, but also to a wider understanding that racialised politics was now alive and at large in the Cold War world beyond these shores.

Britain seems to have begun to appreciate that it had to do something if the pitfalls of racial conflict that were being revealed in newsreels of riots and mayhem in the US and South Africa were to be

Jamaican-born
Ska singer Jackie
Edwards (1938–92)
in front of the Albert
Hall, 28 April 1967

Facing page:
A demonstrator
with his son on his
shoulders carries
a sign reading:
'Jail Smith Release
Freedom Fighters',
outside Rhodesia
House, London,
while protesting
white minority rule
in Rhodesia (now
Zimbabwe),
11 March 1968

avoided. Images of black children – though not yet of 'mixed' ones – conveyed the prospect that an integrated nation where discrimination was outlawed might indeed avoid those pitfalls. There is an interesting implication that the logic of politics and government had begun to conflict quite sharply with the more organic patterns of cultural accommodation, adaptation and intermixture.

At work, in school or in their shared neighbourhoods, a new generation of Britons was appearing for whom the consequences of racial division would be a routine hazard emphatically disconnected from the country's residual colonial adventures. The composition and structure of Britain's social and economic classes were being changed

West Indian hairdresser with customer, Notting Hill, 29 April 1969

Facing page: Sid Grant photographing a young Jamaican bride-to-be, Merle Johnson, in his Clapham studio

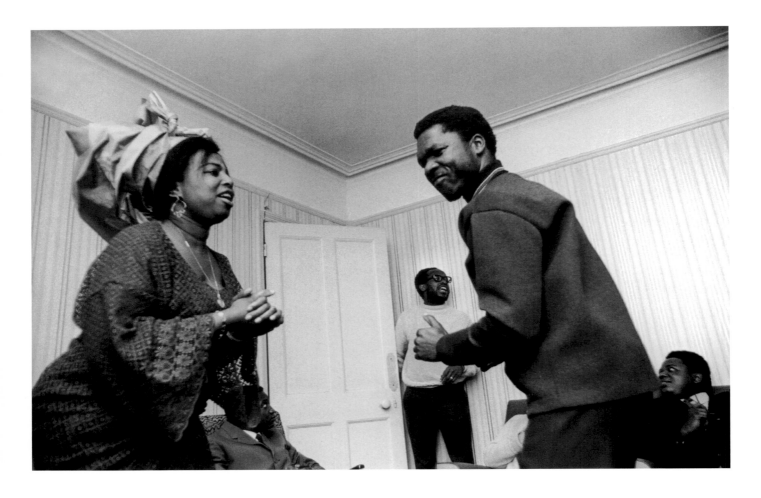

Two Yoruba students
from Nigeria dancing
at a Christmas party
in Waterloo, London,
1967

Facing page, top:
Beatrice McFoy, a
student from Sierra
Leone, at home
in Balham, South
London, 1968

Facing page, bottom:
Bill and Mary Wilson,
two students from
Sierra Leone, at their
home in Balham,
South London, 1968

as well. Forms of solidarity based not on race and colour but generated out of shared experience and exploitation or common vulnerability were intermittently visible. This fitful process was underway at street level, but it would be a very long time before politicians would notice it, let alone find the courage to try and use its positive consequences to banish fear and enhance British democracy.

The emphasis in the racial image-world shifts away at last from the patterns established in earlier phases of the visual record when the moment of original arrival was imagined, revisited and represented over and over again. The cameras turn hesitantly away from isolated individuals burdened with their luggage and their hopes; the lenses point instead towards families, weddings, couples and crowds. Spectators at the cricket test matches were, for example, captured, showing exactly how the independence of their island nations became contiguous with sporting contests that could culminate in the victory of a black team. Black people

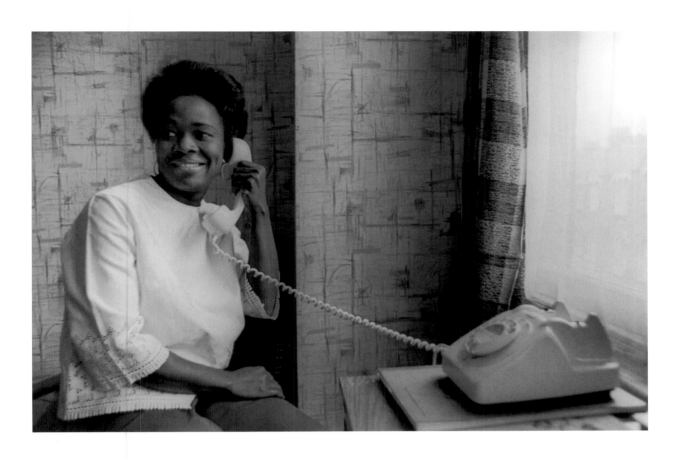

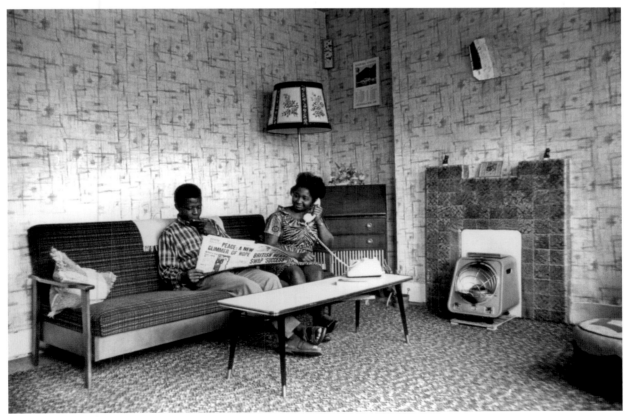

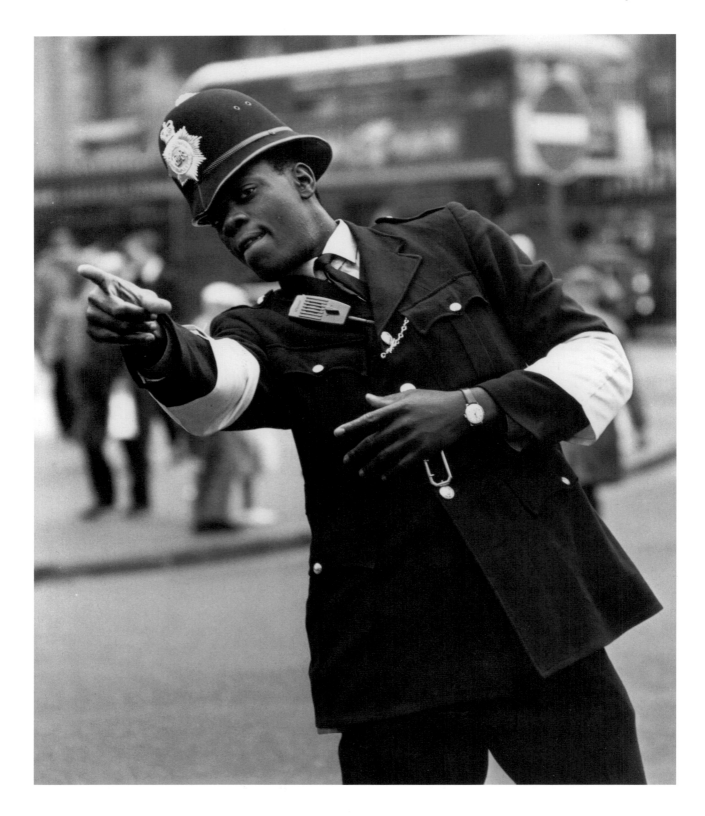

PC Gumbs, London's first black
policeman, 9 September 1968

Facing page: Keith Webster, the first
black chairman of the Handsworth
Labour Party, at work in a
Birmingham factory, 5 March 1965

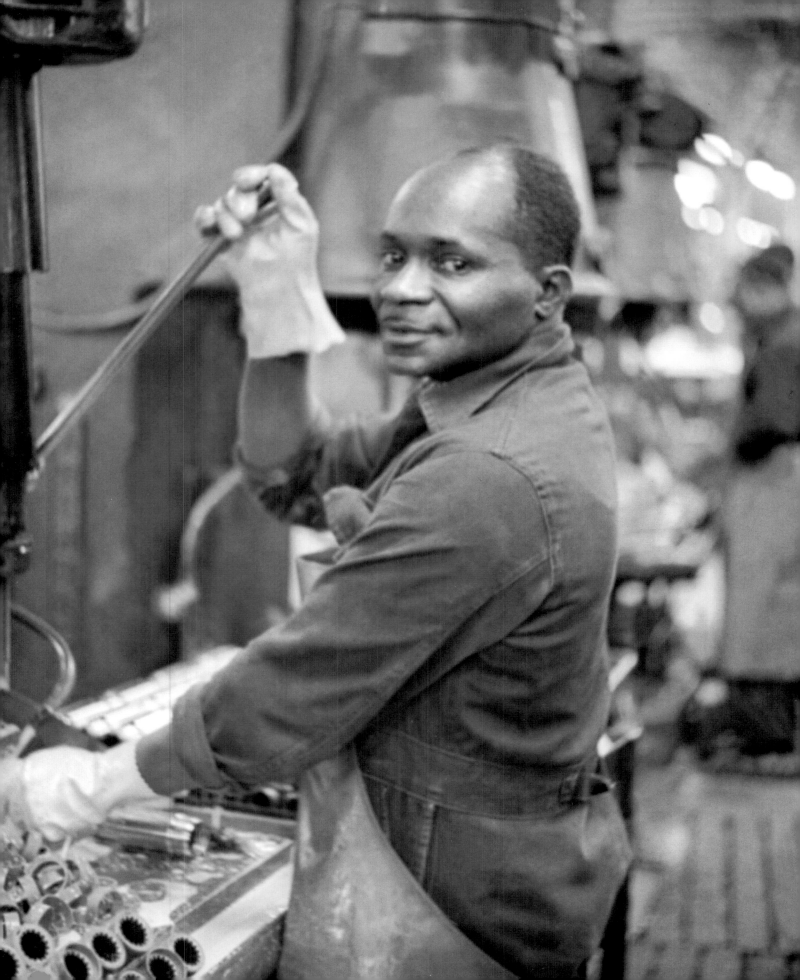

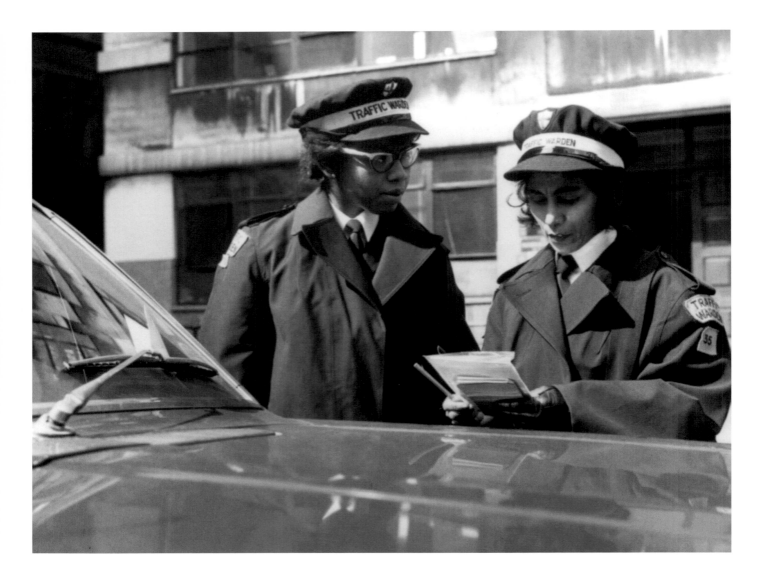

Carmelita Roach
and Maud Aven,
London's first black
traffic wardens,
21 April 1966

(still described as West Indians and immigrants) are found planning their weddings, christenings and parties. They go to church, and are photographed in the living environments they have shaped for themselves rather than just borrowed. Their anachronistic, Victorian habits start to be recognised as quaint, even if they are still judged to be out of place.

If the new collective organism that was Black Britain had been broken down during this period into its constituent parts, the fragments would have been identified as pioneers. This was the great era of 'firsts'. Learie Constantine was not only a dashing figure on the cricket square but a groundbreaking all-rounder in other areas of British life: he became the first black appointee to the House of Lords. Carmelita

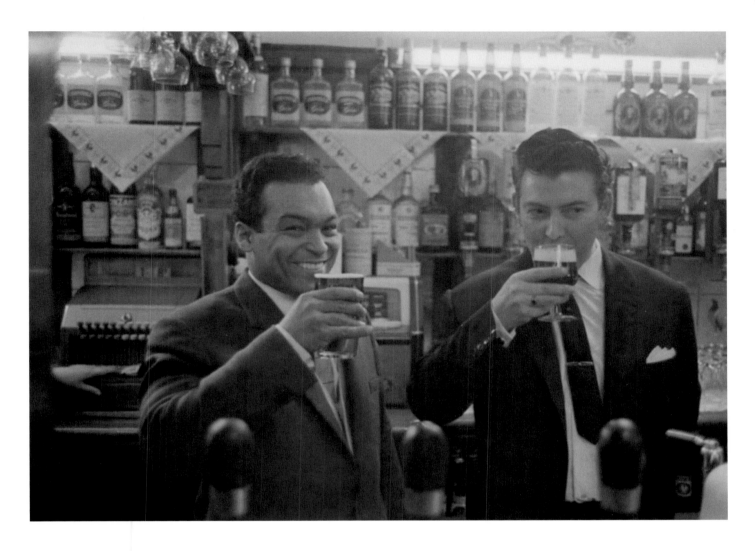

Roach and Maud Aven were London's first black traffic wardens, while Norwell Gumbs was the Met's first black police constable. Here we have George Berry, London's first black publican, and Keith Webster, the first black chairman of the Handsworth Labour Party. These representative achievers were supported by a whole horde of trailblazing councillors, lawyers, justices and senior teachers. All were brought out into the light for consideration as indices of exactly how far Britain had come now that immigration was firmly under control and the first attempts at anti-discrimination law were lodged in the Labour Party's election manifesto and headed for the statute book. Many of the more positive developments were centred on London.

The conduct of the 1964 general election disclosed a different and more disturbing story. It revealed a solid and ugly political formation

London's first black publican, George Berry, enjoying a pint at the bar, 28 April 1965

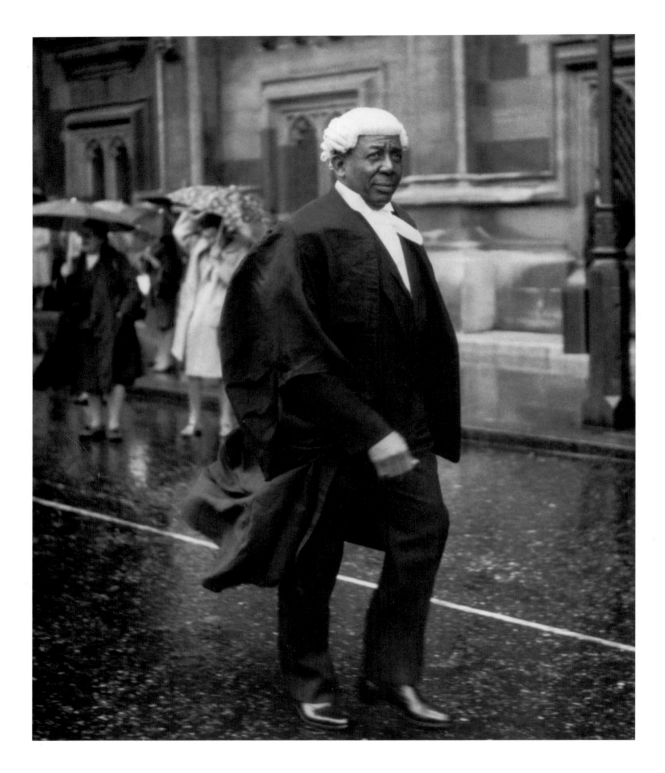

Cricketer and lawyer, Sir Learie
Constantine (1902–71), following
a service in Westminster Abbey
marking the opening of the
Michaelmas law term, walking to the
House of Lords for the traditional
breakfast, 3 October 1966

Facing page: A postal engineer
holding an abusive placard about
Enoch Powell in front of the Post
Office Tower, 30 November 1970

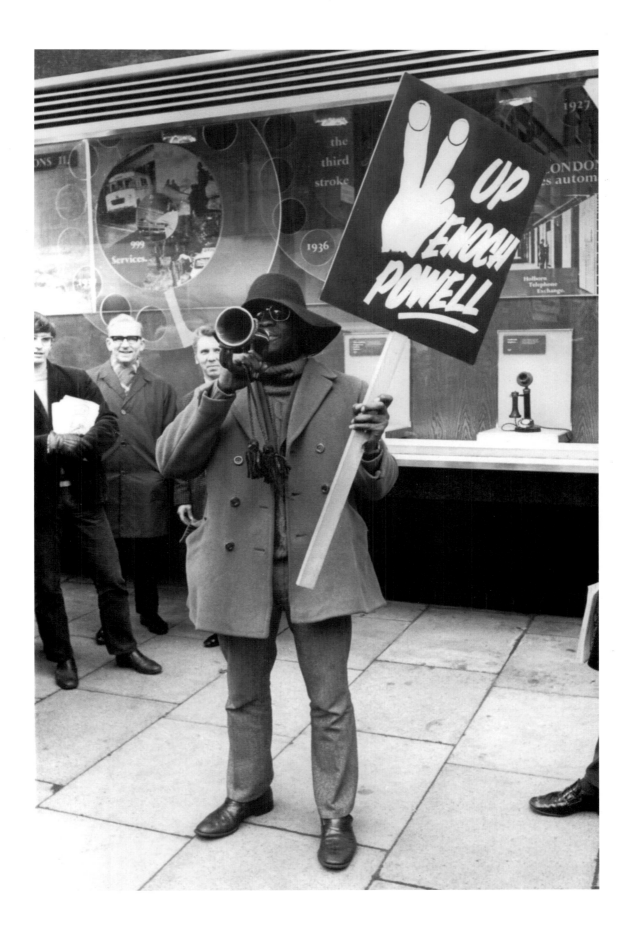

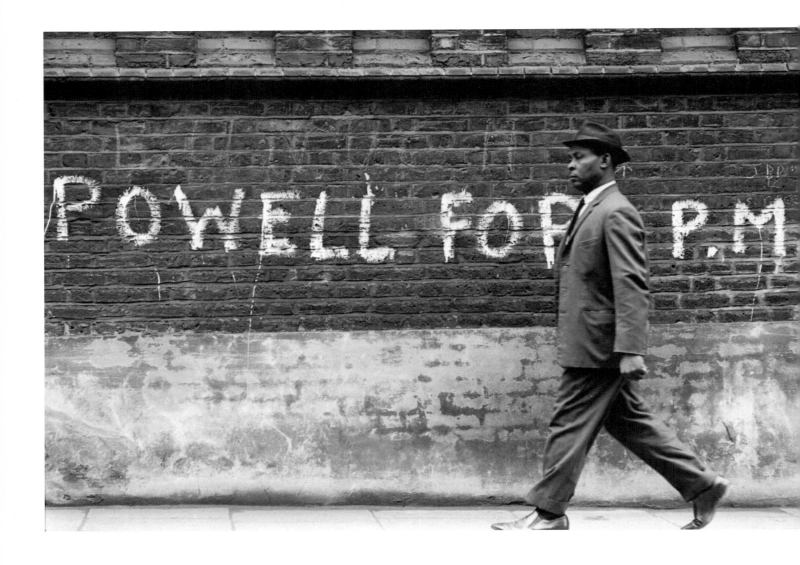

Graffiti reading 'Powell For PM' (Prime Minister) refers to British Conservative politician Enoch Powell, who caused outrage with his hostile attitude to black immigration and racial integration, culminating in his notorious 'Rivers of Blood' speech, 1 May 1968

Facing page:
West Indian cricket captain Gary Sobers congratulating the England captain, Ray Illingworth, after England won the final Test and the series against the West Indies at Headingley, 15 July 1969

that would haunt what commentators were now calling 'race relations' for more than a decade. The themes of race and immigration achieved a novel significance in electoral contests between the Labour and Conservative parties. In particular, they illuminated the ways that the right assembled its bloc of support amidst the loss and destruction of traditional working-class communities and the industrial order that had reproduced them. Race talk was readily combined with new forms of nationalism and xenophobia addressed to Europe as well as to the divided Commonwealth. The resulting mixture was explosive, and it conducted political heat straight into the core of Britain's party system.

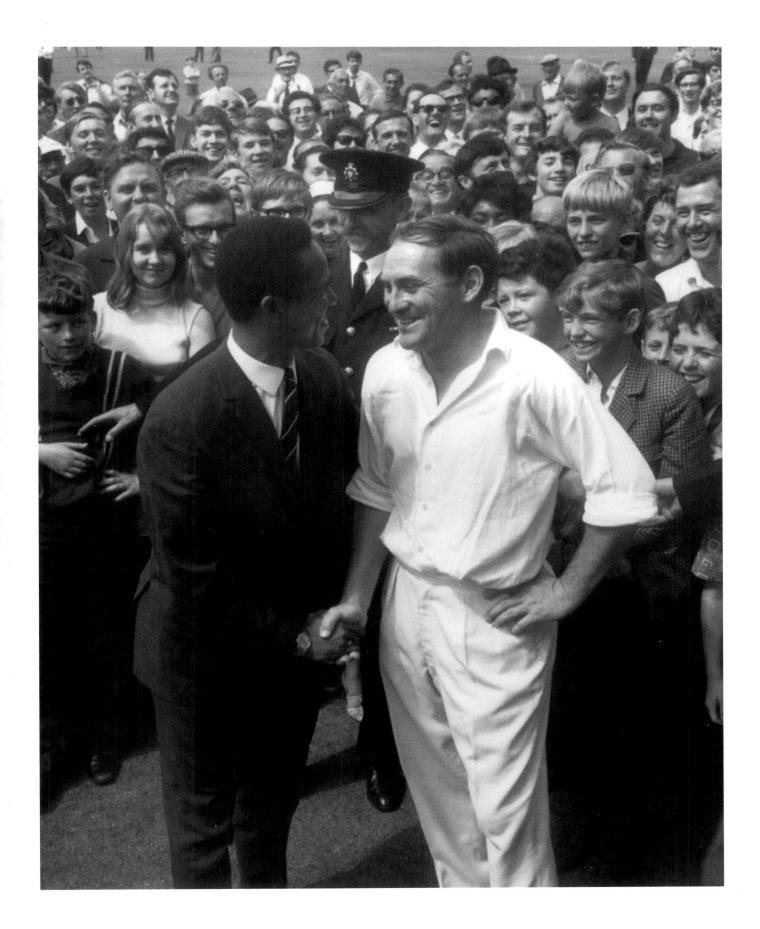

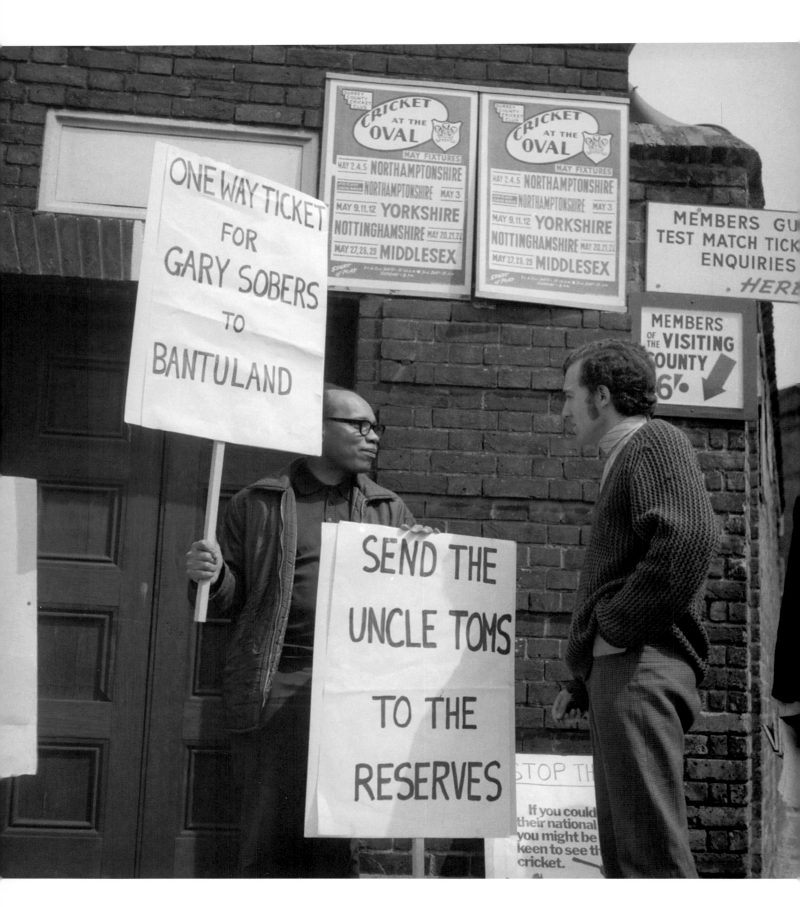

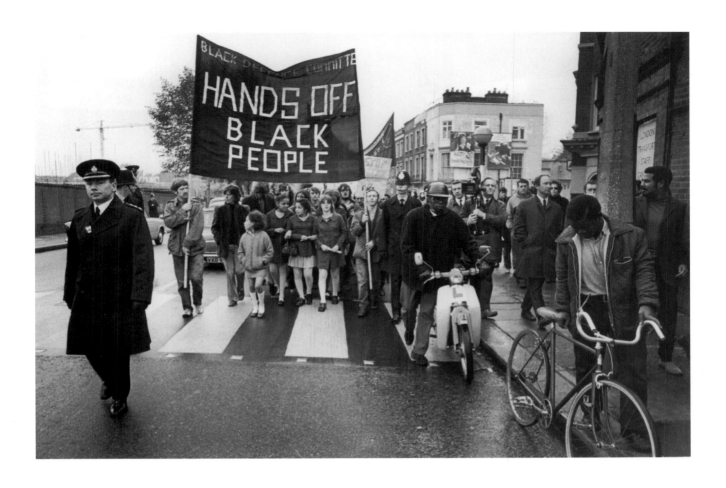

In 1964, the Labour Party discovered that it did poorly in elections wherever immigration became a local issue. In Smethwick, West Midlands, senior Labour politician Patrick Gordon-Walker was unseated by Peter Griffiths, a Conservative candidate who employed the slogan: 'If you want a nigger for a neighbour, vote Liberal or Labour'.

It would take a little bit longer for the epoch-making implications of this dismal episode to be made explicit. Enoch Powell's inflammatory 1968 pronouncement on immigration was that moment of clarity. The speech was a seismic shock that reverberated through the country for twenty-five years, arguably until reactions to the murder of Stephen Lawrence in 1993 created a different set of political and moral codes for managing issues of minority citizenship and black belonging.

Powell's poetic speech is remembered now as a prophecy of inevitable racial war. His scary forecast gained an extra measure of authority because it was delivered just two weeks after the assassination

A march against 'Repression of Black Citizens', organised by the Black Defence Committee, Notting Hill, 31 October 1970

Facing page: Peter Hain, anti-Apartheid activist, talks to a demonstrator outside the Surrey county cricket ground, 20 May 1970. One of the placards condemns the West Indian cricket star Gary Sobers, who said he had no objections to playing a South African cricket team produced according to the rules of Apartheid.

197

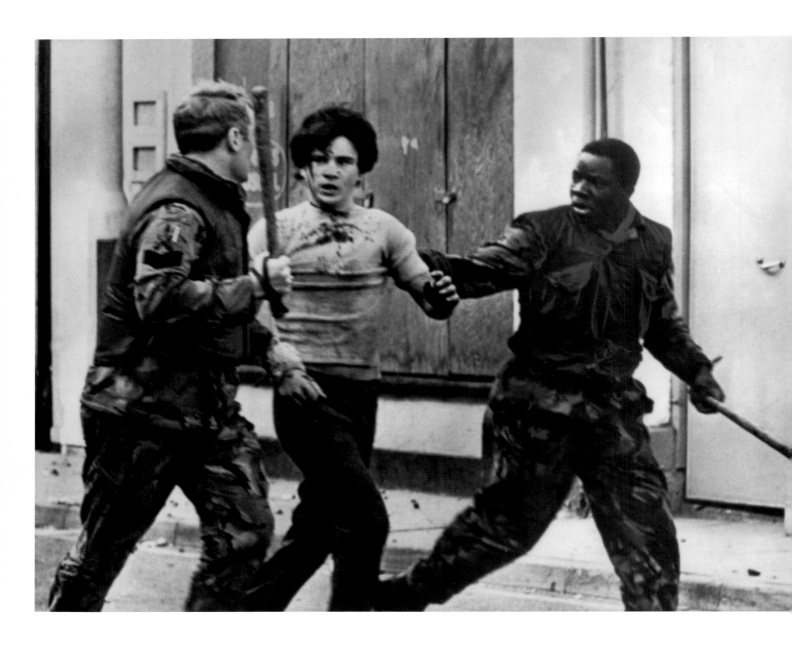

A teenager is arrested by British
troops during a civil rights
demonstration in Belfast, 1969

Facing page: Student teachers Dereck
Tapper and Scilla Nicholls rehearsing
Romeo and Juliet at St Luke's Teacher
Training College in Exeter,
March 1970

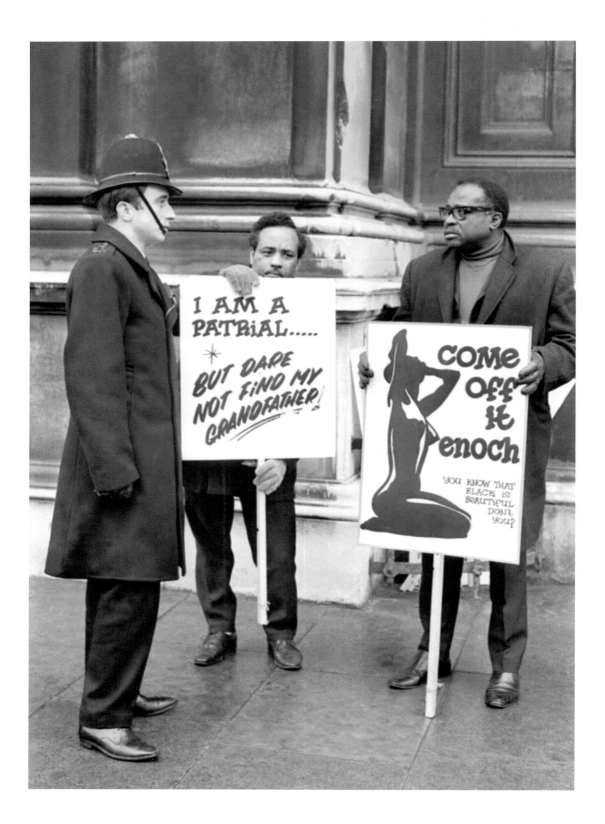

Above and facing page: West Indian
Standing Conference members
staging a protest vigil against an
immigration bill at the Home Office,
8 March 1971

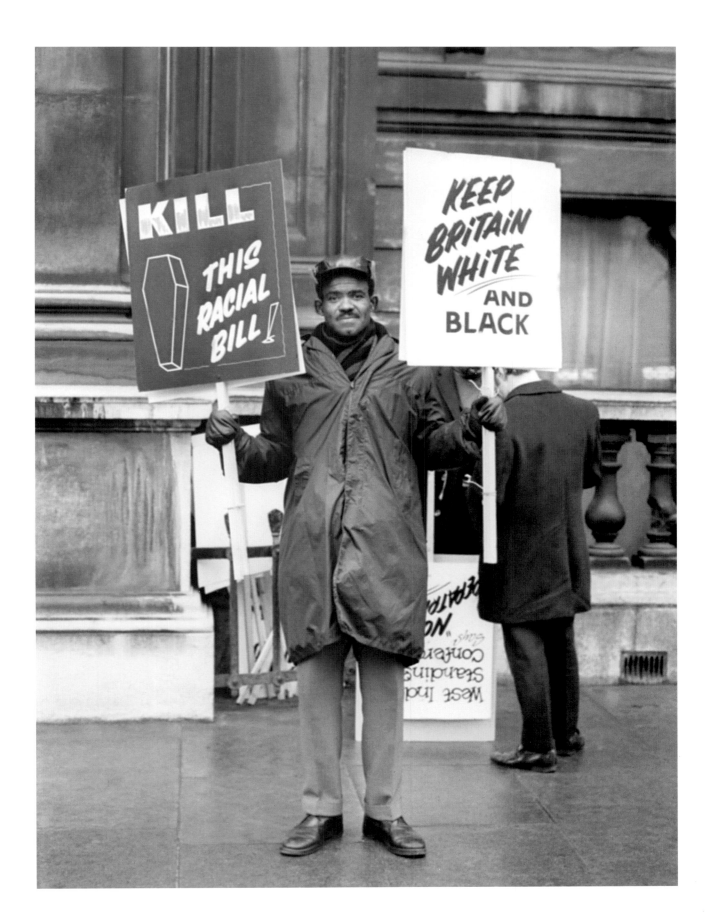

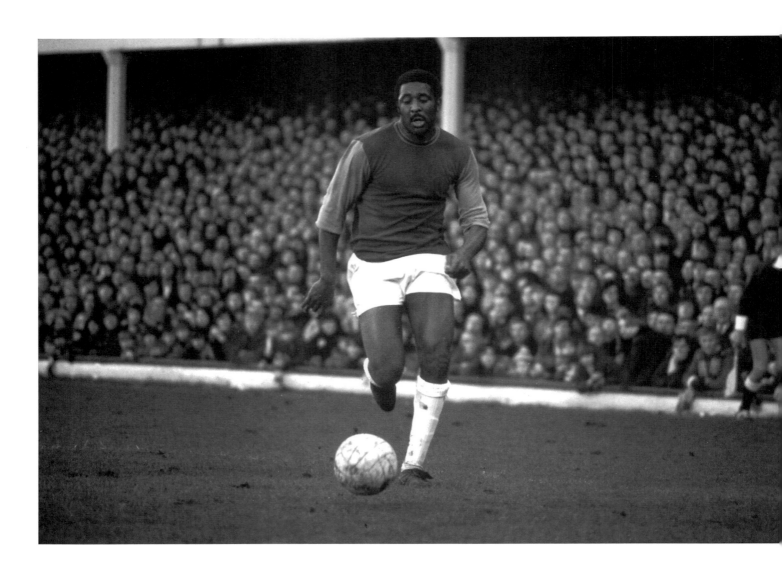

West Ham United's Clyde Best in action during the fourth round FA Cup match against Hereford, 1972

of Martin Luther King, Jr. His populist rhetoric excited London's dockers and meat-market porters – the sinews if not the backbone of the old working class – so much that they marched off their jobs spontaneously in support of him. His classically inspired visions of Britain's rivers awash with human blood had been carefully calculated to wink permissively at the violent para-political forces intent on making the lives of black Britons harder and more fearful.

Powell's first target was the new race-relations legislation that had been proposed by the Labour government of Harold Wilson and Roy Jenkins. This bill, for the first time, outlawed discrimination in the provision of private rented accommodation. It made no difference that many of Powell's spontaneous supporters were now paying out

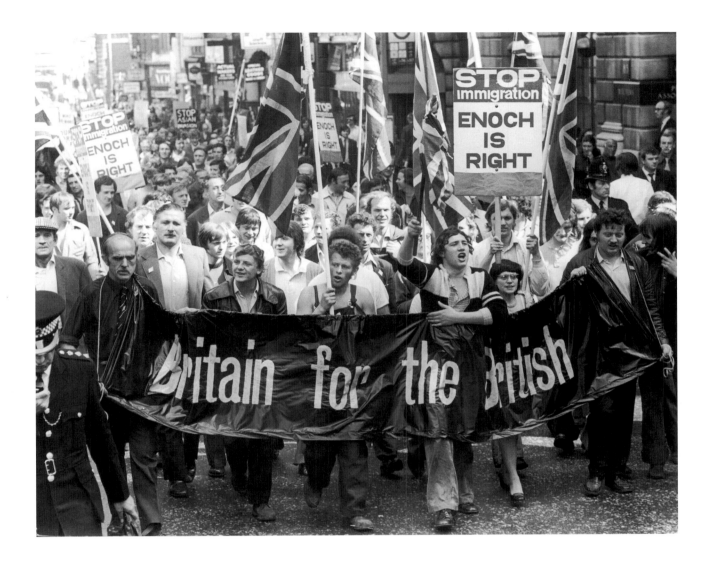

their hard-earned money to watch black footballers perform for their teams on Saturday afternoons. The Powellites saw immigration as an invasive war, and the arrival of Asians who had fled from Kenya and Uganda lent greater urgency to their bid to find a solution. The harsh treatment dished out to these fugitive incomers involved changing the nationality law yet again. Their predicament cemented the racist view of mass immigration as an external force visited on an unsuspecting and undeserving nation from the outside.

Protest against the introduction of further legislation to control immigration and nationality fostered alliances between settlers from different parts of what had once been Britain's empire. Whatever their origins, they were all being stripped of their rights to citizenship and

Smithfield meat porters march on the Home Office, bearing a petition calling for an end to all immigration into Britain, 25 August 1972

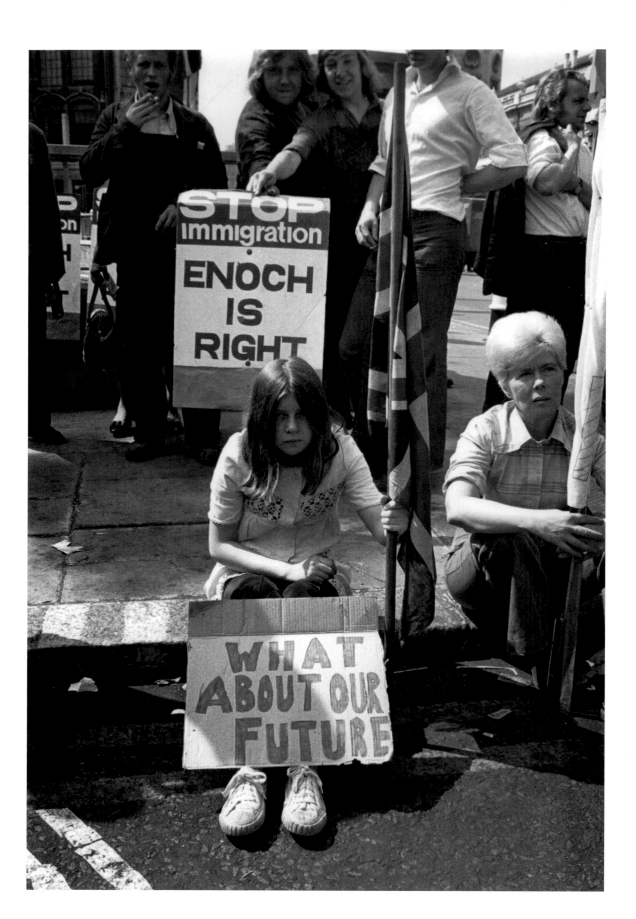

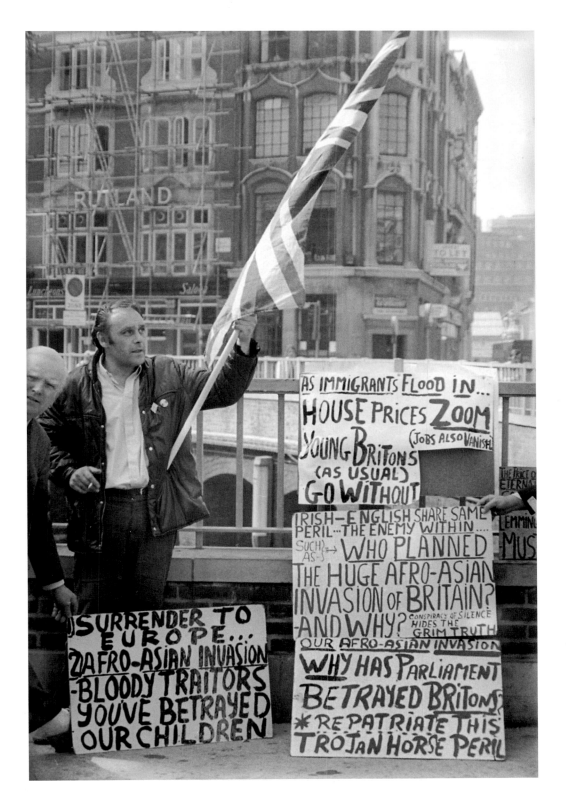

A demonstration in London's
Smithfield against continued
immigration

Facing page: A demonstration
against immigration and in support
of Enoch Powell, 13 September 1972

Stokely Carmichael, activist and 'honorary Prime Minister' of the Black Panthers, speaking in support of Black Power at the Chalk Farm Roundhouse, London, 25 June 1967

Facing page: American civil rights leader and Baptist minister Martin Luther King, Jr (1929–68) preaching at St Paul's Cathedral in London, 6 December 1964

dwelling by ever more ingenious and cynical methods. All were caught up in the shift away from political responses defined by the desire to 'keep Britain white' and towards a more belligerent outlook conveyed by the injunction to 'send them back'. Those parallel imperatives concealed a telling shift of perspective. Old arguments about abstractions like 'Britain' and 'whiteness' were succeeded by a crudely concrete concern: what are we going to do about *them*? The inducements to leave these shores were murderous and informal as well as polite and political. During this period, independent organisations in the black community reported that police and hooligans alike were prepared to make common cause during their various 'nigger hunting' exercises.

The desire to rid the country of alien intruders united the respectable, Conservative right with shady ultra-nationalist and neo-fascist grouplets. To answer this pressure and defend their interests, the settlers, refugees and immigrants forged a common political identity

centred on the idea of blackness, which was opened up to accommodate diverse experiences and postcolonial histories.

Those local dynamics aside, informal alliances against the white supremacist regimes in Southern Africa, and in solidarity with victims of the civil war in Nigeria and the wars that gave birth to Bangladesh, all impacted upon the political culture and agency of black communities in Britain. The US Black Power and civil rights movements had acquired a long international reach, which changed the terms and the rhetoric of political action against racism. African Americans' practical campaign for authentic citizenship and political participation had begun to mutate into more culturally oriented and heavily ritualised affirmations of Black Power, which emphasised human rights rather than civil rights. In that new setting, the situation of people fighting to decolonise and create independent nations could be connected organisationally and conceptually to the struggles of racial and ethnic minorities inside developed countries. This, too, affected the quality of political life and community organisation among blacks in Britain and in the Caribbean. It was not only that prominent leaders arrived from the US bringing their various messages of peace, hope and solidarity. There was also a strong suggestion that Britain might itself benefit from a shocking dose of black militancy administered by political forces that tied the pursuit of rights and justice to a timely tide of revolutionary ferment that ringed the globe, connecting events on the streets of Chicago with conflicts taking place in Paris and Prague.

Malcolm X charmed students at the Oxford Union and the LSE and then returned a few weeks later to tour the mean streets of Smethwick, Wolverhampton and Walsall. Martin Luther King, Jr stopped off in London on his way to collect the Nobel Prize in Oslo and preached his message of militant hope and saintly nonviolence at St Paul's Cathedral. Stokely Carmichael addressed the dialectics of liberation at a conference at London's Roundhouse. The home of British Black Power militancy was identified as the Mangrove restaurant in Notting Hill, which was then subjected to a sustained campaign of police harassment.

Photographic material from the 1970s maintains and extends the

Facing page:
John Lennon and Yoko Ono give their newly cut hair to Black Power militant Michael X (aka Michael de Freitas or Michael Abdul Malik, 1933–75), in return for a pair of Muhammad Ali's bloodied boxing shorts, 19 February 1970

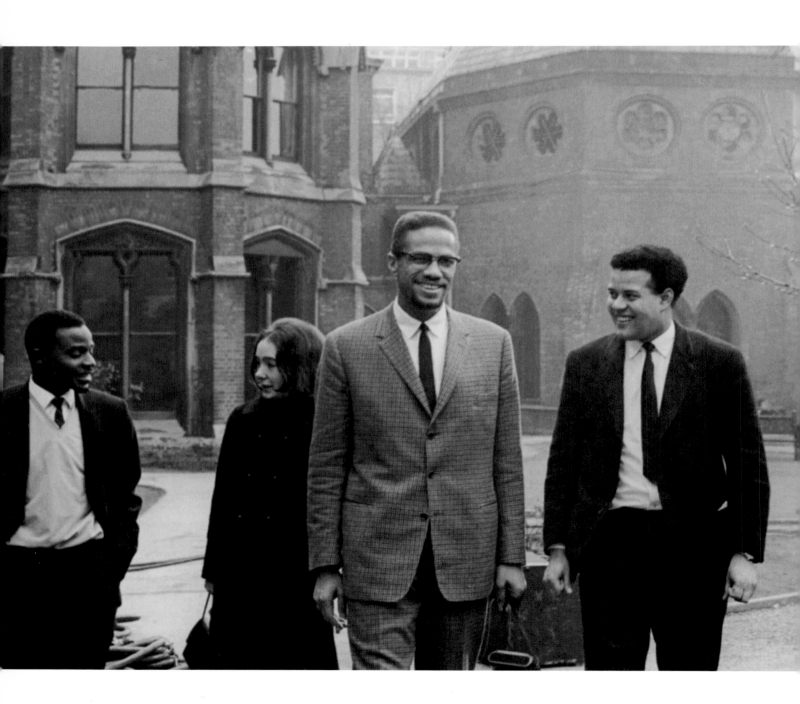

Malcolm X at Oxford, 2 December 1964

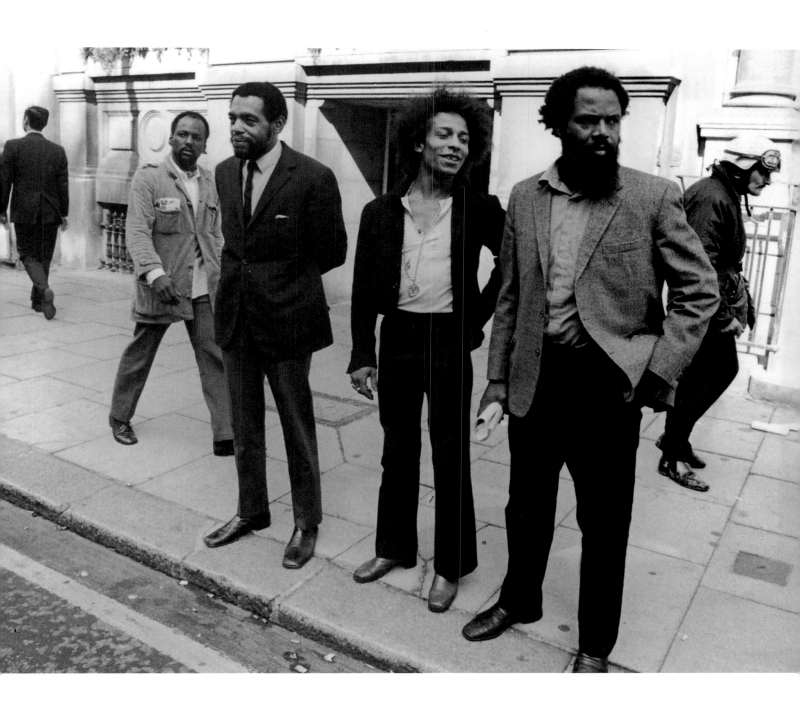

Roy Hemmings, Jean Cabussel
and Frank Critchlow after
appearing at Kensington Petty
Sessions, 15 August 1970

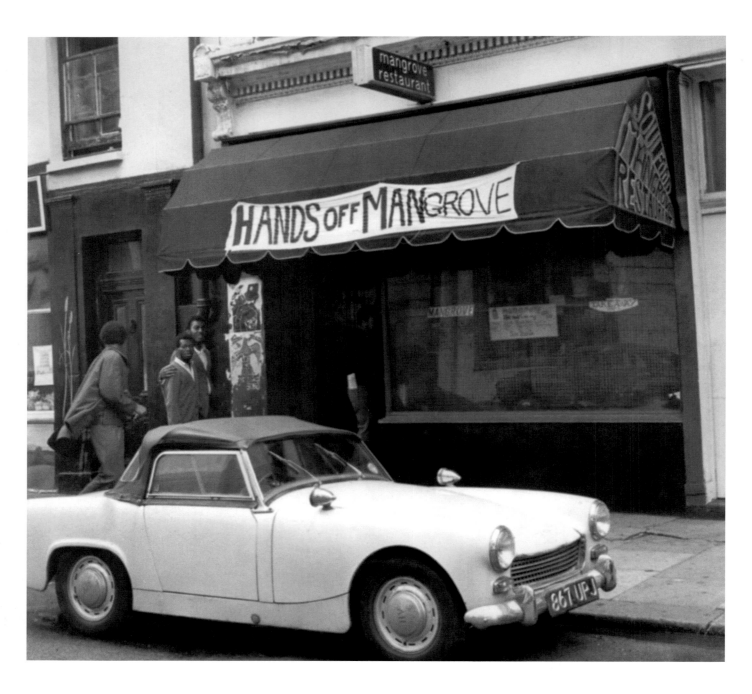

West Indian immigrants outside the
Mangrove restaurant, Notting Hill,
10 August 1970

Poster advertising events at the
Metro Club, Notting Hill, May 1971

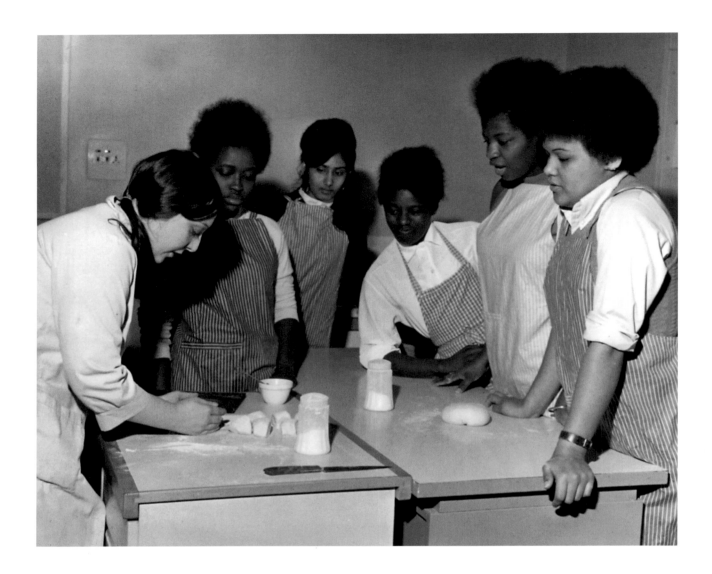

Girls being taught
bread-making
at the Aylwin
Comprehensive
School for Girls,
Bermondsey,
5 November 1971

Facing page:
Asian immigrants
arriving at Stansted
Airport after being
airlifted from Uganda
by an 'immigrant
special' charter flight,
18 September 1972

earlier focus on youth. The children who composed black Britain's 'second generation' are now identified as troublesome, rebellious teenagers. Their new label communicated the shifting demographic contours of Britain's black communities as well as capturing the distinctive character of their newly combative political outlook. A history of chronic, disorderly and even riotous conflict with the police confirms that Britain's young blacks had achieved official recognition as a substantial and profound political and economic problem in their own right. Their leisure spaces, schools and youth clubs were placed under intense surveillance. Their skirmishes with white supremacists and neo-Nazis drew the headlines. A moral panic about their un-British

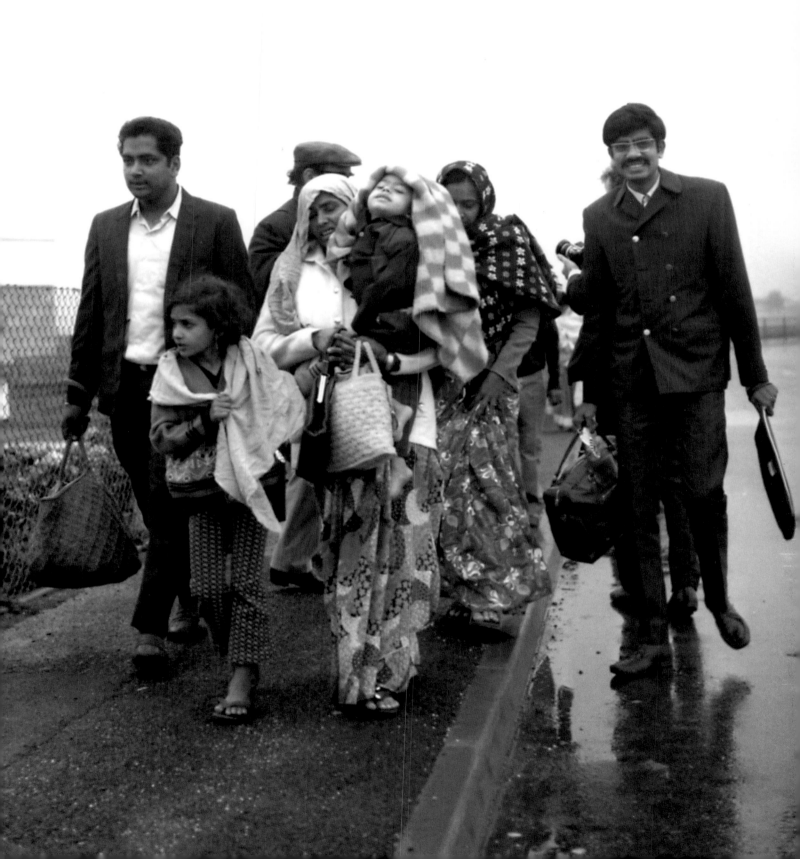

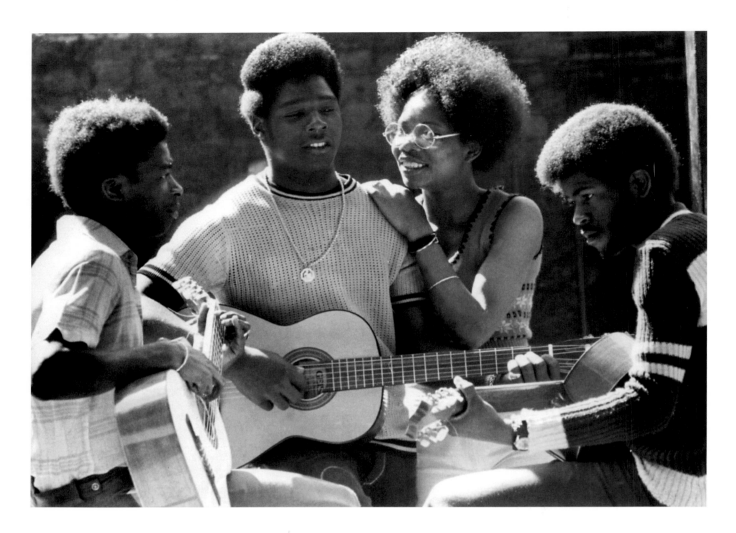

Top: Students at college playing Calypso music, 1972

Right: Pupils at Kennington Park taking part in a student protest, 2 April 1974

Facing page: Protesters campaigning for the release of the Brockwell Three, 1973

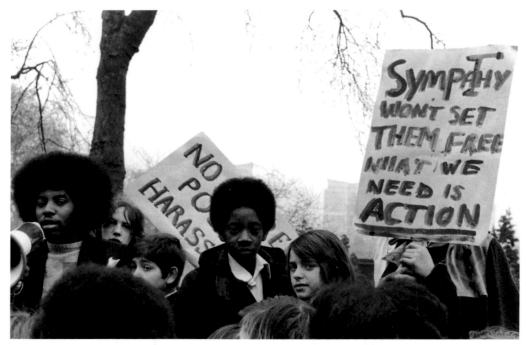

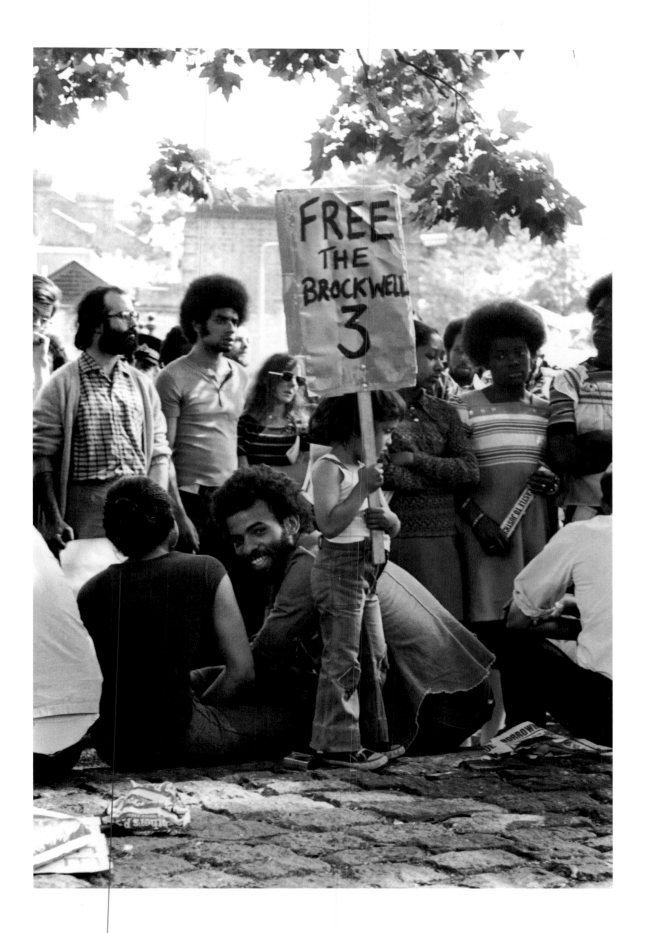

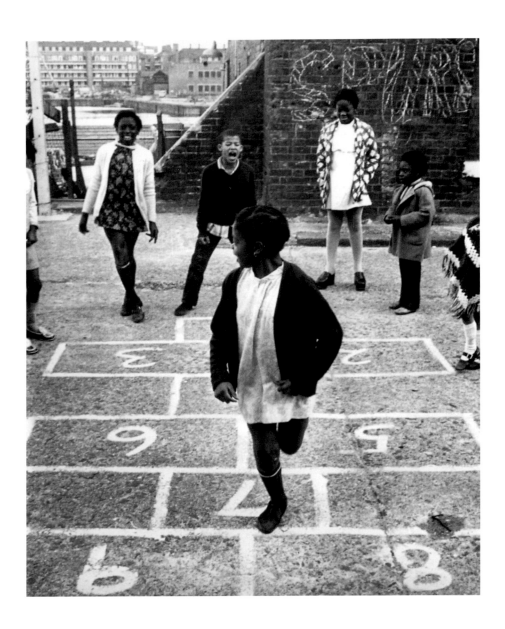

Children playing hopscotch at a community centre run by the Make Children Happy charity near St Katherine's Dock, East London, 23 November 1972

criminality was the trigger for a judicial campaign against them that resulted in their wholesale criminalisation.

Exactly how that happened involves a well-known story of resistance that cannot be documented in detail here. It suffices to say only that they were adamant they would not suffer the indignities and exploitation that their parents had been prepared to tolerate in the interests of advancement.

The protracted resistance of black youth against the lowly racial fate that had been prescribed for them was an important part of this next historical phase. Their militancy, their boldness and their reckless

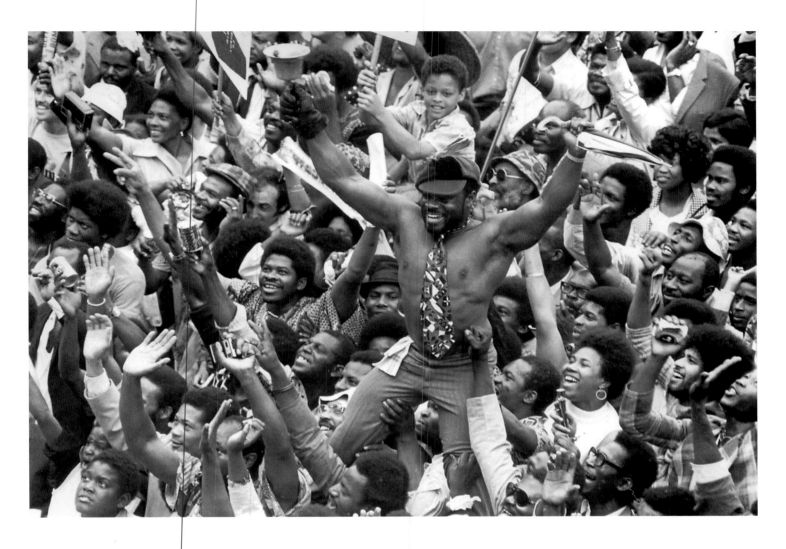

despair were forces that would eventually bring about the ambivalent mainstreaming of black culture in Britain. A special daring, shaped above all by hopelessness, was what generated the tides of protest that gave difficult birth to a small black British middle class buoyed up by tokenism and firmly anchored in the worlds of entertainment, media and local government politics.

Churches, clubs and informal and underground places of recreation and pleasure strengthened and transformed the characteristics of a black community that was increasingly recognised as not going anywhere. The resentful howls of 'send them back' increased in volume, but the settlers and their locally-born children were gradually becoming more confident in their determination to resist what the polite, Orwellian code of those harsh years termed their 'repatriation'. Strikes by nurses

Fans of the West Indies cricket team celebrating its win over England at Lord's cricket ground, London, 27 August 1973

Following pages: A free festival of African, Asian and Caribbean music and art at Kennington Park, 27 August 1973

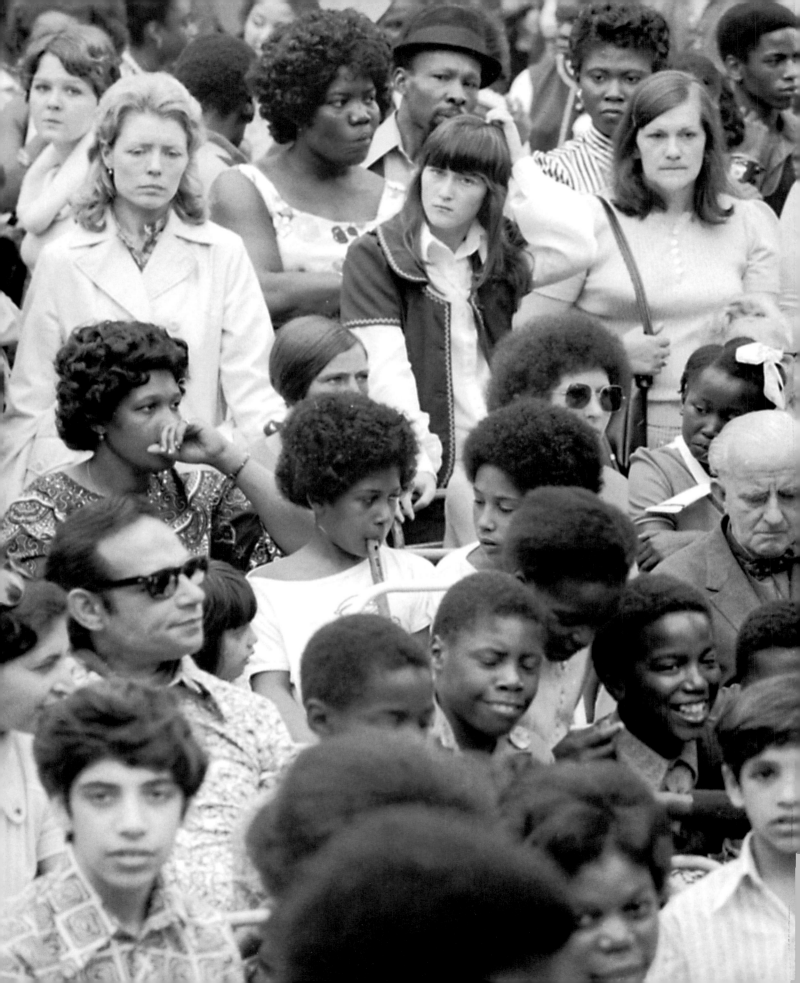

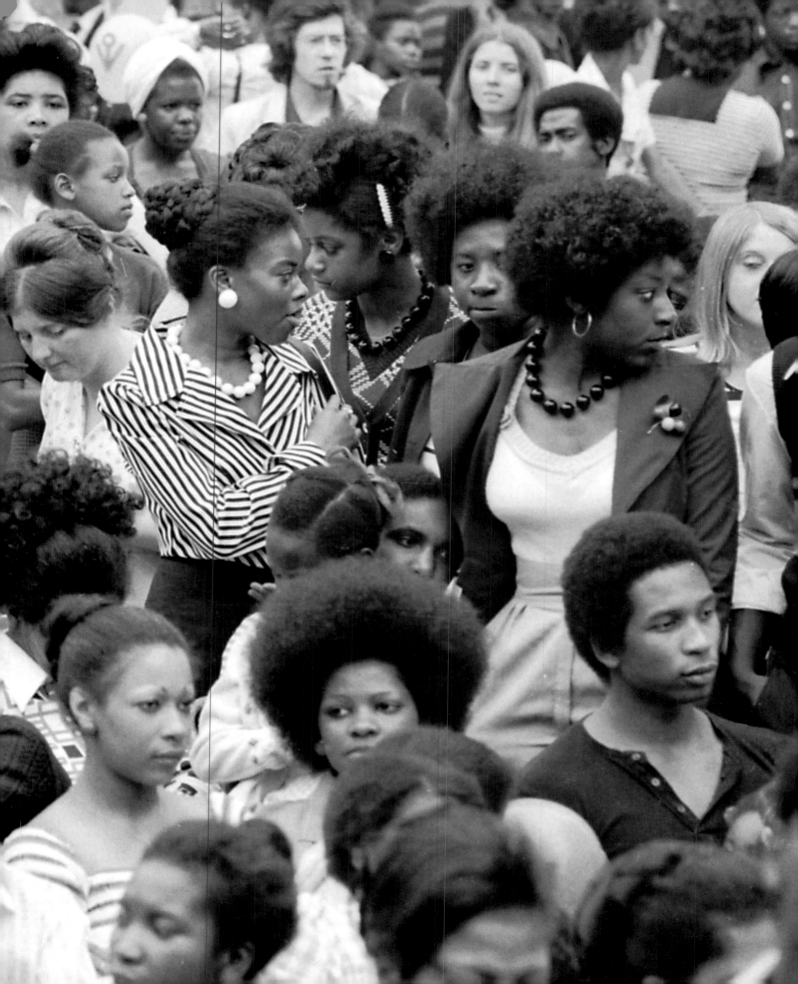

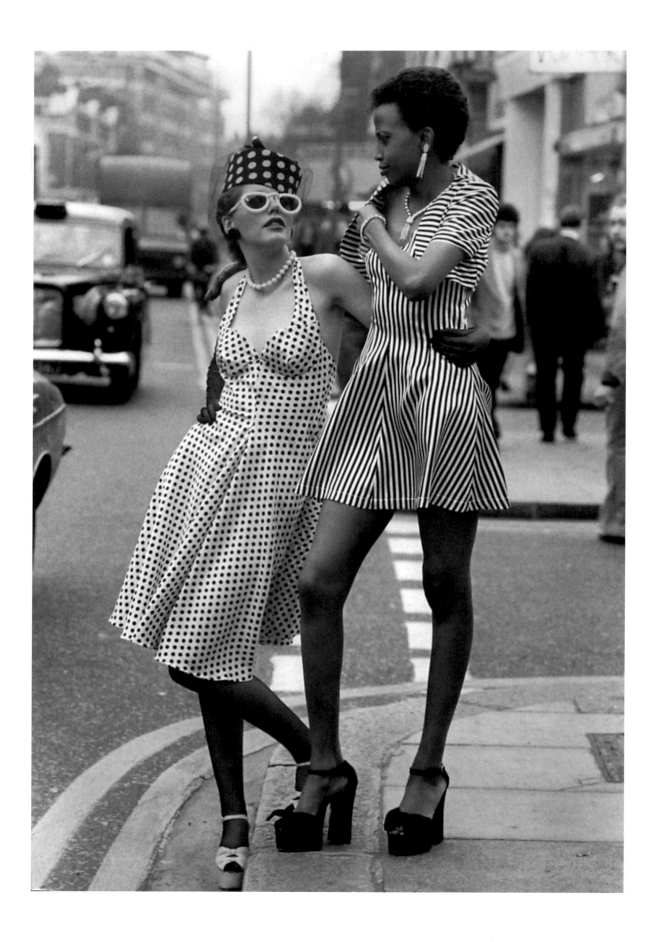

and car workers revealed how much assimilation into the working class had quietly taken place. The community's change of attitude towards its own future inside Britain was exemplified in the growth of cultural and economic institutions that would be the wellsprings from which black musical and artistic expression travelled into what would eventually become the nation's cultural mainstream.

First mods and then skinheads thrived on the borrowed elements of black culture they could mimic or just purchase over the counter. Records, haircuts, shoes and clothing associated with the incomers redefined the content and style of working-class life. Even masculinity and femininity were reworked around imagined or observed glimpses of black interpersonal interaction. However, these youthful white borrowers and copyists often remained deeply hostile to the producers and architects of the racial subcultures that fascinated and inspired

English footballer and stand-up comedian Charlie Williams (1928–2006) at his Yorkshire home with his dog Max, 5 November 1973

Facing page:
Mr Freedom fashion range, 1973

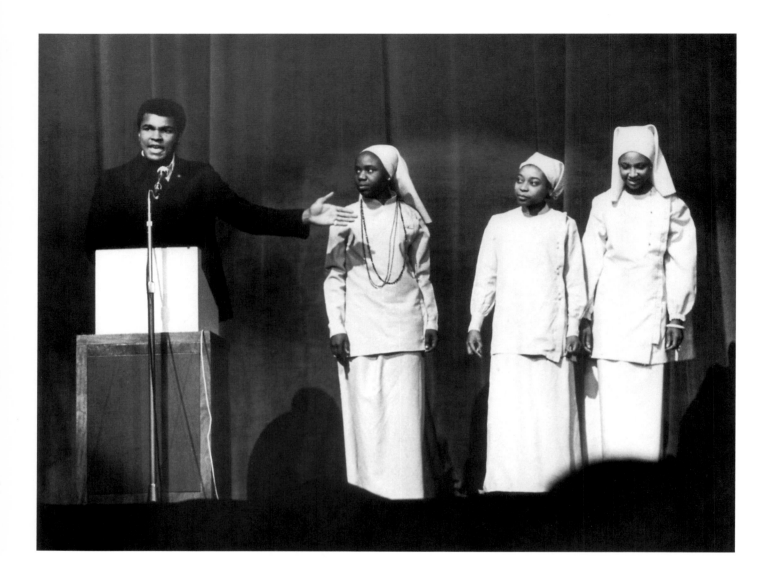

World Heavyweight
Champion boxer
Muhammad Ali
addressing a Nation
of Islam meeting at
the New Victoria
Theatre, London,
2 December 1974

Facing page:
Conroy Campbell,
a pupil at Willesden
High School, 1973

them. This striking ambivalence would persist. Carefully selected aspects of black style were annexed and set to work in new settings, but these borrowings were far from automatically progressive: blacks might, under certain circumstances, become cool and worth imitating – but the odious Pakis, on the other hand, were another story. Cultural, religious, linguistic and other ethnic differences interrupted the continuities of class-based social life.

Britain's young blacks turned decisively away from versions of their culture that were amenable to easy borrowing by outsiders. A sharply politicised subculture developed among them during the 1970s. This combative formation was endowed with pronounced Pan-African and Ethiopianist features. However, its dissident energy animated a broader

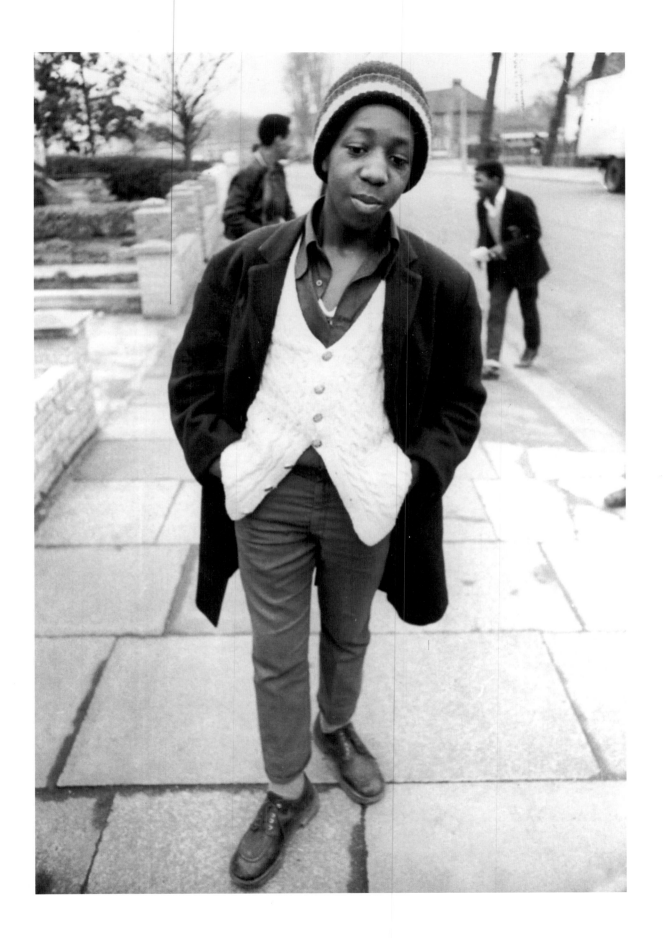

social and political movement that had, in turn, drawn heavily upon the spirit of popular disenchantment found in the Caribbean. Those fruits were combined with elements of African American culture that had been eagerly absorbed on this side of the Atlantic.

This hybrid circuitry grew in a period when the politics of Black Power were being replaced by a more consumer-friendly conception of solidarity tied to stylish objects infused with the magic of Soul and commercial developments like the rise of an international market for blaxploitation films. In Britain, the leather jackets and armed fantasies of US black nationalism did not translate readily into environments that were less than totally segregated. The military style yielded to Afro hairstyles, beads and flares: symbolic weapons in a different cultural battle to make a restorative virtue out of secondariness, exclusion and marginality. That impulse remained, but the style that enveloped it evolved quickly in an unlikely direction by making a detour back towards the direction of the Caribbean.

The low-intensity rebellion practised by young black Britain's disproportionately workless rude boys and a few bold Rastafari created a distinctive style that sometimes divided youth from their parents.

Clyp Youth Club,
18 October 1978

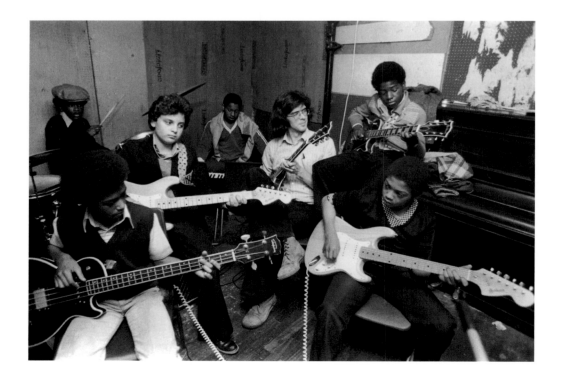

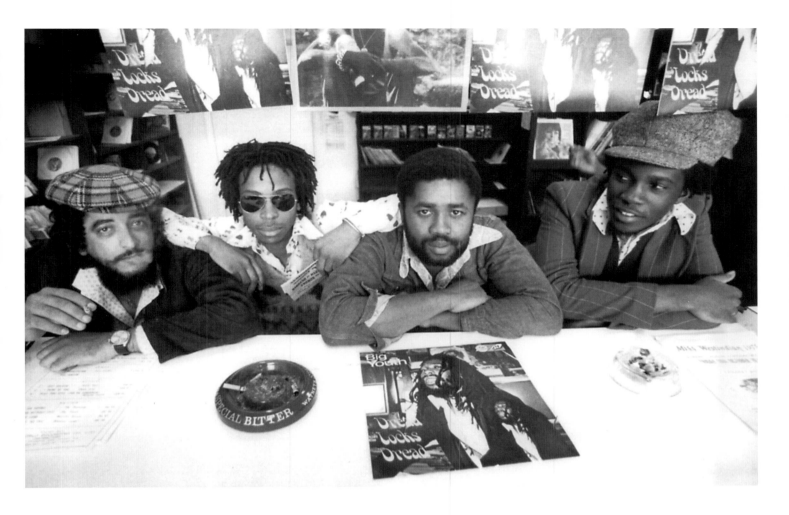

But this social movement was more than just a rebel culture. It fostered a complex political outlook centred on black consciousness, self-reliance and self-worth. Its poets, troubadours and ideologues were sophisticated and astute enough to communicate a deeply serious critique of worklessness, hopelessness and lovelessness even to the denizens of post-industrial Britain's concrete jungle.

More often than not, both generations stood together in opposition to the destructive effects of an educational system that failed the young and mocked their parents' dreams of uplift, and a criminal justice system that saw young and old alike as disposed to criminality by their racial character.

The mood of the time was strongly influenced by a drive to recover the language and political ambitions of the Garveyites who had shaped black political thought so profoundly during the 1930s. Reborn in a

From left: Desmond Bryan, Caesar Andrews, Delroy Witter and Ken Murray, in the 'Into Reggae' record shop, 1975

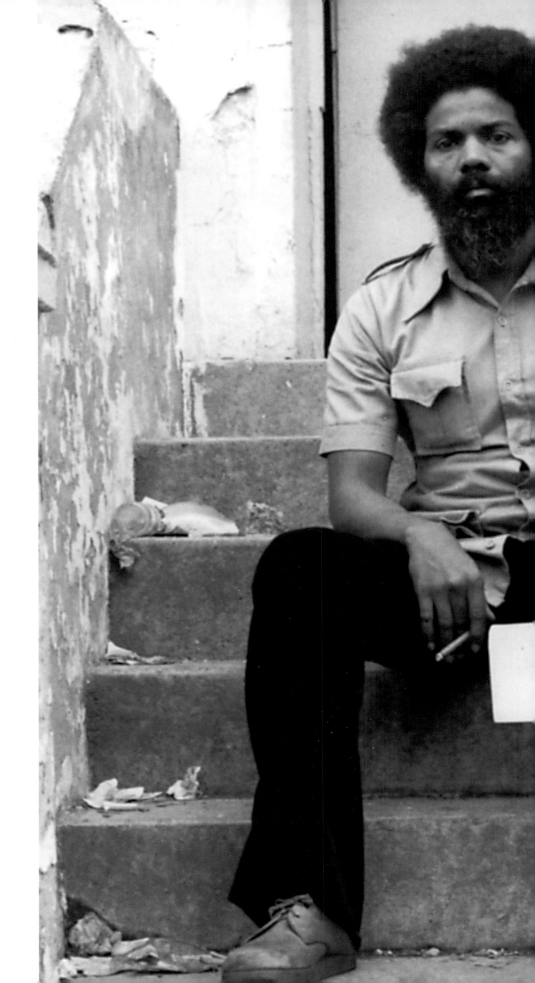

Selwyn Baptiste,
Chairman of Carnival
Activities, outside
his headquarters in
Acklam Road, North
Kensington, surveying
the situation after the
previous night's riots
during the Notting
Hill Carnival,
31 August 1976

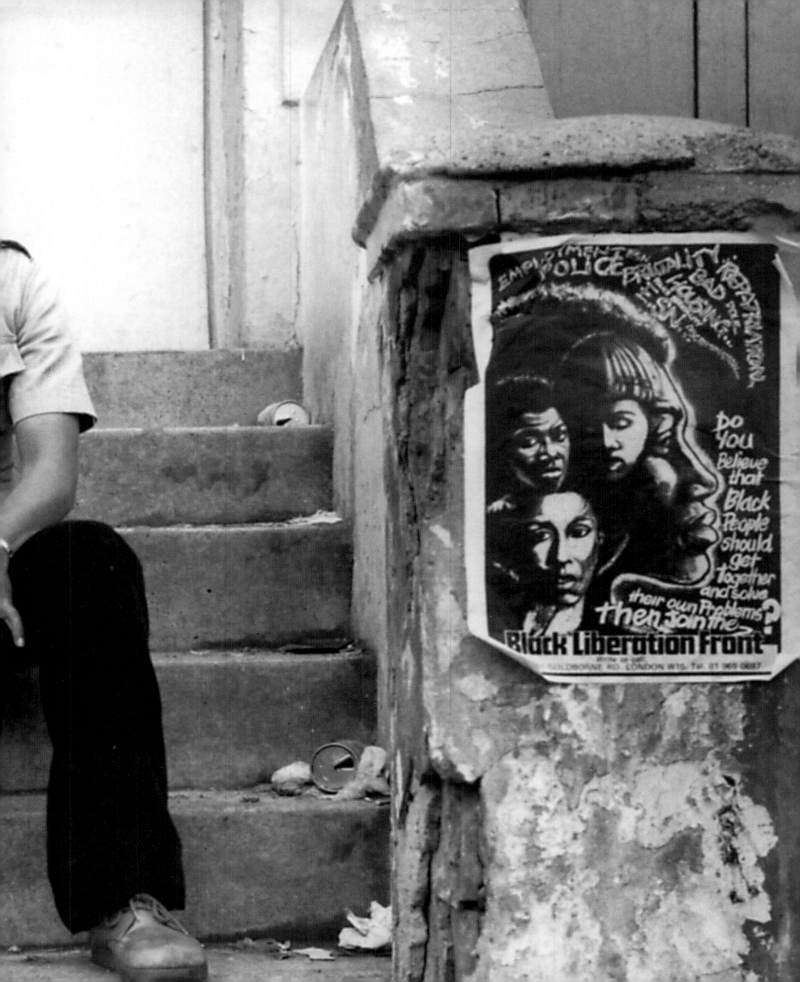

world of independent Caribbean nations, a new trans-nationalism was inspired by that history of struggle. It appealed to the slave past as a means to orient resistance in the present. The commemoration of slavery was also used to legitimate refusal of the dirty and dangerous work that had defined the employment of the preceding generation.

This irreducibly political stance fitted easily into the need for solidarity with the military campaigns to decolonise Africa, which were being conducted in Angola, Guinea, Mozambique, South Africa, Zimbabwe and Namibia. Apartheid, like slavery, supplied an interpretative framework through which young blacks in Britain would consider their own different experiences of racial division. Theirs was often a worldly outlook that sought to connect the experiences of racism's victims wherever they were.

After several years of rumbling conflict with police outside youth clubs, bars and leisure spaces, the 1976 riot at the Notting Hill Carnival would be a watershed event. The battle, which was judged at the time to have been a defeat for the police, initiated a further sequence of antagonism and change that ran for almost a decade and would not come to an end until the sad trail of riotous protest reached the concrete ziggurat of Tottenham's Broadwater Farm estate.

It is worth emphasising the sequence that led up to the 1976 eruption. The black communities in Britain's metropolitan centres had found themselves at the forefront of a bitter struggle. It was not just between their young people and the police, but also involved the media, which articulated the problem of Britain's black settlement through the diabolical figure of the mugger: a deviant, a predator and, though it seems laughable now, the supposed vanguard of black urban insurgency. That scenario was fed both by the unevenly distributed effects of economic recession and by the prospect of contagion from the urban conflict in Northern Ireland.

The special cultural dynamics of this period saw New World black cultures acquire groups of remote listeners in distant locations. This network achieved both social and political significance as those cultures became increasingly global. The producers of Soul, Reggae and

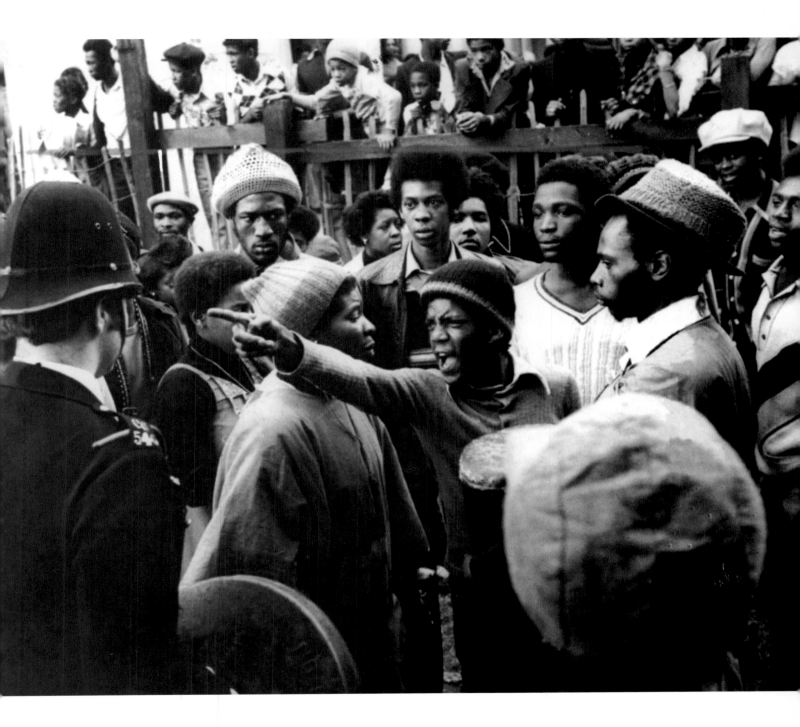

Notting Hill riots, 31 August 1976

Following pages:
Police beat a retreat back up
Portobello Road at the Notting Hill
riots, 31 August 1976

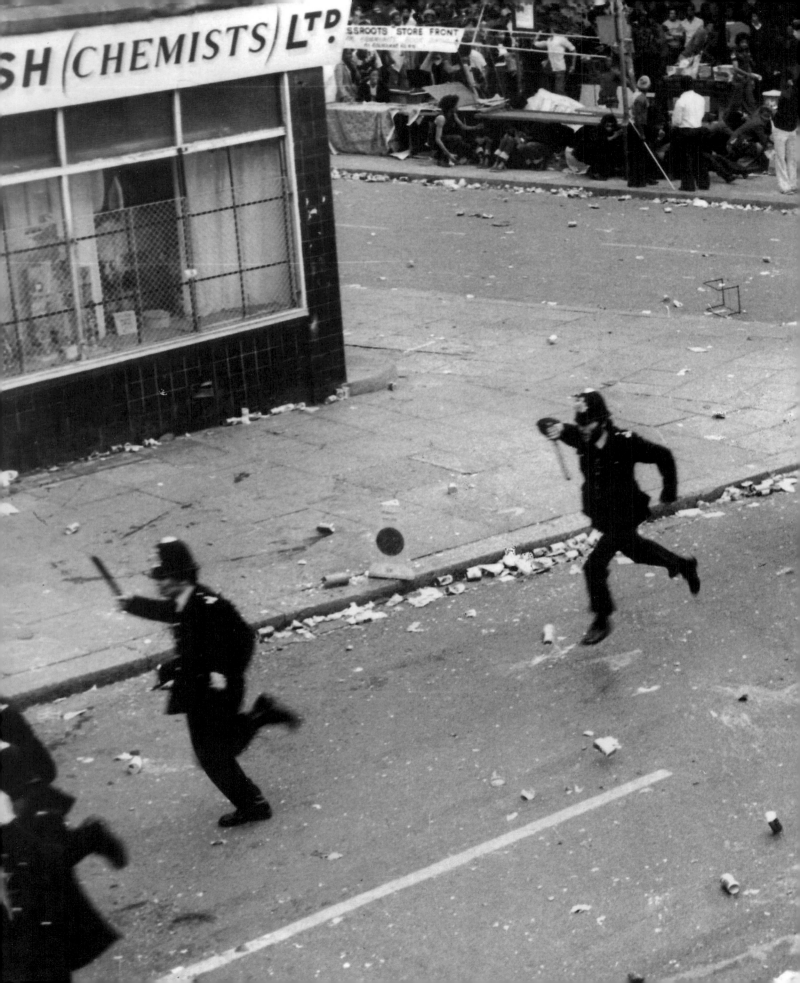

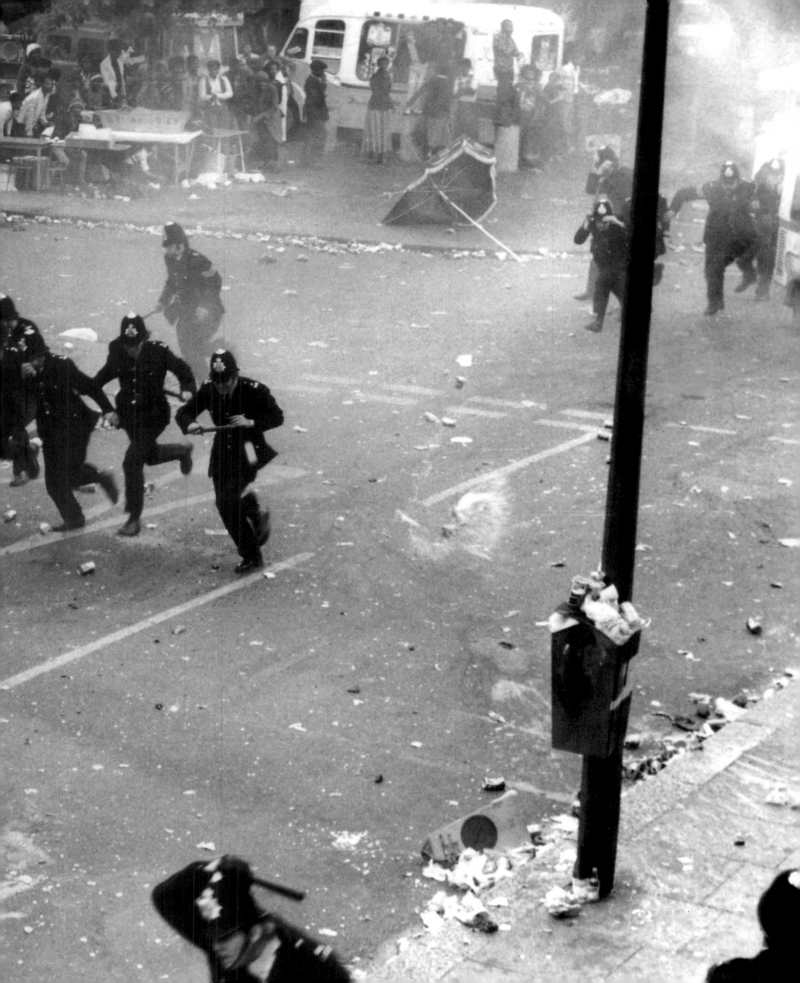

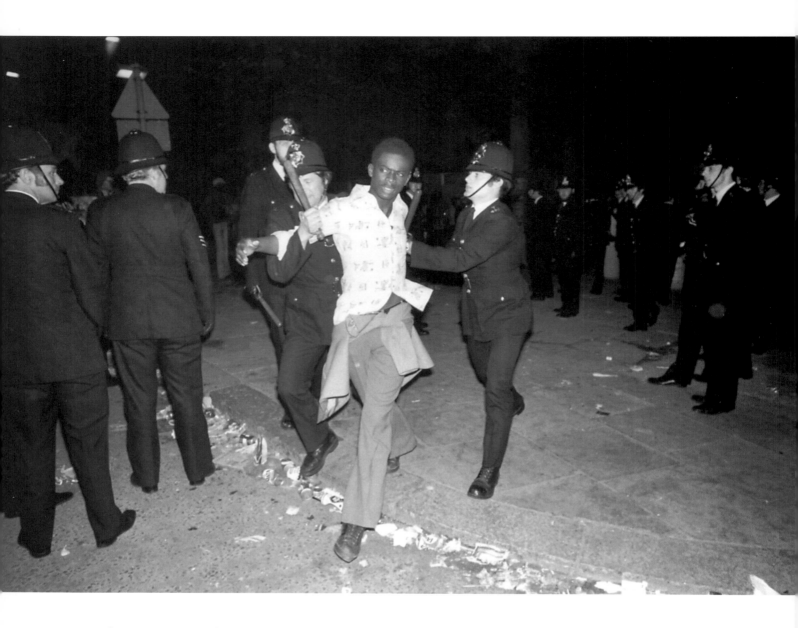

Police arresting a man during riots
at the Notting Hill Carnival, 1977

Facing page: A group of policemen
during the Notting Hill riots,
31 August 1976

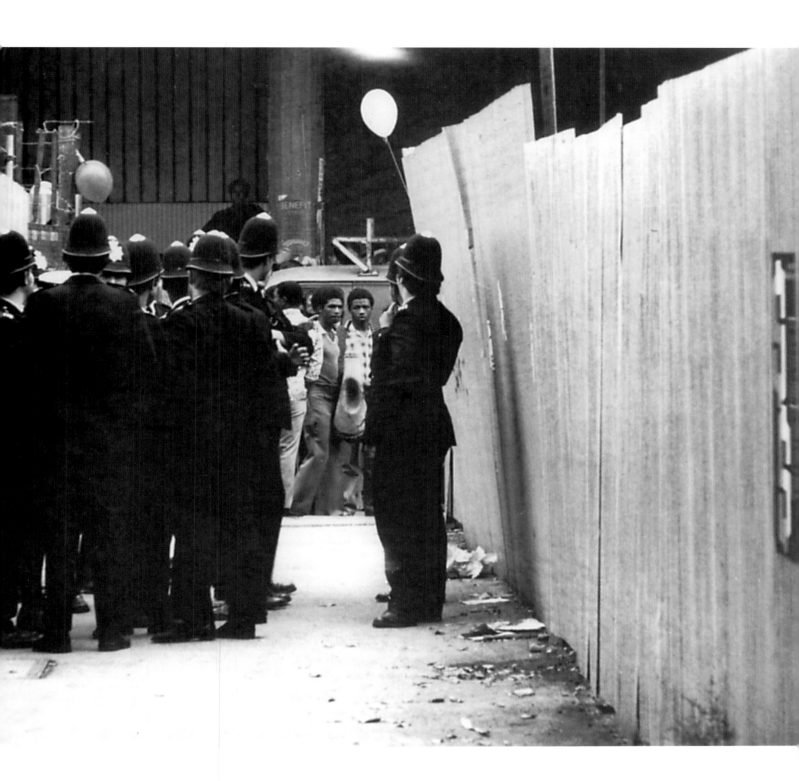

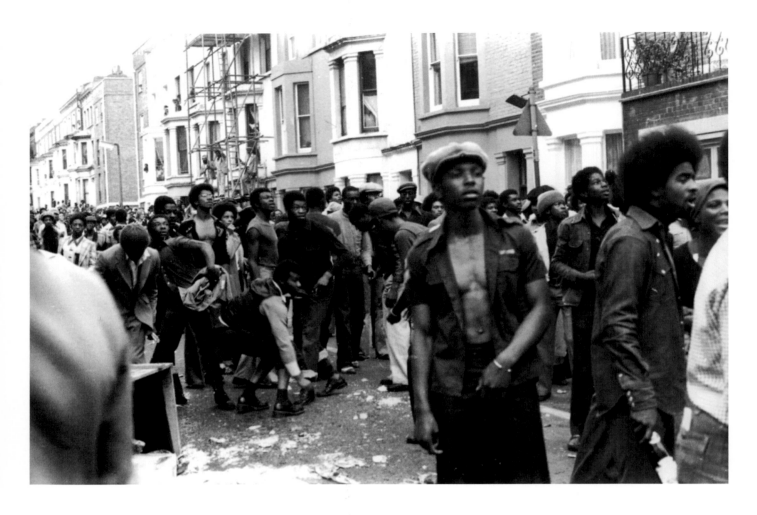

Notting Hill riots,
31 August 1976

Facing page: Rubble
on the streets
of Notting Hill after
rioting, 1 September
1976

Following pages:
Left: Wandsworth,
1973

Right: Bob Marley
(1945–81), London,
6 April 1977

Rhythm n' Blues in both the US and the Caribbean were going through an especially fertile period. Their records, the sound systems that played them and the dances they salved and animated provided a way to connect liberation struggles inside the West with the national liberation movements in what we now call the global South. The geometry of black political culture moved out of the east-west model characteristic of the Cold War and into a new pattern that emphasised north-south flows and connections.

Communication and analysis were also conducted through the popular channels of this distinctive travelling culture. In a small way, Bob Marley's repeated use of the word 'philosophy' in his songs communicates how readily oppositional history and political critique could be transmitted through the inhospitable infrastructure of greedy and hostile cultural industries that had been quietly colonised by a rebel spirit.

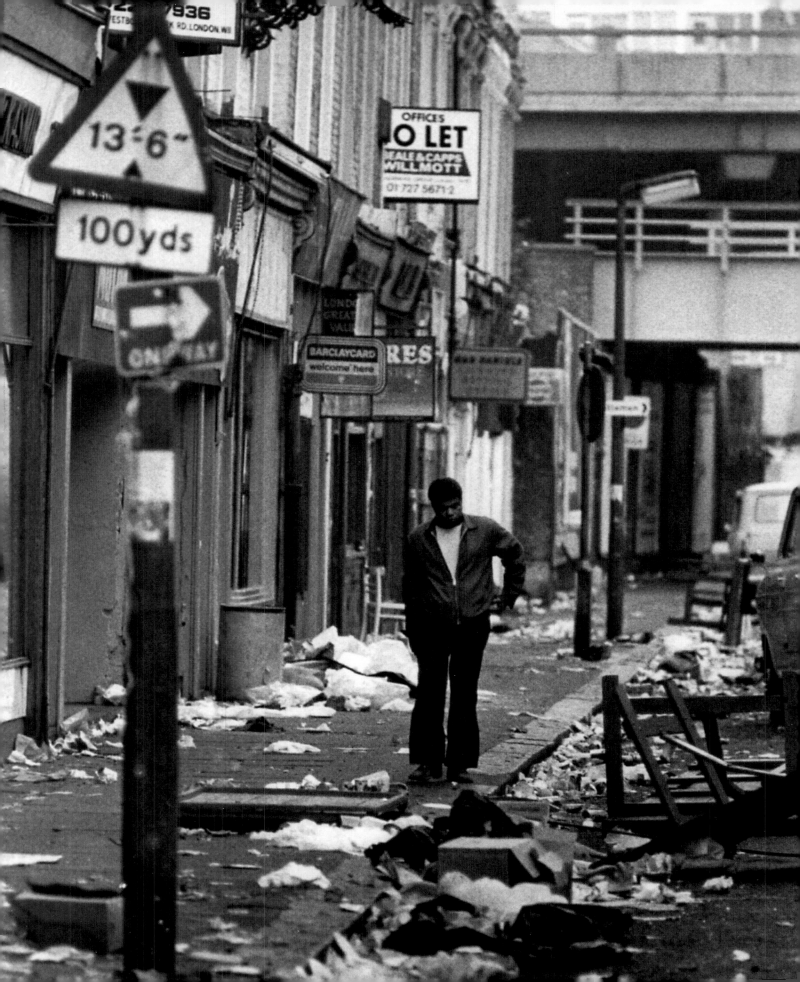

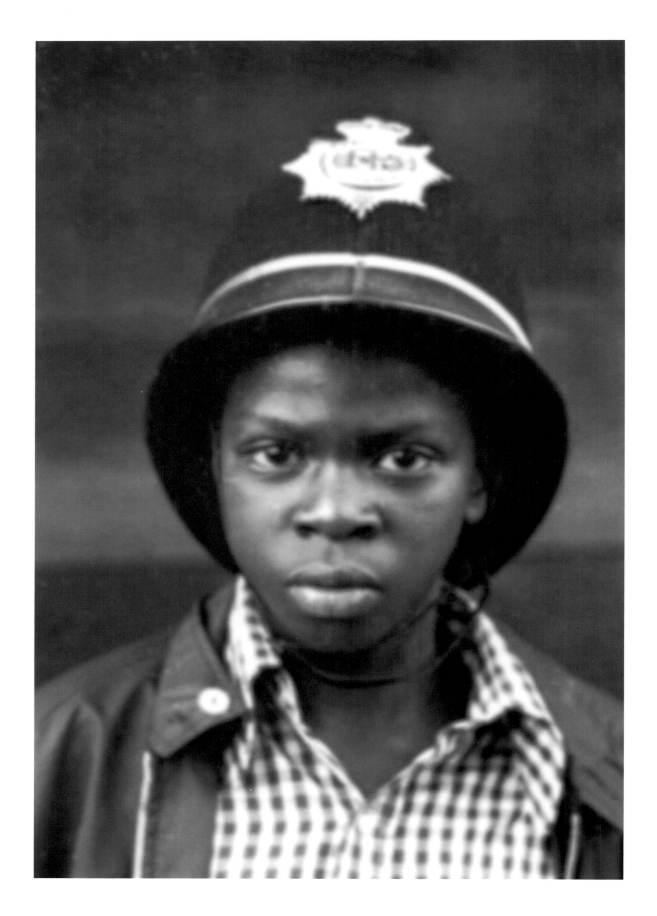

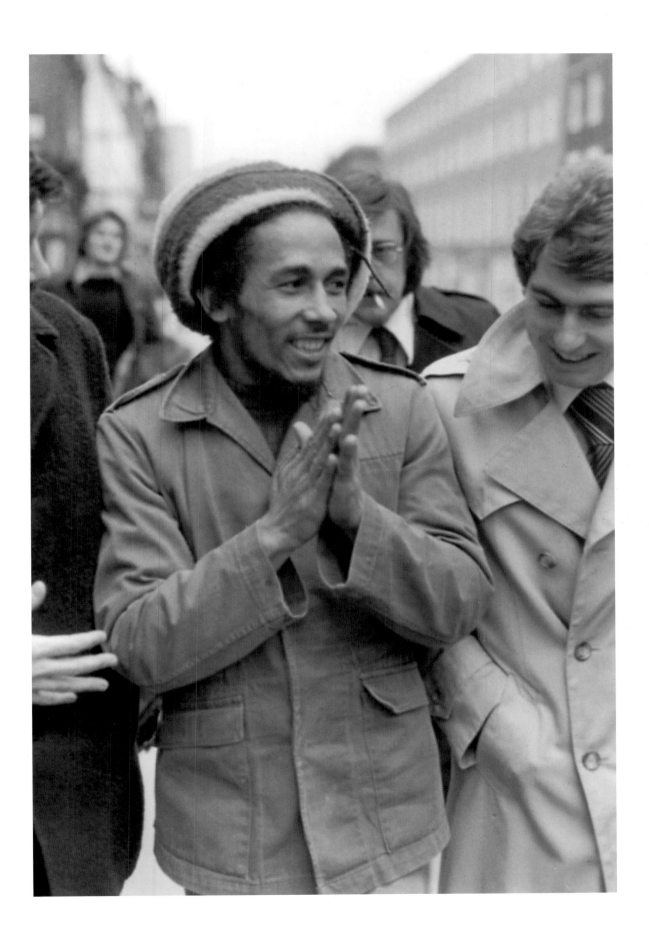

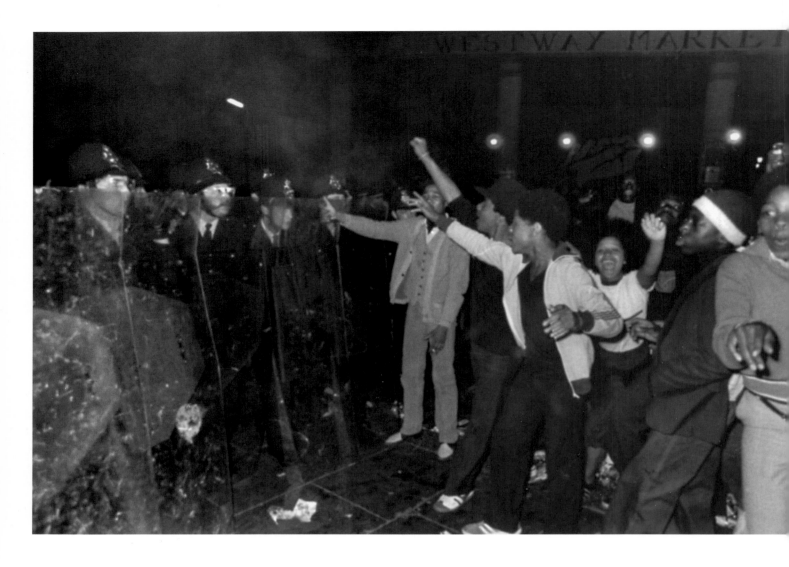

People confronting
police with riot
gear at the Notting
Hill Carnival, West
London, 1978

The musical forms and styles that were popular right across the black world still suggest that listening and dancing together had, at that time, become connected to the possibility of thinking and acting in concert. More than identifiable politics, it was cultural connections that illuminated the larger processes of solidarity enacted in the networking of different black communities from Johannesburg to Harlem and South Carolina via London and Kingston.

Marley's corporate managers used these mechanisms to build up his unprecedented global stardom. However, he was by no means the only oppositional artist to employ the timely ethical and political language of human rights and to accent it with anti-imperialism and Ethiopianism. Those denied rights became something different when

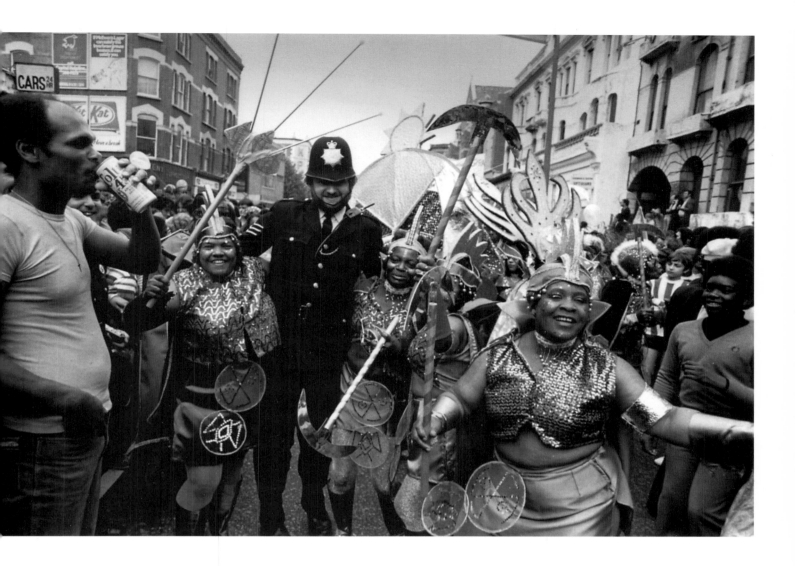

Notting Hill Carnival,
29 August 1978

they were not loftily awarded by willing, liberal governments but won instead in difficult grassroots struggles. For many, the acquisition of those entitlements was linked to a recovery of the human dignity racism had denied.

An authentic, non-racial democracy was being demanded, and it stood in contrast to the thinner, brittle alternatives being served up by politicians who were either held captive by their ideologies ('isms') or stood powerless in the face of economic changes they could neither control nor explain. Democratic aspirations were articulated in the distinctive idiom of the black vernacular and dispatched into the everyday rhythm of postcolonial life at the hub of the old imperial system.

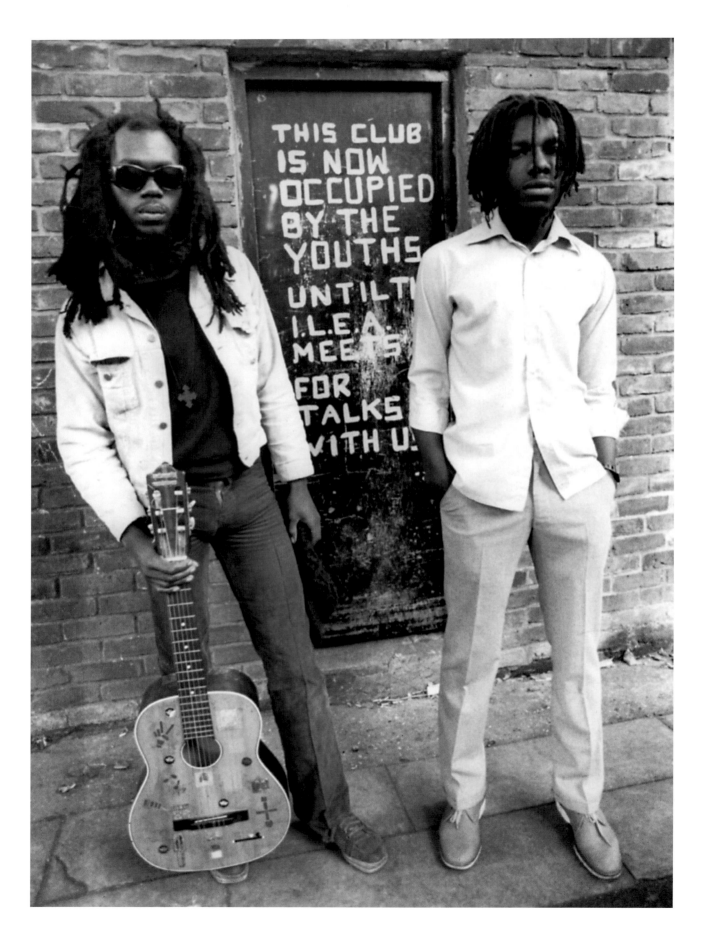

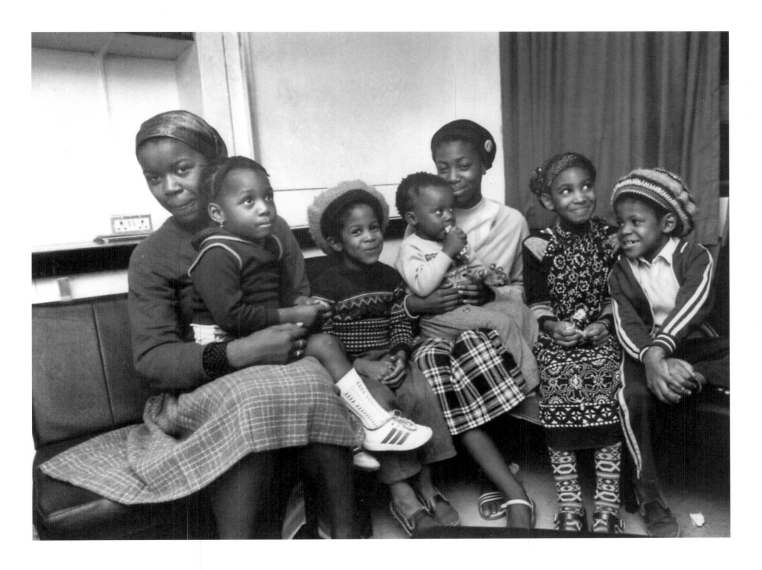

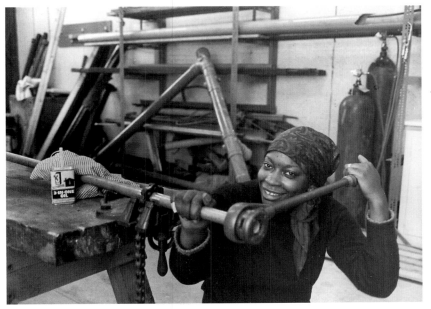

Top: Rastafarians at the Metro
Community Centre, Notting Hill,
15 August 1979

Left: Claudine Eccleston, London's
first female plumber, appointed
by Camden Council, London,
29 November 1977

Facing page: Rastafarians Malcolm
Willidon and John Mills outside
the Metro Community Centre,
15 August 1979

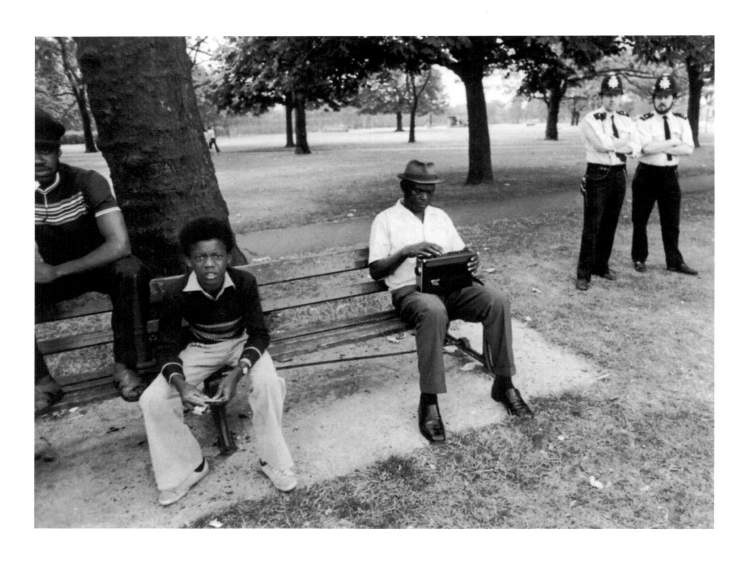

Waiting for a
community relations
cricket match between
local police and local
West Indians to begin,
West Ham Park,
3 August 1977

This emergent community was often imaged in the form of a crowd or mob bound together by its collective mood as well as by its shared emotions. The youthful faces caught by the news cameras as this culture of dissent and resistance took shape were both male and female. These pictures of the carnival riots and their aftershock are drawn from successive years. They are all the more disturbing because the photographs suggest that the rioters were connected by a unanimity of feeling that spans the years, rendering the images from 1976–78 almost interchangeable.

A new genre of racial reportage had been born. The triumph of the carnival crowd lay less in any short-term defeat for the police and more in the immediate pleasure of its autonomy, and in a fleeting sense of its own power being temporarily restored.

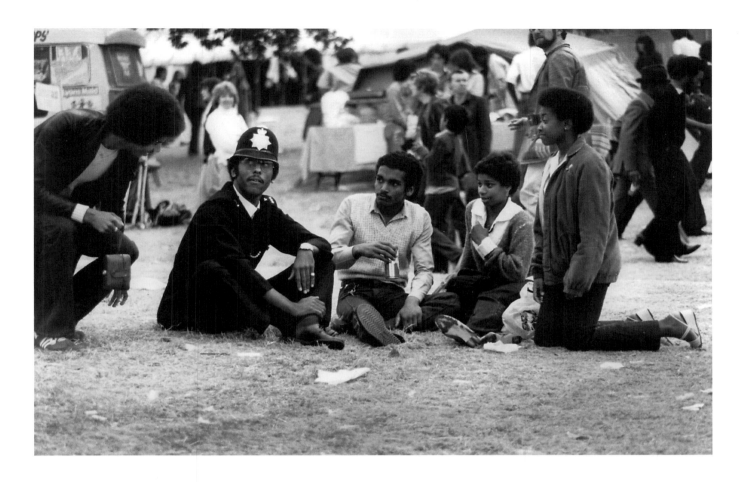

We can see that the rioters were a young and in many cases stylish group. Today photographs of them provide us with a frozen example of what black Britain's first poet laureate, Linton Kwesi Johnson, identified at that very moment as 'a bran new breed of blacks'. We might add that this formation had been, of necessity, developing a culture tempered by life in Britain with its distinctive mixture of feelings: empty promises combined with racist exclusion, violence and thwarted opportunity. Postcolonial society's routine injuries were compounded by the condescension dished out by too many supposed allies, helpers and friends.

That view of black British life still bears upon interpretation of these photographs and, indeed, of the rich soundtrack of militant Reggae and restorative Soul that they silently imply. An empty benevolence mired in the assumption that the lives of black settlers could be defined by their cultural pathology still echoes through historical reflections on

A policeman sitting with music fans at the Jazz Festival at Alexandra Palace, North London, 25 July 1979

Following pages:
Left: Tessa Sanderson, during the javelin event at the World Cup in Dusseldorf, West Germany, 1977

Right: Daley Thompson, Crystal Palace, London, 1977

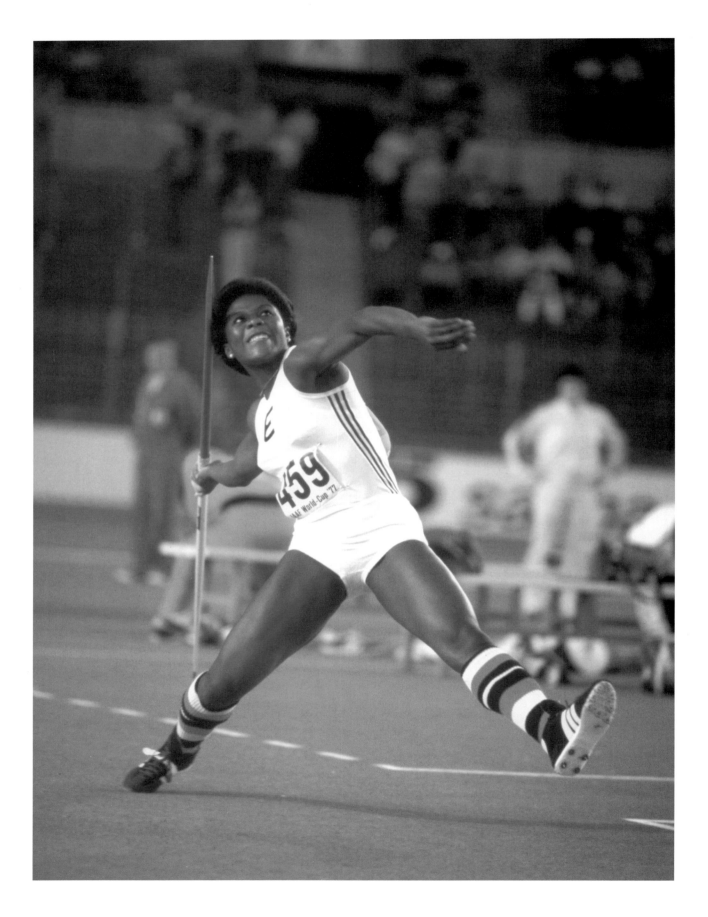

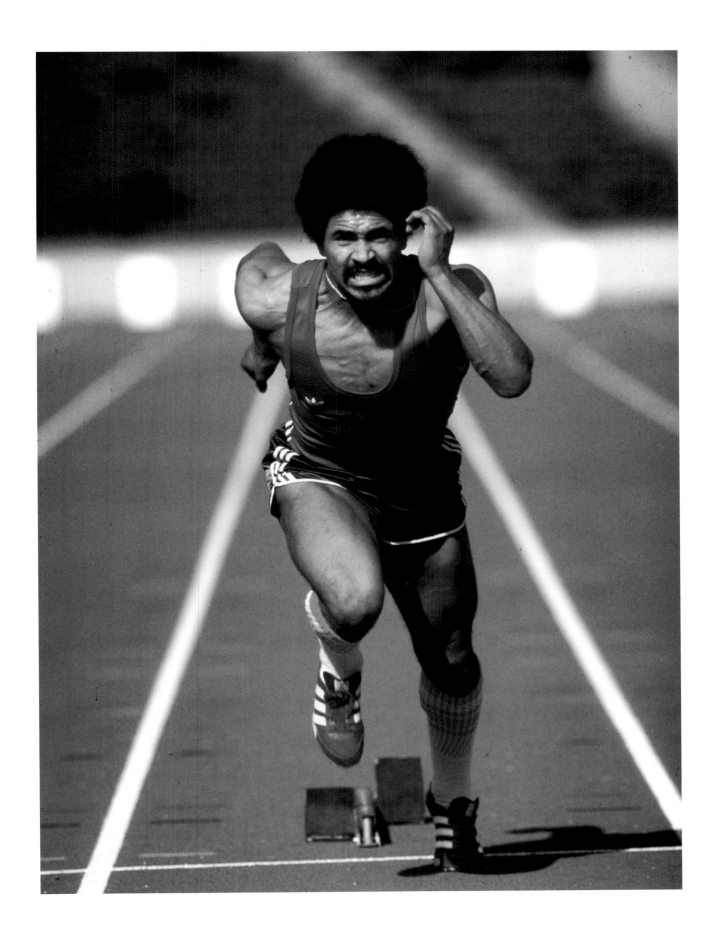

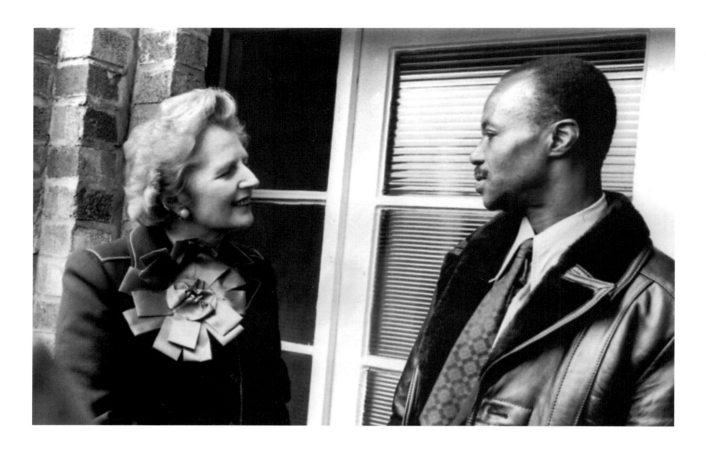

Margaret Thatcher,
electioneering in
Stechford, near
Birmingham,
28 March 1977

Facing page:
Sprinter Sonia
Lannaman, recipient
of an MBE,
13 March 1979

Following pages:
Left: Teenagers
outside the Clyp
Youth Club, 1978

Right: Inmates in
the workshop at the
Junior Detention
Centre in Send,
near Woking,
27 November 1979

the plight and destiny of this transitional generation composed mostly of young people who had not emigrated as their parents had done but rather acceded to the dubious entitlements of British subjecthood conferred by birth alone.

The residues of that interpretation survive today in the common-sense view that makes the generation between the citizen-immigrants of the 1950s and the more assertively British-born groups that succeeded them into the victims of a special crisis of identity, deeper and more disturbing than anything experienced by others before or since.

Against that mistaken supposition, we must consider the photographic evidence, which suggests some other possibilities. They derive from a sense of what that culture of music and dance brought into the lives of the transitional group (to which I myself belong). On reflection, we were not so much a lost generation as a lucky one. An unusually eloquent, militant and musically rich culture oriented us as slave-descendants, as diaspora subjects and as world citizens.

That fortuitous alignment encouraged us to employ vernacular

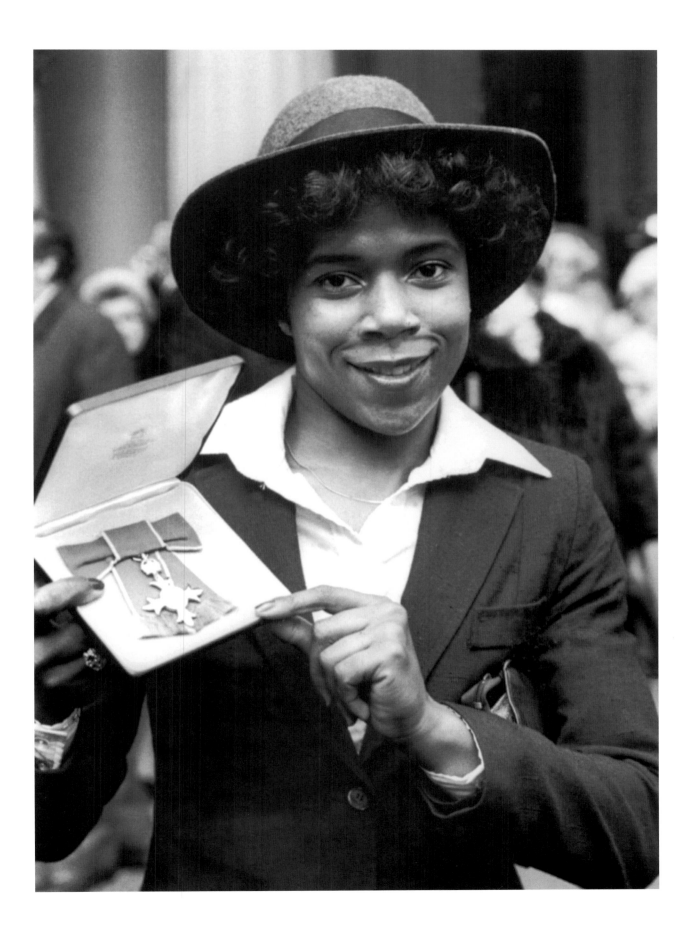

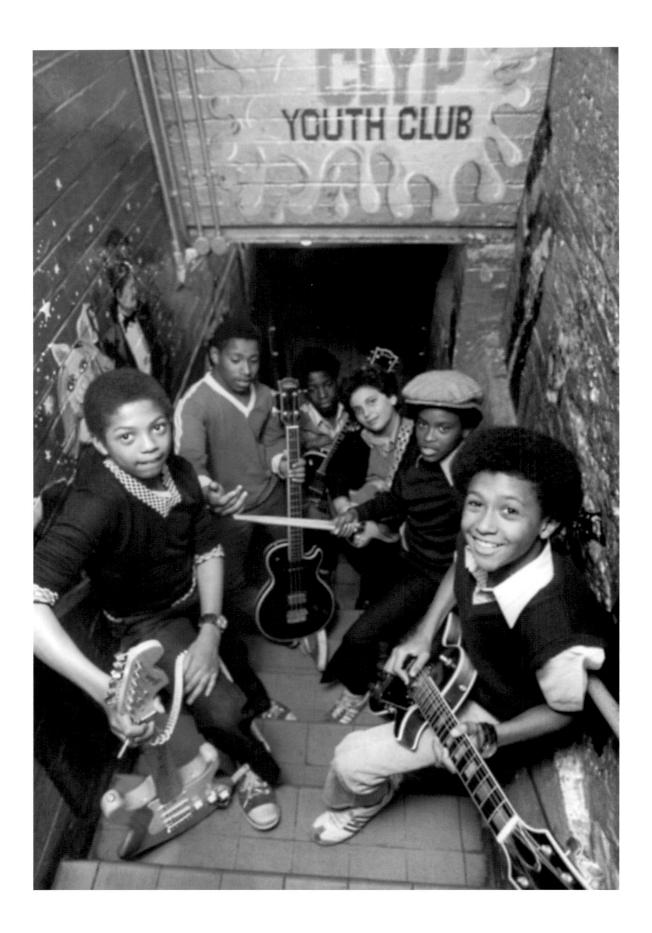

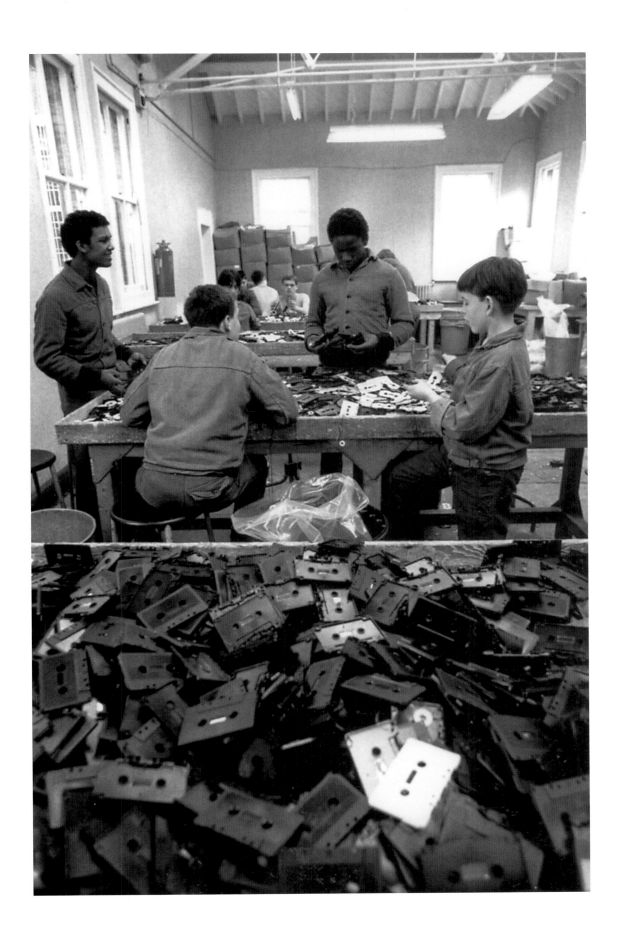

wisdom in order to defend ourselves, identify our interests and change our circumstances. We were bolstered by a cosmopolitan movement for democratic change and energised by the intensity of a very special period in the cultural life of the black Atlantic.

More significant than the rioters' hip headgear, unstraightened Afro hair and soulful poses is the intense concentration common to their resilient expressions. Understandably, some of them seem to be trying to evade the cameras. That practical issue aside, it is as though they do not want to be caught in a moment that reveals them to be as vulnerable as they are unified.

They are united in the vulnerability they shared as a racialised and marginalised group, in the wounds they seem to carry as a collective cultural burden on their journeys towards and also away from Englishness, with its downpressive political and cultural codes. They seem to be and to belong together; but that imperilled togetherness, that apparently elemental collectivity, is an untidy and asymmetrical affair marked by the way racism intervened to block and channel individuality into the patterns demanded by a race hierarchy that was utterly destructive and ruthlessly, if informally, enforced.

Whenever it was, like the carnival, visible in daylight, the informal cultural work more usually to be found in Blues dances and house parties proceeded deceptively, masquerading under the banner of play. The subculture of these black youths was mostly an orphic, underground phenomenon that did not seek public recognition largely because it feared for its own survival in the cold light of metropolitan days. The hidden spaces in which it had made its home and from which it found its own way into Britain's bloodstream hosted a complex process of inter- and trans-cultural mixture that is still poorly understood and only partially mapped.

The creativity of this intermediate generation fused defensive and affirmative elements. They worked over and through the memories of slavery and colonialism. Traces of past suffering were folded into contemporary resistance so that they could provide resources for

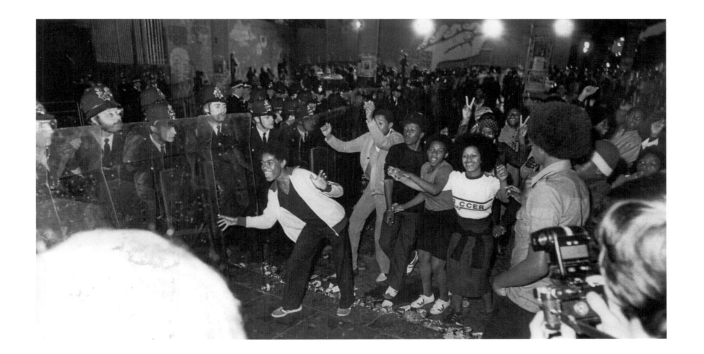

interpreting the present and imagining a better future for blacks, for Africa and for the whole world.

The most enduring result of this elaborate exercise, though perhaps not its most significant, was the ability of many to assert their belonging to Britain with an authority and legitimacy that could not be denied and, in the process, to change what Britain was, largely by forcing acceptance of the fact that they were here to stay.

These possibilities were celebrated and enacted elaborately in the musical cultures to which the photographs allude. They were evident from the emergence of distinctively local styles of toasting and dubbing, from the innovations of 'Lovers' Rock' and from the transformed relationship to African American cultural and political traditions which supplied the conceptual premise of so much black British musicking.

The late-night production involved in these cultural scenes was not, of course, waged labour, though in some circumstances it could be waged labour's active, desperate negation. Claimed back from the harsh, split world that immigrant labour made and held in place, the super-exploited social body composed of immigrants and their persecuted children needed its spaces of healing and autonomy. Musical culture and the elaborate social relations that eddied around it, at least until

A line of policemen behind shields watching a group of revellers during riots at the Notting Hill Carnival, 29 August 1979

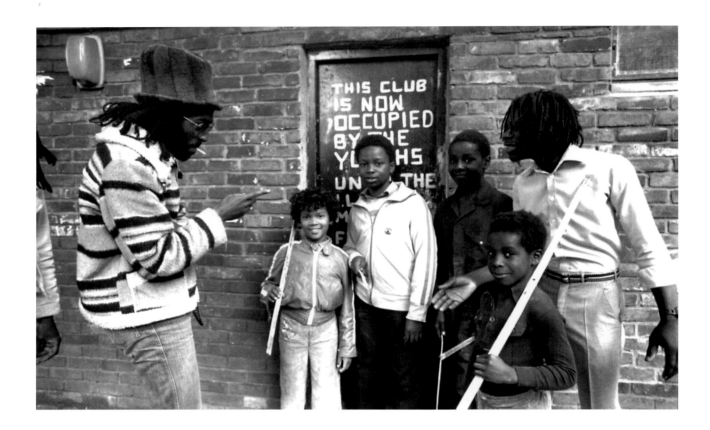

Top: Rastafarians with
children outside the
Metro Community
Centre, Notting Hill,
12 June 1979

Right: Billboard, 1979

Facing page:
Laurie Cunningham
of West Bromwich
Albion saluting the
crowd before a match,
1980

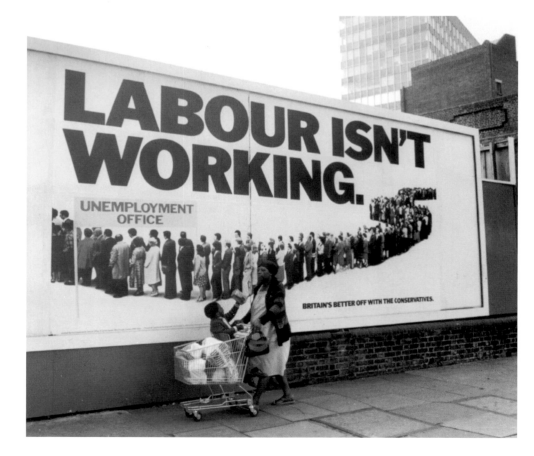

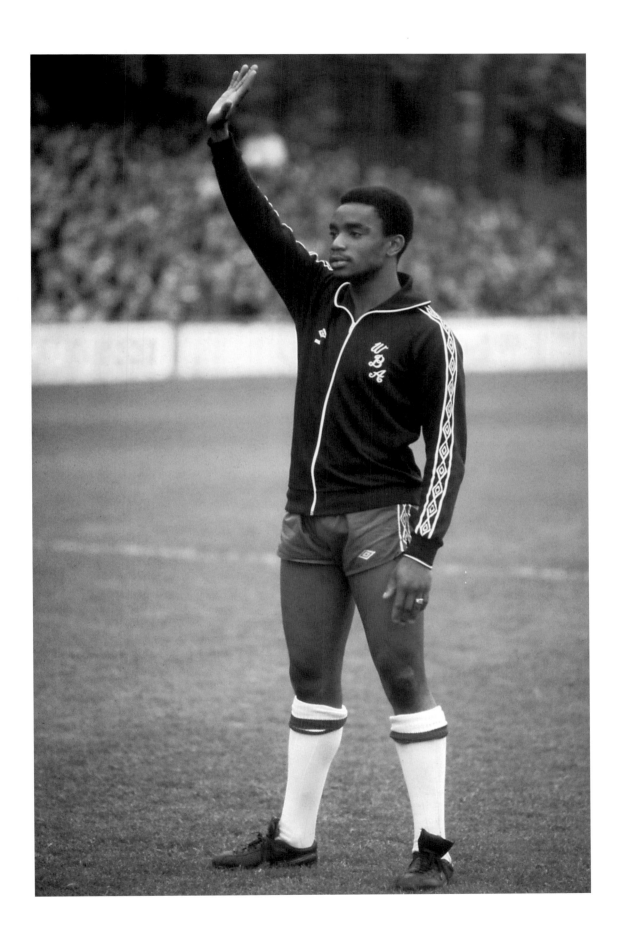

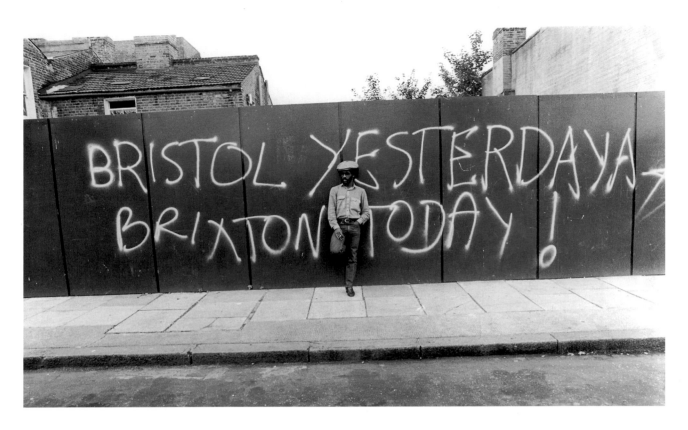

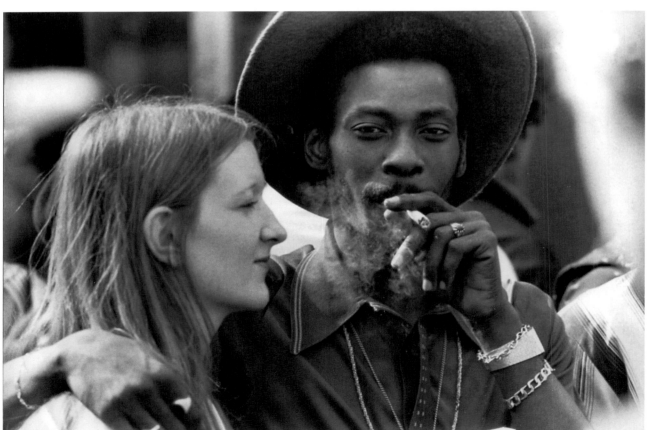

the digital revolution changed the terms of the game, created those locations and invested them with a precious democratic energy that helped audiences and performers interact and collaborate as one.

That struggle and transition interest me now as a motivated historian keen to restore black Britain's patchy political memory. The representation of those carnival crowds as offshoots of an interpretative community is especially appropriate given that the ability to listen in that intense and collective way seems lately to have dropped out of black popular culture in the age of myspace.com pages, MP3-playing phones and iPods. Back then, community and solidarity were momentarily constituted in the very process, in the collective act of interpretation itself. Later on, first pirate radio and then all the antisocial culture of mobile privatisation replaced the ancient authority of that sanctified healing space with something shallower, more personal and consumer-friendly. The pirate radio stations would become legal and then advertising-driven. Primed by the barrow-boy spirit of popular Thatcherism, a new generation of cultural brokers was waiting to hand over ready-mixed versions of black culture to any corporate sponsor with sufficient funds.

Old photographs of the carnival suggest different equations for the calculation of cultural value. They direct attention towards the independent power of music and dance, which was never reducible to the potency and oppositional lyricism of even the best and most compelling songs from that special period. The liberatory sounds we remember and celebrate here were specified hesitantly but repeatedly in the preferred vernacular code as something like a 'bass culture'. It was shaped by a fundamental awareness that as far as understanding the struggle of these sufferers was concerned, vision was not the master sense and words alone could not be a stable or trustworthy medium of expression and communication. This difficult lesson had been administered by cumulative training in tactical communication conveyed to us by the dub cuts that had begun joyfully to damage the integrity of even the most forgettable version sides. The arrival of video technology would change the power of sound irrevocably.

Facing page:
Top: 4 August 1980

Bottom: A couple sharing a joint at the Notting Hill Carnival, 1 August 1980

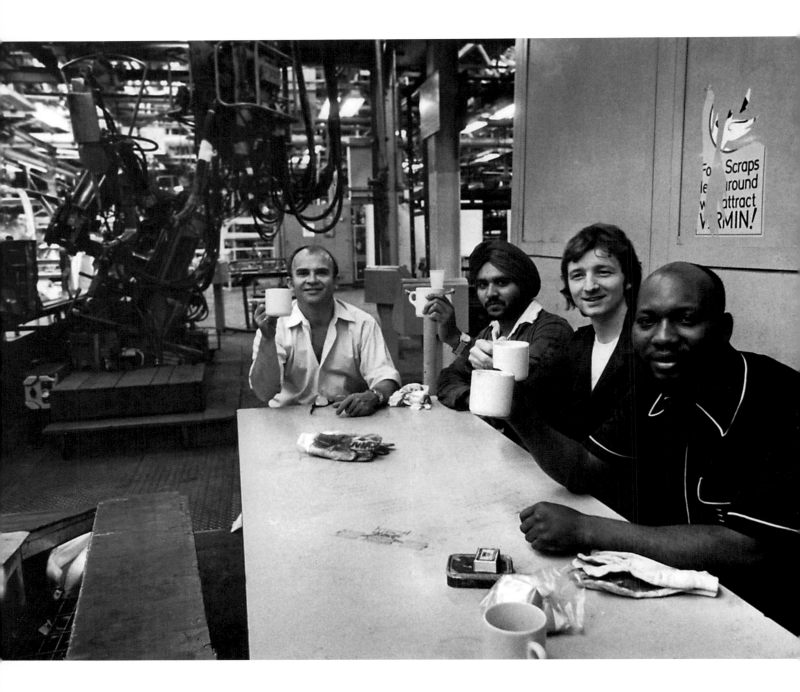

Workers at the first Ford body shop
in Dagenham during a tea break,
8 June 1978

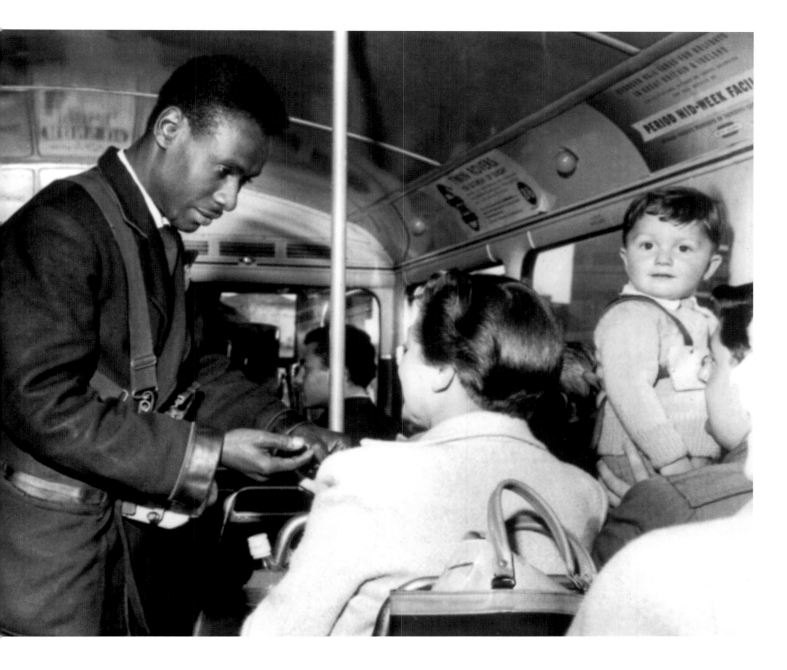

Bus conductor, London,
27 January 1977

It's worth repeating that these photographs offer a striking image of black Britain emerging from the confluence of its Caribbean antecedents with novel North American aspirations. The pursuit of equal rights and justice had already been specified explicitly as an alternative to peace by a whole host of artists. When local DJs rode a Jamaican rhythm or sang over the radically unfinished version sides that had been dispatched northwards in anticipation of their additional input, Britain's black underground could be experienced as contiguous with the increasingly

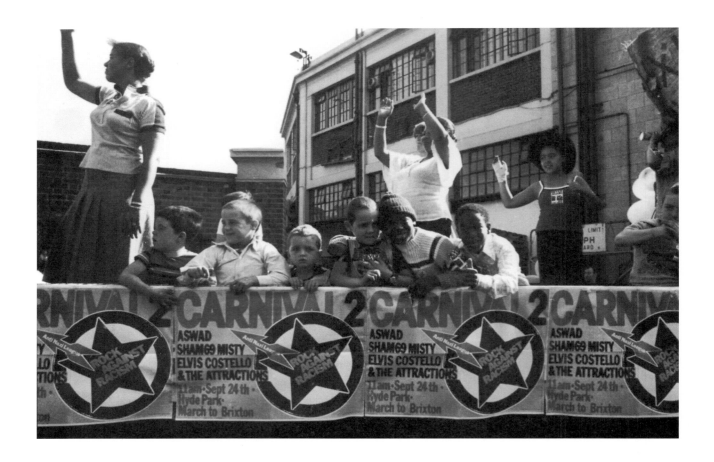

Demonstrators at an anti-Nazi rally, South London, 1978

Facing page: Clearing up rubbish left by the crowds at the Notting Hill Carnival, 1980

distant but more easily accessible Caribbean. The coming together of those divergent elements, expressions of geographically separated but genealogically related cultures, contributed to the appealing manifestation of a third, utopian space, sometimes labelled 'Africa', in which the wrongs and hurt of babylonian existence could be systematically undone and white supremacy overthrown in the name of higher human freedoms. That message, radiated out of Britain's black underground and through initiatives like Rock Against Racism, helped to alter what this country was. Whatever Eric Clapton and his xenophobic ilk might have famously said to the contrary, racism was no longer cool.

The fortunes of Britain's neo-Nazis and ultra-nationalists revived under a Labour government that lacked a working majority. A resurgent Conservative Party led by Margaret Thatcher recycled Powellite themes to accomplish the old populist trick that had worked in 1964 and 1968. Her speech in the run-up to the 1979 election was less vulgar than

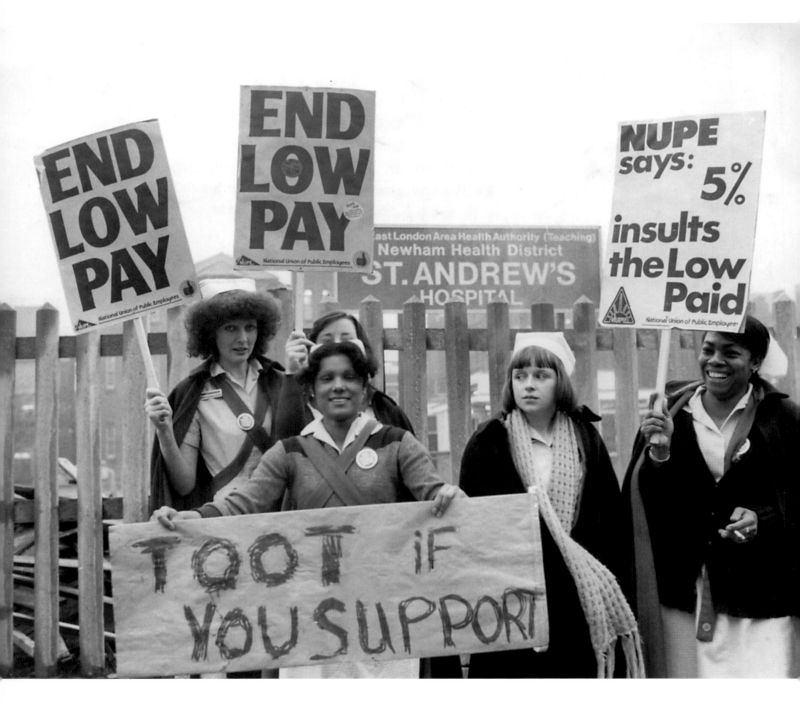

Nurses outside St Andrew's hospital
in Bow, East London, holding
placards during a four-hour strike,
7 February 1979

Griffiths's and Powell's had been, but it sent all the right coded cues. She successfully manipulated racist sentiment so that it would serve the Conservative electoral cause. Her intervention made racism respectable, encouraged the police to continue their criminalisation campaign and persisted in suggesting that additional restrictions on immigration and nationality would provide the best solution to Britain's racial problem. She predicted and sought pre-emptively to justify the idea that fearful, indigenous Britons would react with hostility against the prospect that this country might be rather swamped by people with a different culture. Her words set off a chain reaction that would lead to the riots that swept the country in the early and middle 1980s.

Herman Dee and Anneliese Polan, 15 November 1977

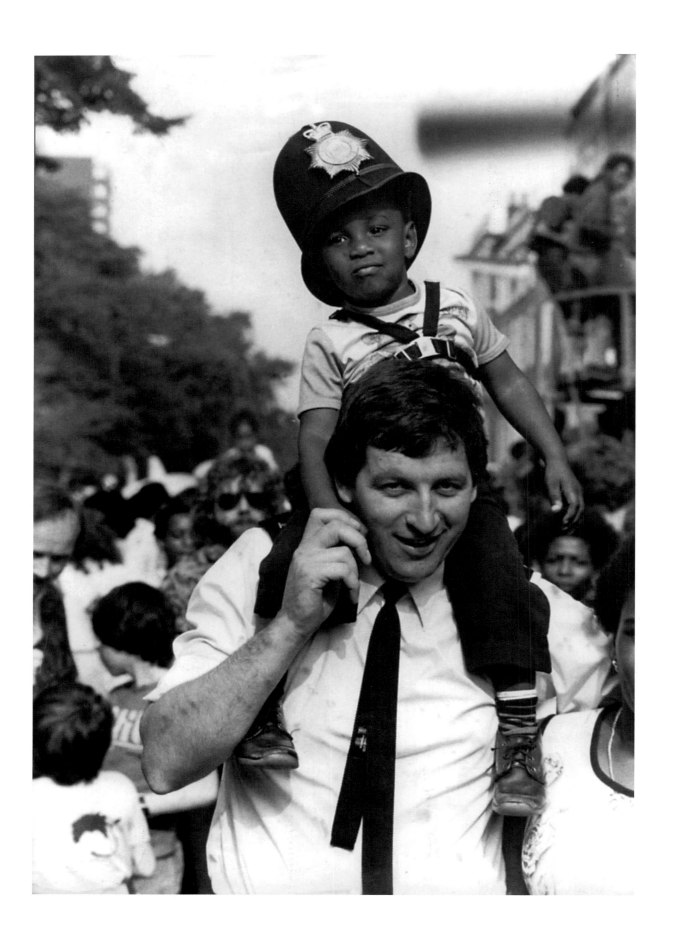

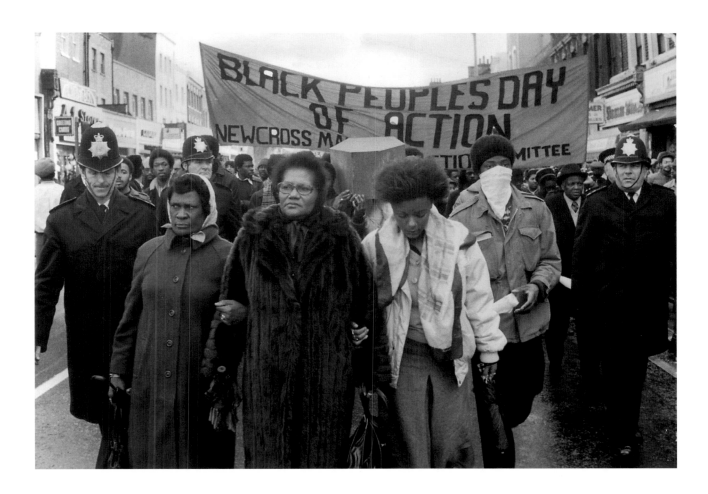

There had been many signs that an explosion was imminent, but the immediate trigger for the riots of the 1980s was supplied by reactions against official indifference to the death of thirteen young people in a fire at New Cross in South London. The disinterest of the authorities in this tragedy, and their enlistment of the media in justifying treatment of the victims as perpetrators of the outrage, created a wave of protest that unified black Britain as a mature political community.

Those events are remembered here through images of the bereaved families leading a march of protest through London's Fleet Street, then the headquarters of all the national newspapers. A few weeks later, rioting erupted in South London and rapidly spread to other cities where young people of all backgrounds seized the opportunity to register their protest against a government that appeared to be indifferent to the deprivation and bitterness that were obvious products of mass unemployment engineered by callous economic policies.

Grieving protesters march from New Cross to the House of Commons after thirteen black people were killed in the New Year fire at Deptford, South London, 2 March 1981

Facing page:
Notting Hill Carnival, 25 August 1980

Following page:
The father of Steve Collins, who was one of thirteen young people to die in a fire in Deptford, protesting outside the High Court after the Court recorded an open verdict on his son's death, 14 May 1981

265

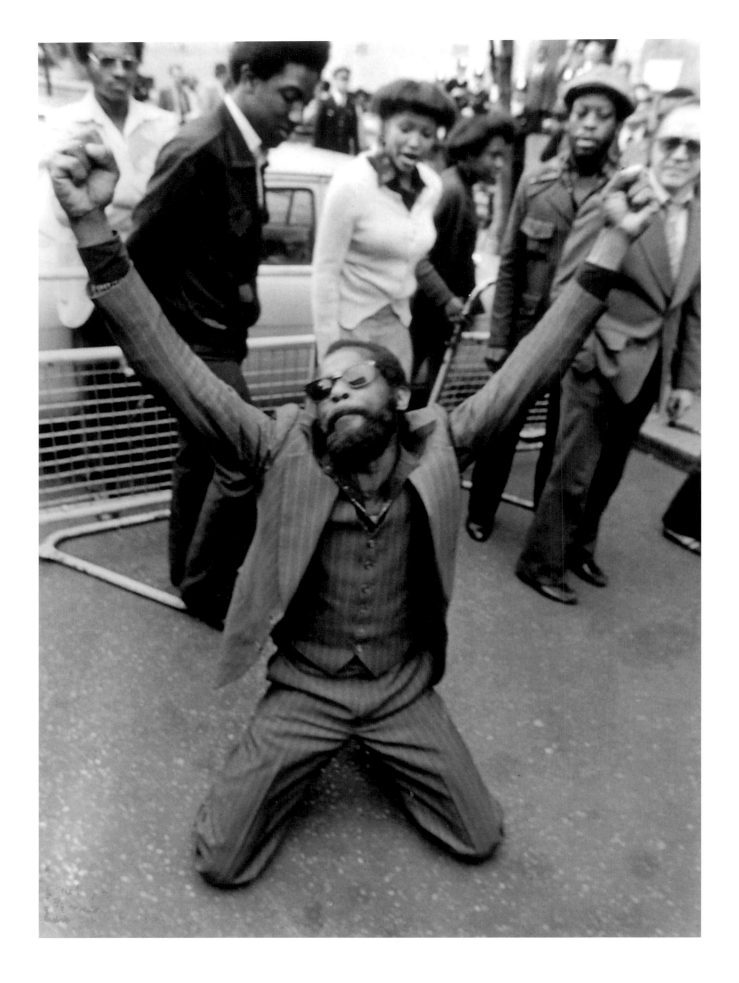

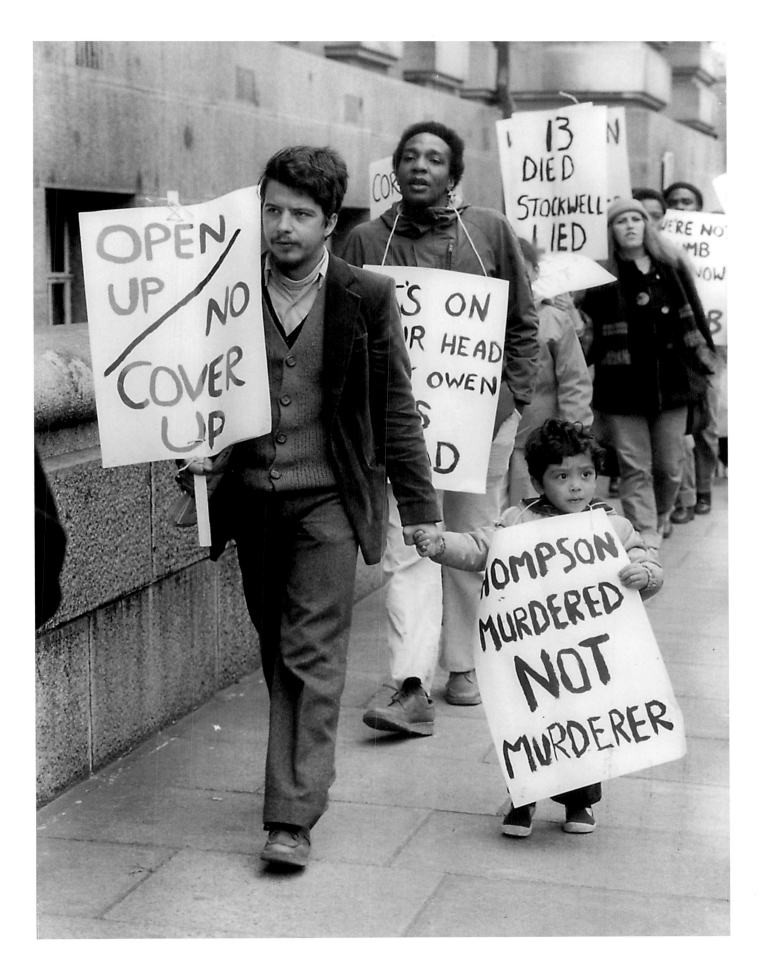

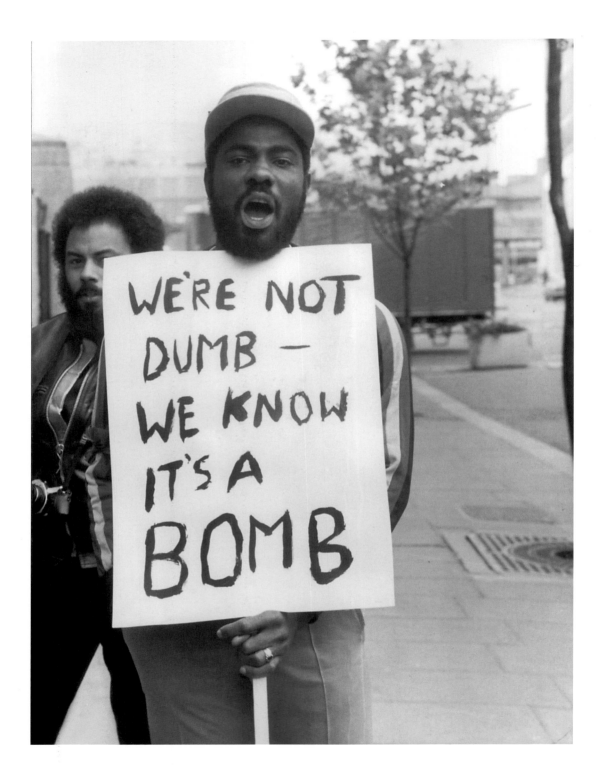

Protesters outside County Hall as the inquest opens into the New Year fire at Deptford, South London, 21 April 1981

Previous page: Per Scheibner and his three-year-old son lead a protest outside County Hall as the inquest into the New Year fire at Deptford opens, 21 April 1981

Facing page: More than 10,000 people march through Central London from Hyde Park to Trafalgar Square to protest against the proposed Nationality Bill, 6 April 1981. The march was organised by the Campaign Against Racist Laws

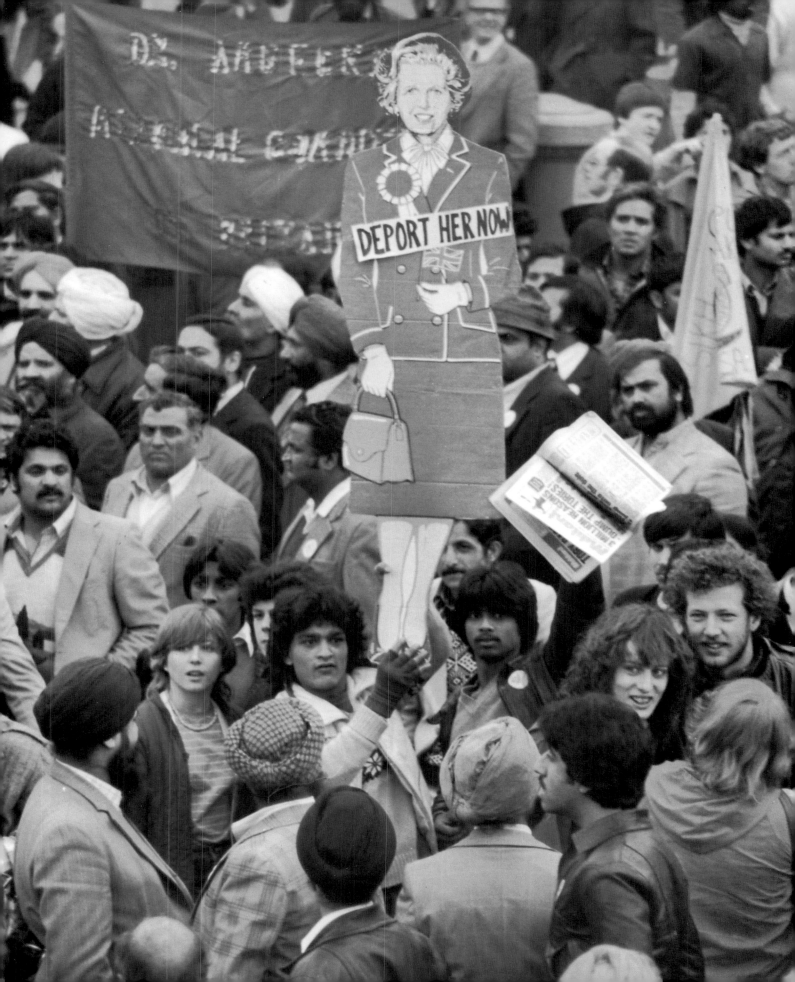

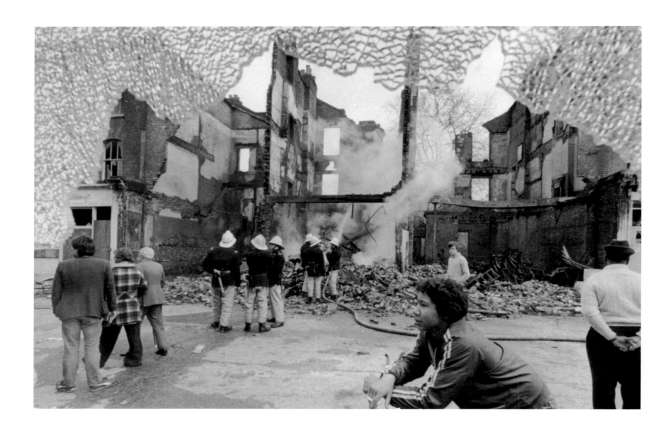

Firemen and
onlookers beside a
burnt-out building
on the second day of
riots in Brixton,
13 April 1981

The same mix of grievances would produce a further outburst of riotous conflict in 1985. A renewed emphasis on the cultural breakdown and dysfunctionality of black families as the causal key was the only novelty involved in making sense of those events.

The aftermath of the riots created important anti-racist initiatives at the local government level. It opened the padlocked door of national politics to a few black MPs and swiftly impressed the value of tokenistic representation upon media outlets and a few other institutions, which identified a gain in breaking the uniformity of whiteness in the way that they were being represented. The productivity of the disorderly protests could be glimpsed not only in the shifting structures of local government with regard to race and racism, but in other unpolitical areas like the greater visibility of black athletes and entertainers.

The general harshening of British social life that characterised these years may have been something blacks were able to negotiate better than others. It is interesting, and perhaps ironic, to note that the culture of selfishness initiated and endorsed by the Thatcher governments would,

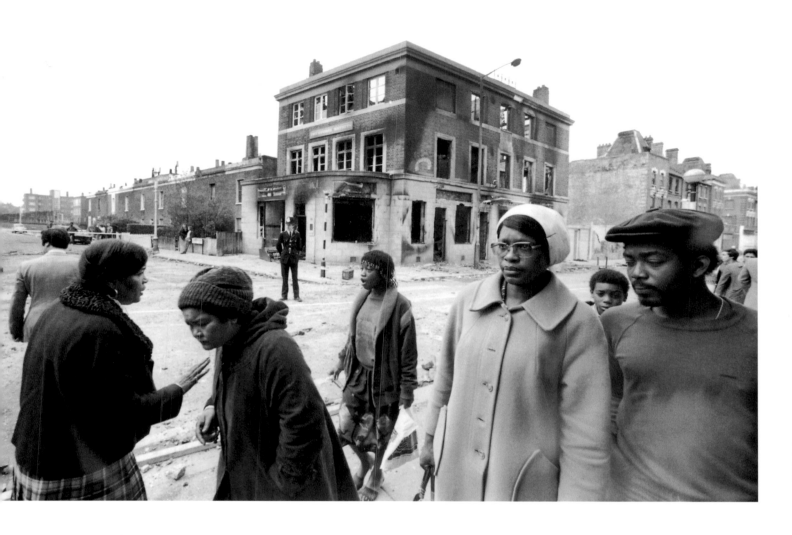

in spite of its obviously Little England character, create opportunities for its black adherents. Indeed, the spirit of entrepreneurship and dogged self-reliance that was familiar among the poor and the desperate was easily bolted onto the pastiche of Victorian conservatism that had secured power for the right. Both political parties started to speak more directly to their black and ethnic minority supporters. The automatic association of blacks and Asians with the Labour Party was broken.

Culturally, these years reveal the demise of the Pan-African and Ethiopianist movements that had shaped the oppositional outlook of many in Britain's black communities. Now Africa emerged in a new guise, appearing as an object of charity. As the political transformation of Southern Africa gathered momentum, the continent could be seen as a place fraught with medical, environmental and governmental

The charred remains of a public house, Brixton, 13 April 1981

Following page: A man giving the Black Power salute and sticking his tongue out as he stands on top of an overturned, burnt-out car which was hit by a petrol bomb during rioting in Brixton, 13 April 1981

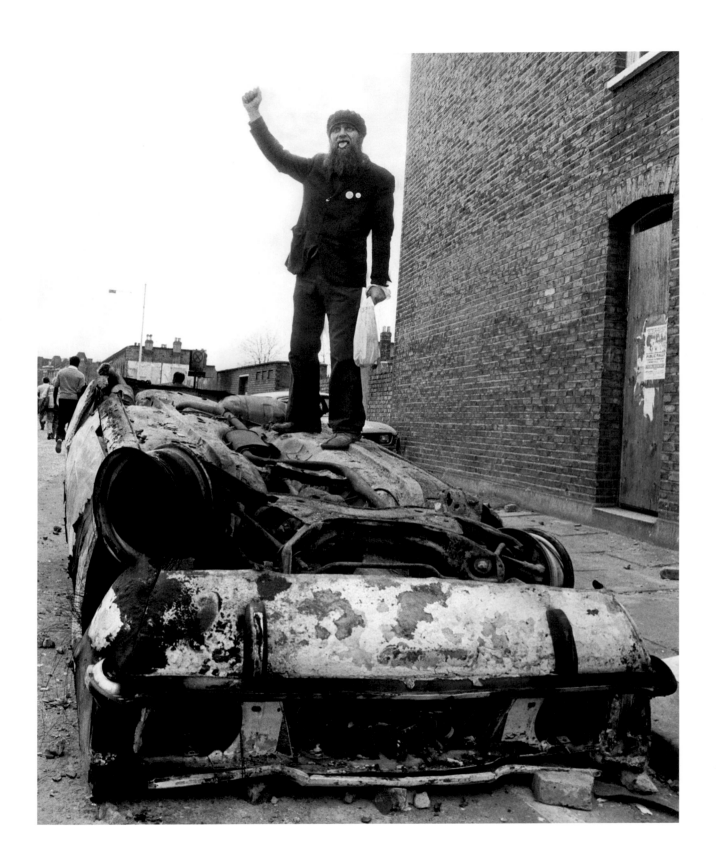

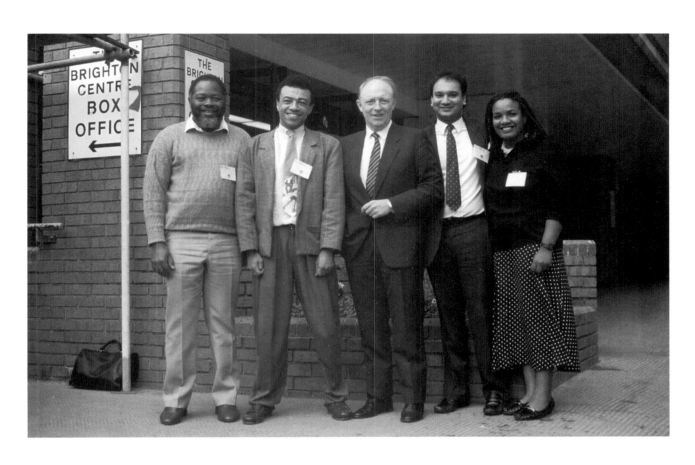

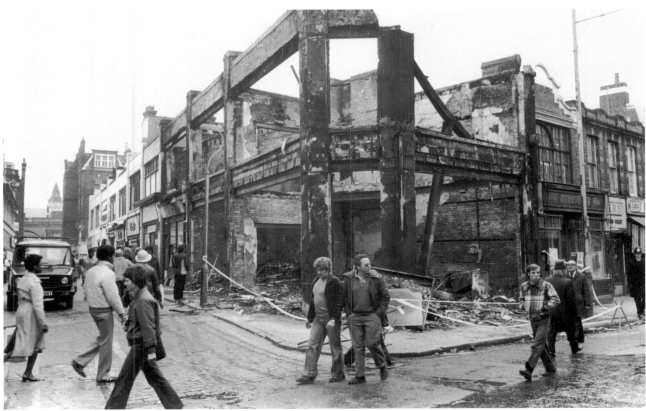

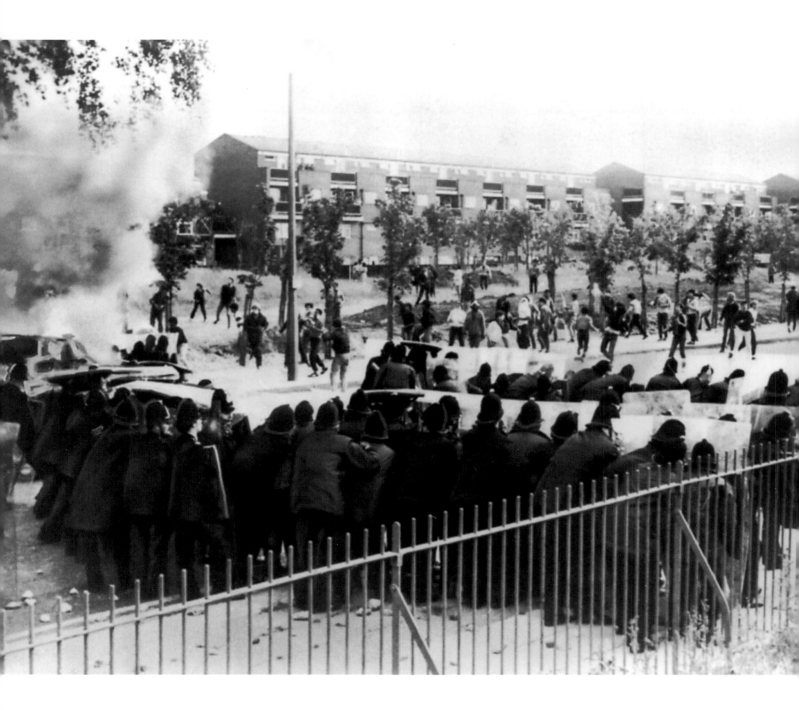

Early Sunday morning in Toxteth; on the left is a vehicle set alight by a petrol bomb, 1981

Previous page, top: Welsh politician and leader of the Labour Party, Neil Kinnock, with four of the first minority Labour MPs to be elected; (from left) Bernie Grant, Paul Boateng, Keith Vaz and Diane Abbott, November 1987

Previous page, bottom: Gutted buildings, Brixton, 13 April 1981

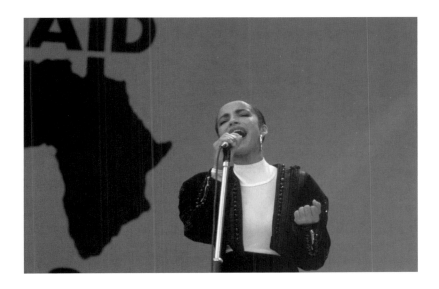

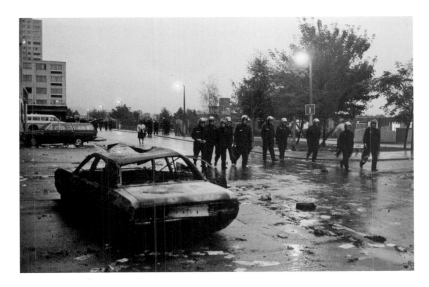

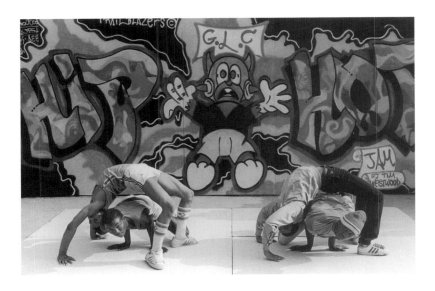

Top: Sade performing at the Live Aid charity concert, Wembley Stadium, London, 13 July 1985

Centre: Police officers in riot gear on the morning after the Broadwater Farm housing estate riot, Tottenham, London, 7 October 1985

Bottom: Greater London Council (GLC) sponsored festival of Hip Hop, London, 1985

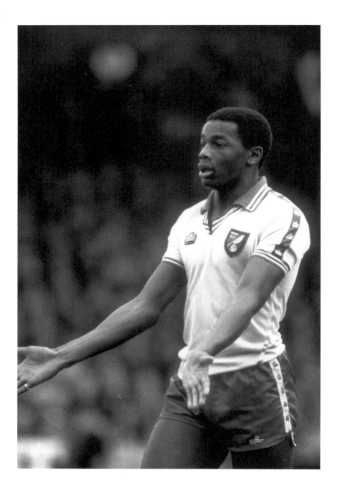 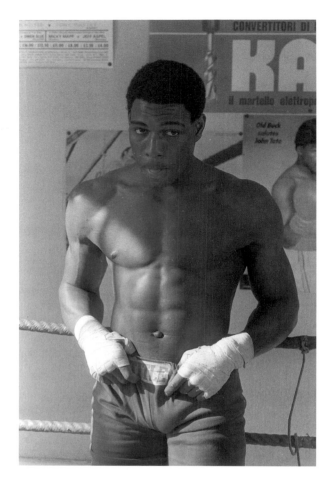

Left: Justin Fashanu of Norwich City during a match, 1981

Right: Twenty-year-old, newly professional heavyweight boxer Frank Bruno prior to his first professional bout against Lupe Guerra, 11 March 1982. He beat Guerra with a first-round KO

Facing page, top: 1985

Facing page, bottom: Five Star, winner of Best British Group at the BPI Awards, 10 February 1987

problems that were not always easy to trace back to the period of colonial rule. This negative view could become entrenched even as the proportion of black Britons who were of African rather than Caribbean origin started to climb.

Continued pressure on under-educated and disproportionately unemployed youth coincided now with the emergence of Hip Hop as an exciting new style that offered novel cultural and musical tools with which to comprehend systematic inequality. A shift away from Africa and the Caribbean and a far greater cultural proximity to African American style, language and cultural codes was the result.

At this point, the visual archive thins out noticeably. The photographs of black life were not newsworthy in the way they had been a few years earlier. Photographers had been the victims of anger during the riots, and may not have wanted to risk that new hazard, but there were other reasons, too. The angle of vision in the print media

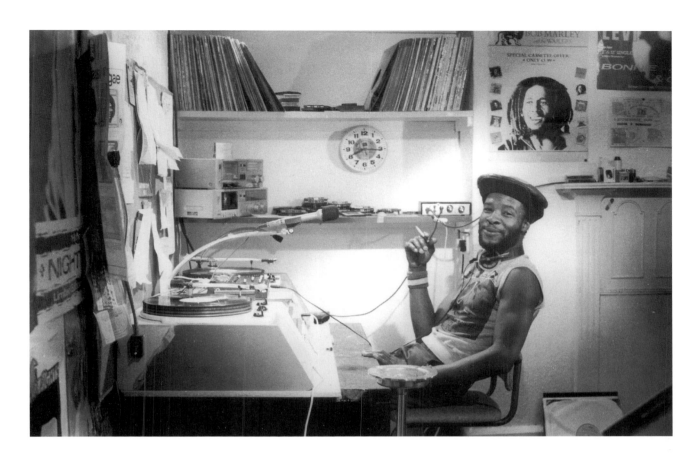

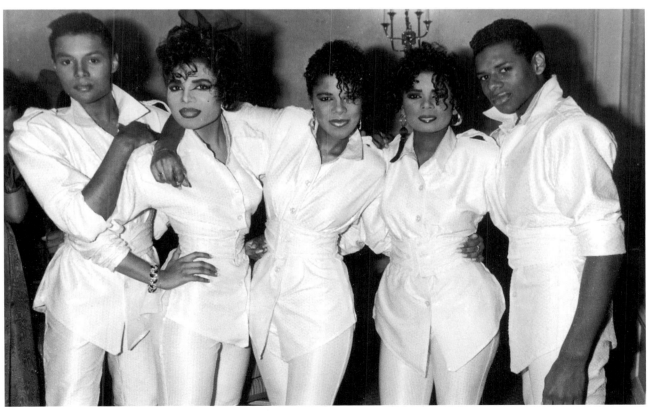

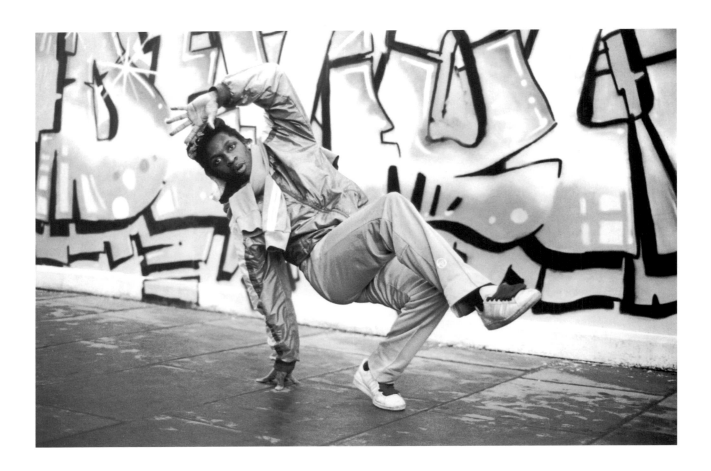

Top: Break-dancer,
1983

Right: Break-dancing,
circa 1985

Facing page:
Jazzy B of Soul II Soul

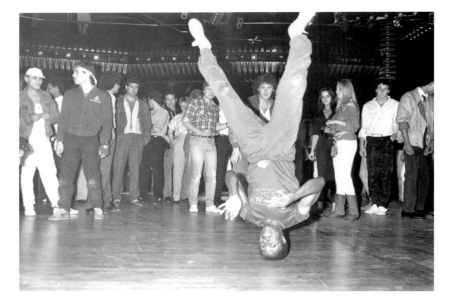

Top: Bill Morris, outgoing General
Secretary of the Transport and
General Workers' Union, at the
Labour Party Annual Conference,
Bournemouth, 1 October 2003

Bottom: TV news reporter Trevor
MacDonald, recipient of the Man of
the Year Award, 1982

shifted away from tracking the routine consequences of British multiculturalism. It moved instead towards an emergent caste of black celebrities, stars and positive icons whose glittering presence was supposed to correspond to the needs of a broken community bereft of the right role models. Here was belated proof that if you were still black and poor, it must be your own fault.

We must remember that there was a time, not so very long ago, when being black and British was an unthinkable combination to many people in this country. That racist and xenophobic attitude had been prevalent long before Norman Tebbit's famous 1990 attempt to revive it and harness it politically. As we move towards the present, these

Diana, Princess of Wales (1961–97), meeting the public during a royal visit to a community centre in North London, 1 February 1985

Top: Adam Afriyie, Tory candidate in Windsor, on the second day of the Conservative Party Conference in Blackpool, 7 October 2003

Left: A mural on the gable end of a house on a nationalist estate in Northern Ireland depicting South African President Nelson Mandela, 1995

Facing page: Comedian Lenny Henry, 2 March 1982

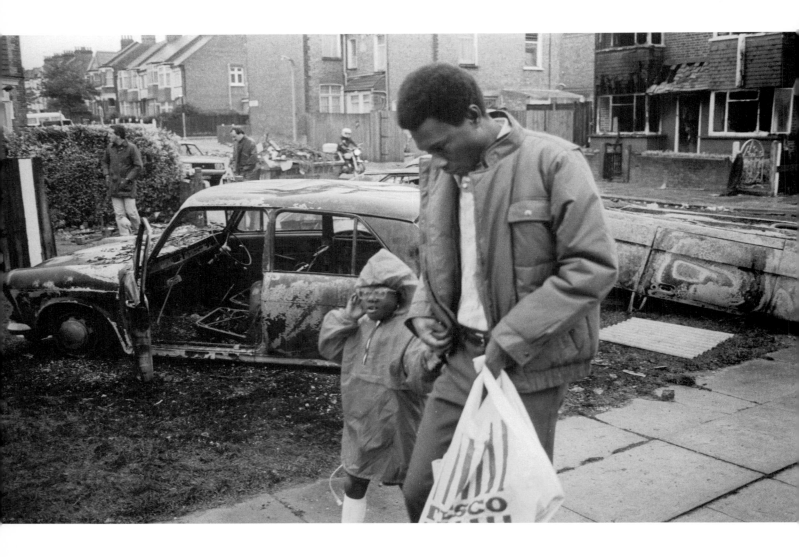

Burnt-out cars the day after the riot of 6 October 1985 at the Broadwater Farm housing estate, Tottenham. The disorder developed after Cynthia Jarrett collapsed and died while police searched her home for stolen property. PC Keith Blakelock died after being attacked by rioters in the ensuing violence

photographs are useful in finding answers to several critical questions. How was it possible in the light of that denial to manifest black Britain's rightful claim to belong? To make the historic demands for recognition and entitlement appear obvious and reasonable?

The dynamic grace of Ian Wright, captured during a game between Arsenal and Blackburn Rovers, might be used to cement this point. Wright proved to be an enduring symbol not only of black Britain's sporting prowess but of the larger issues involved in the integration and mainstreaming of black culture during this period. Like Linford Christie, Denise Lewis and the others, his athletic, superhuman celebrity was one of the first developments effectively to challenge the idea that blackness alone disqualified people from belonging to Britain and, more importantly, from being recognised as British. The particular

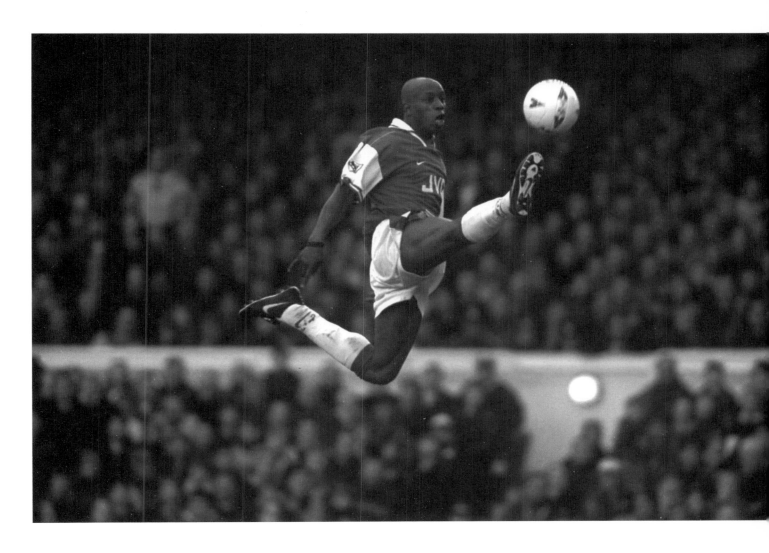

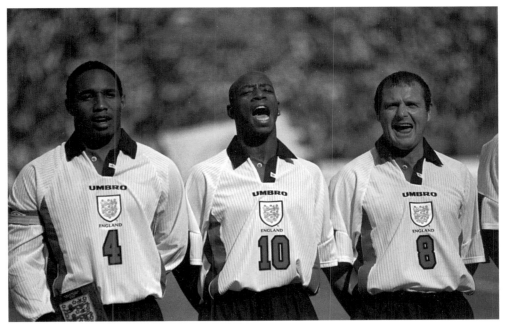

Ian Wright of Arsenal during the FA Carling Premiership match against the Blackburn Rovers at Highbury Stadium, London, 14 December 1997

Captain Paul Ince singing the national anthem with teammates Ian Wright and Paul Gascoigne during the match between Morocco and England in the King Hassan II Cup, Casablanca, Morocco, 27 May 1998

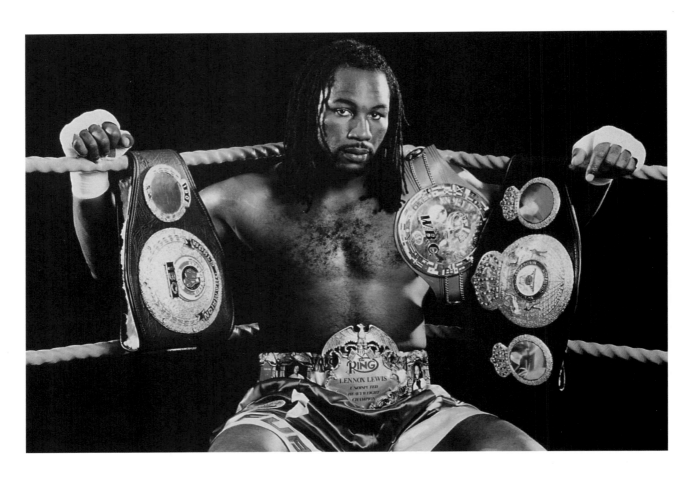
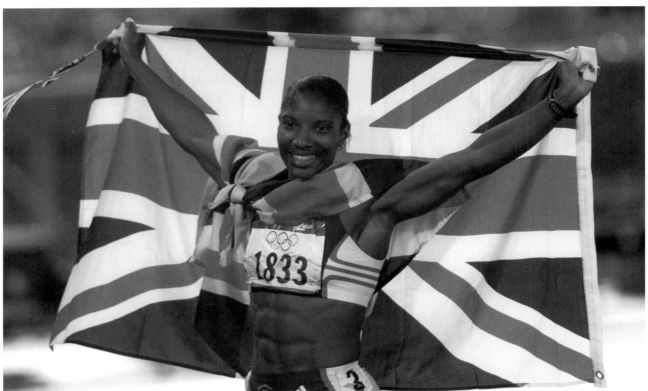

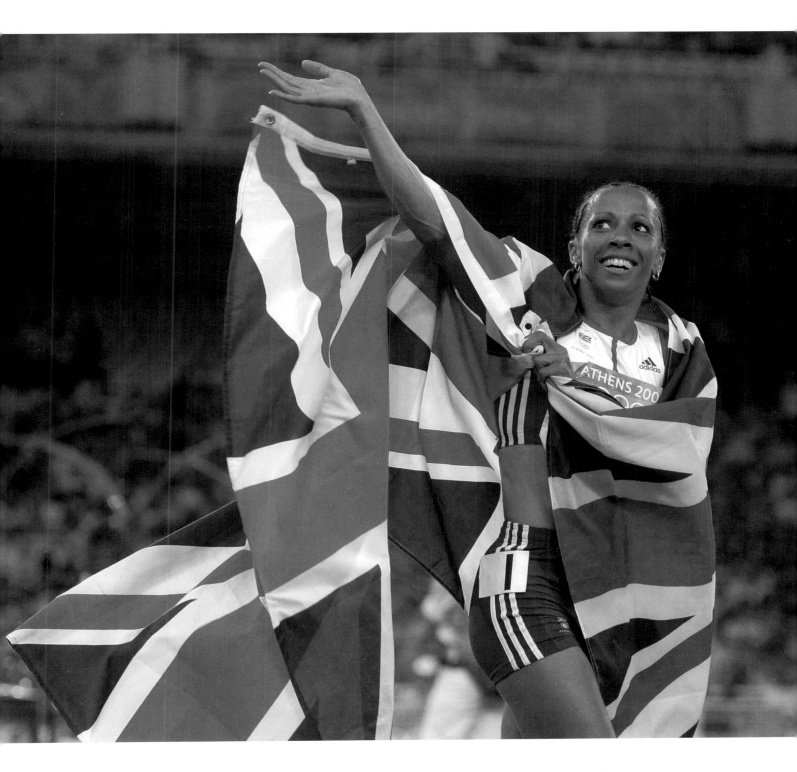

Kelly Holmes celebrating her gold medal in the women's 1,500m final at the Athens 2004 Summer Olympics, 28 August 2004

Facing page, top: Undisputed World Heavyweight Champion Lennox Lewis, with his championship belts, 2000

Facing page, bottom: Denise Lewis celebrating her gold medal victory in the final of the Women's Heptathlon, Sydney, 24 September 2000

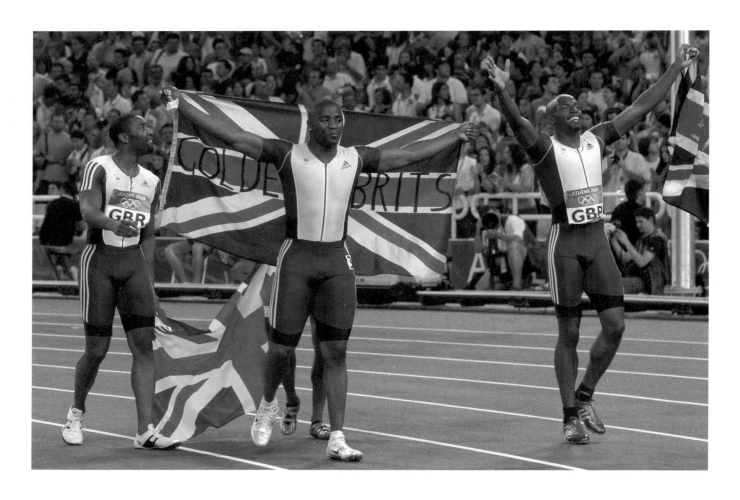

4 x 100m team members Mark Lewis-Francis (centre), Darren Campbell (left) and Marlon Devonish celebrating their gold win at the Olympic Games, Athens, 28 August 2004

attachment of this cohort to the Union Jack suggests that photographers and athletes alike realised that there was a point to prove.

The gritty black midfield players who had brought the First Division football title to Highbury in 1989 and 1991 detonated the racist assumptions about black physiology and temperament which had governed popular sport in Britain up to that point. A few years later, a similar shock was delivered by the presence of a noticeable number of black faces in the crowd grieving over the death of Princess Diana. Their evident bereavement and apparent integration into the mourning jolted complacent commentators who were unable to account for the multicultural snapshot of national life provided by that unhappy event. However, it was the murder of Stephen Lawrence at a bus stop in Eltham, South London in April 1993 that would settle the question of black belonging with a finality that even more recent talk about security and homegrown terrorism has been unable to dislodge.

Top: Linford Christie after his victory in the 100m sprint final at the Barcelona Olympics, 1 August 1992. Christie won the gold in a time of 9.96 seconds

Left: Naomi Campbell modelling a Union Jack shirt with a blue skirt and jacket by designer Clements Riberio at London Fashion Week, 3 February 1997

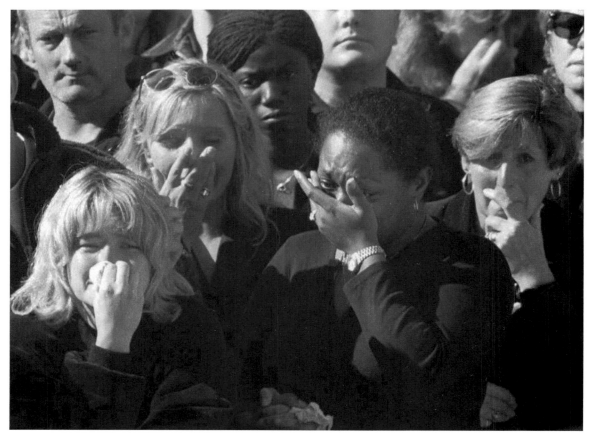

STOP THE GUNS.
Call Crimestoppers anonymously on 0800 555 111.

Left: Campaign material from Operation Trident, which tackles gun crime within London's black communities, 21 October 2004

Bottom: Corporal of Horse Hooper (right) speaks to Melvin Lodge as Lodge begins a week with the Scots Guard, London, 23 September 2002

Facing page, top: Rapper Sway posing backstage after winning the award for Best Hip Hop at the MOBO Awards 2005, the tenth anniversary of the annual music event, at Royal Albert Hall, London, 22 September 2005

Facing page, bottom: Spectators weep along London's Whitehall during funeral ceremonies for Diana, Princess of Wales, 6 September 1997

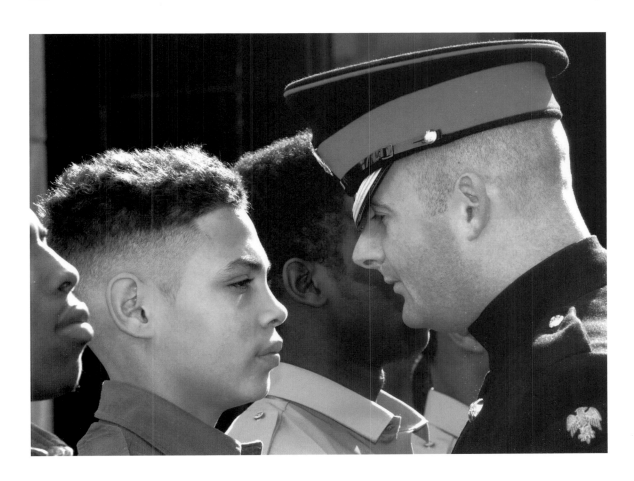

Doreen Lawrence, Lee
Jasper, TY, Raghav
and Big Brovas at the
'Respect 2004' music
festival in Victoria
Park, London, 17 July
2004

Over the years, shocking racist murders were normal if not exactly routine events. The killings of Kelso Cochrane, David Oluwale, Gurdip Singh Chaggar, Altab Ali and Roland Adams had all momentarily focused attention on the shameful acts of Britain's violent racists and the immoral antics of their various apologists on the ultra-right as well as the failures of the criminal justice system. Even after the Lawrence murder, something of that old routine would reappear with the deaths of Damilola Taylor in Peckham, Michael Menson in Edmonton, Anthony Walker in Liverpool, Kriss Donald in Glasgow and Mohammad Parvaiz in Bradford.

What distinguished the Lawrence case in particular was the comprehensive failure of the authorities either to investigate the

Left: Break-dancers at 'The Red Bull Vert Session Tour 2004', Brighton, 5 September 2004

Below: Prince Charles with Stephen Lawrence's parents, Doreen and Neville Lawrence, after giving the inaugural Stephen Lawrence Memorial Lecture at The Prince's Foundation, Shoreditch, London, 7 September 2000

Bottom: The Nokia Urban Music Festival with The Prince's Trust, Earls Court, London, 16 April 2005

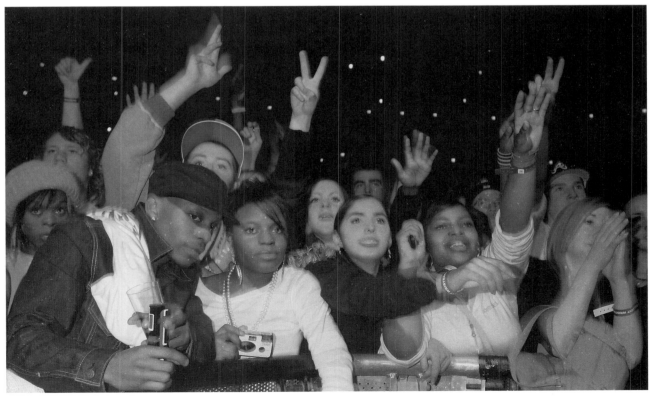

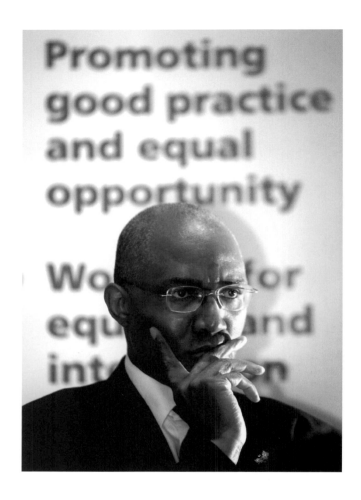

Right: Trevor Phillips, Head of the Commission for Racial Equality (CRE), addressing the media during a London press conference, 8 March 2005

Bottom: The Stephen Lawrence enquiry at Hannibal House, Elephant and Castle, London, 1998

Facing page: Singer Caron Wheeler, 1990

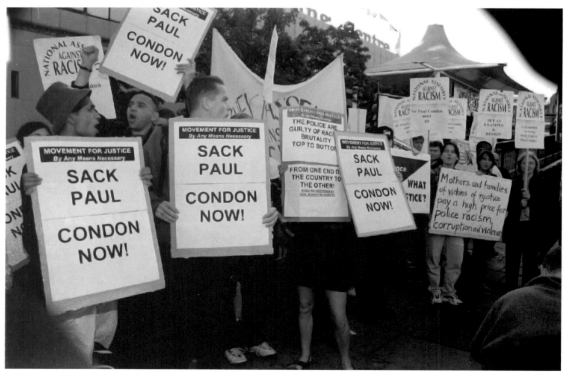

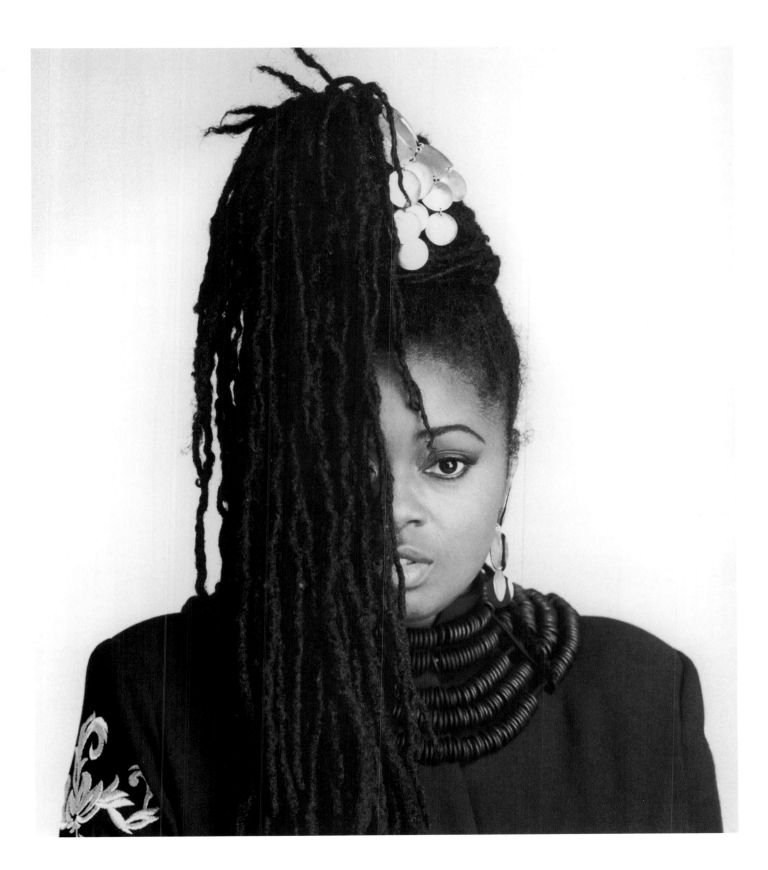

Actor Colin Salmon,
1990

murder or to prosecute the perpetrators whose names had been passed to the family within hours of the outrage. The Lawrence case represented the end of the traditional pattern in which police could treat victims as criminals and then snigger at the loss of black lives valued so much more lightly than their white equivalents. Reactions to the Lawrence tragedy eventually shamed Britain into action that would reverse the influential judgment offered about the country's race relations in 1981 by its official interpreter, Lord Scarman. The learned judge had said there was no institutional racism to be found in Britain. Enquiring into the whole sequence of events on behalf of the newly elected Labour administration, his judicial successor, Sir William Macpherson, amended Scarman's view and charged British public life with the eradication of the institutional racism that had corroded and

compromised it for so long. In the context of a new Labour government, there was a chance that the old cross-party consensus in this area would finally be set aside.

The period since then can be defined through an intensification of the mainstreaming dynamic. Braided into it are other developments in which technology, a saturated media and an experience of globalisation as a process of Americanisation have contributed to a generic form of black culture which corresponds little to contemporary Britain's social and historical circumstances.

The good side of this shift has rendered blackness as a post-exotic, familiar phenomenon with an uncontentious place in everyday life. Its more negative aspects have effectively handed over black culture to the

England coach Hope Powell during a training session as part of the football team's preparations for the Women's Euro 2005 Championship at Milton Keynes Dons training ground, 14 February 2005

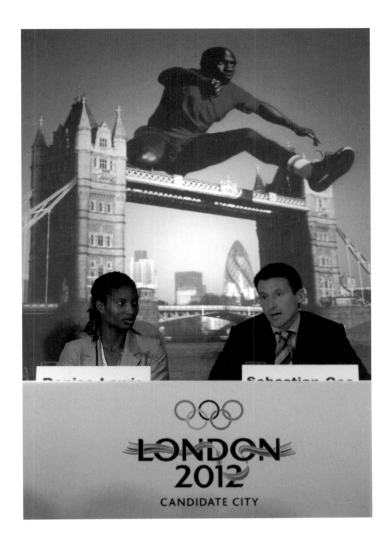

Denise Lewis (left), Olympic Gold Medallist heptathlete, and Sebastian Coe, Chairman of the London 2012 bid team, at a news conference in Singapore, 3 July 2005

Facing page, top: Residents of Bethnal Green and Bow constituency, London, where the seat was contested by Labour MP Oona King and George Galloway of the newly formed Respect Party, 1 April 2005

Facing page, bottom: Mourners wearing basketball and football shirts at the funeral of murdered teenager Anthony Walker, Liverpool, 25 August 2005

Following page: Shocked survivors of the terrorist bombings in London, 7 July 2005

exclusive custodianship of corporate interests eager to take advantage of its reach in their globalised branding operations.

Happily, immigration from the new Commonwealth is no longer at the unstable core of xenophobic Britain's nationalistic anxieties about race, belonging and identity. For the most part, West Indians and their descendants have been grudgingly accepted into the national family portrait. As long as they are not converts to Islam, they have mostly been allowed to pass inside the citadel. Their presence has been judged to make sense at appropriate levels within a new class structure where inequality is increasing quietly, disassociated from some of the more pernicious assumptions of deference. African settlers whose cultures are less familiar and who may have arrived later are liked less, but they are tolerated far more than late-coming asylum seekers, refugees and illegal

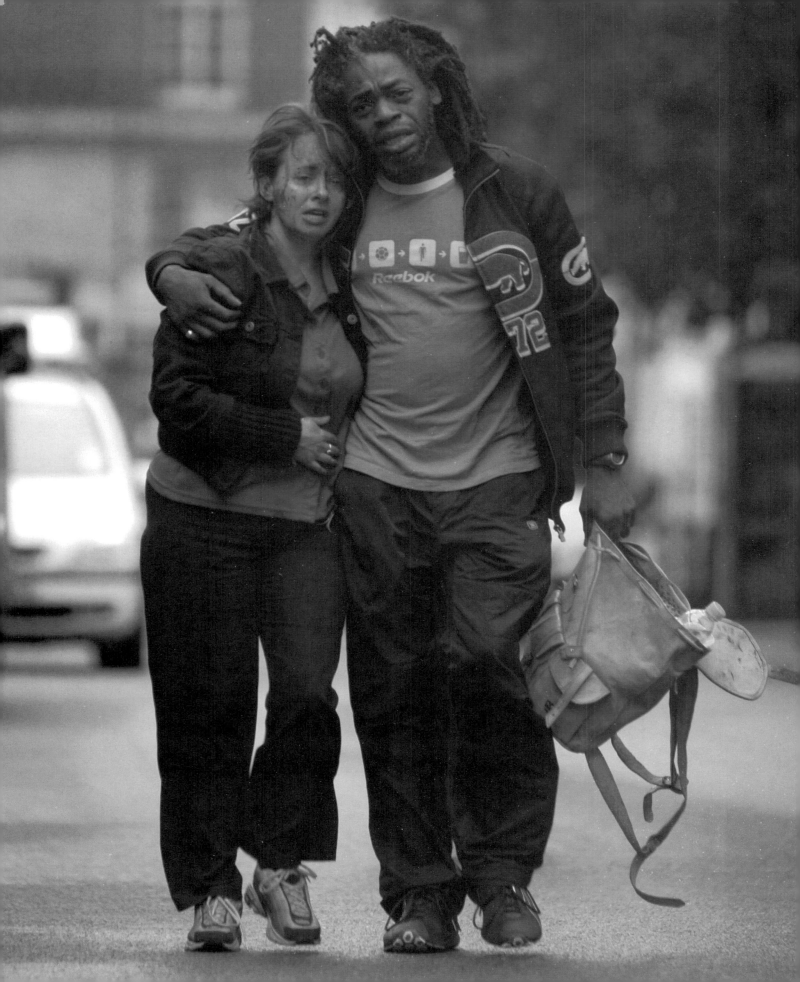

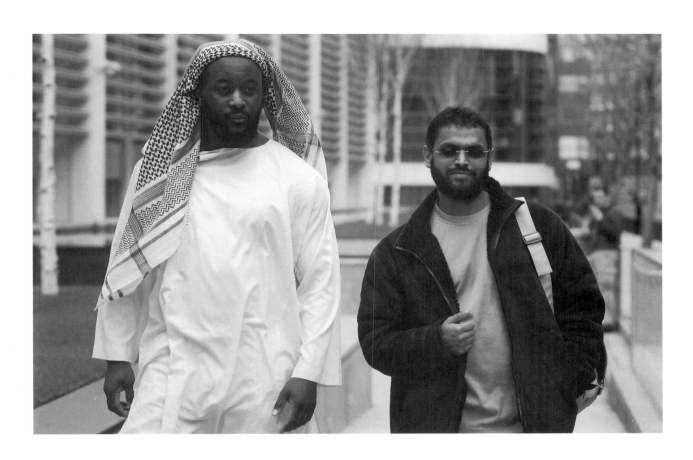

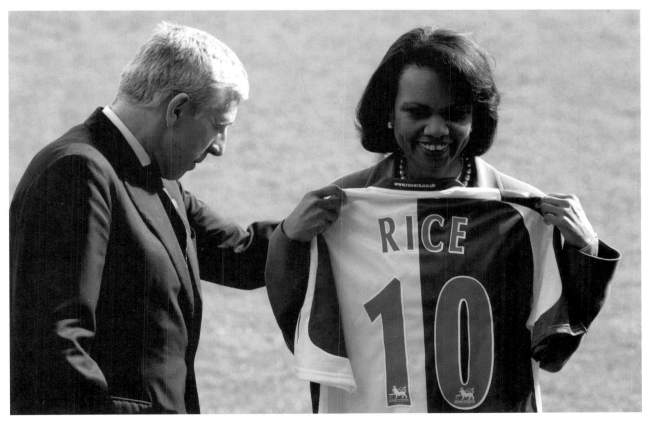

Heavyweight boxer Mike Tyson with fans outside the Grosvenor House Hotel, London, 19 January 2000

Previous page, top: Former Guantanamo detainees Martin Mubanga (left) and Moazzam Begg leave the Home Office after delivering a petition demanding the release of five UK residents still being held at the US prison camp, 14 March 2005

Previous page, bottom: US Secretary of State Condoleezza Rice (right) and British Foreign Secretary Jack Straw at Blackburn Rovers' Ewood Park stadium, Blackburn, 31 March 2006

Facing page: Samantha Mumba, London, 26 October 2002

Options Zoom

So Solid Crew at
the Brit Awards,
Earls Court,
20 February 2002

Facing page:
Ms Dynamite
at an anti-war
march, London,
15 February 2003

denizens whose disruptive demands for inclusion have complicated the old relationship between immigration and colour-coded hierarchy.

These new pariahs have been targeted for the coerced assimilation that can resolve a supposed clash of civilisations in the unpredictable climate of open-ended, neocolonial war. A new version of race politics has emerged with this, squarely centred on problems of security rather than of immigration. British political culture, already fractured by unresolved divisions about the legitimacy of the government's military adventures, has seen the simpler political field that used to contain racial conflicts recomposed around the grand geopolitical themes of religious and civilisational conflict.

African American culture is being reduced to the role of soundtrack to the new imperium. It provides a *lingua franca* for bored and

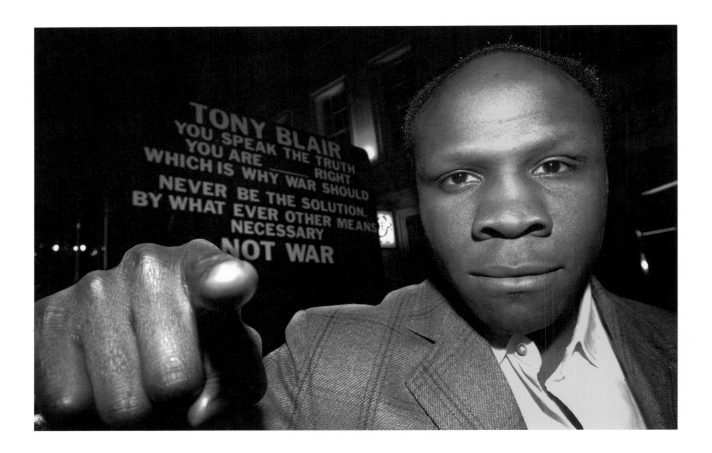

Former boxer Chris
Eubank at the launch
party for a Voyage
store in Conduit
Street, London,
19 March 2003

Facing page:
Members of the new
Royal Scots regiment
during a re-badging
ceremony at the
Shaibah base in Basra,
Iraq, 28 March 2006

disenchanted youth everywhere, but is now also an integral component in the commercial operation that seduces the vulnerable and ignorant young into the machinery of the US military. Sadly, many young black Britons have no idea that their social and economic predicament might differ from the position of African Americans trapped in an environment where rigid segregation remains an unspoken norm.

I hope these photographs will contribute to the growth of a new cultural history that refuses the dubious gift of a generic, US-centred blackness and stays stubbornly tied to the broken edifice of our leaky national state. That choice affiliates black life here with a vital culture that cannot be conceived as a dead piece of property to be monopolised by any particular group of owners. It appears instead as a living but unfinished historical process that resists that kind of transposition and may yet teach the world something.

Of course, other ideas will be promoted by our governments, who are keen to disguise their authoritarian character by sprinkling

Norman Jay playing
his set from the Good
Times Bus during the
Notting Hill Carnival,
27 August 2006

Facing page:
Gaming fans queuing
in the early hours to
purchase the Wii,
Nintendo's latest
games console,
which was released
at the stroke of
midnight, London,
8 December 2006

a glittery, multicultural crust over the horrible social consequences of increasing inequality. We will have to weigh the consequences of unanticipated multiculture against a desperate situation in which there are more young black British men in prison than in higher education. They are not just more likely to be incarcerated because they are victims of racism, but because they are poorer, less educated and less healthy as well as more likely to be distracted and seduced by the empty dreams of a consumer culture that promises them something for nothing and neatly divides their world into the two great metaphysical tribes of winners and losers.

Their prognosis is worse, because the government has opted to associate education with debt and to effectively privatise the task of generating social policies capable of addressing the plight of the country's black and minority communities. An army of consultants is already the flimsy backbone of an insecure black middle class. Whether

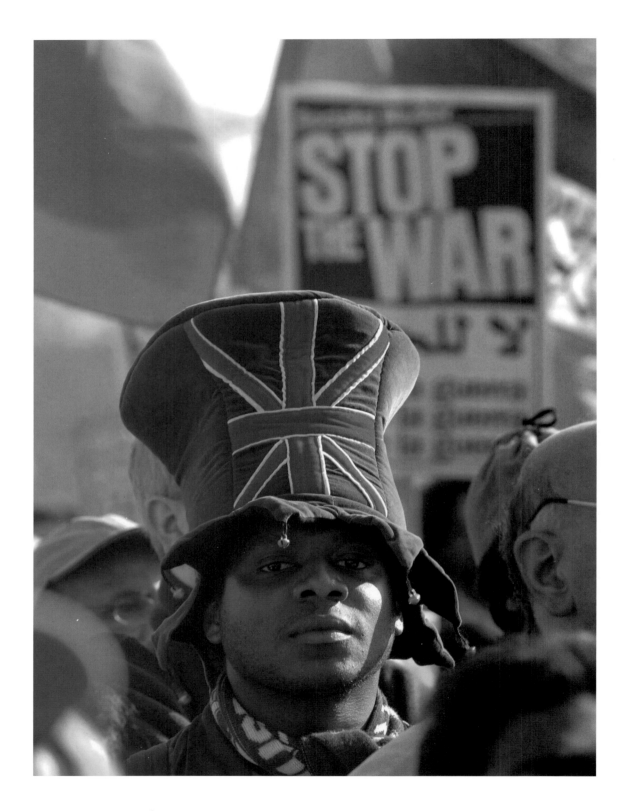

Demonstrator protesting against the
war in Iraq, London, 21 March 2003

Facing page: An anti-war protester,
Piccadilly, 22 March 2003

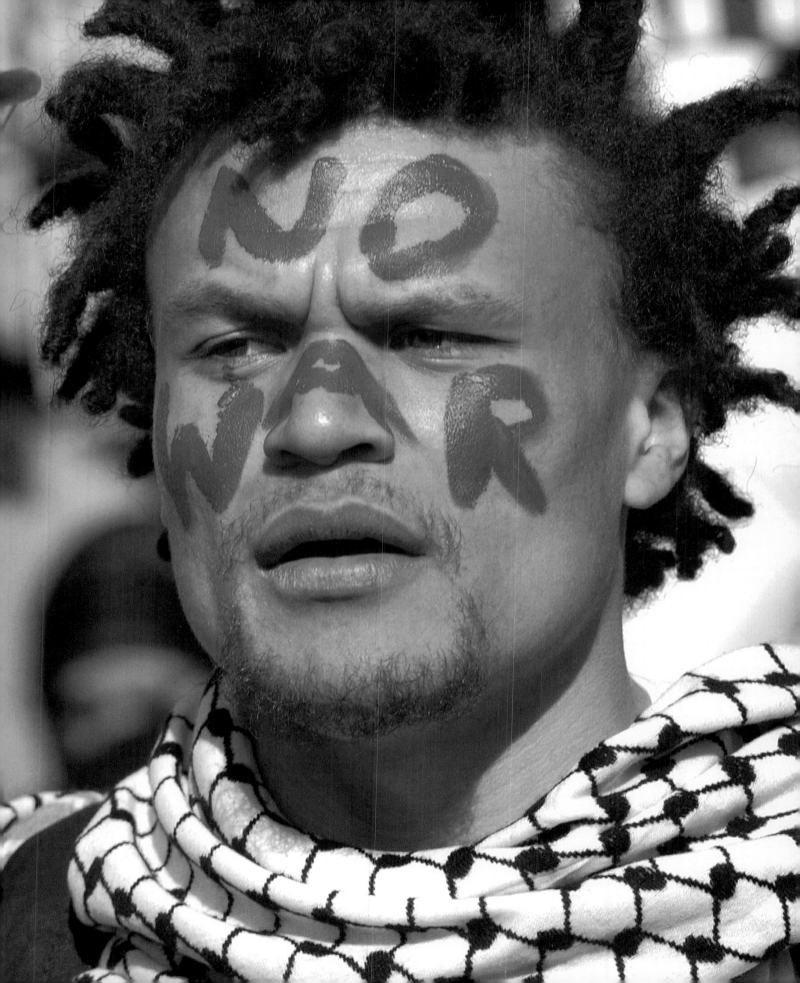

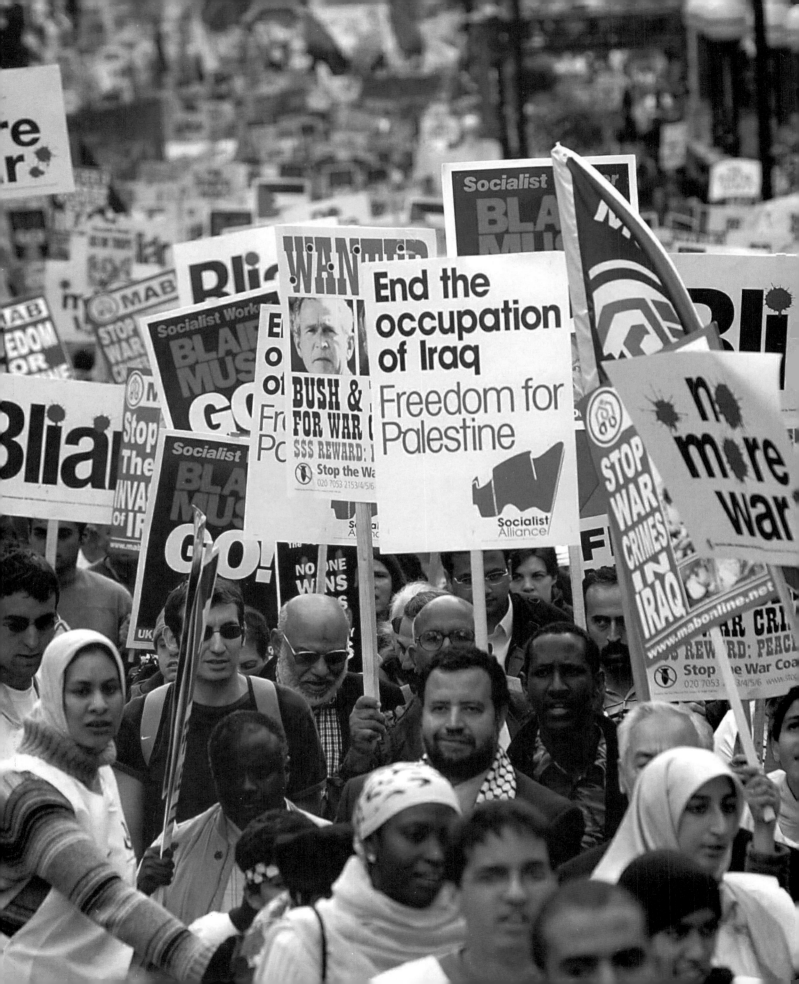

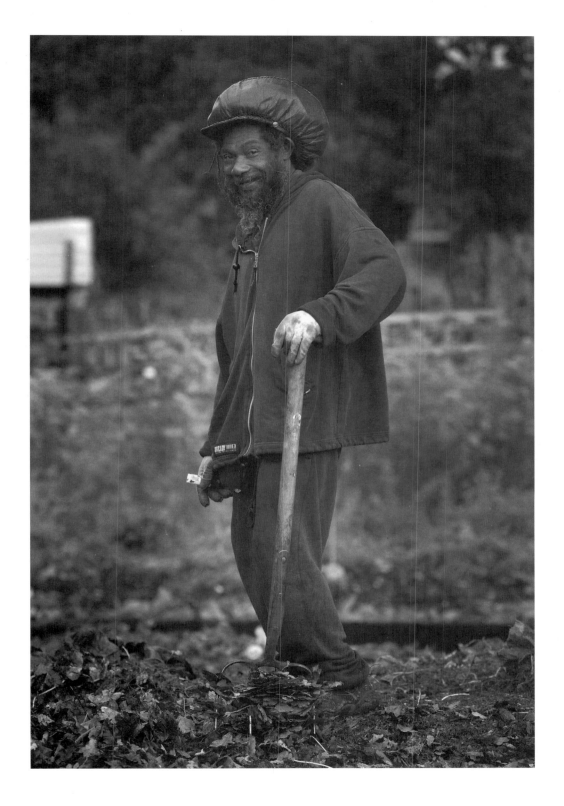

Gardener Rasta Man tending
his plot on the Uplands Allotments
in Handsworth, Birmingham,
17 August 2006

Facing page: Anti-war rally organised
by the Stop the War Coalition on the
eve of the Labour Party Conference,
London, 27 September 2003

Children playing computer games at the Science Museum, London, 20 October 2006

that group has the capacity or the will to serve more than its own narrow interests remains to be seen.

These, then, are the difficult circumstances in which we have arrived at the point where a dynamic history of black life in Britain can be captured in images and readied for sale in the form of a coffee-table volume. The question that serves me here as a conclusion asks you now: Can these precious photographs start to speak for themselves?

Further Reading

Aspden, Kester, *Nationality Wog: The Hounding of David Oluwale*, London: Jonathan Cape, 2007.

Banton, Michael Parker, *The Coloured Quarter: Negro Immigrants in an English City*, London: Jonathan Cape, 1955.

Bourne, Stephen, *Black in the British Frame: The Black Experience in British Film and Television, 1896–1996*, London: Continuum, 2001.

Bryan, Beverley et al., *The Heart of the Race: Black Women's Lives in Britain*, London: Virago, 1985.

Cathcart, Brian, *The Case of Stephen Lawrence*, London: Penguin, 2000.

Foot, Paul, *The Rise of Enoch Powell: An Examination of Enoch Powell's Attitude to Immigration and Race*, London: Penguin, 1969.

Fryer, Peter, *Staying Power: The History of Black People in Britain*, London: Pluto Press, 1984.

Geiss, Imanuel, *The Pan-African Movement: A History of Pan-Africanism in America, Europe and Africa*, New York: Africana Pub. Co., 1974.

Gilroy, Paul, *There Ain't No Black in the Union Jack: The Cultural Politics of Race and Nation*, London: Routledge, 2002.

Green, Jeffrey P, *Black Edwardians: Black People in Britain 1901–1914*, London and Portland, OR: Frank Cass, 1998.

Griffiths, Peter H S, *A Question of Colour?*, London: Frewin, 1966.

Hall, Stuart et al., *Policing the Crisis: Mugging, the State and Law and Order*, London: Palgrave Macmillan, 1978.

Humphry, Derek and David Tindall, *False Messiah: The Story of Michael X*, London: Hart-Davis MacGibbon, 1977.

Jackson, Ashley, *The British Empire and the Second World War*, London and New York: Hambledon Continuum, 2006.

Lamming, George, *The Pleasures of Exile*, London: Michael Joseph, 1960.

Little, Kenneth, *Negroes in Britain: A Study of Racial Relations in English*

Society, London: Kegan Paul, 1948.

Morrison, Majbritt, *Jungle West 11*, London: Tandem Books, 1964.

Phillips, Mike and Trevor Phillips, *Windrush: The Irresistible Rise of Multi-racial Britain*, London: HarperCollins, 1998.

Pilkington, Edward, *Beyond the Mother Country: West Indians and the Notting Hill White Riot*, London: I.B. Tauris, 1988.

Scobie, Edward, *Black Britannia: A History of Blacks in Britain*, Chicago: Johnson Pub. Co., 1972.

Smith, Graham, *When Jim Crow Met John Bull: Black American Soldiers in World War II Britain*, London: I.B. Tauris, 1987.

White, Jerry, *London in the Twentieth Century*, London: Penguin, 2002.

Index

Photo Credits and Acknowledgments

Saqi is grateful to the following sources for their kind assistance

Imperial War Museum pp. 24, 48 and 49
Jonathan Hordle/Rex Features p. 300
Photo News Service/Rex Features p. 294, bottom

All other images in this book are courtesy of Getty Images, including the following which have further attributions:

Agence France-Presse/Getty Images pp. 283, top; 288; 289, bottom; 290, bottom; 301, bottom; 309; 312
Simon Frederick/Getty Images p. 292
Tim Graham/Getty Images p. 293, top right
Leon Morris/Getty Images p. 275, bottom; p. 277, top; p. 278, top
Terry O'Neill/Getty Images p. 296
Steve Pyke/Getty Images p. 295
Tom Stoddart/Getty Images p. 298 top
Kevin Wheeler/Getty Images p. 283, bottom
Val Wilmer/Getty Images pp. 164, 165, 186, 187

Endeavour London Staff

Jennifer Jeffrey: Picture Researcher
Tea Aganovic: Scanning

Saqi Staff

Lara Frankena: Managing Editor
Mitch Albert: Copy-editor